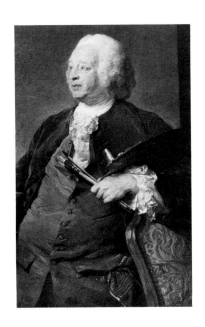

JEAN-BAPTISTE OUDRY
1686-1755

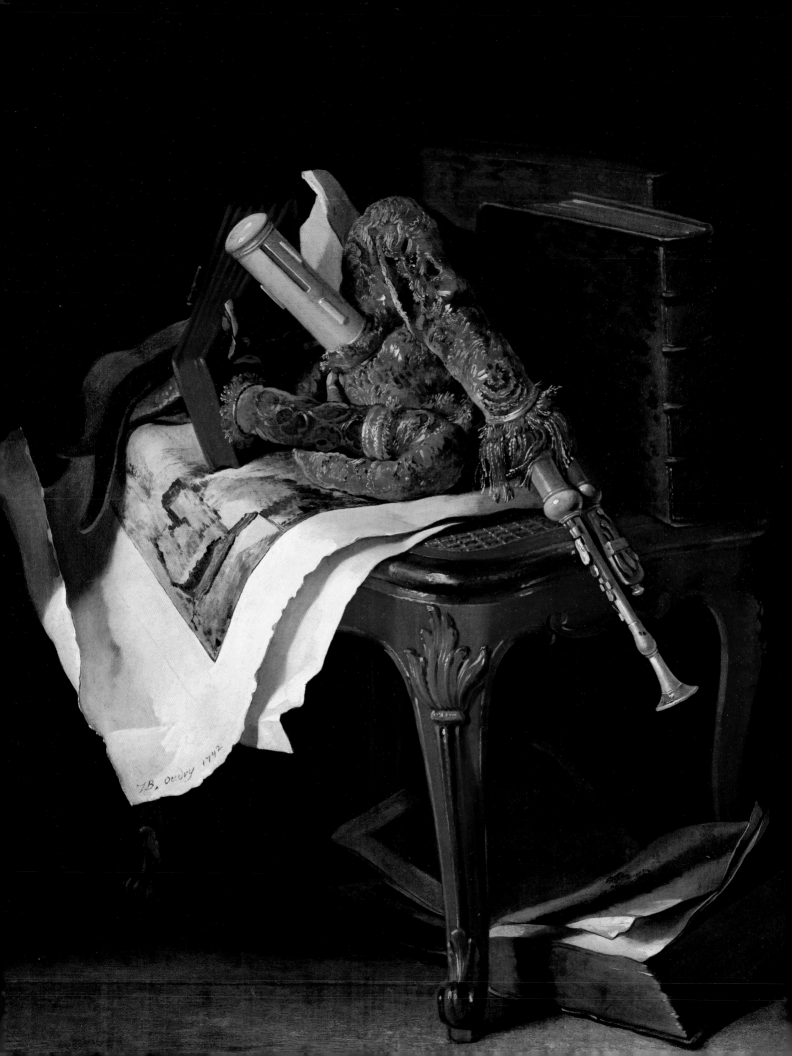

J.-B. OUDRY

1686-1755

By Hal Opperman

KIMBELL ART MUSEUM

Fort Worth, 1983

Distributed by
University of Washington Press, Seattle and London

This catalogue is published on the occasion of an exhibition at the Kimbell Art Museum, Fort Worth
 February 26-June 5, 1983
and at The Nelson-Atkins Museum of Art, Kansas City
 July 15-September 4, 1983

Copyright 1983
by the Kimbell Art Museum
Library of Congress Card Number: 82-84544
ISBN (Cloth) 0-912804-11-4
 (Paper) 0-912804-12-2
Printed in U.S.A.

Design: James A. Ledbetter

COVER:
Indian Blackbuck, 1739
Staatliches Museum, Schwerin
Catalogue number 49

HALF-TITLE PAGE
Jean-Baptiste Perronneau (1715-1783)
Jean-Baptiste Oudry (detail), 1753
Louvre, Paris

FRONTISPIECE
"*Le Tabouret de Laque*", 1742.
Cailleux, Paris
Catalogue Number 60

Contents

1

Lenders to the Exhibition

FRANCE:
Agen
 Musée des Beaux-Arts

Fontainebleau
 Musée national du Château de Fontainebleau

Paris
 His Excellency the Ambassador of Sweden in France
 Messrs. Cailleux
 Musée de la Chasse et de la Nature
 Musée du Louvre

Rouen
 Musée des Beaux-Arts

Strasbourg
 Musée des Beaux-Arts

Toulouse
 Musée des Augustins

Versailles
 Musée national du Château de Versailles

GERMAN DEMOCRATIC REPUBLIC:
Schwerin
 Staatliches Museum Schwerin

GREAT BRITAIN:
Edinburgh
 National Gallery of Scotland

London
 British Museum
 Courtauld Institute Galleries
 Messrs. Edward Speelman Limited

UNITED STATES:
Chicago
 The Art Institute of Chicago

Cleveland
 The Cleveland Museum of Art

Detroit
 The Detroit Institute of Arts

Sarasota
 The John and Mable Ringling Museum of Art

Toledo
 The Toledo Museum of Art

Preface

Jean-Baptiste Oudry (1686-1755) was one of the greatest European artists of the first half of the eighteenth century. Immensely popular in his day, his pictures and drawings were dispersed all over Europe by the time of his death and are much less familiar today than those of many of his contemporaries. At the beginning of his career Oudry absorbed the coloristic principles of Nicolas de Largillierre, his master, to which he added an ever more acute vision of nature. His greatest and most original artistic contributions lie in landscape, still life, and animal painting. Sensitivity to light — a principal feature of his renderings of the forests, fields, and gardens around Paris — sets his landscapes apart from the imaginary scenes of other French painters of the time. His still lifes are masterpieces of the study of color and of a direct and simple illusionism that is faintly surreal. Oudry's numerous pictures of animals and the hunt manifest a new attitude toward man's place in nature.

Through a highly selective group of Oudry's paintings and drawings, and a monographic publication accompanying the display, this exhibition intends to demonstrate the range and quality of Oudry's achievement. The exhibition is being presented jointly by the Kimbell Art Museum, The Nelson-Atkins Museum of Art in Kansas City and the Réunion des Musées Nationaux, Paris. After its American debut in Fort Worth, the exhibition will travel to Kansas City where it will be seen as part of the 50th anniversary of the Nelson-Atkins Museum of Art.

The catalogue accompanying the exhibition will be an important contribution to the scholarly reassessment currently under way of the overlooked and misunderstood period between the *Grand Siècle* of Louis XIV and the Revolution. Oudry played a key role in helping to replace the élite basis of art with an appeal to a broader public. Discussing and illustrating major works from public and private collections in Europe and North America, this publication will constitute the first comprehensive and fully illustrated introduction to Oudry's art in the English language.

Edmund Pillsbury
Director, Kimbell Art Museum

Foreword

Jean-Baptiste Oudry is one of the most prolific artists — and without question the most versatile — of the French eighteenth century. Once established he was also one of the most successful of his time. His works remained in favor with collectors down until the Revolution, when his reputation slumped along with those of the other members of his generation. His critical fortune revived again toward the middle of the following century, but not nearly as much as that of a Watteau, a Chardin, a Boucher. Yet over the last thirty years there is evidence — sporadic but solid — that Oudry is once more beginning to attract the attention of collectors, specialists, and *amateurs* of the fine arts. This comes in the form of rising prices, in the increasing numbers of his works that are gaining places of honor in public collections, and now and then the sensitive remark about this or that picture or drawing, evidence that someone is stopping to look, to see, to understand, to appreciate, and not just passing by.

One must ask why Oudry did not come back to favor as quickly and as fully as many of his contemporaries. We think that the major reason was the diaspora of his works. Many of the most important and the best were out of France. Many others were quietly tucked away in private collections, usually one by one (Oudry did not have his La Caze or his Marcille). When all of the Oudrys that decorated the royal residences in the eighteenth century were called back to the Louvre under the Revolution, they were not exhibited but kept in reserve, and over the years were split up and sent to the four corners of France. It had become impossible to obtain an idea of the whole. Then, too, Oudry did not concentrate his production on tidy collectibles of relatively small and uniform size as, for example, Watteau and Chardin. Another point: his subjects of living animals and the hunt certainly appealed less than the *sujets galants*, the pastorales, the bourgeois interiors, the simple still lifes stereotyped by the frères Goncourt (recall that Desportes' recovery was still less complete than Oudry's, and that he is almost purely an *animalier*). A further problem has to do with Oudry's role as a painter of decorations, most particularly his tapestry designs. In addition to their awkward size and to major concerns of conservation, which make them difficult to display, there still lingers a prejudice against tapestry in general, an unwillingness to consider it as an art form of the same rank as "true" painting. But Oudry's most ambitious works are tapestry models (let us recall in commemoration that 1983 marks the 250th anniversary of the commission of his chef-d'oeuvre, the *Chasses royales*). A full understanding of his accomplishment is impossible without an unbiased acceptance of Oudry's work for tapestry and of eighteenth-century tapestry as a whole, especially Beauvais, most of whose productions even today are poorly known.

There is confusion in the critical vocabulary between "decoration" as destination or purpose, and "decorative" as an ill-defined and usually pejorative stylistic label; Oudry's art has suffered in the public mind by association with both of these terms, even though the first is aesthetically neutral and the second misapplied. Oudry's art is often (but not always and never only) superbly and, in fact, consciously "decorative," if by this we mean that he exploits color, movement and contour brilliantly in terms of the plane surface of a picture. Here he reveals himself as the attentive student of Largillierre and the contemporary of many another artist who shared his "decorative" flair, among them Boucher. When we turn to the other half of the problem, though — that of pictures done specifically as part of a larger decor — there is real justification for considering some of them to be less than works of art. In looking at sale-room activity from about 1830 on, one finds many canvases that come from Oudry's workshop, no doubt for the most part decorative ensembles for dining-rooms, overdoors and buffets, of a quality far below his "original" works, whether these latter be decorations or easel paintings. But they passed as unalloyed Oudrys, and he thus achieved a reputation as an artist of uneven quality. Oudry was in a sense his own worst enemy; had he been thinking more about posterity he might have been less willing to produce these copies and rearrangements of his autograph pictures, done by assistants and retouched in varying degrees by himself. Finally, though, there remains the question that

history must ask of Oudry as of any artist: whether his art responded only to temporary conditions, to an ephemeral taste — call it "decorative" or what we will — that could not outlive the age that engendered it. The only response to this purely aesthetic question is that of quality. When one weeds out all the copies and replicas, when one compares what remains with the abundant documentation of the eighteenth century, when one finally looks at Oudry the artist, one finds that quality, and also an artist unlike any other of his day.

In his lifetime Oudry's studio seems to have been a sort of "Musée Oudry" where he displayed pictures from all the periods of his activity, sometimes sending them to the Salons more than once, keeping them for years before selling them and often not selling them at all. At his death in 1755 this collection was dispersed. The Duke of Mecklenburg-Schwerin purchased much of it which, added to works earlier acquired directly from the artist, composed a magnificent survey of his oeuvre, now housed in the Staatliches Museum Schwerin in the German Democratic Republic. Other repositories almost as important are the former royal collections of Sweden, assembled upon the advice of Carl Gustaf Tessin and today divided among several Swedish public collections; Fontainebleau, where a large and varied group of hunt subjects done for Louis XV was brought together in the nineteenth century; and, for drawings, the Cabinet des Dessins of the Louvre. None of these collections has ever been easily accessible; many of the paintings are very dirty and were long ago altered in size; still today they are often either set into woodwork high on the walls of rooms with poor lighting, or kept in storage. The rest of his immense production (we estimate that Oudry over the forty to forty-five years of his career executed nearly a thousand pictures and more than three thousand drawings) is scattered around the world. Much of it is in private hands; frequently we cannot say exactly where, since his works appear and disappear so often and so quickly with dealers and at sales. Oudry is still very much a collector's artist which, while sometimes causing frustration for historians, also brings its joys: Oudry has many surprises in reserve for the watchful connoisseur.

Much less has been written about Oudry than, for example, Chardin; Oudry's bibliography, if both were fully spelled out, would be a tenth of his. And most of the Oudry bibliography conveys information rather than criticism or interpretation. Scholarship on Oudry is truly in its infancy. Although there is abundant commentary from his own lifetime, after the dispersal of his works in 1755 there is very little for the simple reason that no one knew the oeuvre as a whole. For this reason we have decided to forego presenting a "fortune critique" in these pages, preferring to cite typical passages from older and more recent authors at appropriate places in the catalogue. The exhibition will give the opportunity to see Oudry again, and we hope that a new and a true "fortune critique" will begin here. Although we cannot review the bibliography, we must at least mention the four previous catalogues of his work and the uses we have made of them. The first is that of Louis Gougenot, appended to his life of Oudry read to the Académie royale in 1761. This is mostly an enumeration of pictures shown in the Salons, but sometimes with additional works and new information or comments: we cite it only in the latter cases. Then comes the classic catalogue of Jean Locquin, published in 1912, the point of departure of our own research and the first attempt to bring everything together — paintings, drawings, engravings, tapestries — and to reveal how large was the oeuvre of this artist. In 1930 appeared the catalogue by Jean Vergnet-Ruiz, mostly a simplified repetition of that of Locquin, but with some new works and observations, and for the first time a few illustrations. The fourth catalogue is part of our dissertation for the University of Chicago in 1972, brought up to date for its publication five years later. We can say without false modesty that this catlaogue is much more complete and much more accurate than any of the earlier ones. But we must also admit that since its publication at least fifty works by Oudry have reappeared that are either absent from it, or included only on the basis of mentions in old sales or the like. There will never be a complete catalogue of this artist. Not only are there too many works

to be found, but there is so much to be learned about them. We cite our catalogue raisonné frequently, not because it is the last word, but only in order to avoid encumbering this new study with repetitive information that would defeat its purpose. In our entries we have tried to be exhaustive in bibliographical citations, with the exception of museum catalogues, where we have been selective. We know that references have escaped us, but trust that others who find them will be tolerant of our failure to present them here.

The task we have set ourselves is to make accessible a fascinating and gifted artist who has been neglected and underestimated — misunderstood, perhaps, though never wholly forgotten. We are quite aware that the obstacles enumerated above have been only partially overcome. Nonetheless we can confidently lay to rest the belief all too commonly held, that Oudry's art is unvaried in subject and that it did not evolve. This of course is nonsense, based only on ignorance. The first half of the eighteenth century in France is a period of assimilation and transformation, full of ideas and invention, of discovery and change. Oudry's art is a mirror of this still largely uncharted age, both in content and in form.

H.O.

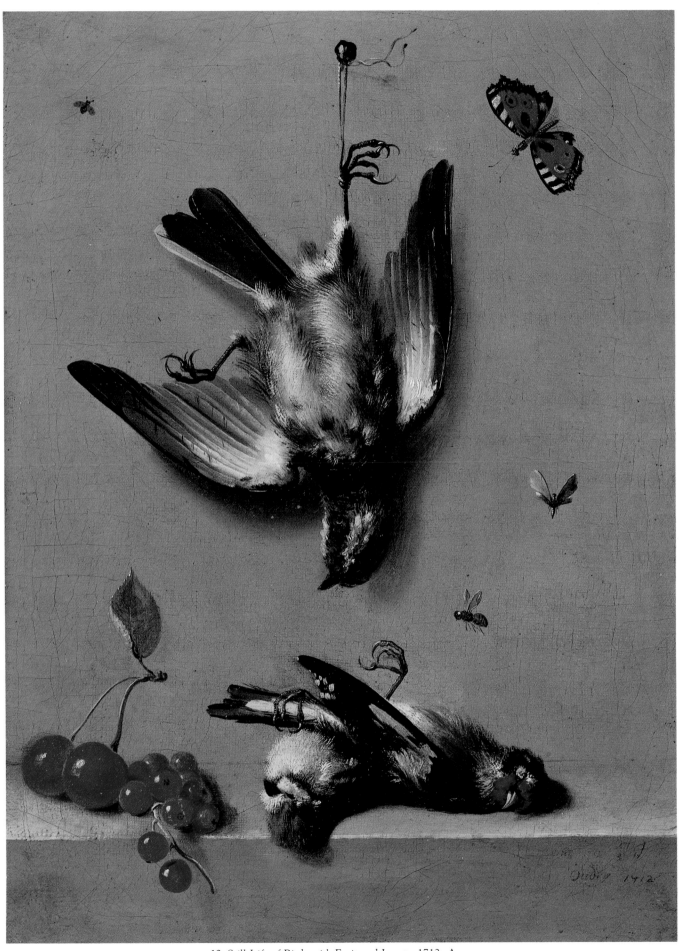

12 *Still Life of Birds with Fruit and Insects*, 1712. Agen.

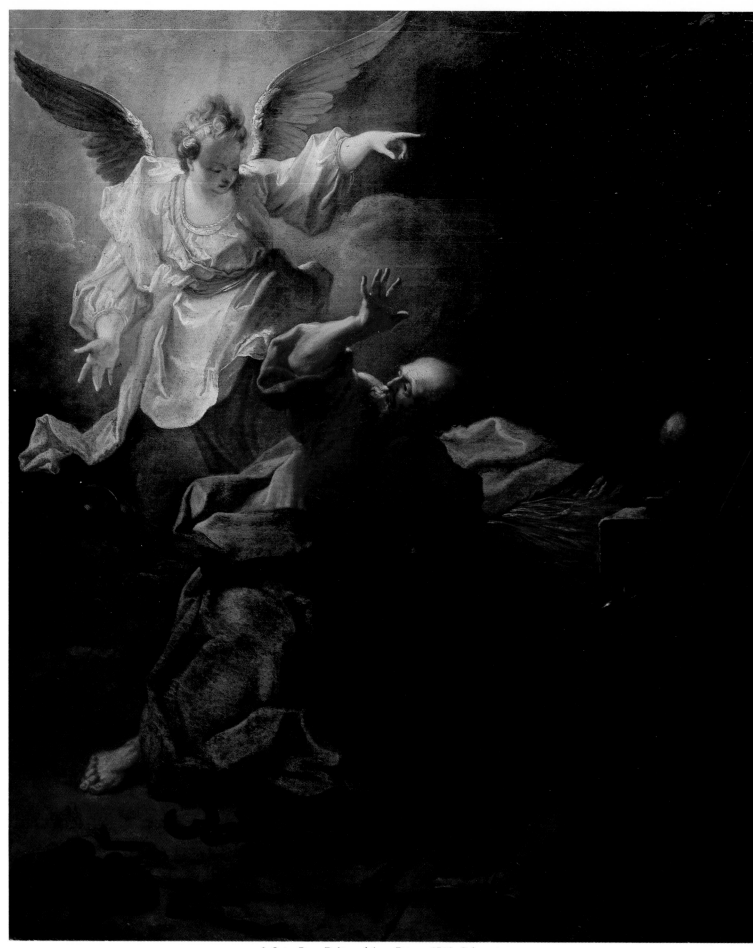

3 *Saint Peter Delivered from Prison*, 1713. Schwerin.

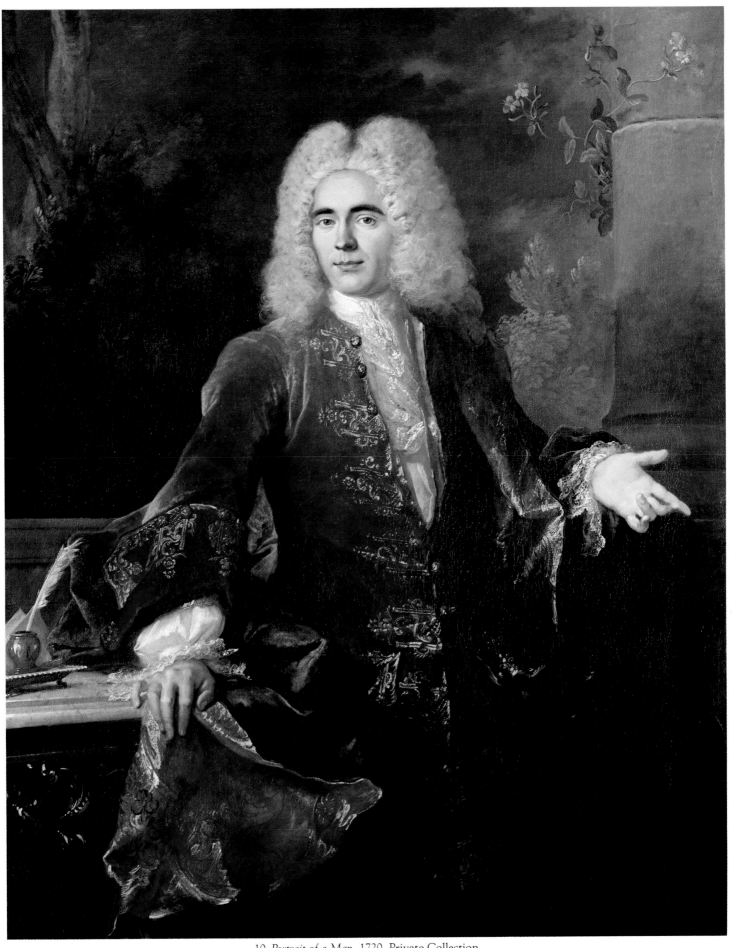

10 *Portrait of a Man*, 1720. Private Collection.

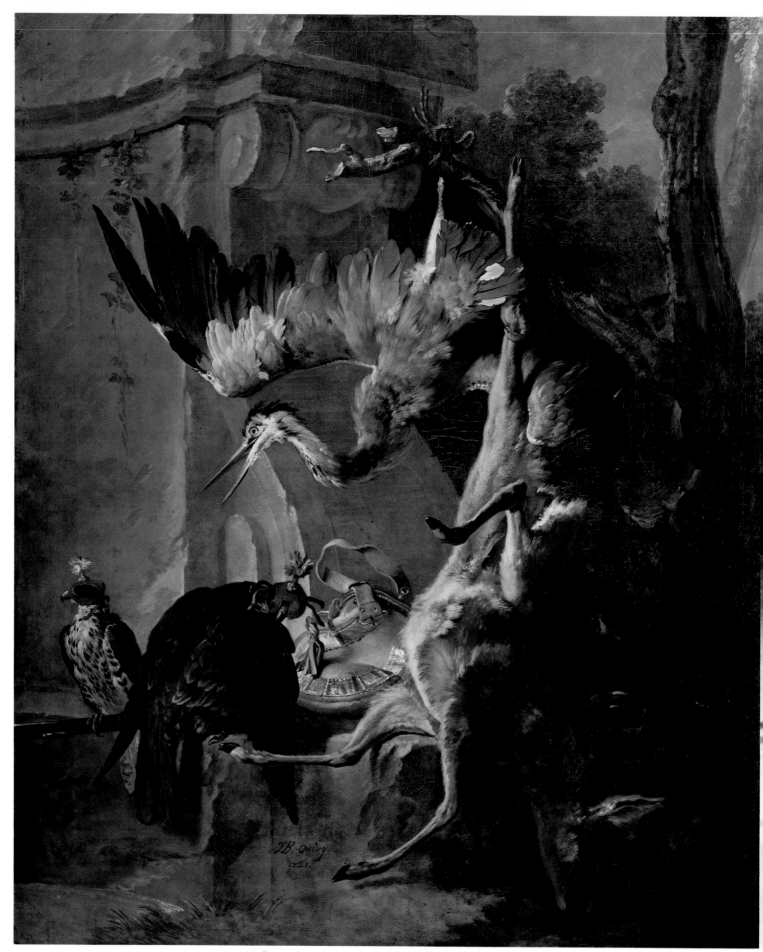

16 *Return from the Hunt with a Dead Roe*, 1721. Schwerin.

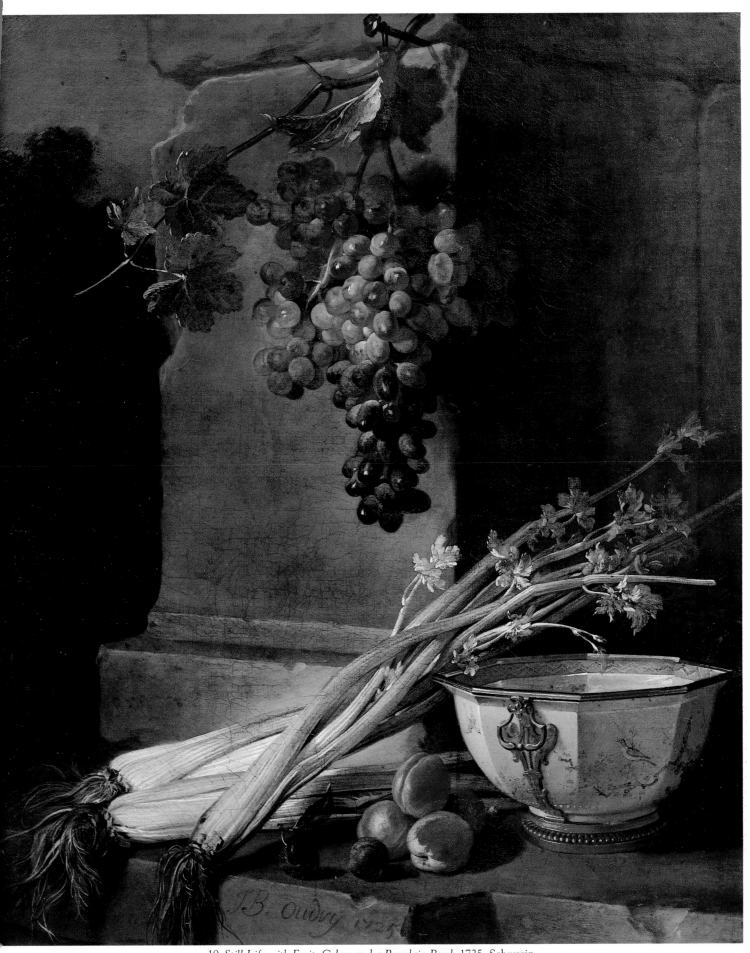

19 *Still Life with Fruit, Celery and a Porcelain Bowl*, 1725. Schwerin.

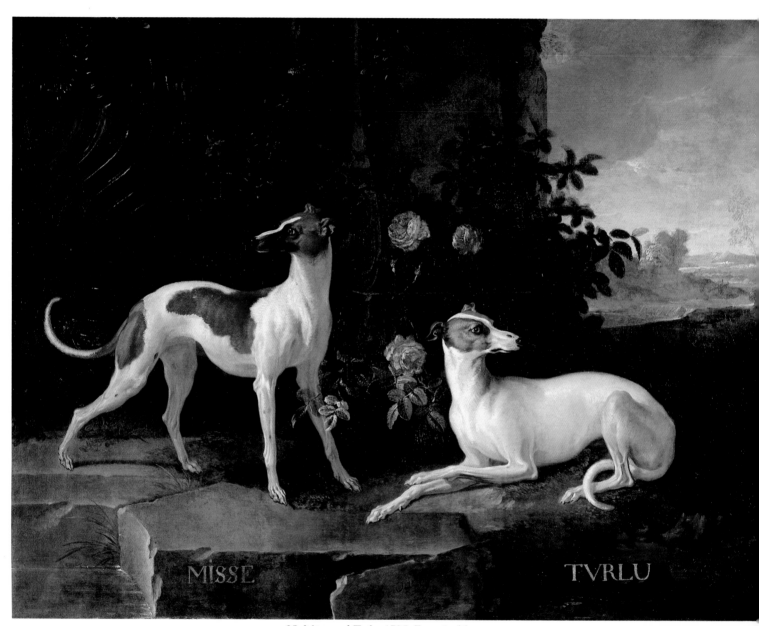

25 *Misse and Turlu*, 1725. Fontainebleau.

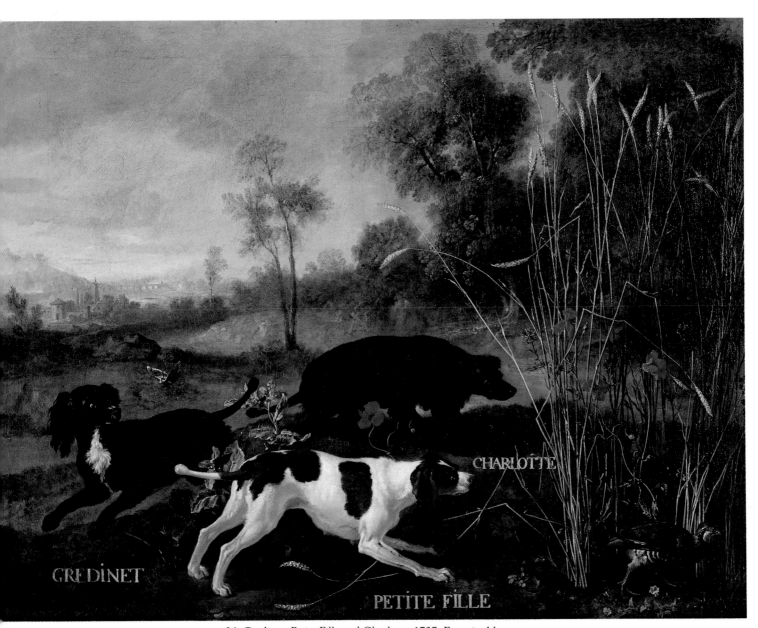

26 *Gredinet, Petite Fille and Charlotte*, 1727. Fontainebleau.

GREDINET

PETITE FILLE

CHARLOTTE

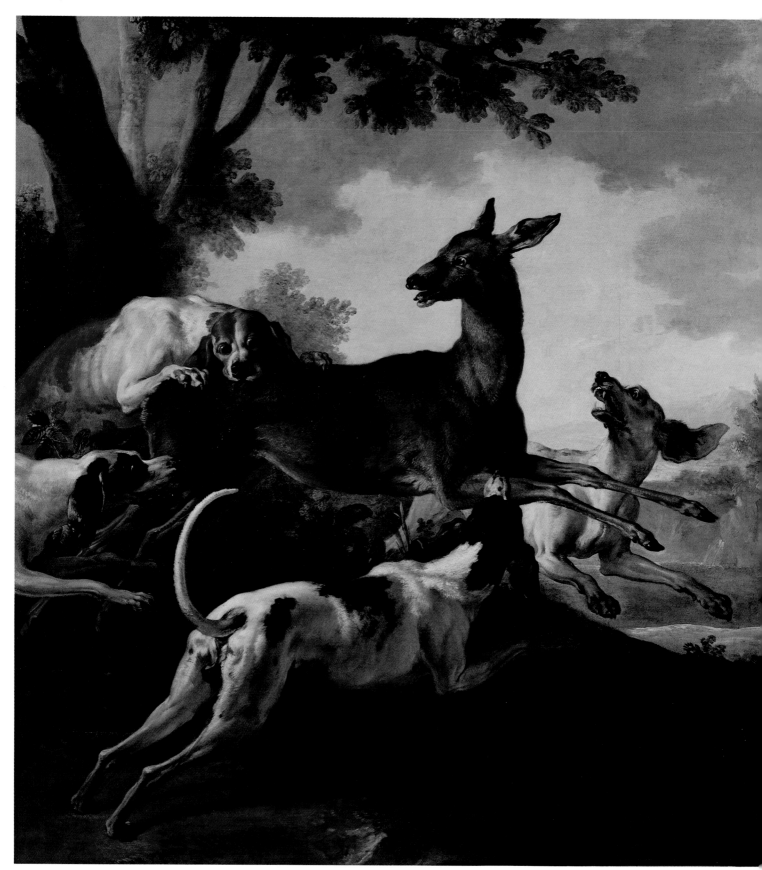

24 Roe Hunt, 1725. Rouen.

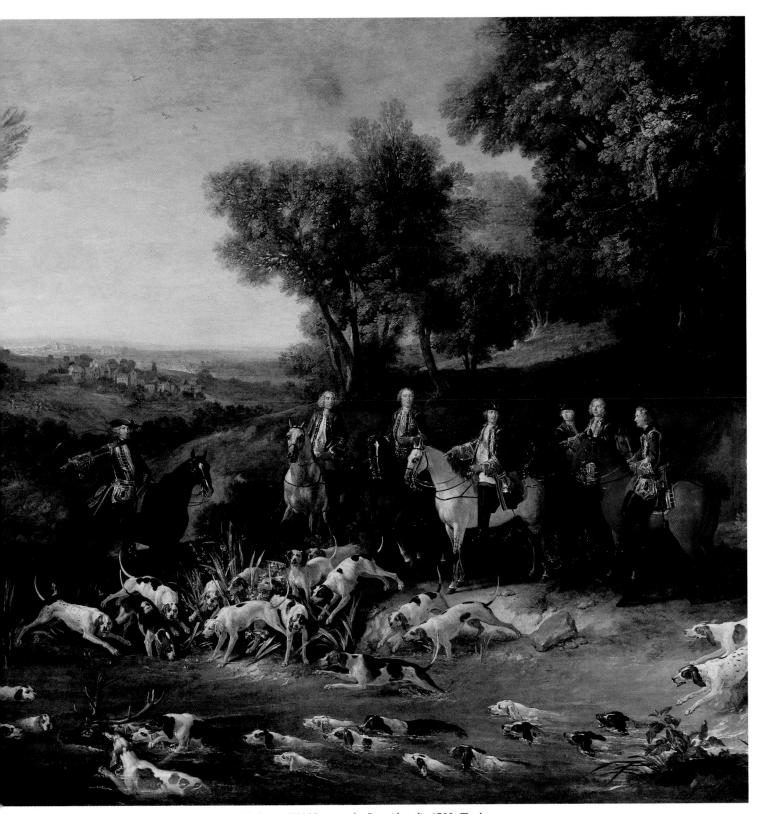

33 *Louis XV Hunting the Stag* (detail), 1730. Toulouse.

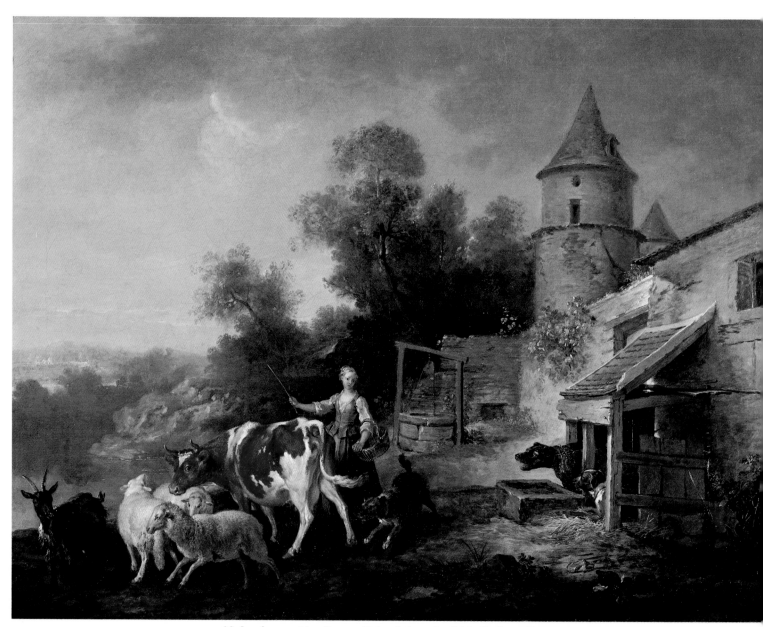

28 *Landscape with a Peasant Girl and Animals*, 1727. Cailleux, Paris.

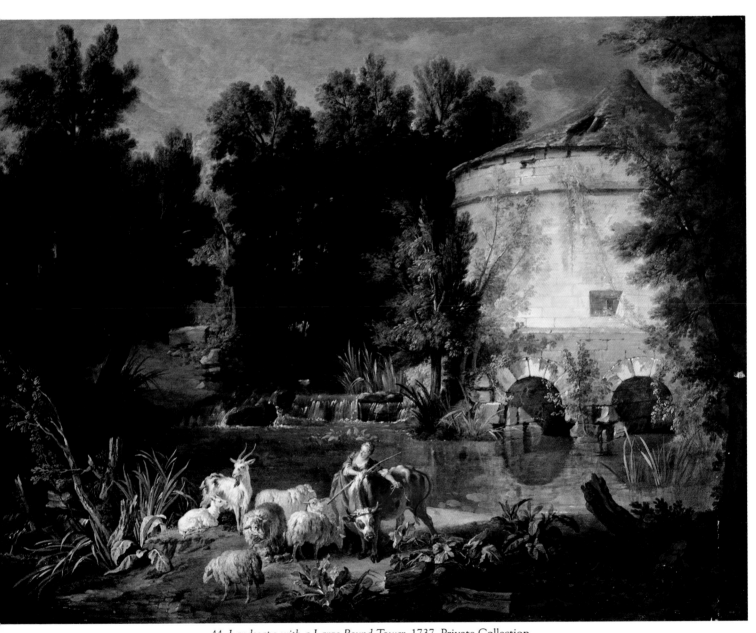

44 *Landscape with a Large Round Tower*, 1737. Private Collection.

40 *"Les Deux Chiens et l'Ane mort,"* 1732. Private Collection.

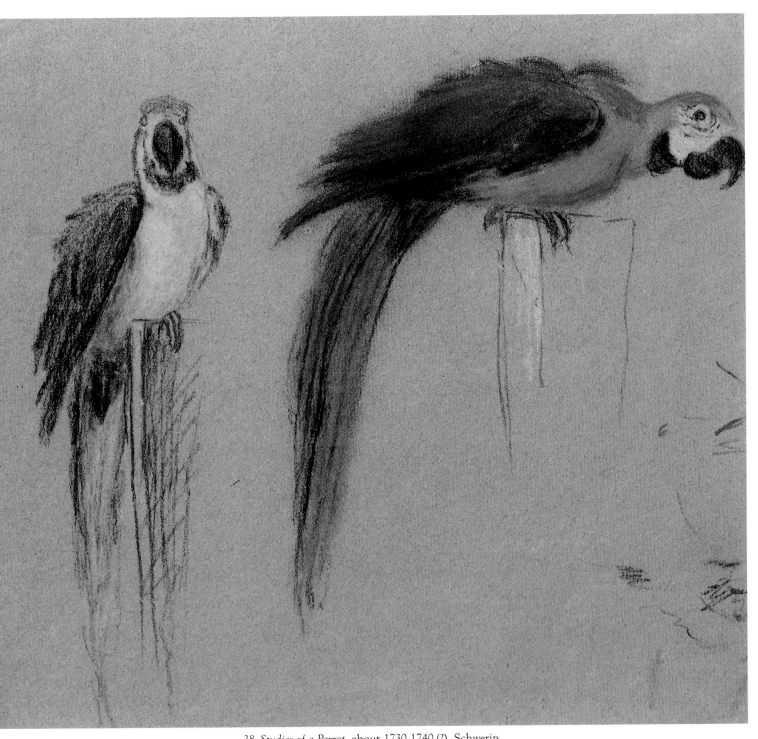

38 *Studies of a Parrot*, about 1730-1740 (?). Schwerin.

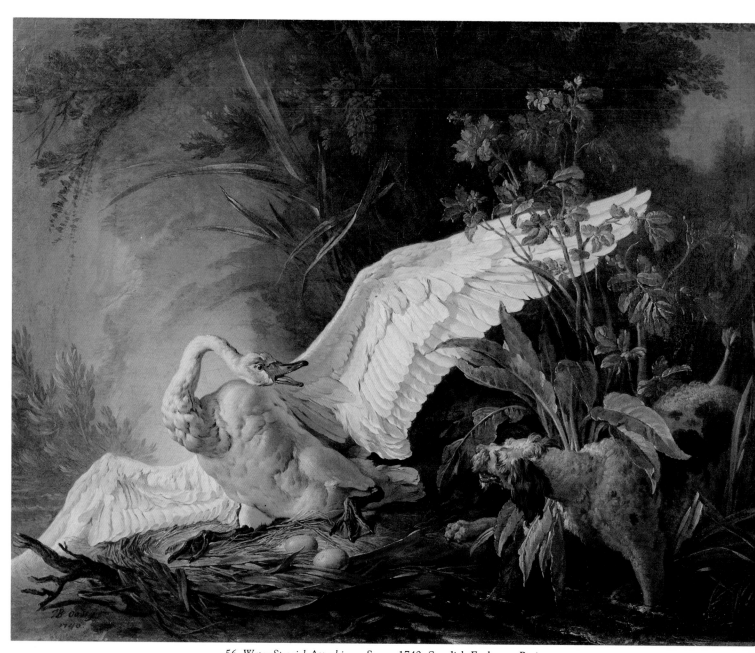

56 *Water Spaniel Attacking a Swan*, 1740. Swedish Embassy, Paris.

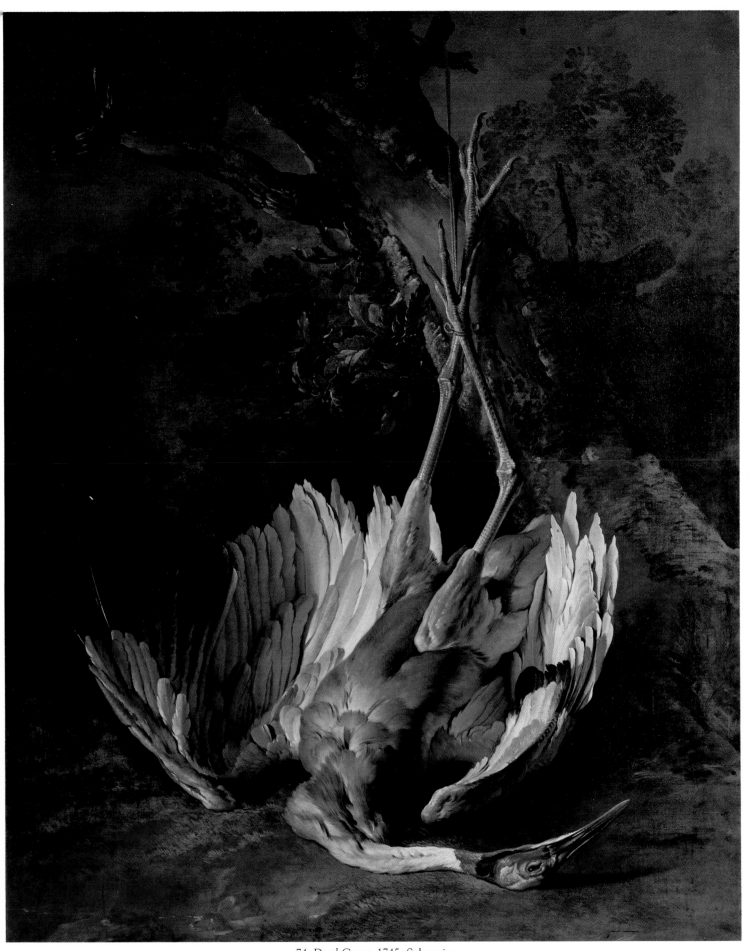

74 *Dead Crane*, 1745. Schwerin.

21

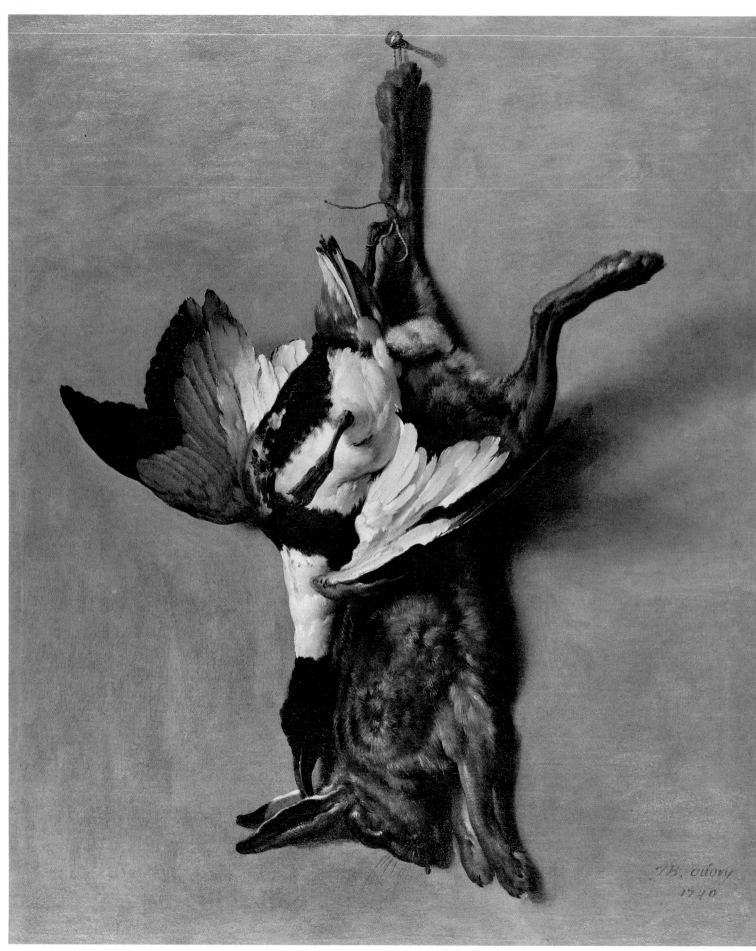

75 *Still Life of a Hare and a Sheldrake*, 1740. Private Collection.

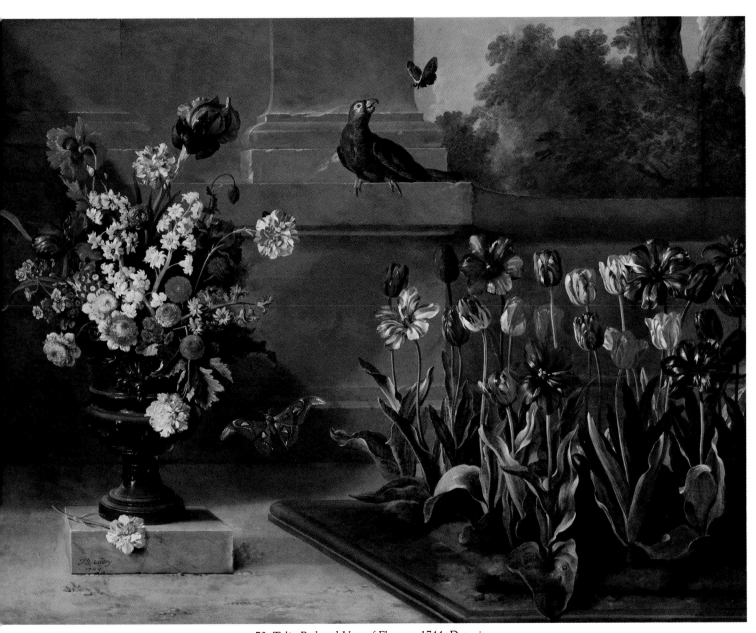

73 *Tulip-Bed and Vase of Flowers*, 1744. Detroit.

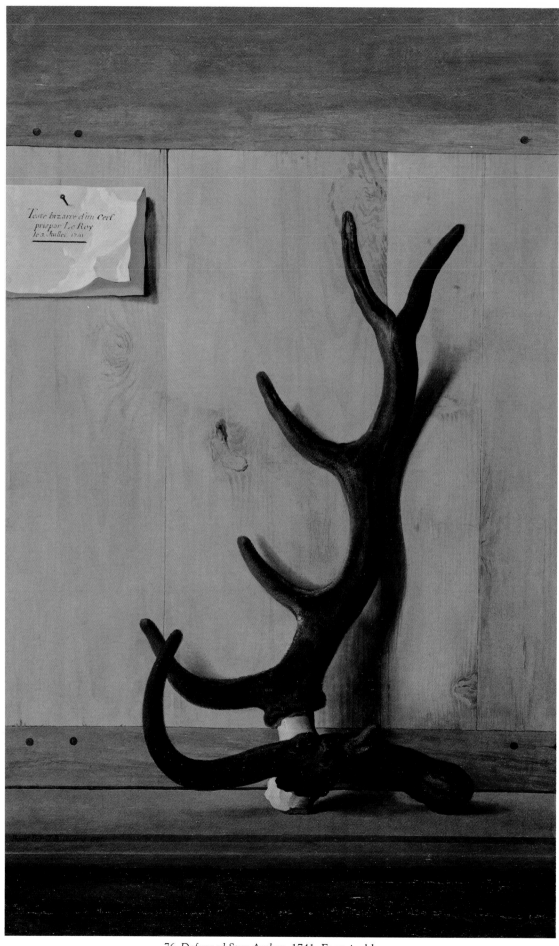

76 *Deformed Stag Antlers*, 1741. Fontainebleau.

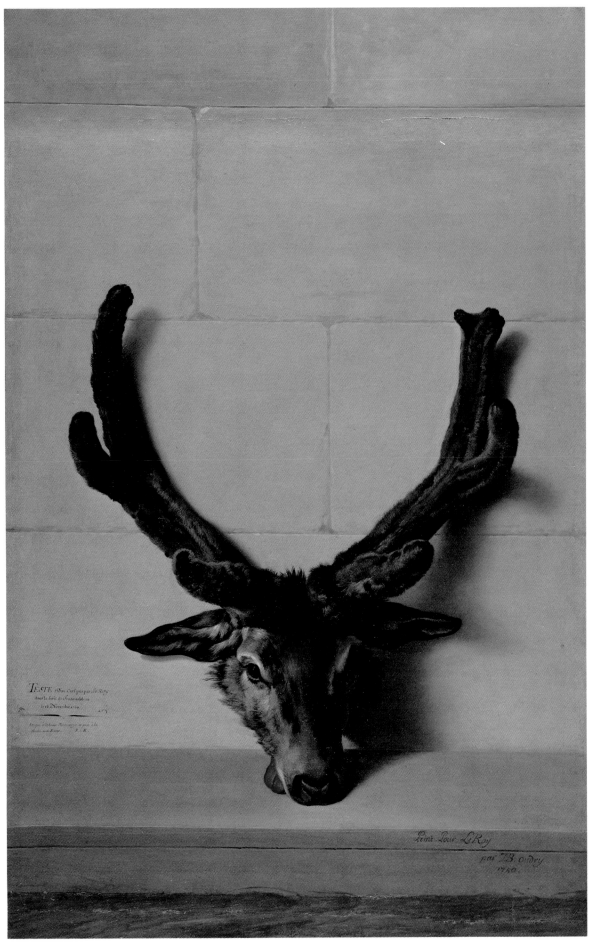

78 *Stag Head with Deformed Antlers*, 1750. Fontainebleau.

68 *Park Landscape*, about 1744-1747. Schwerin.

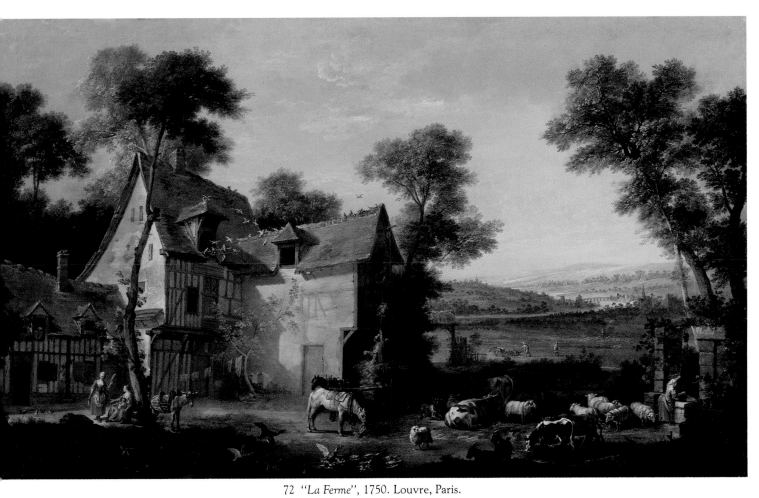

72 *"La Ferme"*, 1750. Louvre, Paris.

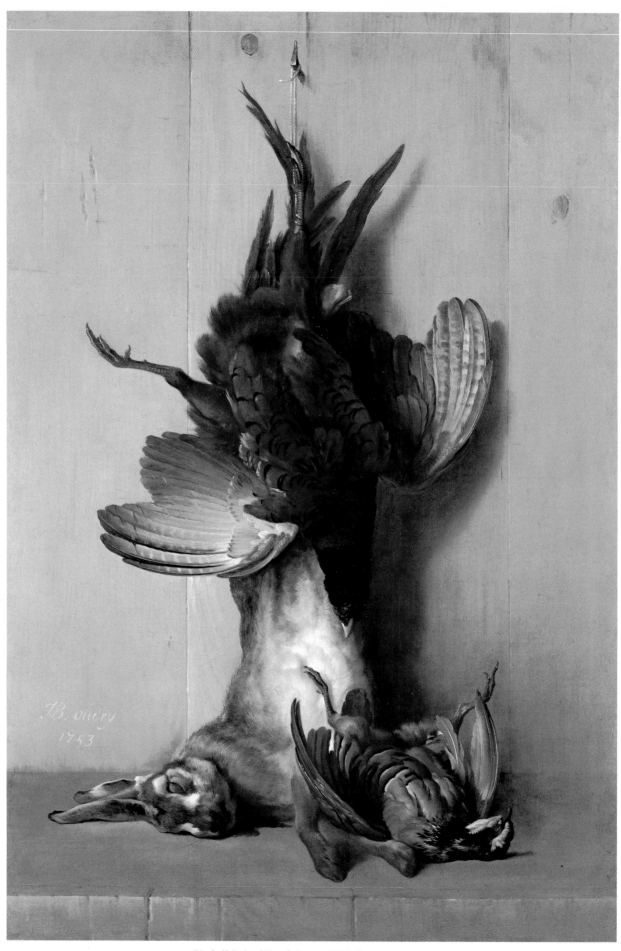

79 *Still Life of Dead Game*, 1753. Louvre, Paris.

Acknowledgments

It remains for us to fulfill the agreeable duty of thanking all those who have helped in the realization of the retrospective exhibition in Paris in 1982 and the American tour to Fort Worth and Kansas City in 1983. M. Hubert Landais, Directeur des Musées de France, and Mlle Irène Bizot, Administrateur délégué de la Réunion des Musées nationaux, along with their staff, performed a gargantuan feat in bringing so many works together for the Paris exhibition and in seeing to the production of the French catalogue, upon which the English edition is based. Mlle Germaine Pélegrin and her able *équipe* assured the beautiful presentation at the Grand Palais, overcoming a host of technical difficulties creatively and with apparent ease. The preparation of the modified exhibition and new catalogue for the Kimbell Art Museum and the Nelson-Atkins Museum of Art has been more pleasurable than burdensome thanks to the enthusiasm and hard work of the curatorial staffs of these institutions; we especially appreciate the steadfast support of Edmund Pillsbury and Roger Ward, whose suggestions for improvements have been gratefully accepted. Our sincerest thanks go to the public institutions who made ready (often at considerable effort and expense) and lent paintings and drawings from all over Europe and North America, as well as the numerous private collectors who have generously consented to part with important works.

Many individuals have helped in the course of our research over the last four years; while conscious that some are overlooked, and asking their pardon in advance, we would like to express our gratitude to Mesdames and Mesdemoiselles V. Atwater, S. Bergeon, G. Bonds, J. Bossu, L. Brion, E. Brugerolles, M. C. Carlioz, S. Cholmondeley, I. Compin, C. Constans, S. Cotté, F. Debaisieux, E. Dee, F. Dijoud, J. Edwards, R. Erly, A. M. Esquirol-Labit, P. Fontaine-Levent, U. Gauss, M. Geiger, L. Gould, L. Granlund, A. Husson, D. Hyde, A. Jacques, L. Jürss, C. Kern, C. Klosa, L. Lacorre, S. Lagabrielle, F. de Lastic, M. Latour, C. Legrand, K. Lindegren, R. Loche, H. McPherson, I. Möller, K. Moore, A. Okada, U. Perucchi, O. Popovitch, C. de Quiqueran Beaujeu, M. Roland Michel, B. Rosenberg, M. N. Rosenfeld, C. Samoyault, K. Schlotterback, I. Schwibbe, B. Scott, E. A. Standen, V. Stedman, M. Stewart, E. Walter-Foucart, B. H. Wiles, C. H. Young, and Messieurs K. Andrews, J. Bean, A. Beit, P. Bjurström, J. H. van Borssum Buisman, E. P. Bowron, A. Brejon de Lavergnée, J. Cailleux, M. Chiarini, F. Cummings, J. P. Cuzin, D. Farr, R. Février, J. Foucart, P. Georgel, P. Grate, E. Hodgkin, J. G. von Hohenzollern, Y. Ito, P. Jaffard, H. Joachim, W. Koschatzky, D. Laing, G. de Lastic, S. Laveissière, P. Lemoine, A. de Ligne, D. Ludman, G. Mabille, S. Makowsky, P. Marandel, P. Mathias, J. F. Méjanès, D. Milhau, B. de Montgolfier, D. Mosby, J. M. Moulin, C. Personne, G. Poisson, J. Rishel, M. Rogers, J. Rowlands, de Salverte, J. P. Samoyault, D. Scrase, M. Sérullaz, C. Souviron, A. Speelman, R. Spear, H. Strutz, W. Stubenvoll, W. Talbot, M. Terrier, J. Vilain, C. Virch, W. Weston, D. Wildenstein, J. Wilhelm, E. Wolf, H. Wytenhove.

But above all we wish to acknowledge nearly twenty years of encouragement and selfless aid on the part of Pierre Rosenberg, whose friendship we treasure. It is not an empty formula to say that without him this exhibition could not have taken place.

H.O.

Notes to the Reader

The present catalogue is based on that of the exhibition in the Grand Palais. The introductory material is essentially unchanged from the French edition but has been rearranged for editorial reasons. The catalogue entries are practically identical; a few have been shortened, and some of the general comments from the French catalogue entries of works absent from the American exhibition have been retained by incorporating them in the introduction or in other entries. The major difference is the elimination of the rubric "oeuvres en rapport": but the essential related works are still discussed and reproduced elsewhere. New observations and information have been added for some of the works shown in Paris, in the form of separate paragraphs at the ends of their entries. Catalogue numbers 7, 9, 10, 27, 28, 46, 60, 75 and 77 here were not exhibited in Paris.

References to the French catalogue have been abbreviated as Paris followed by the catalogue number, in parentheses, e. g. (Paris 124).

Internal references to works exhibited are given as catalogue numbers in bold face, in brackets, e. g. [65].

The catalogue follows a general chronological order by broad periods: the early works [1-15]; the first animal subjects and public success [16-31]; the years of the great tapestry commissions [32-47]; and Oudry's maturity and triumph at the Salons [48-79]. Within each of these periods the arrangement is by subject type rather than by strict chronology, in order to provide coherence in discussing Oudry's development and working methods.

Dimensions are in centimeters, height preceding width.

Important Dates

The following few pages present in chronological order many of the key dates of Oudry's life — enough, we hope, to provide an introduction and guide to the catalogue. The number of both printed and manuscript documents concerning Oudry from the eighteenth century is enormous; many have been published, others only cited or summarized, others still await any form of publication, while many more remain to be discovered. There has not been time to undertake this sort of exhaustive research, although this does not mean that it should not some day be done. We have much to learn about Oudry, his patrons, his financial affairs, and his family, both from analysis of what we already possess and from newly discovered facts. Nearly all of what follows has been published, some of it many years ago, and is well enough known. We have relied particularly on eighteenth-century sources such as the *Almanach royal* and the *Mercure de France* and on the records of the Académie royale, mostly published in the nineteenth century; for the vital statistics we have consulted the older compilations of Guiffrey, Jal, and others, and also the recent and extremely valuable research of Daniel Wildenstein and Mireille Rambaud. However, rather than giving full citations of the various sources, which would have doubled the length of this section, we refer parenthetically to the appropriate volumes and pages of our dissertation of 1972, published in 1977. Full information and, when necessary, interpretation, can be found there.

About 1661
Birth in Paris of the father of Jean-Baptiste Oudry, Jacques, son of Médard Oudry, *maître fondeur* established in the rue de la Ferronnerie, and of Marguerite Moreau, his wife (I, 3).

1685
21 January: Marriage of Jacques Oudry and Nicole Papillon, church of the Saints-Innocents (I, 3).

1686
4 February: Reception of Jacques Oudry as a *maître peintre* in the Académie de Saint-Luc (I, 3).

17 March: Birth of Jean-Baptiste Oudry in the domicile of his parents, who are still living with Médard Oudry in the rue de la Ferronnerie; he is baptized the same day in the church of the Saints-Innocents (I, 3-4).

1697
8 March: The Oudry family is mentioned in a document as residing on the quai de la Mégisserie, at the sign of the Clef d'Or (I, 4).

1700
Jacques Oudry is mentioned for the first time as living in the rue de la Lanterne, on the Ile de la Cité; he is still at this address in 1710 (II, 916).

1704
The young Jean-Baptiste studies for nine months with Michel Serre, *peintre des galères du roi* from Marseille, who is in Paris for most of this year (I, 7-8).

About 1705-1707
Beginning of his apprenticeship with Nicolas de Largillierre, which will last five years (I, 7-9).

1706
Oudry follows the courses of the drawing-school of the Académie de Saint-Luc. He is also said to have studied in the classes of the Académie royale about this time (I, 8, 164).

1708
21 May: Reception of Oudry in the Académie de Saint-Luc, of which his father is now president; he delivers his "chef-d'oeuvre," a bust-length *Saint Jerome* (lost), on 19 July (I, 8).

1709

28 December: Marriage contract between Jean-Baptiste Oudry and Marie-Marguerite Froissé; the painter is now living in the rue Neuve-Saint-Merry (II, 917).

1710

30 January: Marriage of Oudry and Marie-Marguerite Froissé (I, 9).

About 1710-1712

End of the apprenticeship with Largillierre (I, 7-9).

1713

June: Oudry begins his "Livre de raison," where he records in the form of wash drawings all of his works during five or six years (I, 16-18).

The parents of the painter are living on the pont Notre-Dame (II, 916).

1714

May: He is elected to the rank of *adjoint à professeur* in the Académie de Saint-Luc (I, 15).

1715

Oudry is living on the pont Notre-Dame, at the sign of the Soleil d'Or (I, 14).

1716

17 November: Oudry receives official leave to go work in Saint Petersburg, but decides to remain in Paris (I, 14-15).

1717

26 June: Oudry is *agréé* in the Académie royale upon presentation of his *Adoration of the Magi* executed for Saint-Martin-des-Champs (Fig. 51) and of a *Garland of Vegetables* (Fig. 54) (I, 15, 26-27, 33).

1 July: He is elected to the rank of *professeur* in the Académie de Saint-Luc (I, 15).

1719

25 February: Reception of Oudry in the Académie royale upon delivery of *Abundance with her Attributes* [6] (I, 15).

Publication of the earliest biography of the artist, in Orlandi's *Abecedario pittorico*, 2d edition, Bologna (I, 163-164).

Before 1720

Oudry moves to the quai de la Mégisserie, "vers le Châtelet, au grand Louis, joignant la Croix de Fer" (I, 40).

1720

Death of Jacques Oudry, residing on the pont Notre-Dame "à l'Enseigne de la Perle" (II, 916).

1722

4 and 11 June: Oudry is represented by a few works in the "Exposition de la Jeunesse," place Dauphine (I, 178).

1722-1723

Birth of Jacques-Charles, the only one of Oudry's numerous children who will pursue the career of painter (I, 13).

1723

27 May and 3 June: The *Mercure* describes three pictures by Oudry in the "Exposition de la Jeunesse", including an immense *Stag Hunt* (Fig. 17) (I, 178).

It is probably in this year or at the very beginning of 1724 that Oudry is presented to Louis Fagon, *intendant des finances*, and Henri-Camille, Marquis de Beringhen, *premier écuyer du roi*. The two will become friends and patrons of the artist and extremely useful for the advancement of his career (I, 42-43).

Oudry obtains a studio in the Tuileries (I, 43).

1724

Oudry moves again, "rue Jean Pain-Mollet, au coin de la rue de la Tacherie" (I, 40).

22 June: Four pictures at the "Exposition de la Jeunesse," all of them admired, including the *Dead Bustard* (Fig. 93) and probably the *Stag Hunt* already shown in 1723 (Fig. 17) (I, 179).

First commissions from the king: *Meleager and Atalanta* for the Hôtel du Grand-Maître at Versailles, and some hunts for Chantilly [cf. **24**] (I, 377).

Beringhen commissions a sumptuous open carriage for Louis XV, decorated with twelve painted panels of hunt subjects by Oudry (I, 73, 400; Max Terrier is preparing

an article based on the long description in the *Mercure de France*, September 1724, pp. 2018-2021).

Probable date of a large engraving by N.-C. de Silvestre after the *Stag Hunt* of 1723, dedicated to Louis Fagon. This is the first of the numerous prints of animal subjects that will appear over the years (I, 300).

1725
7 June: At least eight pictures in the "Exposition de la Jeunesse", place Dauphine, among them the *Wolf Hunt* (Fig. 18), the *Dead Bustard* (Fig. 93), and the *Spaniel seizing a Bittern* (Fig. 64) (I, 179-180).

25 August-2 September: Twelve paintings in the Salon du Louvre, the only one held between 1704 and 1737, including the *Dead Bustard* and the *Spaniel and Bittern* already shown in June, the *Boar Hunt* (Fig. 19), the *Return from the Hunt with a Dead Roe* [16], and two lost fish-pieces known through drawings (Figs. 21-22) (I, 180-181).

December: Oudry is given lodgings in the Palais des Tuileries, Cour des Princes (I, 40).

1726
10 March: By order of the king, Oudry brings the entire contents of his studio to Versailles, twenty-six pictures including *Misse and Turlu* [25] and the three big hunts (Figs. 17-19), and presents them in three rooms of the Grands Appartements (I, 181-182).

Thanks to Louis Fagon, Oudry is named painter to the royal tapestry works at Beauvais (I, 42).

Date of the first of the drawings illustrating Scarron's *Roman comique*, which will be engraved beginning in 1728 [cf. 29-31].

1728
January: Oudry is ordered to follow the royal hunts and to prepare sketches, one of which will be retained for execution on canvas. The result will be the large hunt for Marly [33], finished in 1730, a picture of the greatest importance for Oudry's career (I, 86).

1729
Beginnings of the illustration drawings for the *Fables* of La Fontaine, which will be engraved many years later [cf. 39-42].

1730
Purchase from the artist of two large hunts (Figs. 18, 19) for the Residenz of Ansbach in Germany (I, 83).

1732
Oudry receives his first commissions from the Duke of Mecklenburg-Schwerin (I, 83-84).

1733
Commission of the *Chasses royales* (Figs. 23-31) which will occupy him for many years and bring him considerable income (I, 89-91).

1734
Oudry is named financial and artistic director of the Beauvais tapestry works, with a twenty-year lease in association with the goldsmith Nicolas Besnier who, it seems, is only the bookkeeper. These will be the most successful years in the factory's history (I, 88).

1736
Oudry is given the responsibility of overseeing the execution of his *Chasses royales* models in Gobelins tapestry; the first of them is placed on the loom this year (I, 89).

1737
27 March: The first mention — and the only one in his lifetime — of works by Oudry in a public sale, that of the Comtesse de Verrue (manuscript catalogue), three paintings in all (I, 228).

18 August-5 September: Seven pictures in the Salon du Louvre, including Figs. 17, 32, 33, 34 (I, 182).

1738
Oudry is named supervisor at the Gobelins for the weaving of the *Tenture d'Esther* from the cartoons of Jean-François de Troy, who has just been appointed director of the Académie de France in Rome (I, 94).

18 August-19 September: Oudry exhibits seven pictures at the Salon du Louvre, among them [46] and probably [44] and [45], as well as Fig. 83 and the painted model of Fig. 26 (I, 183).

1739
4 July: Oudry is elected *adjoint à professeur* in the Académie royale (I, 107).

6-20 September: Nine paintings exhibited in the Salon du Louvre, including [28], [49], Figs. 35, 36, 37 and the original of Fig. 86 (I, 184).

Arrival in Paris of Carl Gustaf Tessin, the Swedish ambassador, who will become a good friend of Oudry's and purchase for himself, or have purchased for the king of Sweden, a large number of his most beautiful pictures and drawings, among others Figs. 11, 12, 13, 14, 17, 33, 35, 36, 40, 64, 83, 87, 90, 93, 113, and probably [56] (I, 84-85).

Beginnings of a commission that will extend until 1745, of a series of paintings of the principal animals of the Ménagerie of Versailles, for the royal botanical garden. These pictures have been in Schwerin since 1750 [49, 52, 74]; cf. Figs. 37, 85, 86, 89, 111 (I, 112-113).

1740

22 August-15 September: Oudry exhibits ten pictures at the Salon du Louvre, [55], [56], and Figs. 40, 104, 105 among them (I, 185-186).

1741

Commission from the king of Denmark, obtained through the intermediary of Count Tessin, of several decorative pictures for Christiansborg Castle, all of them destroyed in the terrible fire of 1794 (I, 109, 401).

1-23 September: Fourteen pictures in the Salon du Louvre, including [20], [52], [76], Figs. 41, 89, 104, and the painted originals of Figs. 28 and 85 (I, 186-187).

1742

22 August-21 September: Ten pictures this year at the Salon du Louvre, including [58], [60], [77], and Figs. 45, 94, 106, 112 (I, 188-189).

1743

5-25 August: Fourteen pictures in the Salon du Louvre, among them [27], [28], [46], Fig. 83, and either [52] or Fig. 89 (I, 189-190).

28 September: Oudry is named *professeur* in the Académie royale (I, 107).

1744

29 February: Upon the death of the sculptor Frémin, Oudry receives the eleventh *logement* of the Grande Galerie of the Louvre (I, 107).

1745

25 August-25 September: Eight paintings and three pastel landscapes presented at the Salon du Louvre, including [67], [73], [74], Fig. 106, and the painting from Fig. 111 (I, 191).

1746

12 April: Oudry loses his mother, at the age of about eighty-five; burial two days later in the church of Saint-Gervais (II, 916).

25 August-25 September: Oudry sends only six pictures to the Salon du Louvre, including Figs. 37, 38, 41 (I, 192).

1747

22 June: Petition of the students of the Académie to the director, calling for reforms in instruction. Among many other complaints it is noted that "M. Oudry ne se trouve jamais au jugement des médailles et ne veut pas non plus faire d'élèves" (I, 132-133).

25 August-25 September: Fifteen works at the Salon du Louvre, including [20] and Figs. 32, 104, 105 (I, 193-194).

1748

Oudry is appointed inspector at the Gobelins for all the weavings, which causes resentment and rebellion among the workers and the *chefs d'atelier*, jealous of his continuing position as *entrepreneur* of the rival tapestry works of Beauvais (I, 94-98).

24 February: Jacques-Charles Oudry is *agréé* at the Académie royale. His reception, upon presentation of a *Dog with Dead Game* today in the Montpellier museum, takes place on 31 December (*Procès-verbaux*, 1875-1892, VI, pp. 91-92, 144).

25 August-25 September: Fourteen pictures in the Salon du Louvre, including [61], [62], and Figs. 39, 42. This is also the first Salon for Jacques-Charles, represented by six canvases (I, 194-196).

1749

7 June: Reading at the Académie of the first of Oudry's two *conférences*, "Réflexions sur la manière d'étudier la couleur en comparant les objets les uns avec les autres" (I, 334).

1750

Oudry founds a free school of drawing at Beauvais (I, 96).

25 August-8 October: Oudry sends twenty-two paintings to the Salon du Louvre, among others [**33**], [**61**], [**62**], [**63**], and Figs. 98, 100, 114, 115. Jacques-Charles shows only one (I, 199-200).

1751

25 August-25 September: Eighteen paintings at the Salon du Louvre, including [**72**] and Figs. 32, 43, 44; five by the younger Oudry (I, 202-203).

1752

2 December: Oudry's second *conférence* is read at the Académie: "Discours sur la pratique de la peinture et ses procédés principaux, ébaucher, peindre à fond, et retoucher" (I, 334).

1753

25 August-25 September: Oudry's last Salon; eighteen paintings, five drawings, and the first engravings of his illustrations for the *Fables* of La Fontaine, including [**65**], [**79**], and Fig. 113. His son does not exhibit, having gone to live in Brussels some months before (I, 204-206).

1754

Expiration of Oudry's lease at the Beauvais tapestry works. He retains the title of director but loses most of the financial benefits (I, 94).

Oudry suffers an attack of apoplexy; very few pictures dated from this year (I, 132).

1755

January: Second attack of apoplexy, much more severe; Oudry recovers but his hands are too swollen to take up his brushes (I, 132).

30 April: Three months later, hoping that a change of air will do him good, Oudry goes to Beauvais where he dies on the morning of 30 April. On the eve of his death "il fut dans les ateliers mesurer des tableaux avec autant de présence d'esprit que s'il se fût bien porté." Inhumation at Beauvais, church of Saint-Thomas, the parish of the tapestry works (I, 132, 171-172).

7 July: Sale of the painter's estate, without catalogue. There is a single published announcement: "[VENTE] D'EFFETS curieux (après le décès de M. *Oudry*, Peintre Ordinaire du Roi, pour les Animaux) comme Tableaux & Ustensiles de Peinture, Études & Desseins de la main de ce célèbre Artiste, Estampes, Bijoux, Tabatieres, Guitarres fort rares, Fauteuils & Portieres de la Manufacture de Beauvais, Médailles, &c. Lundi prochain 7. juillet, au Couvent des Petits Peres de la Place des Victoires. La Collection des Desseins est très-nombreuse, & ils sont d'autant plus précieux, que l'Auteur qui prenoit plaisir à les travailler avec un soin extrême, n'en vendoit aucun" (*Annonces, Affiches, et avis divers. Du Lundi 30. Juin 1755,* p. 396).

1778

3 July: Jacques-Charles Oudry dies in Lausanne (Cailleux, 1982, p. ii).

1780

28 January: Death of Oudry's widow, at her residence, cul-de-sac Saint-Thomas-du-Louvre (I, 132; II, 917).

Introduction

Fig. 1 *Frontispiece of the first volume of the "Livre de Raison".* Dated June 1713. Paris, Musée du Louvre, Cabinet des Dessins.

THE PORTRAITIST (1712-1719) All of the evidence suggests that Oudry continued his apprenticeship with Largillierre until about 1712, even though it is known that he moved from his master's house to an address nearby in the rue Neuve-Saint-Merry when he married early in 1710. There must have been several independent works in 1710 and 1711, but only one — a portrait — has so far been identified with certainty. Then come the two highly accomplished still lifes of dead birds in Agen from 1712 [**12-13**]. And by 1713, when Oudry began his "livre de raison," there can be no doubt that he was on his own. We have thus chosen the date of 1712 for the beginning of the first period of his activity. The ending date of 1719 is that of his reception into the Académie royale de Peinture et de Sculpture; it also marks significant changes in his production as well as in his style.

During this short period of seven or so years the most striking quality of Oudry's art is its diversity, both in the genres he approaches and in the variety of influences upon him. He never settles long in one place (although portraiture does provide a constant). This is true not just of his art but of his personal habits: by 1715 he is no longer in the rue Neuve-Saint-Merry but has moved to the Pont Notre-Dame; in 1716 he applies for leave to go work in Saint Petersburg, then decides against it; and by 1719 he is living on the quai de la Mégisserie. Everything indicates that here is a young artist who, although he must have been modestly successful, is not satisfied with himself and who tries his hand at practically everything, hoping to find his proper niche.

Certainly this quest in search of himself is one of the reasons for the diversity of his early oeuvre, but we cannot forget that Oudry's student

Fig. 2 *Frontispiece of the second volume of the "Livre de Raison".* Dated 1st August 1716. Paris, Musée du Louvre, Cabinet des Dessins.

years and those of his debut as an artist also saw the end of one great epoch in the history of French painting and the beginning of another, based on quite different premises. In Oudry's youth many of the last great painters of the age of Louis XIV were producing the masterpieces of their old age, and many of them died: Charles de La Fosse in 1716, Jean Jouvenet in 1717, Antoine Coypel, who stopped painting because of illness by 1717 and died in 1722. And the young artists, Oudry's contemporaries, were searching for new principles of form and subject that would eventually come together in the *genre pittoresque* or "rococo" style. While the greatest of these artists, Antoine Watteau — born in 1684, two years before Oudry — developed his profoundly original and influential art relatively early, some of the others had to experiment, to absorb the new experiences slowly before discovering themselves in the 1720s, just as Oudry did; one is reminded particularly of Jean-François de Troy (born 1679), Jean-Marc Nattier (born 1685), and François Lemoine (born 1688).

Oudry's training and the milieu in which he spent the first thirty-odd years of his life were filled with contradictions. His father, Jacques Oudry (circa 1661-1720), was a painter and a member of the Académie de Saint-Luc; it was he who taught the young Jean-Baptiste the rudiments of art. But Oudry *père* was also, even primarily, a dealer associated with the Pont Notre-Dame, center of the Parisian *brocanteurs* and of popular art. His son, as we have seen, also lived there briefly during his first period, "au Soleil d'Or." So he, like his father, must have been a picture dealer. His early education suggests that Oudry was destined for a similar career as a painter/dealer, outside official circles. After studying briefly with Michel Serre, a painter from Marseille who was in Paris in 1704, he

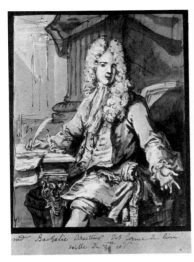 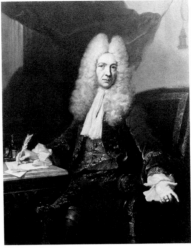

Fig. 3 *Monsieur Bachelier*, from the "Livre de Raison". About 1715. Paris, Musée du Louvre, Cabinet des Dessins.

Fig. 4 *Monsieur Bachelier*. Dated 1715. Ann Arbor, The University of Michigan Museum of Art.

studied drawing in the classes of the Académie de Saint-Luc in 1706, and was received into the membership of that body as *maître peintre* in 1708. And yet, practically simultaneously, he was following the curriculum of the distinguished Académie royale, where he took classes in drawing. It was probably in 1707 that he began a five-year apprenticeship with Nicolas de Largillierre (1656-1746), one of the most respected members of the Académie royale, where Oudry was eventually *agréé* in 1717, five years after leaving his master. This is the first of the contradictions that Oudry had to reconcile, that between an art based on high doctrine as opposed to one more concerned with popular appeal.

But there are other contradictions more profound than the long-standing opposition between the artists of the *maîtrise* and those of the Académie royale. Oudry's earliest training coincided with the latter part of the famous quarrel between the proponents of Rubens and those of Poussin within the Académie royale itself. There he must have been taught academic figure drawing in the tradition of Le Brun, while at the same time he was learning the coloristic principles of Largillierre, one of the most influential of the *Rubénistes*. The dispute died out without having been resolved, probably because the two extreme positions were perceived as irreconcilable: the recording of imperfect nature debases art, while an art founded in idealism cannot convince because it falsifies experience. But it was not forgotten. It posed a fundamental problem for artists of the eighteenth century, who continued to seek a reconciliation or, later in the century, a decision. Is it possible to have an art of history painting entirely based in nature, an opinion Oudry tells us was held by Largillierre (Oudry, 1749 [1844], pp. 40-41)? And is it possible (this goes unstated, but it is

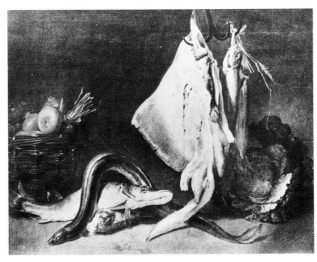

Fig. 5 *Still Life of Fish, a Cabbage and a Basket of Onions.* Dated 1717. Sale, Paris, Galerie Georges Petit, 4 December 1925.

strongly implied) for the lesser genres of painting to be elevated through the application of the principles of *ordonnance, dessin* and *expression* cherished by the Académie? The multiple contradictions arising from this problem have repercussions not just for his beginnings, but for Oudry's whole career.

It is possible to obtain a balanced general view of the early period, even though surviving paintings are not abundant. Many are irretrievably lost, while others reappear briefly in sales or with dealers only to disappear once more for years and even centuries. Yet Oudry left us a record book, begun in June of 1713, containing wash sketches of all the pictures he painted, and also of projects for unexecuted canvases; its two volumes probably cover most of his first period, well into 1718 at least (Figs. 1-3, 10, 55, 56, 58; cf. Paris 7-11). It is regrettable that these precious albums should have lost more than half of their sketches, nearly all of them within a few years of the artist's death; the remainder is now in the Louvre. Detached drawings turn up often enough, and are easy to identify as having come from this "livre de raison," but the valuable inscriptions indicating names of sitters, dates, format and the like are always trimmed away. In our dissertation of 1972, published in 1977 (II, p. 610), we attempted a very approximate reconstruction of the original contents of the albums, based only on the types of subjects represented. Through a series of convoluted arguments, not repeated here, we obtained an estimate of the amplitude of Oudry's productivity in these years and a breakdown by genre. Oudry probably painted about 150 pictures prior to his admission to the Académie royale: that is, an average of about two a month, no doubt fewer at first. About 70% would have been portraits, 24% still life,

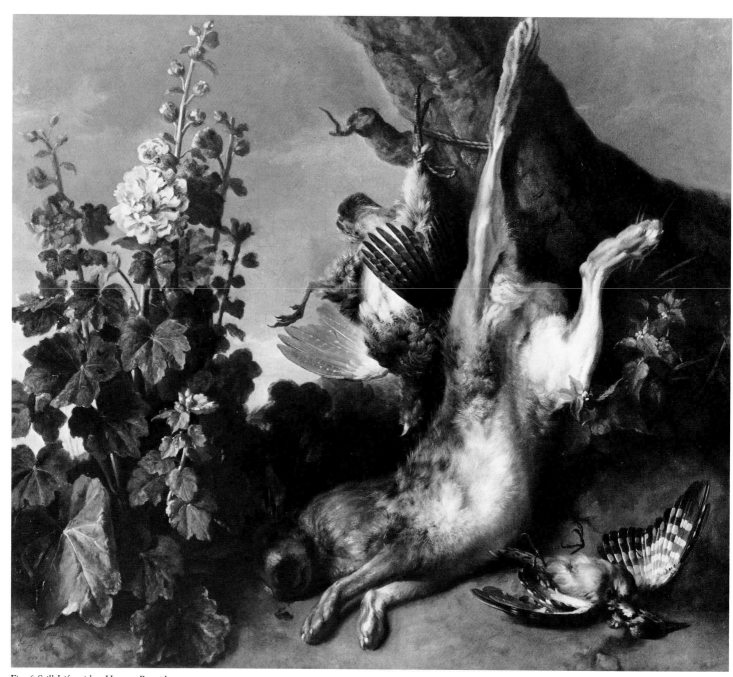

Fig. 6 *Still Life with a Hare, a Partridge,*
a Pied Woodpecker and Hollyhocks.
Dated 1718. Formerly Cailleux, Paris.

Fig. 7 *Stone Bridge with a Mill*, from a landscape sketchbook dated 1714. Paris, Musée du Louvre, Cabinet des Dessins.

4% history, and only about 1% each of landscape and genre (he was not yet painting the hunt except as a portrait or still-life theme).

If we are correct, Oudry painted at least a hundred portraits through 1719. But no more than about fifteen have been identified (and this is an optimistic number, including many we have not seen). Just how many more will someday turn up again, probably as de-christened Largillierres, we cannot predict. From the surviving inscriptions in the "livre de raison" Oudry's clientele for portraiture appears to have been in the middle economic range, with the occasional personage of rank or notoriety coming his way. He developed no distinctive manner as a portraitist and no "trucs" of his own, and was far from achieving the sumptuosity and appearance of ease of a Largillierre or a Rigaud. The very interesting and beautifully preserved canvas from the University of Michigan (Fig. 4; cf. Paris 14) may serve as a typical example. Some of the most attractive of the surviving portraits are in private collections [**9, 10**]; it is also becoming increasingly clear that Oudry's activity as a portraitist extends into the beginning of the second period.

Of the thirty to forty still-life pictures that the young Oudry would have painted, according to our hypothesis, we have knowledge of about fifteen — proportionately many more than of the portraits. These were intended to be, and have remained, *tableaux de cabinet* for the discriminating collector. Types and subjects are varied, as are the influences — mostly Netherlandish [**12-15**]. It is in his early still lifes that Oudry begins to develop his talent for painting feathers, fur and scales (Figs. 5, 6). Most of these pictures are still in private hands, and we are often unaware of their

Fig. 8 *Trees Beside a Brook, with a Manor in the Distance,* from a landscape sketchbook dated 1714. Paris, Musée du Louvre, Cabinet des Dessins.

precise whereabouts.

Oudry painted only about a half-dozen history pictures in his first period, and he also did a few drawings of history subjects; seemingly, all were religious. The paintings range from small easel pictures reminiscent of Rembrandt and his school [3] to enormous *machines d'église* such as the *Adoration of the Magi* (Fig. 51), where one can detect the influence of a century of Parisian ecclesiastical art reaching back to the mannerisms of Vignon.

The "livre de raison," as it exists today, is of little help for subjects other than portraits. Although we can be certain that sketches of history, still life and the other genres were once present — and there was still one drawing of a landscape in the first album in 1929 — they must have been removed early on, since they would have been more salable than portraits. Landscape *painting* cannot have been a very important occupation for the young Oudry, but landscape as a subject of study definitely was. Here we have the evidence of the collection of ink landscape studies begun in 1714, now in the Louvre (Figs. 7-9; cf. Paris 22-25). The drawing from Edinburgh [11] probably comes from the "livre de raison." Like the Louvre sketchbook, it is revealing of Oudry's early interest in natural observation and in the workings of chiaroscuro and atmosphere in establishing recession — qualities that will be fully developed in his landscape paintings and drawings later on.

Given that he was casting about in so many directions, it is not surprising that the young Oudry was attracted by the new fashion for gallant subjects

Fig. 9 *Village in a Plain*, from a
landscape sketchbook dated 1714. Paris,
Musée du Louvre, Cabinet des Dessins.

and for the Italian comedy. The single easel picture involving these themes which he painted in his first period, probably very early, comes right out of Gillot and the early Watteau but with the bright coloration of Largillierre [**2**]. Other painted genre subjects are just as rare; let us mention only the lost picture of a *Galleyslave* whose corresponding drawing from the "livre de raison" survives (Fig. 10; cf. Paris 9). Related to these works are some popular prints, particularly an album of rebuses dedicated to the Duchesse de Berri, which Oudry published late in 1715 (cf. fig. 49); but these are also few in number and, to be frank, of no artistic consequence.

And finally we arrive at the *Abundance*, Oudry's reception piece for the Académie royale, delivered in 1719 [**6**], which as a figure painting and an allegory qualified him for membership as a history painter. The picture is a potpourri of all the "talents" he had attempted and, indeed, summarizes well the lack of cohesion of the whole first period. But one senses here a true promise for fruits, flowers, vegetables, landscape and animals, which suddenly and perhaps unexpectedly will come together in the next few years, when Oudry at last finds not only himself and an appreciative audience, but also the essential element of success that had previously eluded him — a highly placed and faithful clientele.

If one were to look only at the subjects of his pictures, Oudry's second period would seem as varied as his first, but while this may be superficially true, aesthetically it is not. His art is unified by his personal vision, at last acquired. There are a few portraits but they are not at all central; there are no religious subjects. A small but important group of innovative landscape pictures, many still lifes in a new style, entertaining

THE ANIMAL PAINTER (1719-1728)

Fig. 10 *A Galleyslave*, from the "Livre de Raison". Dated 1713. Private collection.

and splendidly executed *scènes de moeurs* in the form of illustrations for the *Roman comique* of Scarron, and most especially the family of subjects of the hunt with living animals, new for Oudry: this is the repertory with which he will build his career.

In February of 1719, the date of his reception in the Académie royale, Oudry was living on the quai de la Mégisserie, where he was to remain for five more years. Between 1719 and 1721 there were no outward signs of any change in his circumstances, yet during this short period he was quietly but decisively developing his own manner, as can be seen from the evolution of the *Four Elements*, pictures he painted for himself although he sold them to the King of Sweden about twenty years later. *Air* (Fig. 11) and *Water* (Fig. 12) date from 1719; *Fire* (Fig. 13; cf. Paris 29) and *Earth* (Fig. 14; cf. Paris 30) from 1720 and 1721. Across these four pictures Oudry moves from the decorative taste of the age of Louis XIV to the Louis XV style or, as contemporaries called it, the *genre pittoresque*. Also from 1721 are the two famous *buffets* in the Wallace Collection — the *Dead Wolf* (Fig. 15) and the *Dead Roe* (Fig.16) — and the bold *Return from the Hunt with a Dead Roe* which the artist kept all his life [16] and which until this year had not been seen outside Schwerin since 1755. After the completion of these works one sees a spectacular rise in his fortunes. Oudry displayed pictures in the traditional Corpus Christi exhibition in the Place Dauphine every year from 1722 through 1725 (and probably earlier; there are no records), with considerable success. He sent twelve paintings to the Salon du Louvre of 1725. The culmination was the command exhibition at Versailles on 10 March 1726, where the king and queen and the whole court admired no fewer than twenty-six

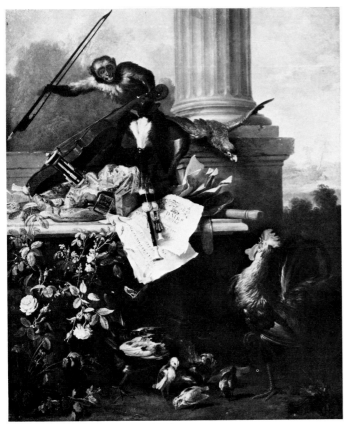

Fig. 11 *"L'Air"*. Dated 1719. Stockholm, Royal Castle (on loan from the Nationalmuseum).

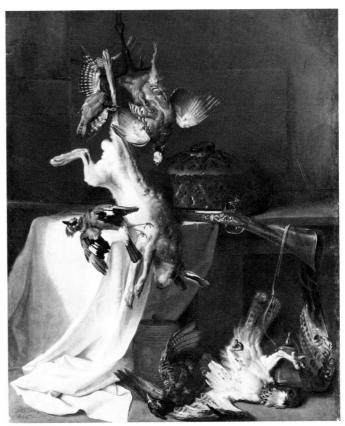

Fig. 13 *"Le Feu"*. Dated 1720. Stockholm, Royal Castle (on loan from the Nationalmuseum).

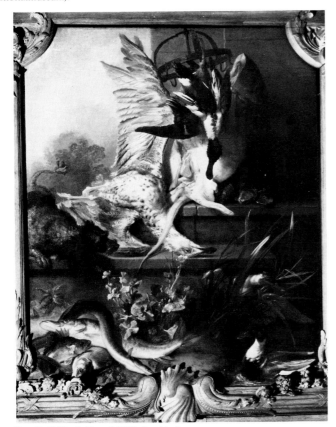

Fig. 12 *"L'Eau"*. Dated 1719. Stockholm, Royal Castle (on loan from the Nationalmuseum).

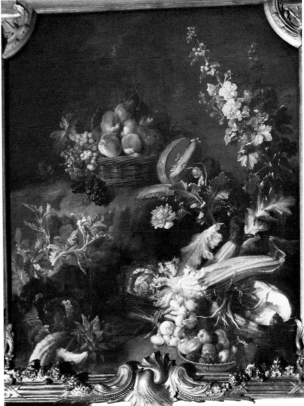

Fig. 14 *"La Terre"*. Dated 1721. Stockholm, Royal Castle (on loan from the Nationalmuseum).

45

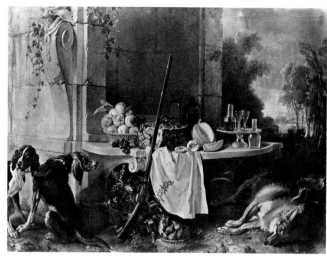

Fig. 15 *The Dead Wolf.* Dated 1721.
London, The Wallace Collection.

of his canvases, most of them done since 1719. In the meantime he had been introduced, in 1723-1724, to both Louis Fagon, *intendant des finances*, and Henri-Camille, Marquis de Beringhen, *premier écuyer du roi*. Beringhen presented him to Louis XV and obtained a studio for him in the Tuileries palace. Oudry's first royal commissions came in 1724 [cf. **24**], and in 1725 he painted the portrait of two dogs in the king's presence [**25**]. Later in the same year he was given lodgings in the Cour des Princes of the Tuileries, and in 1726 Fagon had him named painter to the Beauvais tapestry works. In the short span of about three years Oudry had arrived. From now on he would live comfortably, admired and in great demand.

Oudry's new manner is a version of the *genre pittoresque*, which emerged simultaneously in the works of several painters in the 1720s, most important among them Lancret, de Troy, Lemoine, Noël-Nicolas and Charles-Antoine Coypel, Nattier, and Restout. It is a frankly decorative style, exploiting the irregular and the unusual through the counterplay of arabesques, and achieving its compositional effects through asymmetry. The classic definition was given by one of its practitioners, Charles-Antoine Coypel: "un choix piquant et singulier des effets de la nature" (cited by Kimball, 1943 [1964], p. 62). All of the multiple senses of the word "piquant" are evoked here, particularly its insistence on the lively as opposed to the static, and on the necessity to capture and hold the viewer's attention as in the expression "piquer la curiosité." And then "singulier": the emphasis is on the particular rather than the universal, both in terms of what the artist chooses to represent and how he represents it. Each picture is a totally new experience for both artist and viewer. In this style

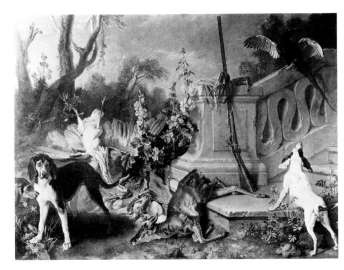

Fig. 16 *The Dead Roe.* Dated 1721.
London, The Wallace Collection.

the artist is all-important as inventor: his "choix" is what determines whether a painting succeeds or fails. But he must also be a perceptive observer, for he makes his choice, not among imaginary images, but rather among the infinite variety "des effets de la nature." And finally there is the word "effets," implying that a painting is the record of a process rather than an arrangement of determined forms. It sets down an irrepeatable moment when certain effects coexist in a certain way, noticed and captured by the aesthetic sensibility of the artist, who in a sense makes permanent through the creative act what is fugitive in nature. Oudry's brand of *genre pittoresque* often exhibits a fanciful and brilliant palette along with theatrical contrasts of light and shade, derived ultimately from Largillierre but applied to still life, animals and landscape, not to portraiture for which they had originally been intended. And yet, for all of these decorative qualities, Oudry remains closer to nature than any of his contemporaries among the first generation of practitioners of the new style ... but by the end of the decade he will face the formidable challenge of Chardin.

Drawings of the second period, though few in number, are remarkable for their beauty and variety. They, too, betray the qualities of the *genre pittoresque.* Finished compositional studies for paintings are usually in pen and brush with both black and brown inks over a red chalk sketch, achieving an astonishing coloristic range [**21**; cf. also Paris 39]. Then there are *premières pensées* and illustrations in loosely handled black and white chalks [**22-23, 31**], and others that have been "finished" with further work in brush and ink to be engraved [**30**]; the latter are particularly effective for their rich chiaroscuro. And finally there is a rare type of rapid sketch

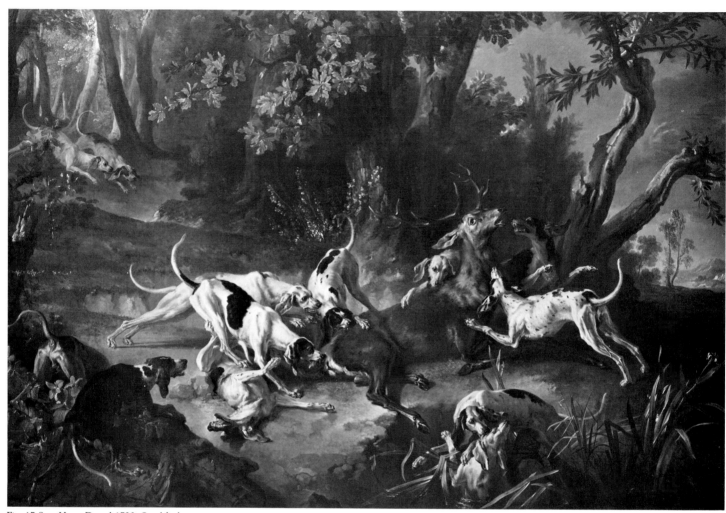

Fig. 17 *Stag Hunt*. Dated 1723. Stockholm,
Royal Castle (on loan from the
Nationalmuseum).

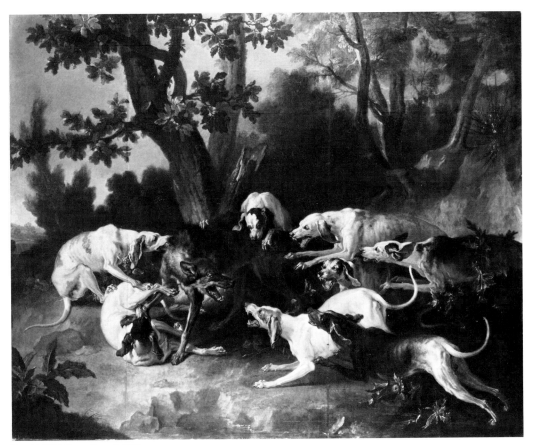

Fig. 18 *Wolf Hunt*. Dated 1724.
Ansbach, Residenz.

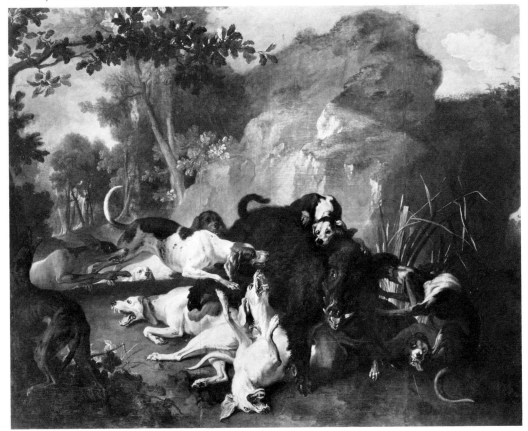

Fig. 19 *Boar Hunt*. About 1725.
Ansbach, Residenz.

with the brush, black ink and white gouache, certainly the most free of all his drawing manners and which he seems to have practiced only in the mid- to late-1720s [29]. We must call attention to the fact that we know of not a single example of a study from nature in the second period. In these years Oudry used drawing exclusively as invention.

The most striking paintings of the period are the three large hunts of the stag, the wolf and the boar that Oudry painted in 1723, 1724 and 1725; for more than two centuries they have been an integral part of the decor of the Royal Castle in Stockholm for the first of them, and the Residenz at Ansbach for the other two (Figs. 17-19; cf. Paris 39). How can Oudry, who had done only a few pictures of living animals on a modest scale beginning in 1719, have reached the decision to attempt so ambitious a work as the *Stag Hunt*, which was originally nearly five meters wide and contains eleven hounds in addition to the stag and an extensive landscape? Let us recall that none of these pictures was commissioned, so that he can only have done them as a challenge to himself...and to François Desportes, the great and, for more than twenty years, unrivalled painter of the hunt. The *Stag Hunt* was so successful that only a year later, in 1724, Oudry was commissioned to do a series of hunts for the king, a commission that was revised somewhat — in fact, Desportes was given a share of it — and completed in 1725; these three pictures — of which the finest, in our opinion, is the one now in Rouen [24] — apparently were a present from Louis XV to the Duc de Bourbon at Chantilly. Curiously, there seems to have been no hostile competition between Oudry and Desportes; there was enough demand for animal subjects to keep both busy. And their manners are different. Desportes retains the naturalism of

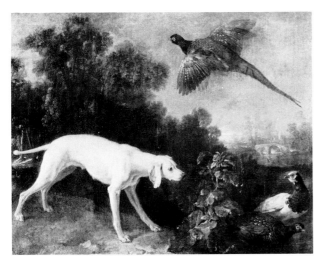

Fig. 20 *Lise and three Pheasants*, painted for the King's apartments at Compiègne. About 1727-1732. Fontainebleau, Musée national du Château de Fontainebleau.

his Flemish roots and the dignity of the age of Louis XIV, while Oudry, with his mastery of the new decorative style, is a kind of Desportes in modern dress.

Louis XV also broke Desportes' monopoly as portraitist of the royal dogs by commissioning, in 1725, the picture of *Misse and Turlu* [25], further honoring the artist by watching him paint it. Its success led to the commission of several more over the next few years, including *Blanche* (Fig. 73, cf. Paris 46), the amusing *Gredinet, Petite Fille and Charlotte* [26], *Lise* (Fig. 20), and the magnificent *Polydore* (Fig. 74; cf. Paris 45). The combination of Oudry's decorative instinct with his ability to give convincing character studies based on observation is seen to perfection in these five pictures. Over the rest of his career Oudry often did canine portraits for private individuals as well (e.g., Paris 91).

Still-life types in the second period range from cabinet pictures of a traditional sort, such as the *Vase of Flowers* [20], to exuberant decorations like the picture from Chicago [17]. A special category characteristic of the 1720s is the fish-piece, including a number of pictures that were done directly from freshly caught fish "peints au port de Dieppe d'après nature, voyage fait exprès," as Oudry tells us in a later memorandum about one of them. The compositions of a lost pair of the Dieppe pictures are preserved in two well-known drawings from the Goncourt collection (Figs. 21, 22; cf. Paris 34-35), marvels of the *genre pittoresque* in their shifting groupings and arabesque contours. Among the still lifes, the two from Chicago and Toledo [17, 18] are illustrative of a special problem. While they are complete and successful works of art in their own right, each is a repetition,

or more exactly a rearrangement with variants, of an earlier painting by the artist. This practice becomes extremely common beginning in the second period and is the result of several factors. First we have Oudry's practice of painting pictures for himself, then keeping them for display in his studio or, when possible, in public exhibitions, for many years afterwards — often until his death. For example, he painted the *Four Elements* between 1719 and 1721, and only sold them to the King of Sweden around 1740...and in the meantime many repetitions were painted. Second, Oudry had become extremely busy and was able to ask prices often prohibitively high for his original works. Repetitions must have been cheaper even when entirely from Oudry's own hand which, unfortunately, was not always the case: witness the oft-cited remark that Desportes "aimoit bien les Oudry, quand ils étoient entièrement de sa main" (Gougenot, 1761 [1854], p. 371). The third factor is Oudry's reputation as a decorator, which was high. Decorative pictures must be made to measure: it would have been rare indeed that a painting from Oudry's stock be of precisely the right format. But his collection did provide a great variety of motifs for readaptation to the particular needs of a client, and the extent of Oudry's personal participation in such works could vary according to his clients' pocketbooks. We might add that such "studio" productions are essentially limited to decorative commissions, and that Oudry almost never signed them. When one finds an easel painting that is a repetition, it is either entirely by Oudry (and there are not many instances of this), or it is a later copy.

Landscape in any form other than backdrops for animal pictures is a scarce commodity between 1719 and 1728 — for example, we have found

Fig. 22 Macaw, Fish and Shellfish.
Drawing of about 1740 after a lost
painting of 1724. New York, Cooper-
Hewitt Museum, Smithsonian
Institution.

no landscape drawings prior to the latter year. Oudry's first concentrated effort in the domain of landscape painting was the series of six small pictures, all or most of them from 1727, done for the Marquis de Beringhen [**27, 28**]. These show rural manors or farm buildings with figures of peasants and animals in the foreground, engaged in the everyday life of the country-side. The arrangements are sprightly, the colors and effects of light "piquants et singuliers," but these are added to an underlying base of Flemish naturalism found in similar pictures by seventeenth-century masters such as Siberechts and Teniers, in exactly the same way that Oudry had transformed the hunting pictures of Desportes.

It is not necessary to do more than simply call attention to the group of illustrations for the *Roman comique*, witty and animated drawings still today underappreciated but to which Oudry, always in pursuit of his public, devoted considerable attention [**29-31**; cf. Paris 49-55]. And yet in 1729 Oudry uncharacteristically abandoned this project, begun and carried through up to that point with his usual energy. The second period thus comes abruptly to an end, not with the self-conscious assertion of a new manner with which it had begun, but rather with a new set of conditions imposed from without: the portrayal of the royal hunts, culminating in the great Gobelins tapestries, Oudry's *chef-d'oeuvre*. While the repertory of subjects he established in the second period will continue to serve him all his life, the freedom and variety of the *genre pittoresque*, without disappearing altogether, will more and more be tempered by the experience of the rigorous, disciplined study of nature exacted by the *Chasses royales*, as Oudry, now turned forty, leaves behind the most exhilarating years of his career and enters his maturity.

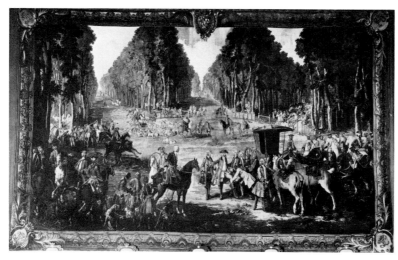

Fig. 23 *Rendez-vous au carrefour du Puits du Roi, Forêt de Compiègne.* Gobelins tapestry from a model of 1735. Florence, Palazzo Pitti.

THE TAPESTRY DESIGNER (1728-1739)

The date of January 1728 marks just as decisive a turning point in Oudry's fortunes as that of February 1719. It was then, almost exactly nine years after entering the Académie royale, that he was ordered to follow the royal hunts and to prepare the very large picture now in Toulouse, which he completed more than two years later [**33**]. From this work naturally followed the celebrated *Chasses royales de Louis XV.* Truly they are the centerpiece of Oudry's *oeuvre*, coming as they do in the middle of his career, and also his most ambitious project, establishing his reputation once and for all and bringing him considerable wealth (payments of 52,000 livres over a twelve-year period, 1734-1746, for the cartoons alone, plus his salary for overseeing their execution at the Gobelins). They are so important that their history must at least be summarized (Figs. 23-31; cf. Paris 60-62). The series includes nine panels — five large ones varying in width from about five meters to nearly ten, and four smaller ones, somewhat less than three meters wide. The commission dates from 1733, and the cartoons (which are actually finished paintings in oils on canvas) were delivered between 1735 and 1746: eight of them were installed at Fontainebleau under Louis Philippe, while the ninth is in storage in the Louvre. They were woven twice, more or less simultaneously, in the ateliers of Monmerqué and Audran. The first set of tapestries is today at Compiègne, for which it was originally destined, and the second, acquired in 1749 by the Infante Don Felipe, Duke of Parma, went to the Palazzo Pitti in Florence in the 1860s. Oudry also prepared small oil sketches for each scene. Eight are in the Musée Nissim de Camondo in Paris; the other is said to be in a private collection.

All but the seventh and ninth panels have portraits of Louis XV and,

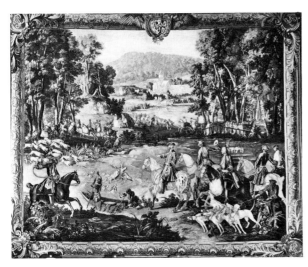

Fig. 24 *La Mort du cerf aux étangs de Saint-Jean-aux-Bois, Forêt de Compiègne*. Gobelins tapestry from a model of 1736. Florence, Palazzo Pitti.

usually, of several other hunters as well. The sites of the same seven scenes are also identifiable — five in the forest of Compiègne, one each in the forests of Fontainebleau and Saint-Germain — and it is probable that the other two are topographically correct as well. The subject of the monarch hunting in his own domains is far from being a mere chronicle of *faits divers*. The celebration in art of the ceremony of the royal hunt goes back to antiquity; Oudry's compositions are perhaps the last such representations on so grand a scale. Their most immediate inspiration is the series of twelve Brussels tapestries woven after the designs of Barend van Orley around 1530-1540. This *tenture*, known as the *Belles Chasses de Guise ou de Maximilien*, is now in the Louvre. It was acquired by Louis XIV in 1665 and copied at the Gobelins several times: for the Duc d'Antin, *directeur des Bâtiments du Roi* in about 1720 (it was he who was to commission the *Chasses royales* from Oudry), for the Comte de Toulouse, *grand veneur de France*, in about 1723; and for Louis XV himself from 1723 to 1729. The *Belles Chasses*, too, show portraits of hunters in topographically recognizable surroundings. It is not by accident that Oudry carefully depicted real localities in his models; Gougenot tells us that he had a plan of the forest of Compiègne drawn up at his expense, which he placed before the Duc d'Antin while showing him his compositions. Nor is it an accident that most of the scenes are set at Compiègne. Of course, this was Louis XV's favorite place to hunt, and the tapestries were to go there, but more important, it is the oldest of the royal hunting domains, going back to Merovingian times; Clotaire I had a castle there and is said to have hunted in the forest. We might also mention that the eighth panel has in the background a view of the abbey of Poissy, which was a royal foundation. Poissy had been a royal residence back as far as the

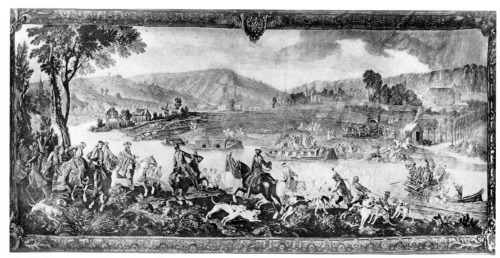

Fig. 25 *Chasse au cerf dans l'Oise à la
vue de Compiègne, du côté de Royallieu.*
Gobelins tapestry from a model of 1737.
Florence, Palazzo Pitti.

fifth century, and Saint Louis was born there. The possession of lands
and the attendant privilege of hunting were among the most important
bases of the legitimacy of the monarchy, and their accurate depiction in
the *Chasses royales* must be seen as an evocation of more than a thousand
years of the history of the Crown of France.

The third period is completely dominated by tapestry. Oudry did carry
out three commissions for Versailles between 1729 and 1733, but after-
wards he received no commissions from the Bâtiments du Roi, other than
the *Chasses royales*, until 1741. And he was also extremely active at
Beauvais. His three most ambitious and most original sets of models for
that factory — the *Amusements champêtres*, the *Comédies de Molière*,
and the *Métamorphoses d'Ovide* [cf. **43**] — were all done after he began
his studies for the big hunt picture in 1728, and before he completed the
first of the *Chasses royales* in 1735. Oudry became co-director at Beauvais
in 1734 and designed two more sets of models over the next two years, but
these are derivative from others of his compositions; afterwards he ceased
designing altogether and commissioned models from others, notably
Boucher. There is some tapestry activity outside the third period, but not
much. His first designs for Beauvais, the *Chasses nouvelles*, precede the
beginning of the period by a year or two, but they were small paintings
rather than full-size cartoons, and they are mostly adaptations of his
earlier hunt paintings, not "new" works (cf. Paris 48). And after 1739
there remained four of the nine *Chasses royales* to be delivered which,
however, in terms of their total area represented only a third of the
commission.

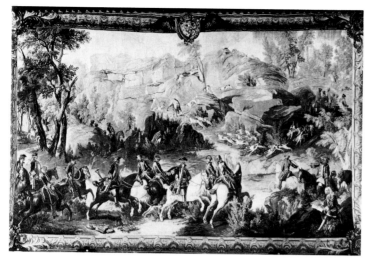

Fig. 26 *Cerf aux abois dans les rochers de Franchard, Forêt de Fontainebleau.* Gobelins tapestry from a model of 1738. Florence, Palazzo Pitti.

The importance of the tapestries cannot be overstated. Today one tends to class tapestry among the decorative arts and therefore — wrongly — to diminish its status. But in a period when large-scale mural and ceiling painting had all but disappeared, it was in the realm of tapestry design that artists could still prove themselves on a grand scale. Perhaps these tapestries are not history subjects in the undisputed sense of the word (although contemporaries accepted the *Chasses royales* as such); nonetheless, they served for Oudry as a demonstration that he possessed the talents, taste and skills necessary for the art of the *grande machine*, elevating him from an artist of the lesser genres into the class of a Rubens, a Le Brun, or a Raphael.

The commission of 1728 and the ensuing *Chasses royales* are indirectly responsible for an important change in Oudry's art, which will not become fully visible until his fourth period. This is a turning away from the decorative effects of line and color of the full-blown *genre pittoresque* as he begins to work more closely from nature. The first time we hear of Oudry painting animals at the menagerie of Versailles is in 1729, with the picture of a family of axis deer now in the Muséum d'Histoire naturelle (Opperman, 1972 [1977], II, p. 482, cat. no. P335). The *Lion* of 1732 was also painted there (Fig. 33; cf. Paris 86). And it is in the third period that we begin to encounter large numbers of drawings from nature, of animals and, occasionally, the human figure. Although they are not without problems, the unique group of chalk and pastel studies of horses and parrots from Schwerin [34-38] is surely done after nature, and probably in the third period. It is in landscape, though, that the study of nature has its greatest impact. The backgrounds of the picture in Toulouse and of the

57

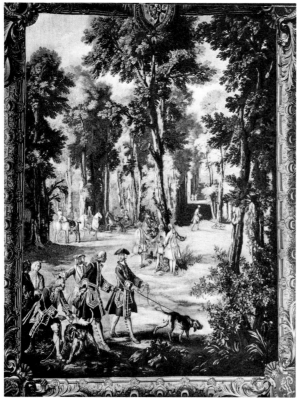

Fig. 27 *Louix XV tenant le limier,
allant au bois, au carrefour du Puits
solitaire, Forêt de Compiègne.* Gobelins
tapestry from a model of 1739. Florence,
Palazzo Pitti.

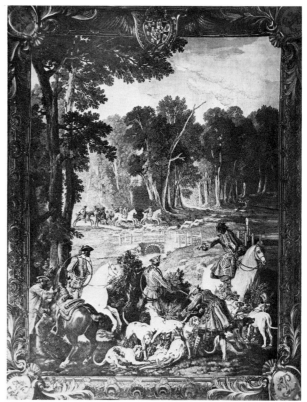

Fig. 28 *On découple la vieille meute au
carrefour de l'Embrassade, Forêt de
Compiègne.* Gobelins tapestry from a
model of 1741. Florence, Palazzo Pitti.

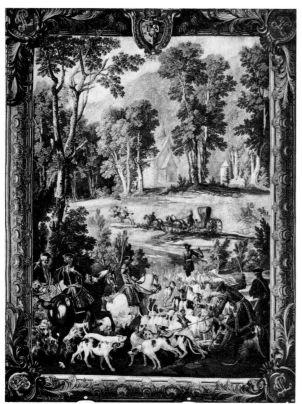

Fig. 29 *Meute de chiens courants qui
vont au rendez-vous.* Gobelins tapestry
from a model of 1743. Florence, Palazzo
Pitti.

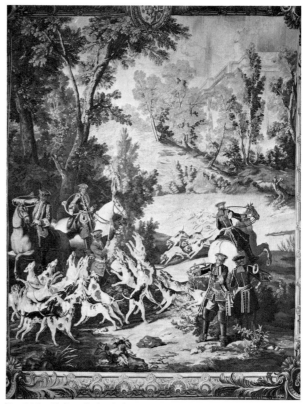

Fig. 31 *Le Forhu à la fin de la curée.*
Gobelins tapestry from a model of 1746.
Florence, Palazzo Pitti.

58

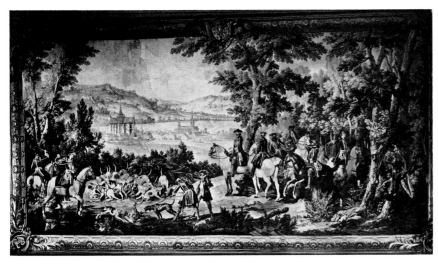

Fig. 30 *La Curée du cerf dans la Forêt de Saint-Germain à la vue de l'abbaye de Poissy.* Gobelins tapestry from a model of 1744. Florence, Palazzo Pitti.

Chasses royales cartoons are topographically accurate, and from now on the natural current will dominate the imaginary one in Oudry's landscape paintings and drawings. Curiously, though, we have encountered practically no landscape drawings from the third period. Must we assume that they have been lost, or perhaps that they mostly consisted of rapidly sketched individual motifs which Oudry considered of little importance and disposed of (we know of his penchant for highly terminated drawings...)? Landscape paintings seem to have been common during these years, but mostly we know them only from old citations in the Salons or Oudry's correspondence. Two fine examples from 1737 and 1738 [**44-45**] manifest Oudry's interest in natural scenery while combining decorative effects with observation. A hunt drawing of 1728 [**32**] is essentially a landscape, and an extremely beautiful one; this is a finished presentation drawing done in the studio, but the setting, with its carefully observed patterning of light and shade, must be based on the study of an actual site. It makes an interesting contrast with the extraordinarily free and imaginative early designs for the *Métamorphoses d'Ovide* [cf. **43**] which were composed completely in the artist's head.

What of the other genres during these years? With the exception of his complete set of illustrations for La Fontaine — done in the evenings in his spare time, when there was no daylight to paint by — one finds very little else besides tapestry, landscape, and decorations done with studio collaboration. Our selection of the La Fontaine illustrations [**39-42**] gives a sampling of the fecundity of Oudry's imaginative powers in face of the formidable task of finding just the right way of conveying the essence of La Fontaine's messages (not always possible) without repeating himself in

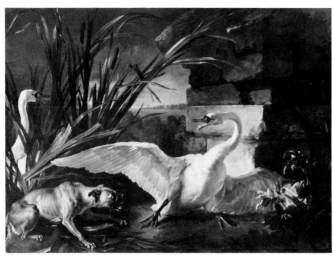

Fig. 32 *Mastiff attacking Swans*. Dated 1731. Geneva, Musée d'Art et d'Histoire.

no fewer than 275 designs. In the interval between finishing the hunting picture for Louis XV in 1730 and starting on the *Chasses royales* in 1733 there are a few other ambitious paintings that Oudry kept many years in his private collection: an imitation of a bas-relief from 1730 [**46**]; the *Mastiff Attacking Swans* of 1731 in Geneva (Fig. 32); the lifesize *Lion* (Fig. 33; cf. Paris 86) and the *Wolf Caught in a Trap* (Fig. 34), both from 1732. After that there are a few odds and ends such as the portrait of dogs and birds painted in 1735 (Paris 91) which demonstrate that Oudry, no matter how busy he was with tapestry, occasionally ceded to the demands of private patrons. In all of these works, one notes a palette more natural than that usual in the second period, and considerably simplified compositions displaying greater reticence in the use of ornamental arabesques.

By 1738 Oudry is beginning to come back to the production of easel paintings done for themselves (not commissioned), and the reason for this is an obvious one. When the Salons began again in 1737 Oudry was caught short. He sent seven pictures and, from all we can tell, none of them was recent: a buffet which Gougenot tells us was a youthful work (Opperman, 1972 [1977], I, p. 567, cat. no. P546); the *Stag Hunt* of 1723 now in Stockholm (Fig. 17), the *Mastiff Attacking Swans*, *Lion*, and *Wolf Caught in a Trap* just mentioned; and two lost works that cannot be dated, one of them a landscape and the other a fable of La Fontaine. Oudry was always most astute when it came to the marketplace, and realized the potential of the Salons at once, for in that of 1738 the story is quite different. He again sent seven works, and insofar as it is possible to identify them, only one was old — the bas-relief of 1730. The others were two landscapes that we think were the same as a pair dated 1737 and

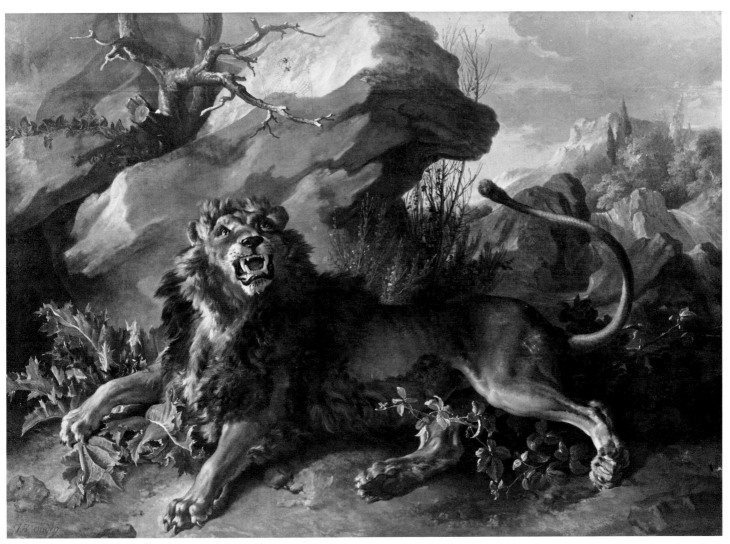

Fig. 33 *Le Lion et le Moucheron*. Dated
1732. Stockholm, Nationalmuseum.

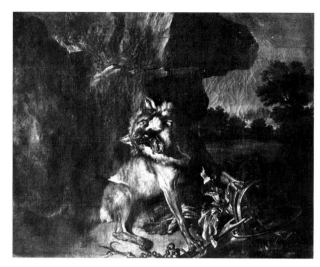

1738 [**44-45**]; the fourth cartoon of the *Chasses royales*, just completed (Fig. 26); a *Stag Hunt* now lost but which we believe to be from 1738 since there is a smaller version of it from that year (cf. Opperman, 1972 [1977], I, pp. 425, 429, cat. nos. P190, P198) and since a drawing of a dog was used both for that picture and for the tapestry model of 1738 just mentioned (Paris 63); the unusual still life of 1738 from Stockholm (Fig. 83); and a lost landscape picture, barely described. Oudry is on the way to the characteristic pattern of his last period. With one exception he will never again send fewer than nine pictures to the Salons.

THE ACADEMICIAN (1739-1755) The last period of Oudry's activity is not easy to classify. Its two most distinctive features are his rise to prominence in the Académie royale, and his productivity of all kinds of works, both commissioned and done to be sold. A group of coincidences has led us to choose the date of 1739 for its beginning. In this year Oudry painted the first *fond blanc* since his youth — the round still life in Drottningholm (Fig. 35; cf. Paris 148) — and also the first of the animal pictures for the Royal Botanical Garden [**49, 52, 74**]. In 1739 he was raised to the rank of *adjoint à professeur* (certainly in recognition of the success of the *Chasses royales*); he became *professeur* in 1743, and was granted lodgings in the Louvre the following year. These marks of distinction are not just tokens. Prior to 1739 Oudry almost never attended the regular meetings of the Académie; afterwards he almost never missed. He delivered two *conférences*, in 1749 and 1752, which are among the most original and important of the century, emphasizing as they do the technical rather than the theoretical aspects of painting. He painted some "academic" pictures as illustrations of the ideas presented in the *conférences*. The most explicit example is the *Canard*

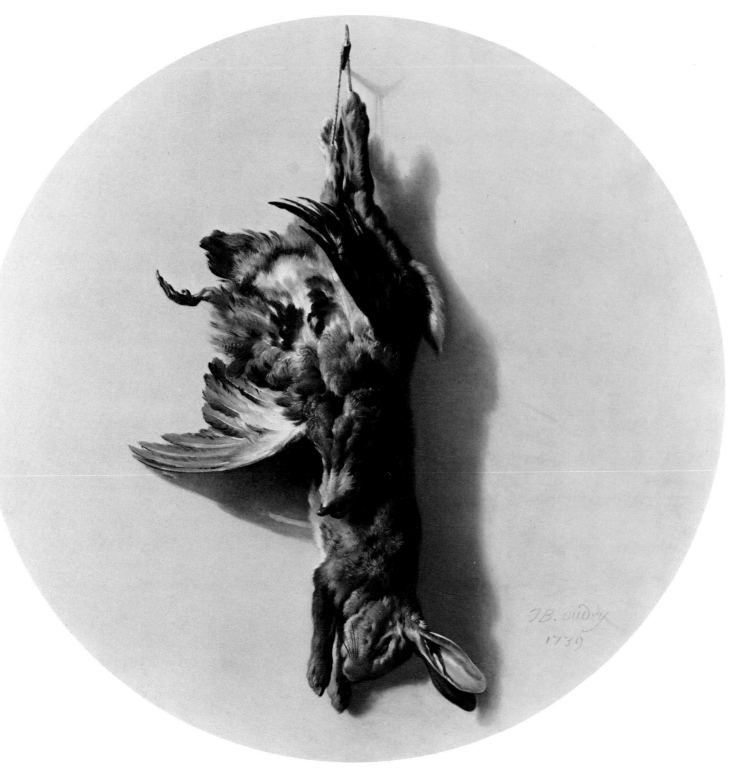

Fig. 35 *Round Still Life with a Rabbit
and a Partridge*. Dated 1739. Drottningholm
Castle, Sweden.

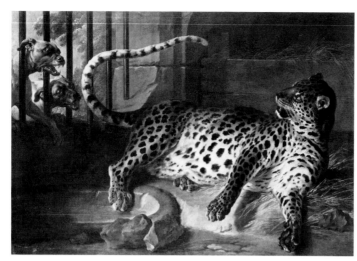

Fig. 36 *Leopard in a Cage confronted by two Mastiffs.* Dated 1739. Stockholm, Nationalmuseum.

blanc (Fig. 113)...but nearly all of the late works can be seen as embodiments of Oudry's principles of light and color observed directly from nature, the foundation of the painter's art.

1739 is also the date of the consolidation of Oudry's international reputation, which actually begins in the third period. He had sold two of the early large hunts to Margrave Carl Wilhelm Friedrich in 1730, to be installed in his Residenz in Ansbach (Figs. 18-19). In 1732 he received his first commission of four pictures from the Duke of Mecklenburg-Schwerin (but two were copies, and it took him until 1734 to finish the others). And he first encountered Count Carl Gustaf Tessin during these years. It was in 1739, however, when Tessin arrived in Paris as the Swedish ambassador, and when Crown Prince Friedrich of Mecklenburg-Schwerin was living there, that important purchases and commissions from Oudry's two greatest foreign patrons really began. Count Tessin bought many works from him; through his intermediary the kings of Sweden and Denmark bought many more. Christian Ludwig of Mecklenburg-Schwerin and his son, buying directly from the artist and from the sale after his death in 1755, put together a remarkable Oudry collection, numbering about fifty paintings and at least as many drawings; although somewhat diminished by loss and destruction over the years, what remains in the Schwerin museum is still the finest ensemble in the world. Oudry was overwhelmed with commissions and with the demand for his non-commissioned works, particularly after the disappearance of his last rival in 1743 with the death of Desportes (let us recall that Chardin only began to turn back to still life at the very end of Oudry's career). From 1739 on he did more than thirty works for the king, and also worked directly for the queen, the

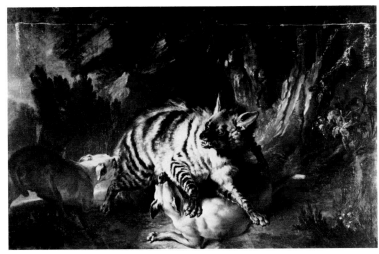

Fig. 37 *Hyena attacked by two Mastiffs*, painted for the Royal Botanical Garden. Dated 1739. Schwerin, Staatliches Museum.

dauphin and the dauphine, and Madame de Pompadour. His other patrons — and this list is far from exhaustive — included painters such as Boucher and Le Lorrain, the goldsmiths Germain and Roettiers, financiers (Bernard, Savalette, Trudaine...), officials like La Peyronie and his old protectors Fagon and Beringhen, and discriminating connoisseurs, notably La Live de Jully. But it is safe to say that more than half of the pictures he painted were not commissioned, but rather done to be exhibited at the Salons where, indeed, many were sold right off the walls [e.g., **65**]. No painter more assiduously sought the attention of the public through the medium of the Salons. In the fourteen exhibitions between 1737 and 1753, Oudry showed 180 paintings, an average of about thriteen in each (including several that were sent more than once...but this practice was not unique to Oudry). Among the other artists who showed in some or all of these same Salons the averages per exhibition are Perronneau, nine; Desportes, seven; La Tour and Pierre, six; Boucher, Collin de Vermont, and Francisque Millet, five; and Aved, Chardin, Natoire, Tocqué, and Carle Vanloo, four. Oudry was the dominant presence in nearly every Salon, in quantity certainly, but also very often in critical success as well.

Perhaps the best introduction to the late period is to cite the pictures that were the most appreciated in the various Salons. These fall into five natural groupings. First, there are the large hunts with figures. Oudry sent two of the *Chasses royales* cartoons to the Salons of 1738 and 1741 (Figs. 26, 28), but they were not remarked upon (however, there is very little critical literature prior to 1746). In 1750 he exhibited the big *Hunt of Louis XV* from Marly, painted twenty years earlier, and it was well received [**33**]. Second, we have the group of large pictures of dogs attacking

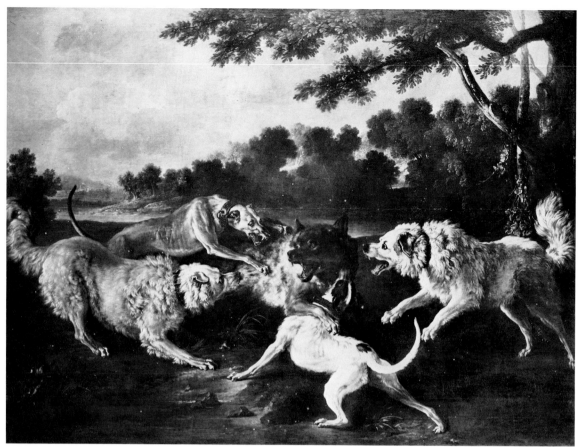

Fig. 38 *Wolf Hunt*, painted for the
dining-room of the Château de la
Muette. Dated 1746. Gien, Musée
international de la Chasse.

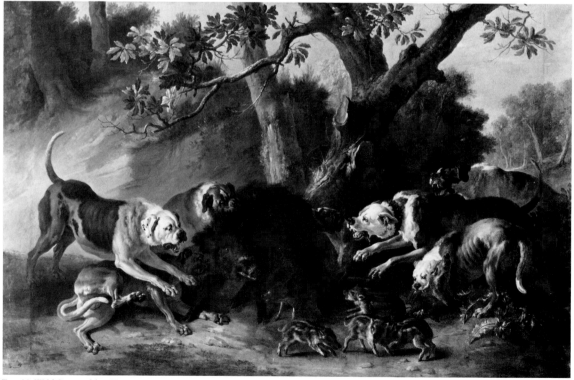

Fig. 39 *Wild Sow and her Young
attacked by Mastiffs*. Dated 1748. Caen,
Musée des Beaux-Arts.

or annoying wild animals and birds. A lost *Stag Hunt*, probably painted about 1738, was admired in the Salon that year and also when shown again in 1751. A *Leopard in a Cage Confronted by Two Mastiffs*, painted in 1739 and today in Stockholm (Fig. 36), attracted attention in the Salon that year as did the picture of a *Hyena Attacked by Two Mastiffs*, one of the first of the wild animal series for the Royal Botanical Garden (Fig. 37). The latter picture was also remarked upon in the Salon of 1746, along with the enormous *Wolf Hunt* for La Muette (Fig. 38). The success of the *Wild Sow and Her Young Attacked by Mastiffs* was enormous in the Salon of 1748 (Fig. 39; cf. Paris 110). And finally, the twenty-year-old *Mastiff Attacking Swans* now in Geneva was favorably received in 1751 (Fig. 32). The third subject group consists of cabinet pictures with subjects of dogs. Several of these stood out, notably the portrait of Pehr, Count Tessin's dachshund, in 1740 (Fig. 40; cf. Paris 111); the two tiny works on copper, one showing dogs with dead game and the other a dog pointing pheasants, in 1748 [**61-62**]; the small picture of a sleeping dog shown in 1751 and since lost from view [cf. **64**]; and most especially the *Bitch Hound Nursing Her Pups* [**65**], the "premier tableau" of the Salon of 1753. The fourth category is landscape. Although landscape pictures are usually difficult to identify from the descriptions in the *livrets*, and although many of them have disappeared, we can state that, in general, Oudry was very much appreciated for his works in this genre. Some specific pictures are two probably shown in 1738 [**44-45**], the view of the aqueduct of Arcueil of 1745 [**67**], the *Mill* of the Nantes museum (Fig. 41; cf. Paris 127) if we are correct in assuming that it was exhibited in 1746, the *Gardener's House* [cf. **66**] and its pendant (Fig. 105) in 1747, and finally the *Landscape with a Wolf Hunt* in 1748 (Fig. 42; cf. Paris 139). The last of the five types of

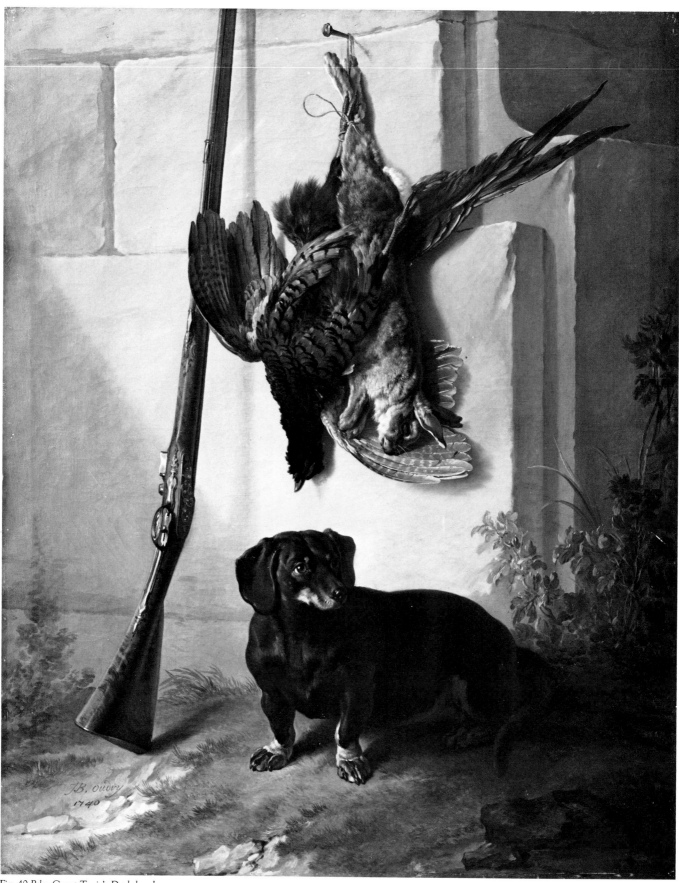

Fig. 40 *Pehr, Count Tessin's Dachshund, with Dead Game and a Rifle.* Dated 1740. Stockholm, Nationalmuseum.

Fig. 41 *Landscape with a Water Mill.*
Dated 1740. Nantes, Musée des
Beaux-Arts.

picture that pleased are devoted to trompe-l'oeil. One category of this is the *devant de cheminée*, a canvas used to close off fireplaces in the warm months and painted illusionistically, as if animals and still-life accessories occupied the volume of the open space. Two painted for Beringhen were praised in 1741 and another in 1751, the *Dog with a Porcelain Bowl Filled with Water*, today in Glasgow (Fig. 43); a famous example of this type is the *Tabouret de Laque* [60]. A similar sort of exercise must have been the smaller "vase de marbre dans une niche, appartenant à M. Berger," exhibited in 1746 and since disappeared; Mariette noted in the margin of his copy of the *livret* that it "a amusé bien des gens." At the 1738 exhibition the painted bas-relief of 1730, after Duquesnoy, was singled out for its perfect illusion [46]. After these we come to the trompe-l'oeil easel paintings typical of the last period. Many of them were especially praised, beginning with the *Bois de cerf* in 1741 [76]. The "fonds blancs" received much critical attention; among them the little picture recently acquired by the Allen Memorial Art Museum at Oberlin College seems to have been particularly successful (Fig. 44; cf. Paris 151). The most remarkable of all of these show white objects on a white ground: the *Gulls* of 1750 (Fig. 114) and the *Canard blanc* of 1753 (Fig. 113). Both have pendants designed to demonstrate another difficult kind of illusionism, colored objects on a colored ground. That of 1753 [79] was appreciated by some critics at the Salon, but its reception was mixed. It seems that it could not stand up beside its illustrious companion.

It is equally instructive to consider the types of pictures that were not consistently noticed. Among these are the numerous overdoors of animal subjects: two for Choisy in 1743 (one now in the Muséum d'Histoire

Fig. 42 *Landscape with a Wolf Hunt.*
Dated 1748. Nantes, Musée des
Beaux-Arts.

naturelle, the other lost); six *Fables* of La Fontaine in 1747, for Versailles
(still there today); four done for Trudaine and shown in 1746, now in the
Wallace Collection; in 1750, four for La Muette (cf. Paris 103) and four
more for the dining-room of the Château de Bellevue (cf. Paris 119-120).
Not one of these twenty canvases was mentioned by a single critic. The
same is true of large-scale wall decorations of dogs and still life, for example,
the lost buffet 325 cm. square done for Choisy and shown in 1743, and
the splendid pair of pictures for Samuel-Jacques Bernard exhibited the
year before [**58** and Fig. 94]. With the exception of the extreme trompe-
l'oeil works, Oudry's still-life pictures did not attract much attention. Nor
did his many subjects of birds of prey attacking ducks, hares and the like
[e.g., **55**] and the equally common scenes of dogs either attacking or point-
ing birds, or guarding dead game; the exceptions are always unusual works,
unusually large as in the *Mastiff Attacking Swans* in Geneva (Fig. 32),
unusually small as in cat. nos. 61 and 62, or unusual in their absolute
perfection, as in the case of *Pehr* (Fig. 40). The big pictures of exotic
animals received little comment, pictures like the *Indian Blackbuck* [**49**],
the *Lion* (Fig. 33), and the *Leopard* [**52**]. And finally the landscapes,
which had always been popular, ceased to be after 1748: the ambitious
La Ferme [**72**] was not remarked upon in the Salon of 1751. But we must
not forget that criticism is scanty or absent for many of these Salons, and
also that Oudry was really in competition with himself by virtue of send-
ing so many pictures. No critic could mention them all.

Nonetheless we can draw some conclusions. Oudry's most successful pic-
tures in the eyes of his contemporaries displayed one of several qualities.
Among the animal paintings those that show dramatic confrontations

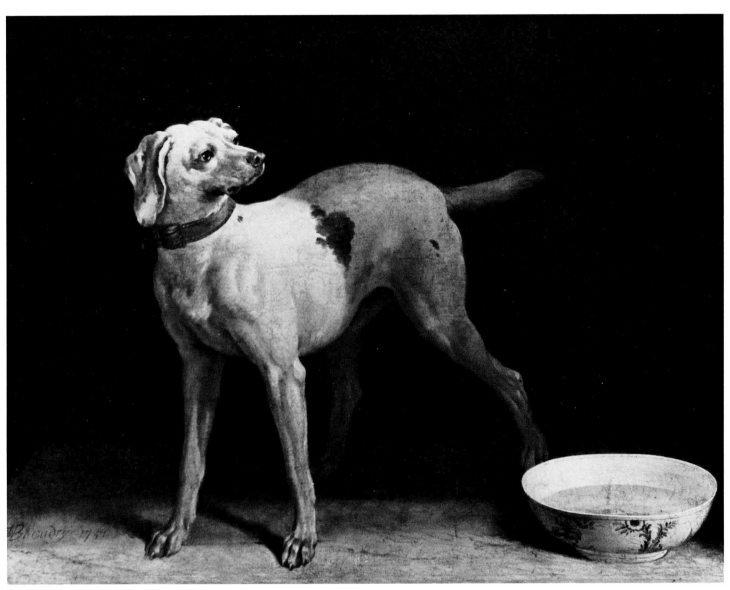

Fig. 43 *Dog in a Fireplace with a blue-
and-white Porcelain Bowl.* Dated 1751.
Glasgow, Burrell Collection, Glasgow
Art Gallery and Museum.

Fig. 44 *A Young Rabbit and a Partridge hung by the Feet.* Dated 1751. Oberlin, Allen Memorial Art Museum, Oberlin College.

attracted much attention; critics "read" them as if they were history subjects, and judged them by the same standards (for example, the *Wild Sow* now in Caen, Fig. 39). And those where a human quality of sentiment is transferred to the animal world were also highly appreciated [cf. **65**]. The landscapes of humble rural scenery around Paris pleased, but those done from the imagination did not. And then, questions of content aside, connoisseurs and the public at large were uniformly appreciative of his tours de force of illusionism, whether it be in the trompe-l'oeil pictures or in the way he handled atmosphere, chiaroscuro and color in the landscapes and animal subjects. It would be well for the modern viewer to bear all of this in mind, for many of the qualities that were essential for arriving at an understanding of Oudry's art in his time — illusionism, sentiment, the passions of the soul — are not held in high esteem today.

Oudry was so prolific and so varied in the last period that it is difficult to discuss it in a few pages. We have arranged the catalogue entries by subject type. At the beginning there is the portrait of Prince Friedrich [**48**]. Then comes the large group of paintings and drawings of subjects of animals and the hunt, sometimes combined with still life [**49-65**]. This is followed by landscape, including a selection of the famous Arcueil views [**66-72**] which are, again, "academic" works, done as embodiments of Oudry's ideas about the observation of light and shade in landscape which he had learned from Largillierre and was to speak about in one of his *conférences*. After the landscapes comes still life [**73-79**], ending with the late trompe-l'oeil pictures, the crowning achievement of his artistic career.

We have touched upon the essential genres and the issues during the last

period as far as painting is concerned; before concluding, it would be well to call attention to the drawings, which show a remarkable variety in subjects, use, and techniques. After about 1739 Oudry increasingly did drawings for themselves, and even when we can demonstrate that they are preparations for paintings, they often appear as the end step in a process, not just as an intermediate step toward a picture, because Oudry finished them so carefully [e.g., **57, 66**]. There are cases where Oudry made drawn replicas of his own drawings or paintings (cf. Paris 34-35, 94, 105). He even sent some works on paper to the Salons to be shown on an equal footing with his paintings: three pastel landscapes in 1745, and some animal combats and Arcueil views in 1753 (cf. Paris 108, 134). Rapid studies of living animals from nature are extremely rare today [**50, 51, 54**]. But his animal studies, even when we can be certain that they were done from life, are usually completely finished. Such is the case of three sheets in three different media — the *Head of a Fox* in pastels [**53**], the *Head of a Dog* in black and white chalks on blue paper [**59**], and the *Sleeping Dog* in black chalk alone on white paper [**64**], which are finished with all the care of Oudry's oil paintings. The numerous landscape drawings are in chalks — notably the Arcueil views [**68-71**] — and in brush and ink with little or no use of the pen (Paris 126, 142, 143, 145). It is interesting that the Arcueil drawings, for all their careful finish, seem to have been done on the spot, with very little retouching in the studio. The ink landscapes, though, show a mixture of the natural and the imaginary.

Oudry overwhelmed the Salon of 1753 with eighteen paintings, five drawings, and six engravings after his La Fontaine illustrations. He seemed to be in full momentum, more productive than ever. Yet this was to be his

last Salon. He suffered an attack of apoplexy in 1754; only a very few works are known from that year. Then he had another seizure, nearly fatal, in January of 1755, and died of a third on 30 April, at Beauvais, where he had gone in the hope that a change of air might lead to his recovery. The contents of his studio were dispersed at the sale of 7 July 1755, without catalogue, and no single large and representative ensemble was left in France: Oudry had disappeared from the public eye. Of the twenty paintings of the last period included in our entries, seven are in Schwerin; nine are from seven different public collections in France, the United States, and Sweden; and four are in French and American private collections. All but three were shown in the Salons. It is up to our present-day public to pass judgment on these works, to choose its favorites in the spirit of those who visited and commented upon the exhibitions of the old Académie, to understand and — let us hope — to admire Oudry's aesthetic of the "beau terminé" [cf. **74**], as he styled it in his *conférence* of 1752.

LIFE AND ART Oudry's roots are twofold, and he maintains them throughout his career: Netherlandish on the one hand, especially the coloristic principles of Rubens and the Antwerp school, acquired through his years of training with Largillierre and, later, his emulation of Desportes, the student of Nicasius who himself had studied with Snyders in Antwerp; and Parisian. He grew up in a neighborhood of artisans, was formed in the milieu of the maîtrise de Saint-Luc, worked for and lived on the Pont Notre-Dame; even though he loved to haunt the woods and fields of the environs of Paris, and regularly visited the nearby royal palaces and the tapestry works at Beauvais, he seems never to have ventured further than 200 kilometers from home. He began by portraying Parisians of all walks of life; he after-

wards filled their dwellings with all sorts of pictures; he ended by pleasing "ignorants" as well as "connoisseurs" at the Salons. He was aware of the art around him, of Watteau [cf. **2**], of Boucher, of Vernet. And of course of Chardin, *le grand Chardin*, younger by thirteen years, whose humble beginnings in the maîtrise, sudden rise to popularity, and Parisian roots so closely resemble those of Oudry.

If, as Pierre Rosenberg remarks in the catalogue of the Chardin exhibition held in Paris, Cleveland and Boston four years ago, the two artists stayed out of one another's way, nonetheless each very much knew what the other was doing. The mutual influences are subtle but recognizable. Chardin began doing still life in the mid-1720s and seems to have noticed some works by his elder in that genre [cf. **19**]. Soon thereafter Oudry essentially stopped doing still lifes because of demanding royal commissions, but Chardin continued and moved away from his pieces of dead game to the "ustensiles et objets de ménage" of the first part of the 1730s, and at the same time abandoned the exaggerated asymmetry and picturesque effects of the "rococo" in favor of a new architectural stability. When Oudry returned to still life at the end of the decade Chardin's lesson was not lost on him (cf. Fig. 45). Oudry moves from his early essays in nearly everything — without notable success — to membership in the Académie royale, the triumph of his animal pictures, and the flowering of his great talent as a decorator in the second period, then inevitably to the tapestry models of the third, particularly the *Chasses royales*, unrivalled in their genre. Here he leaves Chardin behind — or rather, aside — for Chardin did not have Oudry's gift as a decorator on a large scale, probably because he did not have Oudry's academic education; nor could

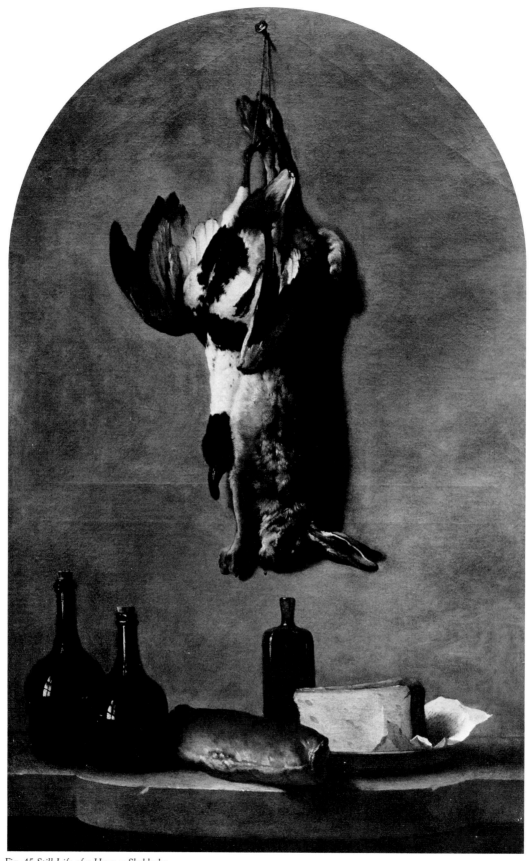

Fig. 45 *Still Life of a Hare, a Sheldrake,*
Bottles, Bread and Cheese, painted for
the dining-room of Monsieur Jombert.
About 1742. Private collection.

he deal with the living animal, no doubt for the same reason. So in the thirties he turned to his unequalled interior scenes with figures, while Oudry was occupied with tapestry. With the institution of the Salons on a regular basis, in 1737, the two were again face to face. Chardin sent eight figure pictures that year, nine in 1738, six in 1739, only five in 1740; Oudry exhibited seven paintings in 1737 (all older works), seven again in 1738 (new this time), nine in 1739 and ten in 1740. For the next nine Salons, through 1751, Oudry sent vast numbers, while Chardin sent almost nothing, to the great dismay of his admirers. Why? It is difficult to say; perhaps Chardin, who worked slowly, simply sold away his small stock during the years of the first few Salons; but the fecundity and versatility of his undeclared rival cannot be discounted as a cause.

We have spoken of Oudry and Chardin at some length because of the interesting parallels and coincidences of their careers. Both of them were approaching the same problem in different ways, that of coming to an understanding of nature while establishing and maintaining their unique artistic personalities. And both of them were trying to transform subjects of "popular" art and the lower genres into "high" art through the integrity of light, composition, color, and their choice of the appropriate technical means of so doing, that is, by métier rather than by mind. We think that Oudry and Chardin would have agreed that the only true art is one based in nature, and that "message" is secondary if not irrelevant — a revolutionary idea in their day, but one that Oudry expounded in his *conférences*, attributing it to Largillierre. Largillierre, of course, was of profound importance for Oudry's art, not just superficially as the model for his early works, but for his whole career, through the principles of light and color drawn

from natural observation he so well taught his pupil (for which see our essay in the Montreal Largillierre exhibition catalogue of 1981). Can it be a simple coincidence that it was Oudry's master who "discovered" Chardin in 1728 and helped to bring him into the Académie?

One obvious difference between Oudry and Chardin is the latter's single-mindedness in limiting himself to a small number of genres on each of which he played a limited but brilliant set of variations. Oudry was open to everything — too open perhaps? His biographer Gougenot seems to have thought so:

> S'il n'eût pas visé à l'universalité, en embrassant tous les genres de la peinture, il eût sans doute été un des peintres les plus accomplis dans ceux auxquels il se seroit fixé. (Gougenot, 1761 [1854], p. 384)

This may be going a little too far, as Oudry is very accomplished indeed in many of the genres — in some more so than others, to be sure. Let us admit that he is not entirely at home with portraiture and with history. Genre subjects are a special case: he did almost none. But many of the landscape pictures are really genre (for example, *La Ferme* [**72**]), as are his illustrations of the *Roman comique* [**29-31**] and many of those for the *Fables* of La Fontaine [**40-43**]; and these contributions are both interesting and original. But one thing Oudry the painter did not approach was domestic genre...was he deliberately avoiding Chardin?

Oudry is a superb painter of the hunt, and here we must again invoke the name of the illustrious Desportes. Is Oudry his inferior? What does he owe to Desportes? Precisely how is he different? Their pictures are

easily distinguished from one another, particularly through the conscious gracefulness — some have called it artifice — of Oudry's compositions, as opposed to the naturalism of Desportes. There is undoubtedly much more to be said, but in the absence of the long-awaited catalogue raisonné of Georges de Lastic no final answers can be given. Comparison between the two also needs to be made for the pictures of dogs, even though there can be no doubt that Oudry's works of this sort are of the first order — masterpieces like *Pehr* (Fig. 40) and the portraits of the dogs of Louis XV done for Compiègne [25-26]. Oudry seems to be unique for the small number of genre-like representations of dogs he did late in his career — subjects of a domestic nature, sentimental and sometimes moralizing [63-65]; curiously, it is perhaps here that he comes closest to the spirit of the figure pictures of Chardin.

We cannot list all of the genres in detail. Let us only mention the pictures of wild beasts [49, 52], works of a surprising vitality; the unusual illustrations of the *Métamorphoses d'Ovide*, done entirely with animals — probably not successful as tapestries by reason of their cryptic subjects, although the designs are beautiful indeed [43]; subjects that defy classification, such as the hunts with figures ([33] — portraiture, landscape, history? shall we call this genre "la petite histoire à grande échelle?"); and the *Tulips* from Detroit [73], at one and the same time still life, architecture, landscape and natural history. We might also point out the great differences in scale, from little coppers [61-62] to colossal machines like the *Wild Sow* from Caen (Fig. 39), shown together in the Salon of 1748. And how can we forget the drawings, of all types, media, genres and sizes, from all the periods? It is impossible to separate Oudry the painter from

Oudry the draughtsman. From his slightest sketch to the most elaborated there is the same interest in setting down what he sees as in any painting. Certainly, Oudry is one of the greatest draughtsmen of the eighteenth century. Invention and observation are in perfect tension in his drawings, and we must insist on reminding ourselves that neither Largillierre, nor Desportes, nor Chardin depended upon, or contributed to, drawing as a means or as an end.

Let us conclude this discussion of the variety of Oudry's oeuvre with a look at two genres where he indisputably made a significant contribution: still life and landscape. In the former genre he moves from the still, simple little pictures of dead birds on light grey grounds at the beginning [**12-13**] to the not dissimilar trompe-l'oeil at the end [**75-79**]. He early does little allegories of the arts with dark backgrounds [**14-15**], then moves on to the exuberant compositions of the 1720s, which in their decorative flair owe something to Largillierre, Desportes and Monnoyer, although they translate the Louis XIV manner of these older artists into the new language of the *genre pittoresque* [**16-19**]. There are isolated masterpieces outside the main groupings, pictures like the *Silver Tureen* from Stockholm (Fig. 83) and the *Dead Crane* from Schwerin [**74**]. And finally there are those that combine still life with living dogs, usually to great effect [**23, 58, 60, 61, 63**]. Within this one genre Oudry shows the same range and variety as in his oeuvre as a whole.

The same is true of landscape, where his principal rivals rarely or never ventured. Largillierre did a few landscapes (and again, Oudry owes him a great debt, acknowledged in his *conférences*); Desportes, despite his justly

famous early oil studies on paper, cannot be considered a landscape painter; and then Chardin practically never set foot out-of-doors. Oudry's importance as a landscapist was well recognized at the time. Critics up until about 1750 noted that he was the only decent one. It is in landscape that he made one of his most important and most original contributions. Right from the start he did a number of wash landscape drawings [11]. A decade later he painted the set of rustic landscapes for Beringhen [27-28], then in the 'thirties and 'forties a whole series of views of the Ile de France [44-45, 67] along with the celebrated and highly original drawings of the gardens of Arcueil [68-71]. The late landscapes such as *La Ferme* [72] are a case apart. And one must not overlook the backgrounds of his figure and animal pictures, which are sometimes imaginary but frequently from nature. The most magnificent of all the landscapes are the *Chasses royales* and their preparations [32-33; cf. Figs. 23-31]. Here Oudry combines his instinctive taste for decorative arrangements with faithful depictions of the sites, and does so to great effect.

In the last few years of his life Oudry's landscapes were no longer so successful, we suspect because the public was bedazzled by those of Vernet. Indeed there are several indications, other than this, that Oudry might not have fared so well at the Salon of 1755 as he did in that of 1753, his last, where he triumphed. Already in 1753 Chardin returned in quantity, with nine pictures including four still lifes, the first he had ever sent. Afterwards, would Oudry's still lifes have stood up to those of Chardin? And one should remember that Greuze was about to appear. How would Oudry's *Bitch Hound Nursing Her Pups* [65] have fared if it had been shown not in 1753, but at the very next Salon in 1755, alongside the

Père de famille qui lit la Bible à ses enfants? Both are sentimental pictures, indeed very similar in their sentiment...but might not Oudry, who after all depicts only dogs, have been seen as an artist of a less noble rank?

There were other disappointments and setbacks as well. Oudry did not obtain the Gobelins tapestry commission for his *Combats d'animaux sauvages* (cf. Paris 107-109). His son Jacques-Charles, received as a member of the Académie royale in 1748, seems not to have made much of an impression in Paris and by the time of his father's death was working in Brussels. And when his twenty-year lease as entrepreneur of the tapestry works at Beauvais expired in 1754, it was not renewed. And finally Oudry, who was accustomed to receiving nothing but applause, was hearing some harsh remarks about his talents at the last Salons. They were few, but they must have rankled. In fact one wonders whether all of these worries might not have contributed to the attacks that brought about his death.

His biographers tell us much about his character and his personal habits. Oudry was a compulsive worker; as Gougenot says,

> Nous remarquerons seulement que, sur ce qu'on lui disoit à la vue de cette multiplicité de travaux, qu'il étoit heureux d'avoir une aussi grande facilité et que l'ouvrage fondoit devant lui, il répondoit avec cette franchise qui le caractérisoit: "Je ne vais pas plus vite qu'un autre, mais je travaille davantage, et souvent ma palette chargée, j'ai attendu qu'il fît jour." (Gougenot, 1761 [1854], p. 377)

Although he enjoyed music and played the guitar well — he occasionally

would join in the presentation of impromptu comedies when invited to the country estate of his friend and protector, Louis Fagon, playing the role of Pierrot — nonetheless he took little time away from his art. Gougenot (p. 377) tells us that even on Sundays and holidays his principal occupation was to draw and paint in the forest of Saint-Germain, at Chantilly, or in the Bois de Boulogne. Another biographer says:

Jamais peintre n'a été si laborieux. Il a fait quantité de tableaux pour le Roy tant chasses qu'autres. S'il quittoit la peinture c'étoit pour dessiner. Il n'a jamais pris un après-midi entier pour son plaisir. Aussi reprochoit-il quelquefois à ses confrères qui venoient l'après-midi le voir qu'ils perdoient la plus belle partie du jour. (Mémoire anonyme, published in Opperman, 1972 [1977], I, p. 171)

But even though he was exacting of himself and of others, he was respected by all and beloved of his friends:

On peut dire à la louange de M. Oudry qu'il a été infiniment regretté par tous ceux qui le connoissoient. Né laborieux, il avoit, quoique modeste, ce degré d'amour-propre si nécessaire pour la perfection du talent. Il étoit d'une probité à toute épreuve; ami fidèle, fort serviable, d'une franchise sans égale, économe et cependant honorable dans les occasions essentielles; infatigable au travail, dur à lui-même, tendre époux, aimant ses enfants, mais voulant peut-être trop exiger d'eux. Enfin il possédoit cette qualité si respectable et si rare, il étoit très-reconnoissant. (Gougenot, pp. 382-383)

This is the perfect portrait of the honest, hard-working bourgeois who also happens to be a painter.

Once his reputation was established Oudry had the means to live more than comfortably — Gougenot (p. 369) calculates an annual revenue of about 18000 livres from his art, his positions and his lodgings combined. His personal life was uneventful. Of the thirteen children born to his marriage with Marie-Marguerite Froissé, seven reached adulthood — two sons and five daughters. Apparently neither of the sons married. For the elder, Jacques, Oudry obtained a post in the administration of the *ponts et chaussées*, while the younger, Jacques-Charles, became a *peintre animaler* like his father. The eldest daughter, Marie, married the painter and academician Antoine Boizot in 1738 and died the following year. Another, Marguerite-Thérèse, also married a painter, a certain Nicolas Nolleau, member of the Académie de Saint-Luc. Of the twin sisters Nicole and Marie-Anne, born in 1727, the first married a *marchand épicier* while the other was a spinster still living with her mother at the latter's death in 1780. We know nothing of the fifth daughter, Geneviève-Henriette, save that in 1740 she was a *religieuse professe* in the Benedictine convent of Villarceaux. Oudry seems to have raised his children correctly and settled them modestly but on the whole satisfactorily.

Oudry's appearance is well documented. He was of average height but took little exercise, and in Gougenot's words was "fort replet." There are several portraits of him, including one done in 1729-1730 for the large *Hunt of Louis XV* for Marly, where Oudry depicted himself drawing the hunt in one corner of the picture [33]. Here, at the age of forty-three,

Fig. 46 Jean-Baptiste Perronneau,
Portrait of Jean-Baptiste Oudry.
Painted in 1753. Paris, Musée du Louvre.

his corpulence is well in evidence, yet Oudry conveys the impression of robust health. The most famous portrait is the one from the Louvre by Perronneau, one of his two *morceaux de réception* for the Académie royale in 1753 (Fig. 46). Oudry rests one arm on the back of an upholstered chair and holds his prepared palette and brushes in his left hand. His costume is of olive velvet, rich but discreetly tailored; behind him on an easel appears a large canvas primed in grey, with the chalk outlines of a hunt picture sketched on its surface. Oudry had advocated making such sketches in chalk rather than the usual practice of doing them in oil paint in his *conférence* of December 1752, which Perronneau quite probably attended. Oudry does not look us in the eye. He is in near profile to the left, gazing out of the picture, eyes bright, smiling or nearly, gesturing with his right hand as if waiting for someone to stop speaking so that he can reply. One sees the age of the painter in his gnarled fingers, but his command and resolve dominate the portrait. Perronneau's execution is superb. Although this work is more tightly handled, more controlled than his usual portraits — it was done to meet the approval of the Académie — nonetheless Perronneau's artistic vitality, his penetrating observation of character, are fully present. This is the true portrait of the painter we have just described in the words of his contemporaries, at the peak — and although no one could have known it, also very near the end — of an illustrious career. Oudry the professor, Oudry the responsible bourgeois, the *honnête homme* displaying the symbols of his well-deserved success, but also not far from the atelier, the métier, the physical manipulation of brushes and colors that had brought him to privilege and prosperity. The portrait was shown in the Salon of 1753, amidst the extraordinary display of eighteen paintings and five drawings by Oudry and six

engravings after his illustrations for La Fontaine, where it must have been a real presence, watching over the consecration of his art.

Oudry left little behind him. The students of the Acadèmie complained already in 1747 that he had no interest in training them. The following year his son Jacques-Charles was received into the Académie, and he was Oudry's only "official" pupil. Never was he able even to come close to his father's ability and success. He died in misery in Lausanne in 1778, where he was eking out a living as a drawing master; Jean Cailleux has recently found his pathetic *inventaire après décès*, and is working toward a study of his art, a worthwhile and necessary project, for he deserves better than he received (see Cailleux, 1982). The progeny of Desportes did little better. His son Claude-François stopped showing in the Salons after 1739, and the more prolific Nicolas, his nephew, received no royal commissions. Oudry seems to have chosen to work with assistants rather than with students in the true sense of the word, paid by the hour or by the task. Who were they? Henri-Horace Roland de la Porte (1725-1793) was certainly among them, even though we have no documented proof; except for Jacques-Charles, he is the only one of Oudry's "pupils" to gain admittance to the Académie. Others who have been named are almost completely unknown — Etienne-Guy Charton of Autun; Gabriel Rouette, who has left us an amusing drawing of the *Sacrifice of Iphigenia*, signed and dated 1729, entirely in the style of the "livre de raison" (Private collection, Paris); Louis Teissier, who like Roland de la Porte executed some *devants de cheminée* in the Oudry manner; Vitry fils — overdoors of dogs pointing birds; and Charles Dagomer. The latter was the master of Jean-Baptiste-Marie Huet, an excellent if occasional animalier who died

in 1811, and in whose art the lesson of Oudry survives. Jean-Jacques Bachelier (1724-1806) also did a few hunts and still-life pictures of stag antlers in the Oudry vein, but with only moderate success.

But Oudry has his posterity. His acute observations of landscape lie behind Corot and the Barbizon tradition, and ultimately the impressionists, as does his pronounced indifference to the subject of a picture as opposed to its artistic content. His hunts have no echo before Courbet, but with him they find a new justification. And more immediately there is his illusionistic, descriptive approach to reality, with cool and calculated colors, particularly in the late still lifes, which will be taken up again in the period of neo-classicism. David's *Death of Marat* has more in common with Oudry than with any earlier artist of the French eighteenth century. It is this true posterity, unrecognized no doubt by those who fulfilled it, that is his greatest legacy, and that assures his key position in the history of French art.

Catalogue

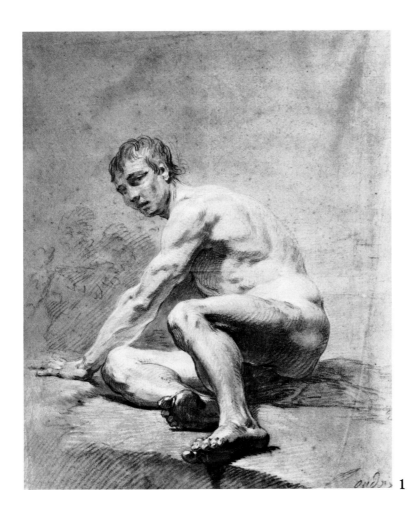

1

1
Male Academy Figure

H. 53; W. 43.3 (maximum dimensions; paper of ir-
regular shape).
Black chalk, stump, white chalk heightening, on
grey-brown paper.
Signed below right, in black chalk: *JB Oudry* (initials
in paraph).
Schwerin, Staatliches Museum, inv. no. 2097 Hz.

Provenance: Unrecorded in Schwerin before 1890, although it
undoubtedly came there in Oudry's lifetime.

Exhibition: 1982-1983, Paris, no. 6 (repr.).

Bibliography: Seidel, 1890, p. 106; Locquin, *Catalogue*, 1912, no.
566; Vergnet-Ruiz, 1930, no. II, 11; Opperman, 1972 [1977], I,
pp. 11, 140, 312, II, p. 650, cat. no. D131, repr. p. 974, fig. 3.

It is tempting to place this rare drawing early in
Oudry's career, perhaps even in his student days,
although there is no absolute evidence. Academy
drawings by Oudry are most uncommon. Aside from
a few mentioned in eighteenth-century sales (Paris, 22
April 1766 and following days, no. 8; Cayeux sale,
Paris, 11-23 December 1769 and 8 January 1770 and
following days, nos. 322-323), there is only the draw-
ing dated 1741 in Marseille (Paris 93), which is very
different from the one in Schwerin and in any case
has special problems related to it. So we have no
comparisons. However, it is similar to the well-
known series of academy drawings by Largillierre now
in the Ecole des Beaux-Arts, Paris, and done between
1699 and 1715, during which time Oudry was his
student for five years. The stylistic mannerisms in

the handling of chalks and the description of the figure both by contour and modeling are particularly close. In addition, there are some anatomical short-comings in Oudry's drawing — the poor understanding of the relation of the right leg to the torso, having "forgotten" the right arm altogether — that point to the work of a student. The modeling with widely spaced, curving, parallel lines of black and white chalk is close to the indisputably early *Head of a Woman* in Schwerin [5]. If the drawing is not very early, it can only be very late, after 1739, when Oudry became *adjoint à professeur* in the Academy and began to pose the model from time to time . . . and the style of the drawing does not agree with what we know of his late work. In any case, despite its faults, this large and, on the whole, fresh sheet is direct and appealing in its confrontation with the human figure, and displays a strong interest in light.

Let us recall Largillierre's remarks on drawing from the model, recorded by Oudry in his *conférence* of 1749:

> Si le naturel ou le modèle dont on peut disposer n'est pas des plus parfaits, doit-on l'imiter avec tous ses défauts? Voilà où commence l'embarras: l'Ecole flamande dit oui; la nôtre dit non. Il faut, dit l'Ecole française, donner du goût à ce que l'on dessine d'après le naturel, afin d'en corriger les défauts et l'insipidité. Il faut, dit l'Ecole fla-mande, accoutumer la jeunesse à rendre le naturel tel qu'elle le voit, et si bien, que dans diverses académies qu'on verra d'elle on reconnaisse les différents modèles d'après lesquels elle les aura dessinés. (Oudry, 1749 [1844], pp. 34-35)

It is precisely this approach to nature that distinguishes the life studies of Largillierre and Oudry from those, for example, of Le Brun and Jouvenet.

2
Italian Comedians in a Garden

Canvas. H. 63.5; W. 80.
Private Collection.

Provenance: Said to come from an old noble family of Lorraine; private collection, Paris, in 1973; acquired by the present owner in London in 1974.

Exhibitions: 1974, London, no. 60 (repr. in color); 1982-1983, Paris, no. 15 (repr.).

Bibliography: Opperman, 1972 [1977], I, p. 223, II, p. 928, cat. no. P105A, repr. p. 1175, fig. 400.

Engraving: Engraved in reverse at an unknown date, probably the first part of the eighteenth century, by an unidentified engraver who signed the work "Ch s^t"; traditionally attributed to Chedel (H. 13.6, W. 17.9; Opperman, 1972 [1977], I, p. 276, no. 22).

On the lists of pictures available for sale Oudry drew up in 1732 for the Duke of Mecklenburg-Schwerin and in 1735 for the King of Sweden (reproduced by Opperman, 1972 [1977], I, pp. 219-223), one finds the following work described: "Un autre [tableau] de plusieurs figures dans un jardin habillées dans le goût du théâtre italien de 2 pieds et demi de large sur 2 pieds de haut . . . 600 livres" (dimensions correspond to 65 by 81 cm.; the later list specifies that there are *five* figures). Locquin connected this citation from the Schwerin list published by Seidel (1890) with the engraving after Oudry attributed to Chedel (Fig. 47). Afterwards Vergnet-Ruiz identified those documents with a painting then in the Pillet-Will collection, Paris, which had formerly been attributed to Lancret; we reproduce (Fig. 48) this version for comparison (H. 65, W. 80; Opperman, 1972 [1977], I, pp. 398-399, cat. no. P105). And then, in 1973, we saw in Paris the painting here catalogued; we are convinced that this is the original version of the composition, the only *tableau de cabinet* on a subject of the Italian comedy that Oudry ever painted. He seems to have been peculiarly attached to it, however. He probably kept it all his life (at least, he still had it in 1735 and was asking a very fancy price for it); it was engraved, probably fairly early and under his instigation; and there exist no fewer than five painted copies or variants, some of which at least may have come from his studio.

We have seen the other version mentioned above only once, in 1968, when it was in the collection of

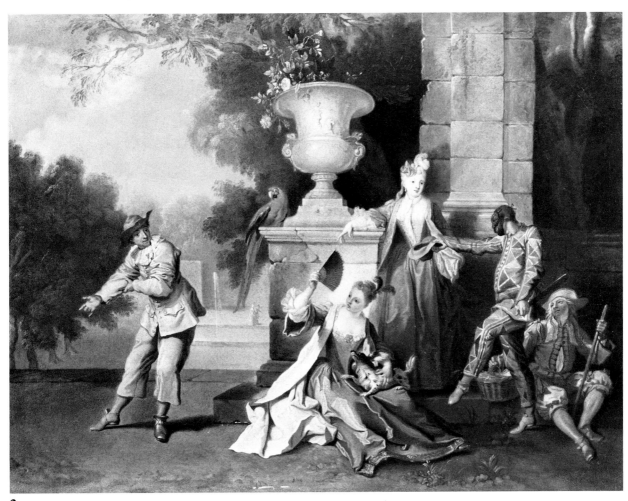

2

the late A. G. Leventis. We recognized it then (and still do) as an autograph early work, and assigned a date around 1715, comparing its composition to certain early works by Watteau, particularly the lost *Pour garder l'honneur d'une belle* engraved by Cochin, probably done between 1708 and 1710. After having seen the version here exhibited, which appeared to us to be much more brilliant in coloration than the other, very close to the palette of Largillierre, we concluded that it was earlier in date. In fact we believe it to be one of Oudry's earliest paintings, done around 1710 when he was still working with Largillierre. The picture is a novelty, not only in the sense that it stands alone in the artist's *oeuvre*, but also in that it is one of the first — per-

haps *the* first — of the many imitations inspired by Watteau's depictions of the theme.

Oudry does occasionally approach this theme in other works, but not in easel paintings. The frontispieces of his early albums consistently display Italian comedians: both volumes of the "livre de raison" (Figs. 1-2), a sheet from 1717 in Dijon, the landscape sketchbook of 1714, and the etched album of rebuses dedicated to the Duchesse de Berri here reproduced (Fig. 49), which can be dated to the last few months of 1715 (see Paris 7-11, 15, 16, 22-25). And Oudry also executed a certain number of decorative panels framed by arabesques on a white ground, in the Audran-Gillot-Watteau manner, per-

Fig. 47 *Italian Comedians in a Garden*, engraving after Oudry, signed with the monogram *Ch.* About 1710-1720 (?). Paris, Bibliothèque nationale, Cabinet des Estampes.

Fig. 48 *Italian Comedians in a Garden.* About 1715 (?). Formerly Leventis collection, Paris.

Fig. 49 *Frontispiece of an Album of Rebuses*, etched by Oudry about 1715. Paris, Bibliothèque nationale, Cabinet des Estampes.

haps already in his first period, that show figures in the costumes of the Italian comedy. The best-known of them are later, though, executed for Louis Fagon at the Château de Voré. We reproduce here an etching by the Comte de Caylus (Fig. 50), one of nine he did after lost drawings by Oudry related to the Voré panels. Contemporaries thought highly of these sorts of decorations, nearly all of which are lost. And Oudry's lone *tableau de cabinet* of the subject must also have been highly regarded. Even today, and despite the fact that it does not easily "fit" with the rest of his *oeuvre*, the picture attracts for its wit and charm.

When we first saw the picture we detected traces of an inscription and reported this in 1977. A careful reexamination during the Paris exhibition has confirmed the presence of what seems to be a partial date in the lower left corner of the canvas, faint but visible, in vermilion: *170... .* If this is indeed the remnant of an original inscription, long since effaced, and if our reading is correct, then the very early date of the picture is confirmed. The reproduction of the version formerly in the Leventis collection was inadvertently omitted in the Paris catalogue.

Fig. 50 Comte de Caylus, *"La Pêche"*, etching after a lost drawing by Oudry for a decorative panel. About 1725-1740 (?). Paris, Bibliothèque nationale, Cabinet des Estampes.

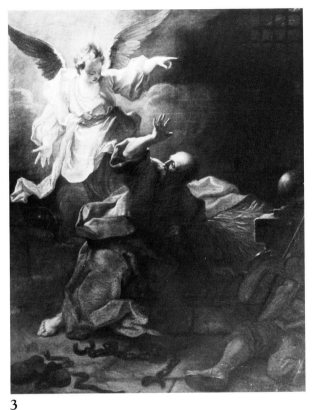

3

3 *(Colorplate on page 8)*
Saint Peter Delivered from Prison

Canvas. H. 81.5; W. 65.5.
Signed and dated, below left: *peint. par / J. B. Oudry. 1713*
Schwerin, Staatliches Museum, inv. no. 559.

Provenance: Purchased at Oudry's sale, Paris, 7 July 1755, for the Duke of Mecklenburg-Schwerin (41 livres).

Exhibition: 1982-1983, Paris, no. 17 (repr.)

Bibliography: Groth, 1792, p. 96, no. O48; Lenthe, 1836, no. 560; Dussieux, 1876, p. 191; Schlie, 1882, no. 765; Seidel, 1890, pp. 81, 87, 104, 108; Bode, 1891, p. 62; Locquin, *Catalogue*, 1912, no. 2; Réau, 1928, p. 197; Vergnet-Ruiz, 1930, no. I, 1; *Katalog*, 1954, no. 275; Opperman, 1972 [1977], I, pp. 32-33, 376, cat. no. P36, II, p. 923, repr. p. 982, fig. 19.

"It is as empty in conception as insipid in coloring and false in execution": such was the opinion of Bode (1891), who had little patience for Oudry. But to be fair, we should remember that this is one of Oudry's earliest pictures (and *the* earliest history painting), that the subject is a hackneyed one where it is difficult to find a new conception without becoming ridiculous, and that both coloring and execution are those of Oudry's time, not his alone. This little painting has many engaging qualities that deepen with experience. The lesson of Largillierre is evident, in the palette and particularly in the radiant angel, reminiscent of the figure of Saint Geneviève in the *Ex-Voto* of 1696 (Paris, St.-Etienne-du-Mont), while the gracefulness and delicacy of the arrangement, as well as the sensitive scheme of light and shade, recall to some extent the paintings of La Fosse. The principal merit of the picture, though, is its unpretentiousness and, for all its conventionality, a refreshing naturalism. The straw of Peter's mattress is painted with a keen sense of observation that looks forward to such pictures as the *Bitch Hound with her Pups* of 1752 [**65**].

4
The Adoration of the Magi

H. 23; W. 20.6.
Pen and brown ink, brush and brown ink wash, white gouache heightening, on greyish paper.
Inscribed on the recto of the old mount: *J. B. Oudry; 7; 5th Day S. 882;* and on the verso: *55.*
London, Courtauld Institute of Art, Witt Collection (Lugt 2228b, on mount), inv. no. 3232.

Provenance: Probably one of two drawings of this subject in the Gabriel Huquier sale, Amsterdam, 14-26 September 1761, nos. 2806 (2 fl. 15 s. to Fokke) and 2809 (1 fl. 14 s. to IJver); purchased at an unknown date by Sir Robert Witt from the dealer Beer, Amsterdam.

Exhibitions: 1968, London, no. 516; 1982-1983, Paris, no. 19 (repr.).

Bibliography: *Hand List*, 1956, no. 516; Opperman, 1972 [1977], I, pp. 33, 141, 243, II, pp. 661, cat. no. D161, 951, repr. p. 990, fig. 35.

The old guide books of Paris consistently list three large religious pictures by Oudry: a *Nativity* and a *Saint Giles* in the choir of Saint-Leu-Saint-Gilles, and an *Adoration of the Magi* in the chapter hall of Saint-Martin-des-Champs. All three were taken

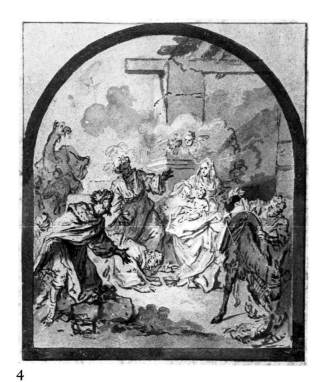

4

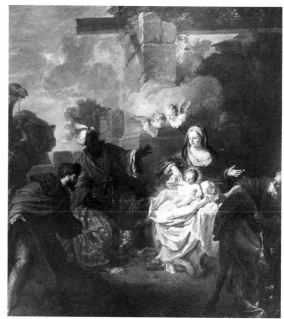

Fig. 51 *Adoration of the Magi*, painted for Saint-Martin-des-Champs. About 1717. Villeneuve-Saint-Georges, Eglise Saint-Georges.

to the Musée des Monuments français in the early years of the Revolution; the first two have disappeared, but the *Adoration of the Magi* was sent out to the church of Villeneuve-Saint-Georges around 1810, where it remained in perfect oblivion for a century and a half (Fig. 51; cf. Paris 20, particularly the article of Schnapper and Ternois cited there).

In our catalogue raisonné of Oudry's work, we stated — perhaps too hastily — that this drawing must come from the "livre de raison". It does have the wide ink border, and its size is right. The problem is the paper which, like that of the albums, has minute, dark fibers: but it appears also to have a bluish, rather than a brownish, cast. A direct confrontation with other drawings during the exhibition will resolve the question. There is also the problem of determining whether the drawing is a study for the painting for Saint-Martin-des-Champs, or rather a copy of it, made as a record. This question will be more difficult to answer. It is interesting to see how Oudry has concentrated his white gouache around the Christ child, who is the main light source in the

picture. Comparison with the drawing shows that the picture was originally rounded above. In fact, the upper corners seem to be repainted. Its dimensions as recorded in 1810 correspond to 308 by 260 cm., and it is clear that its height has been reduced since. It would also appear that the painting has lost a few centimeters at either side, even though it has the same width today as in 1810.

The *Adoration of the Magi* seems to have been Oudry's most important religious picture; it was also probably his last. The early biography of the artist published in the *Mercure de France* in 1726 mentions it: "Après de très grandes & penibles études, il présenta à l'Académie un grand Tableau de l'Adoration des Rois, qu'on voit aujourd'hui à S. Martin des Champs. Il enrichit cet Ouvrage de divers animaux, de fleurs & de fruits. On lui ordonna pour son chef-d'Oeuvre de traiter l'*Abondance*" D'Argenville also says that Oudry was *agréé* in the Academy on the basis of this picture. Thus we can fix the date of completion with some certainly as 1717; Oudry must have been working on it, though, for a year or two.

It is quite possible that, desiring to enter the Academy as a painter of history, he devoted special attention to it and brought it in as soon as it was finished, before delivering it to the church. The ploy was successful. Upon finishing the *Abundance* [**6**], he was *reçu* as a painter of "tous les talents" . . . and promptly abandoned history painting.

The *Adoration of the Magi* is a most interesting contribution to our understanding of the religious art of the end of the reign of Louis XIV and of the Regency. It is mannered, to be sure, with its slender, swaying figures and the complicated mass of drapery around the Virgin's knees. And it is rather obvious in composition: the two repoussoir figures in the foreground corners, the dromedary's neck that follows the original curve of the upper left part of the canvas Eighteenth-century critics were no more than benignly tolerant of Oudry's early history pictures, and we must admit that he does not have the simple grandeur and nobility of, for example, a Jouvenet (cf. his last painting, the *Magnificat* in Notre-Dame, exactly contemporary with Oudry's *Adoration*); he is unable to rise above the exact representation of what he sees, as he moreover tells us, and frequently, in his academic *conférences*. The drawing, though, is magnificent in its rich and varied handling of the brush and the varied application of ink and gouache.

There are several drawings of history subjects in Huquier's sale of 1761: a *Holy Family*, an *Annunciation*, a *Saint Jerome* [cf. **14**], a *Madonna*, the *Brazen Serpent*, and two of the *Adoration of the Magi*. The first of them is said to be on blue paper, while the paper of the second is undescribed.

At the exhibition in the Grand Palais, we were able to examine the picture closely for the first time (it hangs very high on the south wall of the nave of the church of Villeneuve-Saint-Georges). Its dimensions are 291 by 255 cm., rather than 290 by 260 as we reported in the catalogue. Also, there seems to be *another* inscription below left, hidden by the frame except for the tops of several letters. We hope that the picture can be examined unframed before its return to the church. In our Introduction (p. 42)

we allude to the eclectic nature of the picture. We might cite in this regard a similar *Adoration of the Magi* in Le Mans by the young Philippe de Champaigne who, like Oudry, borrowed many Rubensian motifs (Bernard Dorival, *Philippe de Champaigne*, 2 vols., Paris: Léonce Laget, 1976, II, no. 42). As for the provenance of the drawing: some discoloration from exposure to light, as well as the unusual amount of white gouache, account for the apparent difference in paper, and we now believe that it indeed comes from the "livre de raison."

5

5
Head of a Woman

H. 29.4; W. 18.5.
Red chalk, light touches of black chalk, white chalk heightening, on grey-brown paper; water stains to the right and left.
Signed below left in pen and brown ink: *JB Oudry* (initials in paraph).
Schwerin, Staatliches Museum, inv. no. 2098 Hz.

Provenance: Unrecorded in Schwerin before 1890, although it undoubtedly came there in Oudry's lifetime.

Exhibition: 1982-1983, Paris, no. 21 (repr.).

Bibliography: Seidel, 1890, p. 106; Locquin, *Catalogue*, 1912, no. 563; Vergnet-Ruiz, 1930, no. II, 8; Opperman, 1972 [1977], I, pp. 33-34, 140-41, 312, II, pp. 650-51, cat. no. D132, repr. p. 989, fig. 33.

Apparently a study for the head of the woman standing directly above the infant Mary in a lost painting of the *Birth of the Virgin* (Opperman, 1972 [1977], I, p. 379, cat. no. P47), this beautiful sheet gives us a glimpse of Oudry's chalk manner for the preparation of large history subjects. It can be assumed that he routinely made such studies for all of the major figures in his early religious pictures, but almost none has been identified. This is a very different manner from the wash drawings that are so common in the first period, more academic and somewhat old-fashioned. The three-crayon technique comes ultimately from Rubens, whose works Oudry had studied intensively, but the modeling and the handling of line

are more reminiscent of artists such as Louis de Boullongne the Younger and Antoine Coypel.

The lost painting of the *Nativity of the Virgin* is something of a mystery. It is not cited in any eighteenth-century guide to Paris or in biographies of the artist (unless the *Nativity* in Saint-Leu-Saint-Gilles was in fact a *Nativity of the Virgin*, which is not likely). The composition is known through a drawing in the Louvre (Fig. 52; cf. Opperman, 1972 [1977], II, p. 660, cat. no. D160) and an engraving by Louis Loisel (Fig. 53; cf. Opperman, 1972 [1977], I, pp. 299-300, no. 115). The engraving is clearly inscribed *J. B. Oudry delineavit et pinxit*, so it must have been painted, not just drawn (although the engraving was probably made directly from the drawing in the Louvre). If we are correct in associating the Schwerin *Head of a Woman* with it, this is a further assurance that a painting existed or at least was intended. Only one copy of the engraving has so far been found (Bibliothèque nationale, Cabinet des Estampes), and it has had the legend, below, completely trimmed away: an intact impression might well bear information as to the picture's destination. However, we have been able to identify the coats of arms in the upper corners. The arms to the left are those of Louis-Antoine de Noailles, archbishop of Paris since 1695, cardinal since 1700, who died in 1729; those to the right are of Clement XI Albani, pope from 1700 to 1721. Clement XI was very much involved in French political and religious affairs such as the War of the Spanish Succession and the Jansenist controversy.

Fig. 52 *Birth of the Virgin*. About 1715-1716. Paris, Musée du Louvre, Cabinet des Dessins.

Fig. 53 Louis Loisel, *Birth of the Virgin*, engraving after Oudry. About 1715-1716. Paris, Bibliothèque nationale, Cabinet des Estampes.

Noailles in 1700 had just been raised to the purple by the aged Innocent XII, and he participated in the election of Clement XI, from whose hands he received the red hat. However, he was already the head of the Gallican party and would oppose the authority of Rome throughout the long reign of the new pope.

The artistic relations between Oudry and the Noailles family, occasioned no doubt by the commission of a series of retrospective portraits, have been known for many years (see Opperman, 1972 [1977], I, pp. 368, 373-374, cat. nos. P17, P28-P32; II, pp. 634-637, cat. nos. D77, D83-84). One might also suppose that the well-known picture of the *Fire on the Petit-Pont* in the Musée Carnavalet, dated 1718, was done for Cardinal de Noailles (see Paris 27). But where is the painting of the *Nativity of the Virgin*, and where was it then? Did it go off to Rome, and if so, by whose authority?

In the absence of the painting and of comparable drawings, it is difficult to determine a date, but it is possible that these works were done around 1715-1716.

6
Abundance with Her Attributes

Canvas. H. 180; W. 145.
Versailles, Musée national du Château de Versailles, inv. no. MV 7205.

Provenance: Collections of the Académie royale de Peinture et de Sculpture until the Revolution; French national collections; recorded as having been sent from the museum at Versailles to the Louvre in 1803; installed in the Grand Trianon in 1845, in the Salon de Famille de l'Appartement de la Reine des Belges.

Exhibition: 1982-1983, Paris, no. 28 (repr.).

Bibliography: Orlandi, 1719, p. 235; *Mercure de France*, March 1726, pp. 628-29; Gougenot, 1761 [1854], pp. 369, 384-85; Soulié, 1852, p. 7, no. 35; *Procès-verbaux*, 1875-1892, IV, pp. 254, 279; Monavon, 1876, p. 10, no. 35; Montaiglon, 1893, p. 126; Locquin, *Catalogue*, 1912, no. 3; Fontaine, 1930, p. 198; Vergnet-Ruiz, 1930, no. I, 2; Opperman, 1972 [1977], I, pp. 15, 377, cat. no. P37, II, p. 923, repr. p. 1006, fig. 68; Constans, 1980, p. 104, no. 3538.

Oudry presented a sketch of the *Abundance* to the Academy for approval on 25 September 1717; it is not heard of since. He delivered the definitive version on 25 February 1719 as his *morceau de réception*, and was received into full membership as a history painter. One curious result of this distinction was that, in the latter part of his life, his pictures of animals and landscape were among the first to be described in the annual Salon *livrets*, which sometimes puzzled critics: in fact the *livrets* were arranged according to rank, "talent" (with history being the highest), and seniority.

The picture is a compendium of everything Oudry had attempted in his first period — the human figure, drapery, fruits, flowers, vegetables, animals and landscape — and lies at the threshold of the second period, his early maturity, where he will develop all of these talents separately, leaving the human figure behind. It does not seem to have been particularly well thought of in the eighteenth century. After mentioning it in his life of Oudry, Gougenot goes on to say: "Ce morceau étant sous les yeux de l'Académie, nous nous croyons dispensé d'en faire la discussion. Au reste, ce n'est pas toujours sur ces sortes d'ouvrages qu'on doit apprécier le mérite des artistes: fruits d'une jeunesse dont les talents commencent à se manifester, ils n'ont point encore acquis ce degré de maturité qui seul peut mettre, dans la suite, leurs auteurs en état de contribuer à la gloire de notre école. M. Oudry en est un exemple frappant dans différents tableaux qu'il a faits depuis sa réception, et surtout dans ses chasses d'animaux, grandes comme nature, qui sont composées avec beaucoup de feu et très-bien exécutées."

The debt to Largillierre is great, both in figure type and in color; one might confuse it as an allegorical portrait were its origins unknown. The still-life elements in the foreground recall the large *Garland of Vegetables* (Fig. 54) which was one of the pictures Oudry presented for his *agrément* in 1717, very much admired by Gougenot (pp. 367-68, 398) and which he kept all his life; sold to Schwerin in 1755, it disappeared from the museum there during the last war (Opperman, 1972 [1977], I, p. 540, cat. no. P475). One of the other pictures he presented at that time was the *Adoration of the Magi* (Fig. 51). It might be said that the *Abundance* represents a combination of history painting with Oudry's talent for fruits, flowers and vegetables. Probably this is why the Director of the Academy assigned the subject to him in 1717.

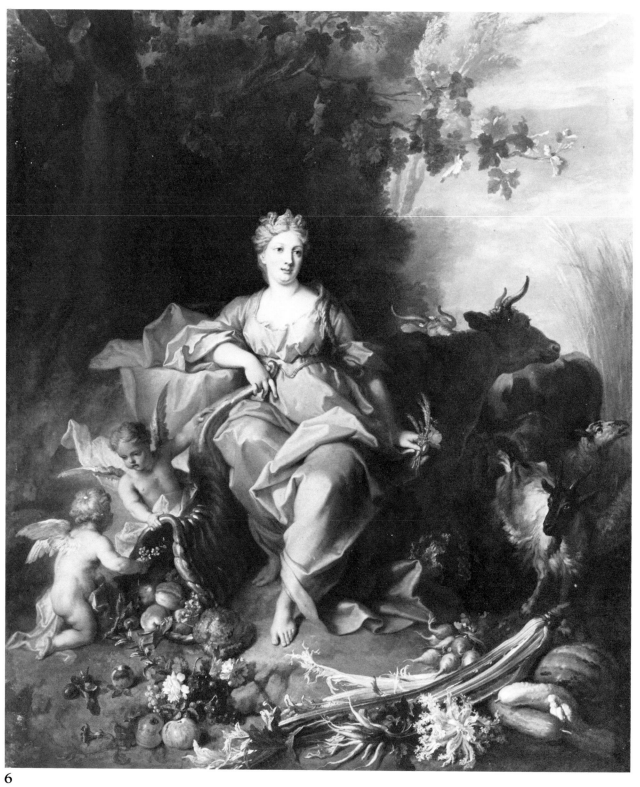

6

Fig. 54 *Garland of Vegetables*. About 1717. Formerly Schwerin, Staatliches Museum (disappeared around 1945).

At the time of writing the manuscript of the Paris catalogue, the painting measured 248 by 136 cm. inside the frame, including a large addition above and a smaller one below which it had borne since 1845. Once the painting was detached from the wall at Trianon and removed from its frame, its full width of 145 cm. (not 136 cm.) was revealed. The additions above and below were then removed; the original height is precisely 180 cm.

7
Family Portrait

H. 20.1; W. 16.1.
Pen and brush, brown ink wash, white gouache heightening, on grey-brown paper.
The old mount bears an attribution to Oudry.
Private collection.

Provenance: Probably sale of Lantsheer, de Vries and others, Amsterdam, 3-4 June 1884, no. 245 (6 fl.); W. Pitcairn Knowles (Lugt 2643, on verso of mount); anonymous sale, Paris, Palais Galliera, 16 June 1967, no. 176 (repr.); Seiferheld and Company, New York; Christian Humann, New York; sale of the estate of Christian Humann, New York (Sotheby's), 30 April 1982, no. 44 (repr.).

Exhibition: 1982, Paris, no. 2.

Bibliography: Opperman, 1972 [1977], II, pp. 644-645, cat. no. D108, repr. p. 987, fig. 29.

7

Without doubt this is a drawing cut from the "livre de raison"; the paper is the same, and the wide ink frame survives. No corresponding painting has been cited; if it was ever carried out, it must have been one of Oudry's most sumptuous portraits. He follows a conventional type of full-length figures in a garden, with familiar attributes such as statuary, a cascade, one of the daughters offering a bowl of fruit, and the other playing with a parrot whose cage is held by a young black servant. The richness of the washes and the lavish brushwork in both ink and gouache are particularly effective in this characteristic example of his early manner. A date of 1715 or even earlier is probable.

8

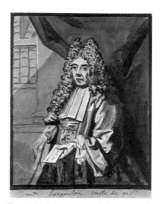

Fig. 55 *Monseigneur d'Argenson*, from the "Livre de Raison". About 1715. Paris, Musée du Louvre, Cabinet des Dessins.

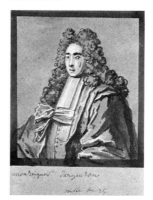

Fig. 56 *Monseigneur d'Argenson*, from the "Livre de Raison". About 1717. Paris, Musée du Louvre, Cabinet des Dessins.

8
Portrait of a Magistrate

H. 22; W. 15.8.
Pen and black ink, brush and black ink wash, white gouache heightening, on grey-brown paper.
Private collection.

Exhibition: 1982-1983, Paris, no. 12 (repr.).

Bibliography: Opperman, 1972 [1977], II, pp. 950-51, cat. no. D109A, repr. p. 1172, fig. 397.

Dimensions, technique, paper and style all make this drawing a good candidate for having come from the "livre de raison." Unfortunately, all of the sheets cut out in the eighteenth century seem to have been trimmed down to the edges of the drawings themselves, so that Oudry's valuable inscriptions have disappeared.

This portrait, if in fact it was carried out on canvas, must have been large; it is rare in France in this period to see ceremonial, seated portraits on a small scale. Gougenot (1761 [1854], p. 385) mentions almost no specific portraits in his life of Oudry, but he does single out one of Marc-René de Voyer d'Argenson as well as two others of his sons. This fact alone suggests that the portrait of the father must have been a particularly important work. The "livre de raison" still contains two portraits of Voyer d'Argenson (Figs. 55-56), one of them three-quarter length and the other half-length (Opperman, 1972 [1977], II, p. 621, cat. no. D32, and pp. 632-33, cat. no. D70), both of them described as having been painted. The costume is identical with that of the unknown sitter in this drawing, which may represent a third portrait of Voyer d'Argenson, perhaps the most important. But Oudry painted other magistrates as well, so a positive identification is difficult.

9
Woman Beside a Fountain

Canvas. H. 100; W. 90.
Cailleux, Paris.

Provenance: Sale of the Marquis d'Houdan, Angers, 20-31 August 1888, no. 1200; Galerie Pardo, Paris; acquired by Cailleux, Paris, in 1982.

Exhibition: 1982, Paris, no. 4.

Bibliography: Locquin, *Catalogue,* 1912, no. 15 (Houdan sale); Vergnet-Ruiz, 1930, no. I, 320 (Houdan sale); Opperman, 1972 [1977], I, pp. 364-365, cat. no. P9, II, repr. p. 979, fig. 14.

When we first saw this portrait at the Galerie Pardo in 1970 it was attributed to Largillierre; our reattribution to Oudry and subsequent identification with the picture from the Houdan sale have been generally accepted. Its pendant from that sale, a *Portrait of a Man as a Hunter,* has been in the Musée des Arts décoratifs, Paris, since 1905 (Fig. 57). Apart from a minor discrepancy of size the sale catalogue descriptions correspond point for point with the two pictures. However, the Houdan paintings were said to be signed and dated 1723, while the male portrait today bears an authentic signature and a date that looks like 1743, and the female portrait has no apparent inscriptions. But Jean Cailleux has just informed us that evidence of a signature concealed by overpainting has been revealed by laboratory examination. We hope that this will be made visible once more in time for the exhibition. Others have suggested that the correct date for the companion piece is 1713; we agree completely. A proper restoration, which the picture sorely needs, would doubtless confirm this. The dates of 1723 in the Houdan sale must have been due to a misreading, if not to a typographical error.

An argument in favor of a date of 1723 is put forth in the exhibition catalogue cited above, based on stylistic similarities with other paintings by Oudry of about that date, on the supposed identification of the sitters, and on the coiffure of the woman. The last argument, we believe, is poorly founded. In fact one need look no further than the second page of the "livre de raison" where Mademoiselle de Montargis, in a drawing dated 1713, has a costume and a hair style almost exactly identical with those of our portrait (Paris 7). The stylistic argument has to do with Oudry's manner of painting gold embroidery: but one finds this already in the portrait of the Condesa de Castelblanco in the Prado which is probably even earlier than 1713, and in that of Monsieur Bachelier done in 1715 (Fig. 4). In our opinion the evidence of style accords with a date near the beginning of Oudry's independent career, more for a lack of coherence among the parts than for ineptness in the handling of any one of them. And in the male portrait it is clear that Oudry is still a long way from mastering the technique of painting feather and fur he would display already by 1718 (cf. Fig. 6).

There have been persistent attempts to identify the sitters as members of the Nédonchel family, often citing the authority of Cordey's definitive publications of the "livre de raison." But Cordey made no such assertion (See Opperman, 1972 [1977], I, pp. 360-361, cat. no. P2). A drawing on folio 68 of the first volume of the "livre de raison" is inscribed "dessein pour monsieur de nédonchelles," and the very next drawing *in the album as it exists today* (Fig. 58), which corresponds more or less closely to the *Portrait of a Hunter* in the Musée des Arts décoratifs, has the inscription "dessein pour monsieur son feu [?] fraire le marquy", that is, "drawing for his (or her) deceased [?] brother the marquis." Thus the latter too easily became the Marquis de Nédonchel, brother of the Monsieur de Nédonchel of the first drawing. However: four pages have been cut out of the album between the two drawings, which evidently nullifies this identification. We suspect that the immediately preceding (missing) drawing corresponded to the painting here catalogued. In which case our two paintings would represent, not a husband and wife as one might presume, but the late [?] Marquis of X . . . and his sister.

The evidence of the "livre de raison" solves no problems of identity but rather poses two others. If we assume that the sketches were executed chronologically, then the drawing of a hunter would have been done right around the beginning of 1715, that is, at least a full year and maybe as many as two years after the presumed date of the painted portraits. Further, Oudry made a careful distinction in his inscriptions between drawings that were carried out as paintings (by adding an indication of the format of the canvas) and those that remained unexecuted (as in the case of the one

9

Fig. 57 *Portrait of a Man as a Hunter*. Dated 1713 (?).
Paris, Musée des Arts décoratifs.

Fig. 58 *Portrait of a Man as a Hunter*, from the "Livre de Raison." About 1715. Paris, Musée du Louvre, Cabinet des Dessins.

that concerns us, labelled simply "drawing for...").
The implications of these problems are open to many
interpretations. Rather than listing all of the possibilities,
let us note only that Oudry frequently repeated
himself; that there are more drawings absent from
the "livre de raison" in its original condition than it
contains today; and that we still have much to learn
about Oudry's first period, in particular the portraits.

The portrait was once said to be that of Madame de
Lambert, which is probably a recent guess, based on
typological similarities with a portrait by Largillierre,
dated 1696, sometimes thought to represent Marie
Marguerite Bontemps, wife of Claude Lambert de
Thorigny. This work, in the Metropolitan Museum
in New York, also shows a woman standing beside a
fountain, her hand outstretched as the water flows
across it. A parrot and an anemone are also present,
as in Oudry's picture...but these are common attri-
butes in portraiture of the period.

10

Académie in 1719, probably until he had established enough of a reputation for animals and still life to be able to make a living from these alone, around 1722-1724. Oudry's portrait concept and technique do not seem to have evolved much, though, and this beautiful example fits well with his early period, despite its slightly later date. The painting of the carved and gilded wood of the furniture is the same as in the portrait of Bachelier from 1715 (Fig. 4), and the lace cuffs are identical to those of the pair of portraits probably from 1713 just discussed [9]. Oudry's manner in all of these portraits is entirely derivative from that of Largillierre. Yet there are differences. Oudry's hands are always like these: slender fingers, the exaggerated articulations of the open hand, the smooth, enamel-like surface of the skin. His faces are harsher than those of his master, perhaps more minutely described but with less assurance. Although it falls short of being great, this portrait comes closer than most to equalling Largillierre's gift of making a portrait with all of its accessories into a unified piece of painting, a work of art.

10 *(Colorplate on page 9)*
Portrait of a Man

Canvas. H. 149; W. 114.
Signed and dated, below right: *peint par/J. B. Oudry/ 1720* (dark and difficult to read)
Private collection.

Provenance: Sale of Gustave Rothan, Paris, Galerie Georges Petit, 29-31 May 1890, no. 178 (6000 francs); Rodolphe Kann; anonymous sale, Paris, Palais Galliera, 21 March 1969, no. 179 (repr.).

Bibliography: Catalogue de la collection Rodolphe Kann . . . , 1907, no. 154 (repr.); Locquin, *Catalogue,* 1912, no. 24; Vergnet-Ruiz, 1930, no. I, 325; Opperman, 1972 [1977], I, pp. 19, 365, cat. no. P10, II, repr. p. 994, fig. 43; Opperman, 1981, p. 313 (repr.).

The recent discovery of the date of 1720 came as something of a surprise; we had originally assumed that the portrait was painted at least five years earlier. Oudry apparently continued his activity as a portraitist for some time after his admission to the

11
Landscape with a River and a House Beneath a Bluff

H. 18.3; W. 24.
Point of brush and brown ink, brown ink wash and white wash, white gouache heightening, on grey-brown paper.
Inscribed in ink on the verso: *J. B. Oudri*
Edinburgh, National Gallery of Scotland, inv. no. RSA 227.

Provenance: David Laing; Royal Scottish Academy (Lugt 2188, below, recto); on permanent loan to the National Gallery of Scotland since 1966.

Exhibition: 1982-1983, Paris, no. 26 (repr.).

Bibliography: Opperman, 1972 [1977], II, p. 966, cat. no. D1109A, repr. p. 1173, fig. 398.

The surface of the paper is almost entirely washed with brown ink and white, but seen from behind, it appears identical with the paper of the "livre de raison." Also visible at all four edges is a trace of

the wide brown ink border, mostly trimmed away, that frames the drawings of Oudry's record book. And the size is right. There still remained one landscape sketch in the "livre de raison" when Cordey published it in 1929 (Opperman, 1972 [1977], II, p. 641, cat. no. D98, repr. p. 982, fig. 20), and several small, wash landscape drawings appeared in Huquier's sale of 1761 (see Paris 7-11). It is possible, then, that the Edinburgh drawing records the composition of a lost painting, though we cannot be sure.

Its technique is rather different than that of the landscape sketchbook of 1714 (see Introduction, p. 42), with no use of the pen and a much more sophisticated, and fluid, use of wash, and a more sparing application of gouache. Partly this can be attributed to its presumed later date, but the differences must also be due to its having been done essentially from the imagination. In its beautiful understanding of light and atmosphere this is certainly the most attractive and interesting of the early landscape studies.

11

12 *(Colorplate on page 7)*
Still Life of Three Dead Birds with Currants, Cherries, and Insects

Canvas. H. 31; W. 23.5.
Signed and dated (somewhat indistinctly), below right:
peint [par] J. B / Oudry 1712
Agen, Musée des Beaux-Arts, inv. no. 13Ai.

Provenance: Seized from the collection of the Duc d'Aiguillon, Château d'Aiguillon (Lot-et-Garonne), in 1792; Préfecture d'Agen.

Exhibition: 1982-1983, Paris, no. 1 (repr. in black and white; color repr. p. 7).

Bibliography: *Inventaire général des richesses d'art de la France,* Province, Monuments civils, V, 1891, p. 283; Locquin, *Catalogue,* 1912, no. 30; Vergnet-Ruiz, 1930, no. I, 262; Recours, 1933, p. 33; Mesuret, 1958, p. 34, repr. in color opp. p. 34; Faré, 1962, II, repr. fig. 348; Vergnet-Ruiz and Laclotte, 1965, p. 246; Opperman, 1972 [1977], I, pp. 22-23, 538, cat. no. P471, II, repr. p. 975, fig. 5; Faré and Faré, *La Vie silencieuse . . . ,* 1976, p. 107, repr. fig. 158.

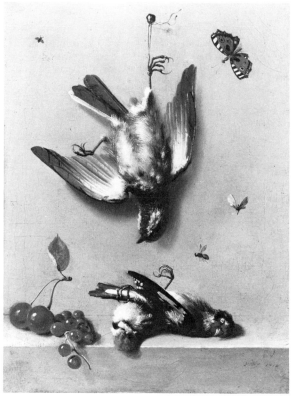

12

A house sparrow is suspended from a nail by one foot; below, a blue tit and a goldfinch lie on a shallow ledge beside two cherries and a bunch of red currants; four insects rest on the wall or fly in the air. This picture and its companion [13], for all their simplicity, are Oudry's earliest surviving accomplished works. Their appeal lies in the skillful *trompe-l'oeil* where the varied colors of the fruits, birds and insects are set off against a light grey background. Oudry achieves a great sense of depth in a shallow space through his delicate shadows. Although the two paintings from Agen cannot be said to demonstrate a profound originality (they belong to the venerable Netherlandish tradition of illusionistic still life which Oudry learned from Largillierre), nonetheless they exhibit a frankness or freshness — perhaps even a *naïveté* — that separates them from the majority of similar seventeenth-century Dutch or Flemish pictures, and also a lack of ostentation that belongs to the new spirit of the eighteenth century. We may assume that these paintings were not commissioned, if for no other reason than that Oudry was too young to have acquired patrons in any significant sense. Also, one finds no trace of these or other like paintings in collections or sales prior to the end of the eighteenth century. Gougenot tells us that Oudry and his wife worked for the Pont Notre-Dame during the first two years after he left Largillierre. These pictures must have been made to be sold there, which helps to explain their simplicity: in a sense, they belong to "popular" art.

Both pictures have suffered somewhat, but not enough to spoil the illusion. This may be due to careless cleaning in the past, or — just possibly — to their having been transferred from panel to canvas. In fact, the catalogue of the pictures in the Hôtel de la Préfecture in Agen, written by Tholon and published in the *Inventaire . . . des richesses* in 1891, describes them as painted on wood. Perhaps this is an error, or possibly they were transferred to canvas when they came over to the Musée des Beaux-Arts in the early years of this century.

The pictures were very successfully cleaned and restored for the Paris exhibition. The exact date of their transfer to the museum is 1906-1907.

13

13
Still Life of Two Dead Birds
with a Mouse and Three Insects

Canvas. H. 31; W. 23.5.
Signed and dated, below left: *peint par /*
J. B. Oudry / 1712
Agen, Musée des Beaux-Arts, inv. no. 14Ai.

Provenance: As its companion at the preceding number.

Exhibitions: 1979-1980, Moscow and Leningrad, no. 101; 1982-1983, Paris, no. 2 (repr.).

Bibliography: Inventaire général des richesses d'art de la France, Province, Monuments civils, V, 1891, p. 283; Locquin, *Catalogue,* 1912, no. 29; Vergnet-Ruiz, 1930, no. I, 261; Recours, 1933, p. 33; Vergnet-Ruiz and Laclotte, 1965. p. 246; Talbot, 1970, repr. p. 153; Opperman, 1972 [1977], I, pp. 22-23, 538, cat. no. P470, II, p. 943, repr. p. 975, fig. 6; Faré and Faré, *La Vie silencieuse* . . . , 1976, p. 107, repr. fig. 159.

Hung by one wing from a nail is a greenfinch; below it on the ledge lies a goldfinch. Here, in addition to the flying bumblebee and two butterflies, Oudry includes a live mouse. The latter further contributes to the down-to-earth quality of the pair of pictures in Agen: like the mouse, all of the birds and insects are extremely common. Oudry seems to be seeking to reveal the beauty of the ordinary, as Chardin was to do later on. The mouse may also serve as a symbol of vanity; in association with the dead birds, the little rodent reminds us that time eventually gnaws everything away. Mice often appear in Netherlandish still-life pictures in a similar context. The curious object placed on the ledge to the left has never been identified. It consists of a glass cylinder mounted on a turned foot of boxwood, and fitted with a boxwood lid. It does not seem to belong to the repertory of common domestic utensils. We find it again in the very similar picture of a bullfinch and a housesparrow in Marseille, dated 1713 (Fig. 59; cf. Paris 3). Could it be a naturalist's implement of some kind, perhaps a killing jar? Let us hope that it will be identified during the course of the exhibition, so that its contribution to the meaning of the picture can be determined.

The three pictures from Agen and Marseille are the last such simple *trompe-l'oeil* on a clear, neutral ground Oudry would undertake for nearly thirty years. In 1739, he suddenly returned to the type (Fig. 35) and

Fig. 59 *Still Life of a Bullfinch and a House-Sparrow.* Dated 1713, Marseille. Musée des Beaux-Arts.

executed many others, culminating in the famous *Canard blanc* (Fig. 113). The reasons for his coming back to such pictures are bound up with his position as a professor in the Academy, where he stressed the proper study of color, a discipline in which, he believed, the French school was notably weak. The academic discourses he delivered late in life are full of references to his own experience as a young man in the studio of Largillierre, who prescribed still-life exercises similar to the pictures in Agen and Marseille. But in 1712-1713 Oudry had only just left Largillierre's studio. Thus the similarities between these early works and the later group mentioned above: both are, more than anything else, embodiments of the coloristic principles of the painter's *métier* (see Opperman, 1981).

14

14
Table in an Artist's Studio, or Allegory of the Art of Painting

Canvas. H. 41; W. 45.
Schwerin, Staatliches Museum, inv. no. 263.

Provenance: Purchased at Oudry's sale, Paris, 7 July 1755, for the Duke of Mecklenburg-Schwerin (23 livres 13 sols).

Exhibition: 1982-1983, Paris, no. 4.

Bibliography: Groth, 1792, p. 5, no. C5 (unknown artist); Lenthe, 1836, no. 553; Dussieux, 1876, p. 191; Schlie, 1882, no. 766; Seidel, 1890, pp. 87, 104; Bode, 1891, p. 62; Locquin, *Catalogue,* 1912, no. 32; Vergnet-Ruiz, 1930, no. I, 303; *Katalog,* 1954, no. 276, repr, pl. X; Faré, 1962, II, repr. pl. 337; Opperman, 1972 [1977], I, pp. 23-24, 561, cat. no. P527, II, 917, 946, repr. p. 973, fig. 2; Faré and Faré, *La Vie silencieuse* . . . , 1976, p. 107.

It was Professor Gérard Le Coat who first suggested to us the complete interpretation of this very early, unsigned still-life painting: it is an allegory of the training and discipline necessary to become an artist. Not only does one have the usual implements of the painter — prepared palette, brushes, inkstand and quill, chalkholder — and examples of the usual media of the graphic arts — a pen-and-wash figure drawing, an architectural sketchbook in red chalk, an engraving — but also a more penetrating statement. The two books indicate that the true painter is also learned; the sketchbook, with its view of Southern buildings with their characteristic arches, small windows, and tile roofs, is evocative of the Italian trip necessary to the formation of a young artist; and the wash drawing, while indicating that the painter must prepare his compositions by consulting the model, also evokes by its subject of *Saint Jerome in the Wilderness* the spiritual discipline an artist must have, and which indeed is the ultimate goal of art. A very simple yet harmonious composition with a developed understanding of light and shade, this work recalls still-life pictures of the Leiden school in the 1620s, particularly in the dark background and the rendering of paper, while at the same time it looks forward to certain works of Chardin in the 1730s (e.g., Rosenberg, 1979, nos. 31-32). It is also a "private" painting, which Oudry kept all his life. Done at about the same time as the two preceding numbers (or possibly slightly earlier), it shares with them the concern for the artist's *métier* as subject and *raison d'être.*

15
Allegory of the Arts

Canvas. H. 86; W. 127.
Signed and dated, below left: *peint par.*
J. B. *Oudry. / 1713*
Schwerin, Staatliches Museum, inv. no. 188.

Provenance: Purchased at Oudry's sale, Paris, 7 July 1755, for the Duke of Mecklenburg-Schwerin (36 livres).

Exhibition: 1982-1983, Paris, no. 5 (repr.).

Bibliography: Groth, 1792, p. 91, no. O29; Schlie, 1882, no. 767; Seidel, 1890, pp. 87, 92, 104; Bode, 1891, p. 62; Locquin, *Catalogue,* 1912, no. 31; Vergnet-Ruiz, 1930, no. I, 263; *Katalog,* 1954, no. 277, repr. pl. IX; Faré, 1962, II, repr. fig. 334; Venzmer, 1967, repr. in color pl. 1; Opperman, 1972 [1977], I, pp. 24-25, 80, 223, 539, cat. no. P473, II, repr. p. 977, fig. 10; Faré and Faré, *La Vie silencieuse* . . . , 1976, p. 107, repr. fig. 161; Mirimonde, 1977, II, p. 12; Evans, Mirimonde, *et al.,* 1980, p. 215 (repr.).

Engraving: A very similar composition was engraved, in reverse, by Gabriel Huquier, as the seventh and last subject of a "Recueil de dessus de portes" whose publication was announced in the *Mercure de France,* May 1737 (Opperman, 1972 [1977], I, p. 286, no. 57): see the discussion in this entry, below.

Like the preceding picture, which it resembles thematically, Oudry retained this in his private collection all his life. Spread across the composition in a somewhat negligent arrangement are some rolled drawings and engravings, a bronze-tinted plaster bust of Apollo (here serving both as an attribute of sculpture and as the image of the patron of the arts), a violin and its bow, a guitar and a musical partition, palette and brushes leaning against a book, and finally a candlestick fitted with a pivoting shade, used by artists to control cast shadows. Many of the objects have by themselves a *vanitas* connotation — the bust; musical instruments; *folie, branle* and *gigue,* the names of dances inscribed on the pages of music; the snuffed candle — but the key to the picture's meaning (as again suggested to us by Professor LeCoat) is the large amaranthus plant whose leaves are in the process of changing from green to brilliant red. Since Antiquity, the amaranthus has been a symbol of immortality. Thus the artist achieves immortality through his art, which lives on after him. In the related engraving by Gabriel Huquier (Fig. 60), a celestial globe replaces the bust, extending the application of the allegory to the sciences as well, and referring once more to the passage of time as measured by the stars. We have argued elsewhere that this engraving and the others of the

15

series to which it belongs were done from drawings originally contained in the "livre de raison" where Oudry made sketches of all of his pictures and projects from 1713 to about 1718 (now in the Louvre; see general entry for Paris 7-11). The drawing has long since been detached and has disappeared; it no doubt was a *première pensée* for the Schwerin picture of 1713, or possibly the record of a variant replica.

According to eighteenth-century sources, Oudry enjoyed music and played the guitar quite well. Its prominent position in the center of the picture may indicate that the beautiful guitar belonged to him personally. At the penurious beginnings of his career, it may well have been his proudest possession. By the end of his life, however, he was quite well off, and the announcement of his sale mentions, in addition to paintings and drawings, "bijoux, tabatieres, guitarres fort rares . . ." (*Annonces, Affiches, et avis divers*, du lundi 30 juin 1755, p. 396). Perhaps this

one, the first, was among those in the sale. Shortly before his death, Oudry designed an ornamental frame for the portrait Largillierre had painted of him in 1729, for the use of Tardieu, who was engraving the portrait (Fig. 80). We mention this only because we have here, at the end of his career, a grouping of a guitar and attributes of painting very close in arrangement and in spirit to this early painting.

But the most appealing aspect of the picture is Oudry's already developed mastery in rendering the various surfaces of things: dull painted plaster, polished woods, paper, the ribbon of rose, light blue, and grey, and the tarnished brass. The illusionism which will assure his popularity in the late years begins in pictures like this. Bode was right to remark that this painting, as well as the preceding one, foretell Chardin in their motifs, but not in execution.

Fig. 60 Gabriel Huquier, *Allegory of the Arts*, engraving after a lost drawing of about 1713 by Oudry. About 1737. Paris, Bibliothèque nationale, Cabinet des Estampes.

16 *(Colorplate on page 10)*
Return from the Hunt with a Dead Roe

Canvas. H. 163; W. 129.
Signed and dated below: *J. B. Oudry. / 1721.*
Schwerin, Staatliches Museum, inv. no. 184.

Provenance: Purchased at Oudry's sale, Paris, 7 July 1755, for the Duke of Mecklenburg-Schwerin (351 livres 19 sols).

Exhibitions: 1725, Salon; 1982-1983, Paris, no. 31 (repr.).

Bibliography: Mercure de France, September 1725, 2nd vol., p. 2263; Groth, 1792, pp. 68-69, no. M1; Lenthe, 1836, no. 426; Dussieux, 1876, pp. 190-191; Schlie, 1882, no. 770; Seidel, 1890, pp. 88, 92, 104, 109; Bode, 1891, p. 62; Locquin, *Catalogue*, 1912, no. 45; *Gemälde alter Meister*, n. d., repr. pl. 48; Vergnet-Ruiz, 1930, nos. I, 280 (Schwerin), and VII, 34 (Salon of 1725); *Katalog*, 1954, no. 278, repr. pl. XI; Lauts, 1967, p. 10, repr. pl. 1; Opperman, 1972 [1977], I, pp. 57-59, 80, 148, 180, 222, 526, cat. no. P441, II, p. 943, repr. p. 1008, fig. 71; Faré and Faré, *La Vie silencieuse* ..., 1976, p. 112, repr. fig. 170.

Engraving: Engraved by Oudry himself with variants, in 1725, as the frontispiece for three other engravings of hunts (Fig. 61; cf. Figs. 70-72; Opperman, 1972 [1977], II, pp. 883-84, cat. no. E51).

For its composition, this is one of the most audacious works of the artist's second period. The outspokenly rococo arrangement, the willful arabesques, the curving architecture seen at an angle, the off-center placement of the animals, grouped to form a sort of Louis XV cartouche with a void in the middle: all of these qualities justify the comment in the *Mercure*

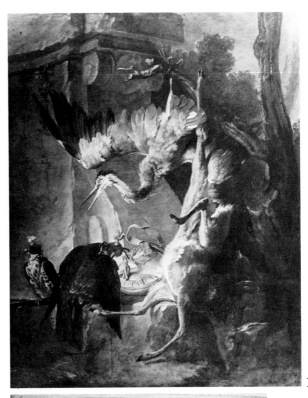

16

Fig. 61 *Title-Page of three Hunts dedicated to Louis Bontemps.* Etching by Oudry dated 1725. Paris, Bibliothèque nationale, Cabinet des Estampes.

111

de France's review of the Salon of 1725, where the picture is described as a "composition assez bizarre." This is also a picture of unsettling contrasts, of the dead roe, freshly killed and hanging limply with its legs akimbo in a graceful design, turned away from the heron, still very much alive, struggling as it hangs from the limb, while the silent falcons, blinded by their hoods, nonetheless seem to be keeping watch. The color range — dominated by greys and browns — is also unusual, and should be enhanced when the painting is cleaned for the exhibition.

The picture seems always to have been recognized as a particularly important work. Oudry kept it all his life, even though it appeared on his lists of 1732 and 1735 (see cat. no. 2 above) priced at 400 livres, and it brought a relatively high price at his sale. Dussieux recognized it as "un des plus beaux tableaux du maître," and Bode — who usually was harsh with Oudry — placed it among his best works.

The cleaning of the picture, as revealed during the Paris exhibition, was thoroughly successful.

Fig. 62 Jean-Baptiste Monnoyer, *Decorative Still Life with Silver Vessels, Flowers, Fruits and a Monkey.* About 1680-1685 (?). Musée de Quimper.

17
Still Life with Monkey, Fruits and Flowers

Canvas. H. 142; W. 144.
Signed and dated at the base of the architecture, to the right: *J B. Oudry 1724*
Chicago, The Art Institute of Chicago (Major Acquisitions Centennial Fund), inv. no. 1977.486.

Provenance: Louis Aubert of Lyon sale, Lyon, Hôtel des Ventes, 12-13 April 1886, no. 43; private collection, Paris, around 1970; acquired by the museum in 1977.

Exhibition: 1982-1983, Paris, no. 32 (repr.).

Bibliography: Opperman, 1972 [1977], I, pp. 78-79, 528-529, cat. no. P447, II, repr. p. 1022, fig. 100; *Art Institute of Chicago Annual Report 1977-1978,* p. 31, repr. in color inside front cover; *Art Institute of Chicago,* 1978, p. 69, no. 31 (repr. in color).

One of the most important lost pictures by Oudry is the large buffet (H. 260, W. 195) which appears on his lists of 1732 and 1735, priced at 1200 livres. It was also in the "Exposition de la Jeunesse" of 1723

and the Salon of 1725. The most thorough description comes from a report of the last-named exhibition (*Mercure de France,* September 1725, 2nd vol., pp. 2262-63; see Opperman, 1972 [1977], I, p. 528, cat. no. P446):

Un grand Buffet ceintré de 8. pieds de haut sur 6. d'un arrangement aussi pittoresque que singulier. Sur une table de marbre on voit une corbeille pleine de fruits, dont une partie est renversée par un Singe qui tire des grapes de raisin. Sur le même plan, à droite, se trouve un jambon, des laituës, un seau où il y a une bouteille de vin au frais; de l'autre côté une jatte remplie de figues. Une décoration d'Architecture sert de fond au dessus de la table, avec des consoles ornées de masques; un surtout imité de vermeil est au milieu, & derriere trois grands plats d'argent chantournez, un vase de porcelaine, deux vases de porphire canelez, remplis de fleurs. Le haut est terminé par un Buste de bronze, d'où sortent deux guirlandes de raisins de toute espece, qui entourent les côtez presque jusques au bas.

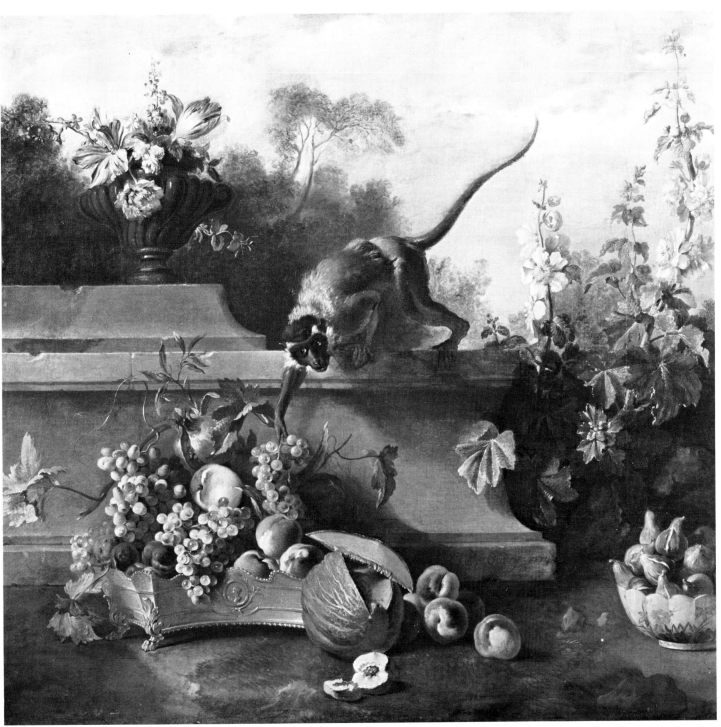

17

The painting in Chicago is quite probably a rearrangement of some of the elements of the much larger lost buffet. The monkey is stealing grapes from the epergne rather than from a basket of fruits; the bowl of figs is on the right rather than the left; there is only one porphyry vase of flowers. The still-life elements are on the ground instead of on a marble table, and the background architecture is different. There can be no doubt of the picture's authenticity, though. This is no studio replica but a wholly autograph work. The lost painting must have been completed around 1721-22, or in 1723 at the latest, since it was exhibited that year. So the Chicago picture is an early variant of it, commissioned, no doubt, by someone who had admired the larger picture, but who needed a smaller, square one for a specific location, most likely a dining-room.

Still another variant (to judge from reproductions, largely studio work) was in two sales in Paris nearly thirty years ago (canvas, H. 173, W. 111; Opperman, 1972 [1977], I, p. 535, cat. no. P465). It has the same monkey stealing grapes from an epergne filled with fruits, a porphyry vase, the bowl of figs, and also the ham and the bottle of wine cooling in a bucket from the original version. It also has a few elements not found in either of the others: a fluted column, a pheasant, a duck

The Chicago picture is wholly characteristic of Oudry's developed rococo palette, dominated by bluish greens and shades of pink. The composition, too, is characteristic: the two words "pittoresque" and "singulier" from the Mercure's description of the lost original sum up the essential qualities of the aesthetic of this period of his career. Even in his choice of fruits and flowers he seems to avoid the regular and the ordered whenever he can, preferring unruly plants like hollyhocks, and not even slicing his melon straight. In this regard the painting resembles La Terre (Fig. 14; cf. Paris 30), three years earlier in date. It is a "rococo" transformation of the decorative still-life tradition of the time of Louis XIV, particularly the paintings of Jean-Baptiste Monnoyer, whom Oudry admired (see remarks at cat. no. 73 below). For comparison we reproduce a decorative still life with a monkey by Monnoyer, from the Quimper museum (Fig. 62).

18
Still Life with Musette and Violin

Canvas (oval). H. 87.5; W. 65.5.
Signed and dated on the architecture, beneath the vase: J B. Oudry / 1725
Toledo, The Toledo Museum of Art, inv. no. 51.500.

Provenance: Cailleux, Paris; Gift of Edward Drummond Libbey, 1951.

Exhibitions: 1946, Paris, no. 50; 1982-1983, Paris, no. 33 (repr.).

Bibliography: "Musical Instruments through the Ages," Museum News (The Toledo Museum of Art), no. 133 (1952), repr. p. 1; Grigaut, 1956, p. 53, repr. fig. 4; Museum News (The Toledo Museum of Art), N.S., III no. 4 (Autumn 1960), pp. 92-93 (repr.); Mirimonde, 1965, pp. 113-114, repr. fig. 4; Watson, 1967, p. 464, repr. p. 462; Opperman, 1972 [1977], I, pp. 79, 546-47, cat. no. P493, II, p. 944, repr. p. 1036, fig. 128; Faré and Faré, La Vie silencieuse . . . , 1976, p. 120 (dated 1735); Toledo Museum of Art, 1976, pp. 119-120, repr. pl. 199; Mirimonde, 1977, II, pp. 11-12, repr. fig. 1.

L'Air of 1719 (Fig. 11) — one of the Four Elements Oudry sold to Stockholm around 1740 — has as its focus this same grouping of music and instruments. Oudry painted nothing more popular, as attested by the astonishing number of repetitions enumerated in the Paris catalogue. We have chosen the stunning oval canvas in Toledo to represent the composition. Our version was most likely done to measure, perhaps as an overdoor or an entre-fenêtre, but more probably as a dessus de glace, given its format and dimensions. The main attraction is the musette, with its vermilion and prussian blue tones and the gold brocade, constrasted to the dull, soft stone of the architecture and the hard, polished porphyry and framed by the varnished wood of the violin and the crumpled paper.

The music has been identified by M. François Lesure (as reported by Mirimonde). It comes from a Recueil d'Airs sérieux et à boire, published by J.-B. Christophe Ballard, fascicule of October 1718, pp. 183-85. The music is by Louis Lemaire and the words — most of which are legible in the painting — by Bruseau. The song is a petition to "Divine Sleep" not to work his effects on happy drunkards who are enjoying new wine.

18

The date has always been read as 1725, except by Michel and Fabrice Faré (but their date of 1735 may be only a misprint). It should be examined closely at the exhibition.

19 *(Colorplate on page 11)*
Still Life with Fruits, Celery, and a Porcelain Bowl

Canvas. H. 92; W. 75.
Signed and dated on the ledge, below: *J B. Oudry 1725*
Schwerin, Staatliches Museum, inv. no. 176.

Provenance: First cited in Schwerin in 1792, but undoubtedly came there during Oudry's lifetime.

Exhibition: 1982-1983, Paris, no. 37 (repr.).

Bibliography: Groth, 1792, p. 70, no. M9; Lenthe, 1836, no. 436; Dussieux, 1876, p. 191; Schlie, 1882, no. 773; Seidel, 1890, pp. 88, 106; Bode, 1891, p. 62 (among his best pictures); Locquin, *Catalogue*, 1912, no. 53; *Gemälde alter Meister*, n. d., repr. pl. 67; Vergnet-Ruiz, 1930, no. I, 283; *Katalog*, 1954, no. 280, repr. pl. III; Venzmer, 1967, repr. in color, pl. 4; Opperman, 1972 [1977], I, pp. 63-64, 545, cat. no. P490, II, p. 944, repr. p. 1034, fig. 123; Faré and Faré, *La Vie silencieuse* . . . , 1976, p. 117, repr. fig. 184.

On a ledge, beside an early eighteenth-century Kakiemon-type bowl with a gilt bronze mount, lie four peaches, two plums, and three celery plants; above them is a large bunch of grapes hanging from a nail against an architectural background. This is one of Oudry's most sophisticated still-life pictures. The contrast between the natural and the artificial, between the mundane kitchen garden and the arcane porcelain factories of the East, is brought out by the precious bowl with the unruly celery leaning casually and precariously against it. Yet the bowl, so regular and harmonious in design, is decorated with a free, irregular, overall pattern of birds in flowering branches, which brings us back to nature again. The arrangement is a variant of the standard niche-type still life, but rather than facing the niche frontally and centering it on the canvas, Oudry shows us only half of it, and from an angle, revealing again his taste for rococo asymmetry. Once more we might suggest an influence on Chardin, not only in subject and composition but even in the lighting and palette:

19

Fig. 63 Jean Siméon Chardin, *Still Life with a Partridge, Fruits and Celery.* About 1729. Karlsruhe, Staatliche Kunsthalle.

116

compare his picture in Karlsruhe (Fig. 63), dated four or five years later according to Pierre Rosenberg (1979, no. 18). The picture was not shown in any of the Salons, which is somewhat unusual for so important a work; once the Salons started up again in 1737, Oudry did not hesitate to exhibit works he had painted many years before. Perhaps it was completed after the Salon of 1725, and had gone to Schwerin already in the 1730s. But it is one of the very few of his pictures there not mentioned in the documents published by Seidel.

The porcelain bowl probably belonged to the artist. Gougenot (1761 [1854], p. 371) mentions that Oudry put together a first collection "de vases, de figures, de porcelaines et de curiosités de la Chine" which he tired of and sold for 9000 livres, only to come back and form a second one, sold at his death along with his pictures and drawings for 40,000 livres.

20

20
Vase of Flowers with a Nest of House-sparrows

Canvas. H. 78; W. 65.
Signed and dated, below left: *J B. Oudry 1725*
Schwerin, Staatliches Museum, inv. no. 186.

Provenance: Purchased at Oudry's sale, Paris, 7 July 1755, for the Duke of Mecklenburg-Schwerin (269 livres).

Exhibitions: 1741, Salon, no. 29; 1747, Salon, no. 46; 1982-1983 Paris, no. 38 (repr.).

Bibliography: Lenthe, 1836, no. 698; Dussieux, 1876, p. 191 ("magnifique tableau"); Schlie, 1882, no. 774; Seidel, 1890, pp. 88, 104; Bode, 1891, p. 62 (among his best works); Locquin, *Catalogue*, 1912, nos. 54 (Schwerin), 81 (Salon of 1747), 320 (Salon of 1741); Vergnet-Ruiz, 1930, no. I, 284; *Katalog*, 1954, no. 281; Venzmer, 1967, repr. in color, pl. 3; Opperman, 1972 [1977], I, pp. 63-65, 186, 194, 546, cat. no. P492, II, p. 944, repr. p. 1036, fig. 127; Faré and Faré, *La Vie silencieuse . . .* , 1976, p. 117, repr. fig. 179.

This flower piece is a startling change from the still life discussed at the preceding number, for here we are suddenly back in the seventeenth century, in the Netherlandish tradition of vases of flowers seen frontally on a ledge against a dark background, with anecdotal insects and a nest of birds. The picture is a *tour de force* of illusionism (note the spilled water on the ledge) and must have been popular with the public: Oudry kept it all his life and showed it in two later Salons. In the Salon of 1746 he showed a similar little *trompe-l'oeil* of a marble vase in a niche, which has since disappeared, and Mariette noted that it "a amusé bien des gens" (see Opperman, 1972 [1977], I, p. 192).

The vase is of smooth porphyry with an elaborate ormolu handle. There are three insects — an emperor moth flying above right, a scarce swallowtail perched on a tulip leaf, and a beetle on the ledge. In only one way is the picture noticeably "modern": in addition to the usual garden flowers (tulips, narcissi, a poppy, pansies, peonies . . .), the bouquet is composed of wild flowers and even of weeds, loosely arranged.

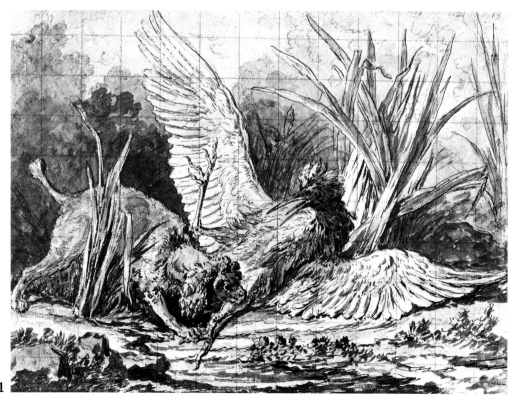

21

21
Water Spaniel Seizing a Bittern

H. 23.5; W. 30.8
Pen and black ink, brush point and brown ink, brown ink wash, on white paper, over a red chalk sketch. Squared for transfer at 2.4 cm. intervals, in red chalk. The squares are numbered in red chalk across the top, left to right, 1 through 13, and along the right edge, from top to bottom, 1 through 10.
Schwerin, Staatliches Museum, inv. no. 4575 Hz.

Provenance: Purchased at Oudry's sale, Paris, 7 July 1755, for the Duke of Mecklenburg-Schwerin, with three other drawings (48 livres for the lot; the other three are lost).

Exhibition: 1982-1983, Paris, no. 41 (repr.).

Bibliography: Seidel, 1890, pp. 104-105; Locquin, *Catalogue*, 1912, nos. 627 (Schwerin), 628 (the 1755 purchase, confused with another drawing of the same lot); Vergnet-Ruiz, 1930, no. II, 62; Opperman, 1972 [1977], I, pp. 142, 312, II, p. 742, cat. no. D623, repr. p. 1032, fig. 120.

The drawing, squared for transfer to canvas, is one of the rare surviving final studies for a picture of the second period. It was done in view of a painting signed and dated 1725, now in Stockholm (Fig. 64). A similar preparation exists for the *Wolf Hunt* of 1724 in Ansbach (Paris 39; the painting is reproduced above, Fig. 18). Both drawings, in the richness of their mixture of chalk, pen and brush, the different tones and densities of red and brown, witness to Oudry's great mastery of his medium. The theme of dogs pursuing game birds comes in at the beginning of Oudry's second period (cf. *L'Eau* of 1719, Fig. 12), a bit earlier than his scenes of dogs hunting four-legged animals. The Schwerin drawing and the painting for which it is a preparation are fine examples of his approach to this type, emphasizing the beam of light that falls on the bird's open wings, the aquatic setting, and the characteristic natural attitudes of the animals. Let us cite just one earlier example, the *Water Spaniel confronting a Heron* (Fig. 65), signed and dated 1722, in Geneva (canvas, H. 160, W. 110; Opperman, 1972 [1977], I, p. 433, cat. no. P208; we have since re-examined the picture and there is no doubt that the date is 1722): this encounter has just begun, as the dog crouches tensely, awaiting the moment to attack, while the awkward heron seeks to take flight. Oudry's sensitivity to the

"character" of the animals — and, more generally, his new interest in the study of living nature — cannot be found to this degree in his early works, and are the most surprising developments of his second period.

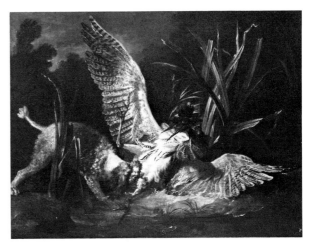

Fig. 64 *Water Spaniel seizing a Bittern*. Dated 1725. Stockholm, Nationalmuseum.

Fig. 65 *Water Spaniel confronting a Heron*. Dated 1722. Geneva, Musée d'Art et d'Histoire.

22

22
Water Spaniel Seizing a Duck in Flight

H. 19.3; W. 23.6
Black and white chalk on light brown paper.
Signed and dated in pen and brown ink, below left:
J B Oudry / 1726
Schwerin, Staatliches Museum, inv. no. 4576 Hz.

Provenance: Unrecorded in Schwerin before 1890, although it undoubtedly came there in Oudry's lifetime.

Exhibition: 1982-1983, Paris, no. 42 (repr.).

Bibliography: Seidel, 1890, p. 106 ("Pudel und Schwan"); Locquin, *Catalogue*, 1912, nos. 622 ("un caniche"), 785 ("un cygne"); Vergnet-Ruiz, 1930, nos. II, 57, 82 (follows Locquin); Opperman, 1972 [1977], I, pp. 142, 312, II, p. 740, cat. no. D616, repr. p. 1038, fig. 132.

A drawing of remarkable freshness, free in execution, this must have been set down for its own sake rather than as a project for a specific painting, even though it may have inspired a canvas of the same format and theme, with a dog in a similar position but with a different duck and background, signed and dated 1728

(Fig. 66; sale, Paris, Palais Galliera, 30 March 1979, no. 16, repr.; H. 96.5, W. 127). It is an excellent example of Oudry's ability to use black and white chalk quickly to describe light and shade among the animals, the reeds, and the architectural fountain on the left. Because of its size and shorter neck, the bird must be a duck rather than a swan.

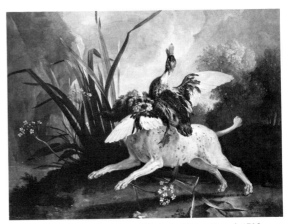

Fig. 66 *Water Spaniel seizing a Duck in Flight.* Dated 1728. Private collection.

120

23

23
Two Hounds Disputing Dead Game

H. 17.9; W. 24.5
Black and white chalk on light brown paper.
Signed and dated in black chalk, on the stone parapet
to the right: *J B Oudry 1726*
Schwerin, Staatliches Museum, inv. no. 4577 Hz.

Provenance: Unrecorded in Schwerin before 1890, although it
undoubtedly came there in Oudry's lifetime.

Exhibition: 1982-1983, Paris, no. 43 (repr.).

Bibliography: Seidel, 1890, p. 105; Locquin, *Catalogue*, 1912, no. 592;
Vergnet-Ruiz, 1930, no. II, 34; *Führer durch die Kunstsammlungen
des Staatliches Museum Schwerin*, 1965, repr. p. 47; Opperman,
1972 [1977], I, pp. 142, 312, II, p. 829, cat. no. D974, repr. p.
1039, fig. 134.

In a landscape, two hounds growl at one another
beside a still life of a wild boar's head, two partridges,
and a pheasant suspended from a rifle. This is just
possibly a *première pensée* for a picture of similar
subject and date in Copenhagen, whose composition
is very different (Fig. 67; canvas, H. 124, W. 157;

Opperman, 1972 [1977], I, p. 506, cat. no. P395). It
is quite similar in execution to the preceding number,
but if anything even richer in its chiaroscuro and the
brilliance with which chalks are handled. The com-
position is quintessentially rococo: note especially the
tail of the standing dog to the right, a perfectly
hooked rococo C-curve.

Fig. 67 *Two Hounds disputing a Boar's Head, with a
Dead Duck and Pheasant.* Date 1726. Copenhagen,
Statens Museum for Kunst.

24 *(Colorplate on page 14)*
Roe Hunt

Canvas. H. 171; W. 156.
Signed and dated, below left: *J B. Oudry 1725*
Rouen, Musée des Beaux-Arts, inv. no. D 820-1.

Provenance: Commissioned in 1724 for the Salle des Gardes of
the Château de Chantilly, apparently as a present from Louis XV
to the Duc de Bourbon; Oudry asked 1600 livres for the picture
and received only 700; seized at Chantilly in 1797; sent from
Versailles to the Louvre in 1803; ceded to the Ministère de l'
Intérieur in 1819 for distribution to the provinces; attributed to
the Muséum de Rouen in 1820.

Exhibitions: 1725, "Exposition de la Jeunesse" (?); 1934, Paris,
Muséum, no. 108 (repr.); 1982-1983, Paris, no. 40 (repr.)

Bibliography: Mercure de France (June 1724, 2nd vol., pp. 1390-91);
Mercure de France (June 1725, 2nd vol., pp. 1400-1401); *Catalogue
raisonné des tableaux exposés au Musée de Rouen,* 1820, no. 132;
Courajod, 1878, p. 381; Lebel, 1890, p. 50, no. 457; Engerand,
1900, pp. 362-63; Minet, 1911, p. 94, no. 708; Locquin, *Catalogue,*
1912, no. 261; Furcy-Raynaud, 1912, p. 280; Vergnet-Ruiz, 1930,
no. I, 35; Vaultier, 1956, repr. p. 684; Vergnet-Ruiz and Laclotte,
1965, p. 246; Belloncle 1967, detail repr. p. 25; Opperman, 1972
[1977], I, pp. 46-47, 179-180, 420-21, cat. no. P181, II, p. 932,
repr. p. 1028, fig. 111; Lastic, 1977, p. 294; Popovitch, 1978,
pp. 114-115.

Engraving: Engraved by Oudry himself in 1725 (Fig. 70). Design
H. 31cm., W. 27.1cm.; copper plate H. 37.4cm., W. 29.2cm.
(Opperman, 1972 [1977], II, p. 884, cat. no. E52).

24

The *Mercure de France* tells us that in 1724 Oudry
"...travaille actuellement par ordre du Roi à quatre
morceaux, qui ne diminueront pas la juste réputation
qu'il s'est acquise. Ce sont les Chasses du Loup, du
Sanglier, du Cerf & du Renard." And in 1725, again
in its account of the "Exposition de la Jeunesse," the
Mercure states:

> Le même Peintre a fait trois Tableaux de chasse
> pour la salle des Gardes du Château de Chantilly,
> d'environ 6. pieds en carré. Ils représentent un
> Loup aux abois, au pied d'un arbre entouré de
> chiens. Un Chevreuil lancé par les chiens, & un
> Renard qui se défend contre les chiens.

In the accounts of the Bâtiments du Roi published by
Engerand, one also finds these three pictures, paid
for in 1726 at 700 livres each (Oudry had asked 1600
livres apiece for them). It is doubtful that they were
actually exhibited in 1725; the wording of the article
in the *Mercure* is that of a simple announcement.

Fig. 70 *Roe Hunt,* etched by Oudry in 1725. Paris,
Bibliothèque nationale, Cabinet des Estampes.

Fig. 68 *Wolf Hunt*, painted for the salle des gardes of the Château de Chantilly. Dated 1725. Chantilly, Musée Condé.

Fig. 69 *Fox Hunt*, painted for the salle des gardes of the Château de Chantilly. Dated 1725. Chantilly, Musée Condé.

Fig. 71 *Wolf Hunt*, etched by Oudry in 1725. Paris, Bibliothèque nationale, Cabinet des Estampes.

Fig. 72 *Fox Hunt*, etched by Oudry in 1725. Paris, Bibliothèque nationale, Cabinet des Estampes.

There can be little doubt that the commission mentioned in 1724 was the same as that completed for Chantilly in 1725, and that it had been modified. The *Wolf Hunt* (Fig. 68) and the *Fox Hunt* (Fig. 69) were completed along with a *Roe Hunt* (not mentioned in 1724); but the *Boar Hunt* and the *Stag Hunt* were not. The probable reason is that, in the meantime, the commission for the last two subjects had been given to Desportes instead. Indeed, in 1724-1725, Desportes executed a *Boar Hunt* and a *Stag Hunt* for the Appartement du Roi at Chantilly, both paid for by the Bâtiments du Roi (now at the Château de Grosbois; *Mercure de France*, September 1725, 2nd vol., p. 2261 — Engerand, 1900, p. 156 — Lastic, 1977, p. 294). Again, he received less than he asked for: 800 livres apiece instead of 1200.

Oudry's pictures joined three earlier ones by Desportes in the Salle des Gardes at Chantilly, all dated 1719: a *Stag Hunt* and a *Fox Hunt* (both now in the Musée de la Vénerie, Senlis) and a *Boar Hunt* (Musée de Lyon).

The dimensions of Oudry's pictures given in the accounts of the Bâtiments du Roi are not necessarily accurate, but we cite them for the record: the *Wolf Hunt* was said to be six feet square (195 cm.), and the other two five and a half (178 cm.). At the present time all three have about the same height, from 171 to 175 cm., and probably they were all originally five and a half feet high. The *Wolf Hunt*, which was said to be 195 cm. wide now measures 196 cm. (much of it is hidden by the present woodwork at Chantilly), so it must indeed have been six feet wide. The other two are only 155-156 cm. wide, however. We may safely assume that they have been trimmed a bit at the sides, and that their original width was five feet (162 cm.). Thus the original height of all three was about 178 cm.; the original width of the *Wolf Hunt* was about 195 cm., and of the *Roe Hunt* and *Fox Hunt* about 162 cm.

It is still not clear how two of the paintings returned to Chantilly. All three were seized in 1797 and became national property. The *Roe Hunt* was deposited in Rouen in 1820, and the other two are not mentioned in the earliest inventories of the Louvre, from the 1820s. More than likely they had been restituted to the Condé family, who returned to favor under the Restoration.

Oudry painted no gentler hunt that this. Gone is the savagery of the Flemish tradition, largely continued by Desportes. Hounds and roe are posed in lilting arabesques, and seem to move in rhythm to some *fanfare de chasse*. The coloration is delicate (and, it must be admitted, not wholly natural): the pale rose tints in the fur of the dogs, the light yellow of the sky, pale greens in the foliage We might also mention that Oudry's engravings of the three hunts for Chantilly (Figs. 70-72), published in 1725 with a title-page after an earlier painting of his (Fig. 61), are among his most accomplished works in the medium.

25 *(Colorplate on page 12)*
Misse and Turlu, Two Greyhounds Belonging to Louis XV

Canvas. H. 127; W. 160.
Signed and dated below, in the middle: *J. B. Oudry. 1725*. The names of the dogs appear in large gilt letters, below.
Fontainebleau, Musée national du Château de Fontainebleau, inv. no. B586.

Provenance: Painted for Louis XV; at Compiègne in 1732 (and probably throughout the eighteenth century); French national collections; sent from the Louvre to Compiègne in 1827, to be placed in the faisanderie; cited in the Compiègne catalogues of 1832 and 1837 in the château proper (but no longer in that of 1841); probably in storage in the Louvre until 1848; exhibited in the Louvre from about 1848 until 1889; sent to Fontainebleau in 1889.

Exhibitions: 1726, shown in the command exhibition at Versailles; 1923, Paris, no. 108; 1976-1977, Paris, no. 7; 1982-1983, Paris, no. 44 (repr. in black and white; color repr. p. 10).

Bibliography: Mercure de France, September 1725, 2nd vol., p. 2265; *Mercure de France*, March 1726, p. 627; A.-N. Dézallier d'Argenville, 1755, p. 350 (2nd ed., p. 395, 3rd ed., p. 446, 4th ed., p. 452); *Notice des tableaux placés dans les appartements du palais royal de Compiègne*, 1832, p. 15, no. 169 (Desportes); *Idem*, 1837, p. 21, no. 150 (Desportes); Villot, 1855, p. 244, no. 384; Engerand, 1900, pp. 375-76 note; Tuetey, 1901-1902, I, p. 315; Locquin, *Catalogue*, 1912, no. 137; Brière and Communaux, 1924, p. 326, no. 204; Vergnet-Ruiz, 1930, no. I, 134; Robiquet, 1938, pp. 30, 93; Opperman, 1972 [1977], I, pp. 46, 181, 473-474, cat. no. P311, II, repr. p. 1041, fig. 137; Lastic, 1977, p. 294.

In September 1725, the *Mercure* announced that "M. Oudry vient de peindre d'après nature, par ordre du

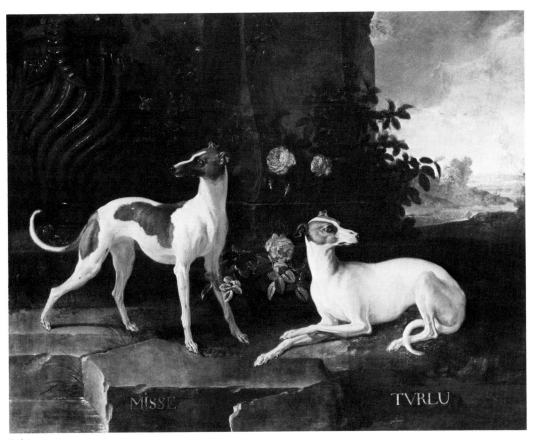

25

Roi, les portraits de quelques levriers Anglois, dont S. M. a été fort contente," so content that six months later the *Mercure* reported that "Le S^r Oudri, Peintre de l'Académie, eut ordre...de faire porter au Roi, un Tableau qu'il a peint devant S. M. representant *Turlu* & *Misse*, deux levriers Anglois, dans un fond d'Architecture & de paysage." This he did, on Sunday, 10 March 1726, along with twenty-five other pictures, which were extremely well received by the young King and Queen and by the whole court. *Misse and Turlu* was followed by a whole series of similar works, placed above doors in the King's *appartements* at Compiègne, as revealed by a document of 1733 published by Engerand. They are now dispersed; let us give a summary of them here.

1) *Misse and Turlu*, dated 1725; now at Fontainebleau. In 1733 was in the *chambre du roi*.

2) *Gredinet, Petite Fille and Charlotte*, dated 1727; now at Fontainebleau, and catalogued at the following number. In 1733 was in the *chambre du roi*.

3) *Blanche*, probably done in 1727; now at Compiègne (Fig. 73; cf. Paris 46). In 1733 was in the *cabinet du conseil*.

4) *Polydore*, dated 1728; now at Fontainebleau (Fig. 74; cf. Paris 45). In 1733 was in the *cabinet du conseil*.

5) *Mignonne and Sylvie*, dated 1728; now at Fontainebleau (Opperman, 1972 [1977], I, p. 474, cat. no. P312). In 1733 was in the *cabinet du conseil*.

6) *Lise*, undated; now at Fontainebleau (Fig. 20; Opperman, 1972 [1977], I, p. 451, cat. no. P452). In 1733 was in the *chambre du roi* (Engerand calls her *Lune*).

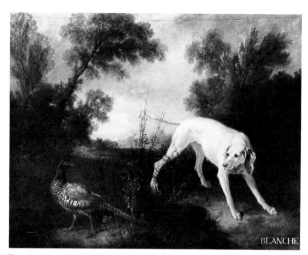

Fig. 73 *Blanche pointing a Pheasant*, painted for the King's apartments at Compiègne. About 1727. Compiègne, Musée national du Château de Compiègne.

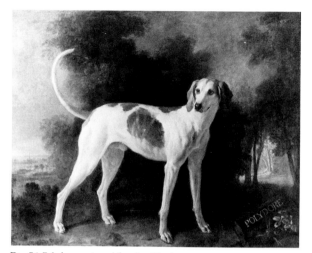

Fig. 74 *Polydore*, painted for the King's apartments at Compiègne. Dated 1728. Fontainebleau, Musée national du Château de Fontainebleau.

7) *Perle and Ponne*, undated; now at Fontainebleau, whose old *fichier* records a date of 1732...but the picture is very dirty today and its signature illegible (Opperman, 1972 [1977], I, p. 450, cat. no. P451). In 1733 was in the passageway before the *cabinet du conseil*.

8) *Cadet and Hermine*, undated and reduced in size; private collection, Paris (Opperman, 1972 [1977], I, p. 451, cat. no. P253). In 1733 was in the *cabinet du jeu*.

9) *The Gamekeeper La Forêt with Lise and Fine-Lise*, dated 1732; said to be in a private collection, Paris (Opperman, 1972 [1977], I, p. 364, cat. no. P7 — cf. Lastic, 1977, p. 294). In 1733 was in the passageway before the *cabinet du conseil*.

10) *"Les Canards de Marly,"* not cited since 1733, when the picture was in the passageway on the terrace side (Opperman, 1972 [1977], I, p. 497, cat. no. P373).

11) *A Cat called "Le Général,"* dated 1732 (?), last cited in two sales in Vienna in 1952 and 1955 (Opperman, 1972 [1977], I, p. 532, cat. no. P456). In 1733 was in the passageway on the terrace side.

It is impossible to identify any of these pictures specifically in later references to Compiègne in the eighteenth century, although the different editions of Dézallier d'Argenville's guide as well as documents cited by Robiquet refer to overdoors by Oudry in various rooms there. In 1792, an inventory of the château mentions eight animal pictures by Oudry as in storage (published by Tuetey). By the Restoration period, the first seven listed above had become part of the collections of the Louvre, while the other four had been disposed of.

In the same year, 1725, that he delivered his first royal commission for pictures of the hunt, we thus find Oudry painting the favorite dogs of Louis XV in the King's presence — a further invasion of the territory hitherto reserved for Desportes. But just as in pictures such as the *Roe Hunt* [24] Oudry instinctively, perhaps deliberately, moves away from the uncompromising description of the animal as animal — that is, as beast — so in the portrait of *Misse and Turlu* he seems to be seeking, rightly or wrongly, a human quality in the dogs, something that Desportes might not willingly have accepted. But then, this picture, set in a park rather than a forest, is not a

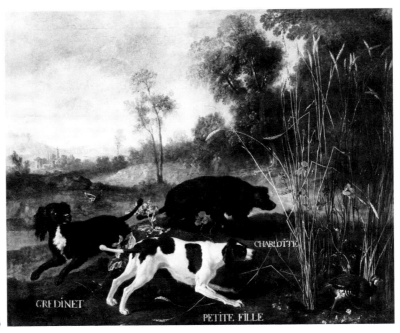

26

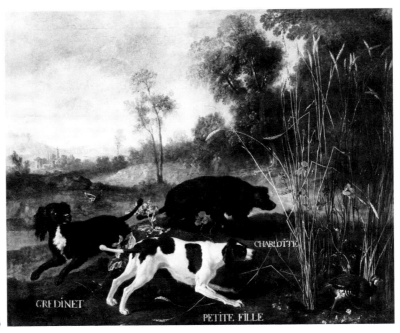
GREDINET · *CHARLOTTE* · *PETITE FILLE*

subject of the hunt but rather a "portrait de société." Oudry has emphasized the nervousness of the breed of dog in attitude and tenseness of outline, without in any way sacrificing their graceful beauty. The canvas, dirty and somewhat repainted, is being restored for the exhibition. Preliminary work has already revealed an unexpected range of colors as well as the marvellously skilled building up of paint in various parts, particularly the dogs' heads.

The restoration was somewhat disappointing, particularly in the background and in the flowers, which have suffered beyond help. The dogs themselves are magnificent. We might add that the cleaning of *Polydore* for the Paris exhibition revealed the date of 1728, not 1726 as we recorded it in the Paris catalogue, and that the dog's name in large gilt letters reappeared on a rock, below right.

26 *(Colorplate on page 13)*
Gredinet, Petite Fille and Charlotte, Three Spaniels Belonging to Louis XV

Canvas. H. 130; W. 163
Signed and dated, below left: *J B. Oudry 1727*
Their names appear beside the dogs in large gilt letters.
Fontainebleau, Musée national du Château de Fontainebleau, inv. no. MR 1498.

Provenance: Painted for Louis XV; at Compiègne in 1732 (and probably throughout the eighteenth century); French national collections; recorded as having been sent to Fontainebleau from the Louvre in 1820; appears nonetheless in the Compiègne catalogue of 1837 (but not in that of 1832); appears again in the Fontainebleau catalogue of 1841 (but not in those of 1839 and 1840).

Exhibitions: 1934, Paris, no. 107; 1982-1983, Paris, no. 47 (repr. in black and white; color repr. p. 11).

Bibliography: A.-J. Dézallier d'Argenville, 1762, IV, p. 413; *Notice des tableaux placés dans les appartements du palais royal de Compiègne*, 1837, p. 17, no. 84 (Desportes); *Notice des Peintures et sculptures placées dans les cours et les appartements du palais de Fontainebleau*, 1841, p. 48, no. 191 (Desportes); *Notice des tableaux appartenant à la collection du Louvre exposés dans les salles du Palais de Fontainebleau*, 1881, p. 58, no. 113; Engerand, 1900, pp. 375-76 note; Locquin, *Catalogue*, 1912, no. 142; Vergnet-Ruiz, 1930, no. I, 135; Opperman, 1972 [1977], I, p. 449, cat. no. P248; Lastic, 1977, p. 294, repr. fig. 8.

En 1727, notre artiste peignit en présence du Roi, quatre chiens de chasse dans deux tableaux, chacun de cinq pieds [162 cm.] de long sur quatre [130 cm.] de haut: l'un est un braque en arrest ferme sur un faisan d'un beau plumage que le Roi avoit tiré dans le parc de Versailles: le second tableau représente trois épagneuls du Roi arrêtant des perdrix rouges, à l'entrée d'une piéce de bled, l'un des chiens court après des papillons.

This report by d'Argenville, in 1762, refers certainly to two pictures of the Compiègne series (see the preceding number): *Blanche* (Fig. 73) and the one here catalogued. If the author is to be trusted, then these two pictures, like *Misse and Turlu*, were painted in the King's presence. Oudry here gives us an extensive landscape behind the three dogs on a foreground rise: Petite Fille and Charlotte pointing two red-legged partridges in a mixed tuft of wheat, poppies and cornflowers, while Gredinet pursues an emperor-moth. These dogs are not hunting in the "professional" sense, but rather play at hunting. The emphasis is on a childlike sort of innocence, with the dogs made part of a human, rather than a natural, economy. This picture, too, will be cleaned for the exhibition. Old repainting in the background has altered, giving a completely false sense of Oudry's color scheme.

The cleaning was particularly successful, revealing a painting in quite good condition and bringing forth the astonishing atmospheric landscape. Examination in Paris also disclosed that *Blanche* is signed and dated on a rock, below left: *J B. Oudry/17. . .* — but the date is illegible. Its correct height is 124 cm. rather than 122 cm. as reported earlier (Paris 46).

27
Landscape with Figures, Animals and a Horse Frightened by a Dog

Canvas. H. 65; W. 81.
Signed and dated below, to the right of center: *J B. Oudry. 1727*
Cailleux, Paris.

Provenance: Painted for the Marquis de Beringhen; his sale, Paris, 2 July 1770 and following days, no. 20 (part); Baron Triqueti; sale of Madame Lee Childe (née baronne de Triqueti), Paris, Hôtel Drouot, 4 May 1886, no. 25 (3050 francs); anonymous sale, Paris, Hôtel Drouot, 3-4 May 1956, no. 34 (635,000 francs together with its pendant); Wildenstein; Maharanee of Baroda; anonymous sale, Versailles, Hôtel Rameau, 15 June 1977, no. 49 (repr. in color); there acquired by Cailleux, Paris.

Exhibitions: 1743, Salon, no. 39; 1979-1980, Stockholm, no. 512 (repr.); 1980-1981, Paris and Geneva, no. 27 (repr.); 1982, Paris, no. 7.

Bibliography: Locquin, *Catalogue*, 1912, nos. 410 (Triqueti collection and sale of 1886, with false references to two other sales), 435 (Salon of 1743); Vergnet-Ruiz, 1930, nos. I, 218 (as for Locquin 410), and VII, 44 (Salon of 1743); Opperman, 1972 [1977], I, pp. 65-66, 189, 234, II, repr. p. 1055, fig. 165; Roland Michel and Rambaud, 1977, pp. i-iii (repr.).

Henri-Camille, Marquis de Beringhen, was one of Oudry's most ardent supporters. It was he who introduced Oudry to Louis XV in 1724, launching his official career. He also commissioned or purchased quite a few paintings from the artist, most of which appeared in the sale after his death in 1770. The earliest were six small landscapes of uniform format; this one and the following number have remained together ever since they were painted. Of the others, one is (or was until recently) in the Algiers museum (see Paris pp. 78, 110). It was still with another of the set in the Horsin-Déon sale in 1868, but the latter was separated from it then and has not been cited since the Hulot sale in 1892. The remaining two appeared as a pair in an anonymous sale in Paris, 15 November 1905, where both were said to be signed and dated. The catalogue gives the date of 1732 for one of them but is not specific for the other. Since the first four are all signed and dated 1727 we believe that the reading of 1732 must be an error, and that all six were painted at the same time.

They are carefully described in the Beringhen sale catalogue and somewhat less completely in the *livret*

27

of the Salon of 1743, where they were exhibited along with a seventh picture from Beringhen's collection showing fishermen unloading their catch at the port of Dieppe, about the same size but higher than wide (72 by 61 cm.). Its composition is known through an engraving by Oudry himself; the picture was last cited in the Beringhen sale.

In the inventory of Beringhen's Parisian hôtel in the rue Saint-Nicaise drawn up in 1770, cited by Roland Michel and Rambaud, one finds the *Fishermen* in his bedroom, and in the study overlooking the garden "4 paysages et fabriques enrichies de figures et animaux." These must have belonged to the 1727 set; apparently the remaining two cannot be identified from the inventory.

French landscape suffered an identity crisis in the reign of Louis XIV and only began to find its way again in the second quarter of the eighteenth century. Oudry's role in this rebirth and redefinition is slowly

coming to be recognized once more as it was in his day. The Beringhen pictures have been talked about both in terms of their return to nature (which is true if one compares them to the classicizing pastiches of Allegrain and his school) and of their picturesque tendencies that belong to the age of rococo (equally true when they are compared to Netherlandish landscapes of the preceding century). Whether or not they accurately depict sites of the countryside around Paris (we think this unlikely), they are certainly meant to evoke such scenery and not some more or less fantastic ideal. Yet at the same time they represent a view of nature consonant with the *genre pittoresque* as one finds it in Oudry's other works of the 1720s. Nature conditions the artist's choice of subject much more than it does his vision...yet these little pictures ask a fundamental question and, however timidly, begin to seek an answer. Jean Cailleux has perceptively recognized their place among the very first "true" landscapes of the eighteenth century.

28

28 *(Colorplate on page 16)*
Landscape with a Peasant Girl, Animals, and Two Dogs Attached in a Kennel

Canvas. H. 65; W. 81.
Signed and dated to the right on a board of the kennel:
J B. Oudry. 1727
Cailleux, Paris.

Provenance: As the preceding number, but no. 17 of the Beringhen sale, no. 24 of the Childe sale (3050 francs), no. 33 of the sale in 1956 (repr.), and no. 50 of that of 1977 (repr. in color).

Exhibitions: 1739, Salon; 1743, Salon, no. 42; 1979-1980, Stockholm, no. 513; 1980-1981, Paris and Geneva, no. 28 (repr.); 1982, Paris, no. 8.

Bibliography: Locquin, *Catalogue*, 1912, nos. 411 (Salon of 1743, Beringhen and Triqueti collections, sale of 1886, with false references to three other sales), 421 (Salon of 1739); Vergnet-Ruiz, 1930, nos. I, 219 (as for Locquin 411, but without mention of Beringhen or the Salon of 1743), and VII, 47 (Salons of 1739 and 1743); Opperman, 1972 [1977], I, pp. 65-66, 184, 190, 233, 578-579, cat. no. P586, II, repr. p. 1057, fig. 169; Roland Michel and Rambaud, 1977, pp. i-iii (repr.).

The six landscapes for Beringhen are an evocation of daily life in the country, but without the overtones of *amusements champêtres* so common in the contemporary works of Lancret and others. The one now or formerly in Algiers shows a boy seated on a donkey, driving cows, sheep and a goat to pasture (repr. Paris, fig. 48b). Its companion from the Horsin-Déon sale has two hunters with their horses and several hounds and a stag pursued by the pack in a forest background. The pair from the sale in 1905 depicts a seated woman holding a dog barking at a donkey loaded with baskets, with a cow and calf going to drink from a duck pond; and a shepherd with his dog watching over grazing cows, sheep and a horse. All except the hunt scene have modest castles, sometimes partly in ruins, farm buildings, or village church spires in the middle ground and distance. This rustic architecture animated by foreground figures derives from a Flemish landscape type of the seventeenth century; it also recalls Oudry's wash drawings from the landscape sketchbook of 1714,

some of which represent similar unpretentious buildings (for example, Fig. 8). But as for the latter, one wonders whether these are necessarily *real* buildings, or rather invented ones of a common enough sort. It is no doubt significant that neither in the Salon of 1743 where all were shown, nor in that of 1739 where two of them, including this one, had previously appeared, do the *livrets* mention that they were painted "d'après nature"; nearly all of the other landscapes Oudry exhibited at the Salons are so identified. As we have already said, though, topographical accuracy is not an artistic issue as far as these pictures are concerned; general credibility is. The marvelous rendering of light and atmosphere, the pale yellow glow of the sun, the pastel tonalities of light blue, rose and pale green filtered through the translucent air — qualities one finds in others of his landscapes in these years, for example in the backgrounds of *Gredinet, Petite Fille and Charlotte* [26] and of the great hunt for Marly [33] — all of this is a direct contradiction to the artifices of a worn-out tradition, and points the way to Gainsborough.

29
La Scène du grand Baguenaudier

H. 32.1; W. 46.
Brush and black ink, black ink wash, white gouache heightening, on blue paper.
Sarasota, John and Mable Ringling Museum of Art, inv. no. 662.

Provenance: Purchased by the Museum in Los Angeles, 1952, as Gaspare Diziani.

Exhibitions: 1978, Sarasota, no. 61 (repr.); 1982-1983, Paris, no. 50 (repr.).

Bibliography: [This drawing]: Kent Sobotik, in *Ringling Museum Newsletter*, V no. 3 (March 1972), unpaged, repr. (Diziani); Opperman, 1972 [1977], II, p. 952, under nos. D170-D207; [The *Roman comique* illustrations in general]: *Mercure de France*, August 1727, pp. 1853-1857, January 1729, pp. 138-139, October 1729, pp. 2473-2474, January 1736, pp. 133-134, April 1736, p. 767, May 1737, p. 998; A.-J. Dézallier d'Argenville, 1762, IV, p. 416; Basan, 1767, II, p.355; Robert-Dumesnil, 1835-1871, II, pp. 202-205; Le Blanc, 1854-1888/1890, III, p. 133, article Oudry, nos. 10-30; Portalis, 1877, II, pp. 481, 495; Portalis and Béraldi, 1880-1882, III, pp. 241-242; Jusserand, 1892, I, p. liii (and reproductions throughout); Locquin, "L'Oeuvre gravé," 1912, pp. 173-176; Locquin, *Catalogue*, 1912, pp. 176-180, 184-185; Cohen, 1912, II,

cols. 943-944; Magne, 1924, no. 349; Dacier, 1925, pp. 13, 62, 116; Ingersoll-Smouse, 1928, pp. 76-77; Vergnet-Ruiz, 1930, p. 188, no. VI, 1; Reynaud, 1955, pp. 493-494; exhibition catalogue 1965, Ludwigsburg, under no. 18; Opperman, "Notes sur les éditions," 1967; Opperman, "Oudry illustrateur," 1967; Roux *et al.*, 1931 ff., XI (1970), pp. 510-516; Opperman, 1972 [1977], I, pp. 74-76, 142, 280-284, II, pp. 664-682, 886-889, 920-921, 952, 969; exhibition catalogue 1972-1973, Toronto-Ottawa-San Francisco-New York, under no. 101; Duclaux, 1975, pp. 133-138; Fürstenberg, 1975, pp. 17-18; exhibition catalogue 1978-1979, Paris, under nos. 32-35; exhibition catalogue 1982, Paris, under no. 9; exhibition catalogue 1982-1983, Paris under nos. 49-55.

Sometime around 1725, Oudry became acquainted with a series of paintings representing the principal scenes of Scarron's *Roman comique*, which had been commissioned a few years earlier from the painter Jean-Baptiste Coulom, active in Le Mans, by the Maréchal de Tessé. These pictures were installed in his Château de Vernie near Le Mans (where Scarron's novel is set); today they are conserved in the museum of that city. Under what circumstances Oudry saw them is not known. Perhaps he was already thinking about a series of illustrations of his own (see the two following numbers) and heard about them through his relations at court, or perhaps he learned about them accidentally and, having seen them, conceived the idea for his illustrations. In any case, several free copies of Coulom's pictures, in brush and wash, have come down to us, one of which is exhibited here. Discovered in Sarasota with an old attribution to Diziani, the drawing was returned to Oudry by Pierre Rosenberg in 1976. Although larger in size, the sheet is similar in paper and execution to two other drawings of the same group, now in the Louvre and the Biblioteca Nacional, Madrid, that reproduce a total of six other scenes from the *Roman comique* (see Paris 49 and 50). All were done very quickly. One might imagine that Oudry found himself at Vernie, became interested in Coulom's pictures, and had only a short time to copy them. He must have worked standing up. Rather than trying to reproduce them exactly, he only set down the general idea, taking liberties with the compositions and paying no attention to detail. These free copies are intermediate between Coulom's paintings and Oudry's finished chalk drawings of 1726-1727 which were done to be engraved, containing elements from the one or the other and sometimes both, and the influence of Coulom on Oudry is beyond doubt (it cannot have gone the other way, since the Maréchal de Tessé,

29

who commissioned Coulom's paintings, died in 1725, a year before Oudry began his final drawings). Yet it cannot be proven that Oudry himself executed the interpretive drawings. It is not beyond the realm of possibility that he knew the drawings rather than the paintings, and that they were done by someone else. No matter how unusual their technique, we are ourselves convinced that these drawings are by Oudry himself, but the nature of the evidence compels us to mention the possibility of doubt.

The composition is much closer to Coulom's painting (Fig. 75) than to Oudry's final drawing in Washington (Fig. 76; cf. Paris 55), which shows a slightly earlier moment of the same event. The scene is from Book II, Chapter 17, of the novel. The theatre company is performing the *Dom Japhet* of Scarron to an appreciative audience, but the dimunitive Ragotin arrives late, and the only empty chair is behind that of La

Baguenaudière, an enormous man who in addition is wearing a high hat with a plume. Ragotin, in the dark, cannot believe that the man is sitting down, and asks him repeatedly to do so.

Tant que dura la Comedie, Ragotin luy cria de mesme force qu'il s'assist et la Baguenodiere le regarda tousjours d'un mesme flegme capable de faire enrager tout le genre humain. On eust pu comparer la Baguenodiere à un grand Dogue et Ragotin à un Roquet qui abboye après luy sans que le Dogue en fasse autre chose que d'aller pisser contre une muraille. Enfin tout le monde prit garde à ce qui se passoit entre le plus grand homme et le plus petit de la compagnie et tout le monde commença d'en rire dans le temps que Ragotin commença d'en jurer d'impatience sans que la Baguenodiere fist autre chose que de le regarder froidement. Ce Baguenodiere estoit le

Fig. 75 Jean-Baptiste Coulom, *Ragotin tombe dans le trou du jeu de paume*, painted for the Château de Vernie. About 1715 (?). Le Mans, Musée Tessé.

Fig. 76 *La Scène du grand Baguenaudier*. About 1727. Washington, National Gallery of Art (Rosenwald Collection).

Fig. 77 *L'Aventure du pot de chambre*, sketch after a painting by Coulom. About 1725 (?). Paris, Musée du Louvre, Cabinet des Dessins.

plus grand homme et le plus brutal du monde; il demanda avec sa froideur accoustumée à deux Gentils-hommes qui estoient aupres de luy de quoy ils rioient. Ils luy dirent ingenuement que c'estoit de luy et de Ragotin et pensoient bien par là le congratuler que plustost luy deplaire. Ils luy depleurent pourtant et un: *Vous estes de bons sots*, que la Baguenodiere, d'un visage refrogné leur lâcha assez mal à propos, leur apprit qu'il prenoit mal la chose et les obligea à luy repartir, chacun pour sa part, d'un grand soufflet.

La Baguenaudière rose slowly, stumbled, knocked over a spectator in his chair, who in turned knocked down Ragotin in his, and so on to the back of the room, like ninepins. Ragotin fell through a rotten wooden cover that concealed the opening of the storm drain, just beneath his chair, and had his face scratched by the spur of another spectator whose foot got caught

in the drain. Coulom's picture, and Oudry's copy of it, show the later moment when Ragotin is extricated from the drain, rather than the beginning of the incident as depicted in the drawing in Washington.

We reproduce here (Fig. 77) the verso of the drawing after Coulom in the Louvre, representing *L'Aventure du pot de chambre*; by inadvertence the final chalk drawing of the same subject, also in the Louvre, was reproduced in its place as figure 49a of the Paris catalogue.

Fig. 78 *Le Destin se signale dans le combat de nuit*, engraved by Oudry in 1729. Paris, Bibliothèque nationale, Cabinet des Estampes.

30

30
Le Destin se signale dans le combat de nuit

H. 32; W. 27.
Black and white chalk, brush point and black ink, black ink wash, white gouache heightening, on blue paper.
Private collection.

Provenance: "Succession de la comtesse Crisenoy de Lyonne" and other collections, sale, Paris, Hôtel Drouot, 28 May 1971, no. 79 (but *not* from the Crisenoy de Lyonne collection); purchased by the present owner in 1978.

Exhibitions: 1978-1979, Paris, no. 32 (repr.); 1982-1983, Paris, no. 52 (repr.).

Bibliography: Locquin, *Catalogue,* 1912, no. 1240 (the engraving); Opperman, "Oudry illustrateur," 1967, p. 346, no. 9 (the engraving); Opperman, 1972 [1977], II, p. 669, cat. no. D178, repr. p. 1049, fig. 153.

Engraving: Engraved in the same direction by Oudry himself, in 1729 (Fig. 78).

Oudry's idea of providing a complete series of engraved illustrations for Scarron's *Roman comique* is one of his most ambitious projects. In 1726 and 1727, Oudry prepared thirty-eight drawings in black and white chalk on blue paper. All measured about 33 cm. in height; ten subjects were about 44 cm. wide, and the remaining

twenty-eight, about 28 cm. wide. He declared his intention of having them all engraved in a long announcement in the *Mercure de France* for August 1727. Even though the project was never quite completed, it seems to have been well received, since the engravings remained in print until the end of the eighteenth century. Oudry engraved the first ten subjects himself; the *Mercure* announced six in January of 1729, and four more (including this one) in October of that year. He then turned away from the *Roman comique* prints, apparently because all of his time was required for the *Hunt of Louis XV* for Marly [**33**]. An eleventh print appeared with his address but without his name as engraver, then, in January of 1736, Gabriel Huquier placed a notice in the *Mercure* stating that he would finish the series and announcing the completion of five further subjects. Four more were ready in April of 1736 and another seven by April of the following year, but the project was then definitively abandoned, with twelve drawings left to be engraved.

The original drawings remained together in an album that was sold with the collection of Benoist Audran, Paris, 30 March 1772 and following days, no. 243, and in an anonymous sale, Paris, 25 February 1777 and following days. The album was broken up by the early nineteenth century if not before; we have been able to trace all but six drawings into the present century, and the present whereabouts of most of these are known. All of the ten drawings engraved by Oudry himself are much more highly finished than the others. Oudry went over them with brush and ink, sometimes with more black chalk, and often with white gouache in order to increase both detail and contrast with the engravings in view.

In Book I, Chapter 12, Le Destin is talking late one evening with Mademoiselle de l'Estoile, La Caverne, and the latter's daughter, Angélique, in the actresses' room at the inn, when they hear the noise of a dreadful fight next door. Le Destin enters the room, which is totally dark:

> Il s'alla méler parmy les combattans imprudemment et receut d'abord un coup de poing d'un costé et un soufflet de l'autre. Cela luy changea la bonne intention qu'il avoit de separer ces Lutins en un

violent desir de se vanger; il se mit à joüer des mains et fit un moulinet de ses deux bras, qui maltraitta plus d'une machoire, comme il parut depuis à ses mains sanglantes. La meslée dura encore assez longtemps pour luy faire recevoir une vingtaine de coups et en donner deux fois autant. Au plus fort du combat, il se sentit mordre au gras de la jambe; il y porta ses mains et, rencontrant quelque chose de pelu, il crut estre mordu d'un chien; mais la Caverne et sa fille, qui parurent à la porte de la chambre avec de la lumiere, comme le feu sainct-Elme aprés une tempeste, virent Destin et luy firent voir qu'il estoit au milieu de sept personnes en chemise, qui se defaisoient l'une l'autre tres cruellement et qui se decramponerent d'elles-mesmes aussitost que la lumiere parut. Le calme ne fut pas de longue durée. L'hoste qui estoit un de ces sept Penitens blancs, se reprit avec le Poëte; l'Olive, qui en estoit aussi, fut attaqué par le valet de l'hoste, autre Penitent. Le Destin les voulut separer, mais l'hostesse, qui estoit la beste qui l'avoit mordu et qu'il avait prise pour un chien, à cause qu'elle avoit la teste nue et les cheveux courts, luy sauta aux yeux, assistée de deux servantes aussi nues et aussi decoiffées qu'elle.

Oudry has chosen the moment when the candle is brought into the room, following Scarron faithfully for the number of figures, Le Destin throwing his fists about like a windmill, and the innkeeper's wife biting his calf.

There is a brief respite in the fighting shortly later, and the Poet (who is a member of the troupe) explains what had happened:

> Ce fut au Poëte à plaider sa cause; il dit qu'il avoit fait les deux plus belles Stances que l'on eust jamais ouïes depuis que l'on en fait et que, de peur de les perdre, il avoit esté demander de la chandelle aux servantes de l'hostellerie qui s'estoient moquées de luy; que l'hoste l'avoit appellé danseur de corde et que, pour ne demeurer pas sans repartie, il l'avoit appelé cocu.

At which point the fight begins again, worse than before; Oudry illustrates this *Renouvellement du combat* in his next print.

We know the original drawings of nine of the ten scenes Oudry himself engraved. For seven of the first eight (one is missing), the prints are in reverse from the drawings; but for the last two — this one and the *Renouvellement* — they are in the same direction as the drawings. Oudry must have made counterproofs of these two drawings before engraving the plates.

The *Roman comique* is filled with fights, begun on the slightest pretext and described with great humor. It is interesting to see how many of them Oudry chose to illustrate. He seems to have been particularly attuned to this aspect of Scarron's burlesque, which he captures faithfully, very much in the spirit of the author.

The thirty-eight drawings are listed in Oudry's inventory, 7 May 1755, as pointed out by Jean Cailleux (exhibition catalogue 1982, Paris, no. 9). They were evaluated at 48 livres.

31
Ragotin trouve des bohémiens à sa maison de campagne

H. 33; W. 44.
Black and white chalk on blue paper.
Signed and dated below left, in black chalk: *J B. Oudry/1727*
Private collection.

Provenance: "Succession de la comtesse Crisenoy de Lyonne" and other collections, sale, Paris, Hôtel Drouot, 28 May 1971, no. 76 (repr.) [but *not* from the Crisenoy de Lyonne collection]; there acquired by the present owner.

Exhibition: 1982-1983, Paris, no. 53 (repr.).

Bibliography: Opperman, "Oudry illustrateur," 1967, p. 348, no. 31 (the subject only); Opperman, 1972 [1977], II, pp. 677, cat. no. D200, 952, repr. 1052, fig. 160.

Chapter 16 of Book II begins with Ragotin, La Rancune and L'Olive returning together to Le Mans. On the way, Ragotin invites the two comedians to

31

stop off at a small country house he owns to take a meal. There they find a band of gypsies who have been helping themselves to everything — particularly the farmer's chickens — while waiting for the gypsy captain's wife to give birth. Ragotin is beside himself with indignation, despite the flattery of the gypsy captain and his promise to pay for all they have taken. Just then La Rancune and the captain's brother recognize one another "pour avoir esté autresfois grands camarades" (they are embracing to the left), the captain's wife gives birth to a boy (she is seated on the steps to the right, holding the baby), and Ragotin orders that the chickens be killed to make a fricassée. Amid general jubilation, the gypsies bring out partridges and hares they have taken while poaching, two turkeys and two suckling pigs they have stolen, as well as a ham, beef tongues, and a pâté de lièvre, and the feast begins, well washed down, naturally enough, with Ragotin's wine.

In Gabriel Huquier's first announcement of the continuation of the engravings, he makes a particular point about the costumes:

> M. Oudry, en composant les Desseins de cet Ouvrage, ne s'est point assujetti à se servir d'habillemens modernes, il a crû devoir suivre les modes du temps de Scaron, pour mieux caracteriser ses Personnages et les rendre conformes à l'Original sur lequel il travailloit, et au titre même du Livre, en quoi il a eû l'aprobation de toutes les Personnes de bon goût.

His insistence on Oudry's faithfulness to seventeenth-century dress is no doubt a comment on a competing series of prints after Pater which had begun to appear in the interim, where Scarron's characters are dressed in the fashion of 1730. But more than that it is a recognition of Oudry's sympathy for his author. As the artist himself observed in his notice of October 1729, "les Sujets y sont traitez tout-à-fait dans l'esprit de l'Auteur du Roman, c'est-à-dire, d'une manière tout-à-fait Comique." Oudry illustrated no fewer than six episodes from this chapter, but only three of them were engraved, ours not among them. They are as ridiculous as any in the novel, providing a cross-section of provincial life where actors and peasants, ecclesiastics and laymen, the mad and the supposedly sane interact in one comic episode after another,

celebrating the vitality and freedom of the irregular, all of it admirably captured by Oudry. It is to be regretted that so many of his drawings were not engraved.

32
Louis XV Holding the Line-hound

H. 33; W. 55.
Pen, brush point and black ink, black ink wash, white gouache heightening, over a black chalk sketch, on blue paper.
Signed and dated below, in pen and brown ink: *J B. Oudry 1728*
Private collection.

Provenance: Hermès sale, Paris, Hôtel Drouot, 17 November 1948, no. 6 (repr.).

Exhibition: 1982-1983, Paris, no. 57 (repr.).

Bibliography: Opperman, 1970, p. 221, repr. fig. 32; Opperman, 1972 [1977], I, pp. 86-87, 143-144, II, p. 726, cat. no. D579, repr. p. 1066, fig. 188.

In January of 1728, Oudry received orders from Louis XV to follow the royal hunts and to prepare a large painting of the king and his party (see the following number). There are several drawings from 1728, including this one, that must be related to this ambitious project (see Paris 56 as well as our studies of 1970 and 1972 [1977]). All of these drawings are very large and meticulous in execution, hardly simple records of some moment in an actual hunt. Rather they have the look of presentation drawings, and must have been done as models for potential paintings. It could be that Oudry prepared and presented several drawings from which Louis XV then chose one to be carried out in painting: the *Stag Hunt* now in Toulouse. The others would thus be rejected alternates. On the other hand, a drawing such as this one represents a quiet and somewhat secondary moment of the hunt, which has led us to speculate elsewhere that Oudry, already in 1728, must have conceived a *series* of pictures of the royal hunts where a scene like this could have found a place: it would not have made much sense as an isolated picture. The idea came to fruition a few years later with the *Chasses royales*, one of whose nine subjects is the king holding the line-hound (Fig. 27).

Oudry had treated the theme in a model for the *Chasses nouvelles* tapestries of 1726-1727, but in the context of an anonymous hunt (Paris 48). In the case of this drawing it seems clear that the figure holding the *limier* is Louis XV himself, while the person on horseback must be the Comte de Toulouse. Both are wearing the insignia of the Order of the Holy Spirit, and if we compare the larger portraits of both in the painting in Toulouse and the first two of the *Chasses royales* tapestries, the resemblance is clear: the youthful oval visage of Louis XV, always in three-quarters view, and the aged, square-jawed features of the Comte de Toulouse in profile. Still another representation of Louis XV holding a line-hound on a leash is the undated oil sketch in a private collection which, we speculate in the Paris catalogue (under no. 57), was done at Chantilly in 1728 and served as the inspira-

tion for this drawing as well as the later *Chasses royales* cartoon.

The treatment of landscape is of particular interest. While its ancestry in the early landscape sketches of 1714 (see Figs. 7-9) is evident, especially in the study of light and in the abundant white gouache, the descriptive complexity of the various elements is much more pronounced. The setting — perhaps topographically accurate — is a *carrefour* in a forest, marked by a cross on a large stone pedestal. The effects of light in clearings and in the *sous-bois* are remarkable in their contrasts with the shaded areas represented by ink and washes of different densities. The drawing is unusually fresh, and its unfaded blue paper contributes greatly to the chiaroscuro.

32

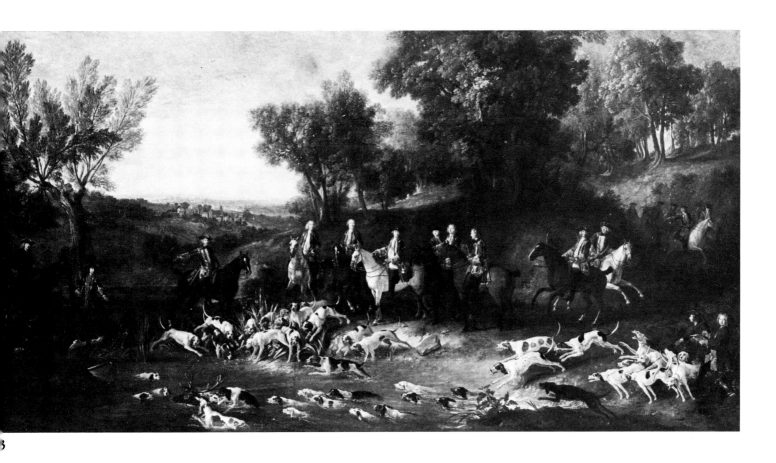

33 *(Colorplate on page 15)*
Louis XV Hunting the Stag in the Forest of Saint-Germain

Canvas. H. 211; W. 387.
Signed and dated, below right, on a rock: *J B. Oudry/ 1730*
Toulouse, Musée des Augustins, inv. no. Ro 182

Provenance: Commissioned by Louis XV in 1728; completed and placed in the Cabinet du Roi at Marly in 1730 (but not paid for by the Bâtiments du Roi); removed from Marly during the Revolution; French national collections; recorded as having been sent from Versailles to the Louvre in 1809; attributed to the Toulouse Museum in 1811, where it arrived the following year.

Exhibitions: 1750, Salon, no. 33; 1982-1983, Paris, no. 59 (repr.).

Bibliography: Mercure de France, June 1730, 1st vol., pp. 1179-1181; Piganiol de la Force, 1730, II, pp. 353-355 (7th, 8th, and 9th editions, II, pp. 262-264); *Encyclopédie méthodique. Beaux-Arts,* 1788-1791, II, p. 133; *Notice des Tableaux...composant le Musée de Toulouse,* 1813, pp. 33-34, no. 330; Roucoule, 1836, pp. 266-267, no.

316; Suau, 1850, p. 156, no. 309; Clément de Ris, 1859-1861, II, pp. 298-299; George, 1864, pp. 139-141, no. 176; George, 1873, pp. 7, 75-76; Engerand, 1900, p. 364 note; *Inventaire général des richesses d'art de la France,* Province, Monuments civils, VIII (1908), pp. 20, 102-103; Locquin, *Catalogue,* 1912, no. 265; Bazin, 1928-1929, repr. p. 114; Vergnet-Ruiz, 1930, no. I, 5; M. Lespinasse, 1937, pp. 279-286; Vaultier, 1956, repr. p. 686; Vergnet-Ruiz and Laclotte, 1965, p. 246, repr. p. 92, fig. 102; Opperman, 1970, p. 218, repr. fig. 29; Opperman, 1972 [1977], I, pp. 86, 91, 131, 199, 201, 407-408, cat. no. P155, II, p. 932, repr. p. 1067, fig. 190; Lastic, 1977, p. 298.

Famous throughout the eighteenth century when it was continuously on view at Marly (except for its brief voyage to Paris for the Salon of 1750), cited at length and with great pride as one of the treasures of the Musée de Toulouse throughout the nineteenth century and into the first few decades of the twentieth, this painting has been somewhat forgotten since. We trust that its presence in the exhibition (it has not been seen away from Toulouse since 1812), and its cleaning in view of the recently completed renovation

of the museum, will bring back some of its former prestige. Oudry painted no picture more consequential than this. It, more than any other, made his career.

Its history has been well known ever since the article of Lespinasse, who in 1937 brought together the eighteenth-century references and cleared up some long-standing misinterpretations. The circumstances of the commission are given by the *Mercure de France* in 1730, repeated in the sixth edition of Piganiol de la Force's guidebook of the same year. In the month of January, 1728, the king ordered Oudry to follow the royal hunts. We can see that he did so from a group of drawings, including cat. no. 32, just discussed. One of them, representing a stag hunt in the water, was accepted, and Oudry began work on the present canvas, of very large size (six and a half French feet by twelve, that is, 211 by 390 cm., almost precisely the same as its dimensions today). It was completed, delivered, and installed at Marly in 1730. Everything, or nearly, is done from nature. Of the figures, thirteen are identified (all except the two in the boat in the left corner, called only "un homme de l'équipage et le marinier," as well as the horsemen in the right background). Beginning from the left, they are: Bonnet, a "coureur de vin," mounted on a donkey; La Bretêche, a "valet de limiers"; the Marquis de Dampierre on horseback, holding a hunting horn, an instrument for which he was a well-known composer; Monsieur de Nestier, "écuyer cavalcadour, commandant de l'équipage de la grande écurie du roi"; Prince Charles de Lorraine, "grand écuyer de France"; Louis XV, mounted on a horse called Le Brasseur; the Duc de Retz, captain of the guards; the Marquis de Beringhen, "premier écuyer du roi"; the Comte de Toulouse; Monsieur de Fourcy, "commandant de la vénerie," with a horn; Monsieur de Landsmath, "gentilhomme de la vénerie"; in the lower right corner, "un valet de chiens nommé Jean, tenant une garde de huit jeunes chiens"; and finally the artist himself, standing, his hat on the ground, drawing the hunt with red and black chalk. The background is a view of the city of Saint-Germain-en-Laye, and a part of the forest, seen from the Petit-Château; it was also done from nature. If we may believe the *livret* of the Salon of 1750, "tous les Chevaux & les Chiens [sont] exactement Portraits." The horses belong to the royal stable; the hounds bear the mark of the royal pack, a triangle, point downwards, with a cross inscribed.

We do not know the price of the picture, since it was not paid for by the Bâtiments du Roi, as was customary; perhaps it was acquired on the king's personal budget. The Crown spent nearly 3000 livres for the frame, unfortunately now lost, which must have been a masterpiece of woodcarving (documents published by H. de Chennevières, in *Revue de l'art français ancien et moderne*, Ire et 2e années [*Nouvelles Archives de l'Art français*, 3e série, I, 1885], pp. 85-86). Juste-Aurèle Meissonier received 50 livres for the drawings, Sébastien-Antoine Slodtz 2000 for the carving, and Leroy 800 for the gilding. It was of oak, ten feet high (325 cm.) and fourteen across (455 cm.); the border was one foot wide (32 cm.). Its description is worth citing:

> Laditte bordure [est] enrichie dans la traverse d'en haut des armes de France et de Navarre avec les cordons de l'ordre, couronne, palmes, festons de chesne et cartouche; dans les montans et traverses sont des trophées de chasse composés de carquois, arcs, couteaux, corps de chasse et autres attributs, comme aussy testes de cerf, de sanglier et chiens avec des branches de chesne; aux quatre angles sont des cartouches avec rocaille, feuilles et volutes, et sur les membres de profil sont plusieurs ornemens de differentes sortes. . . .

Oudry made individual portrait drawings for all of the persons represented. Seven of them passed in an anonymous sale directed by Basan, Paris, 7-19 February 1763, no. 77, but they have since disappeared. We would have liked to exhibit the portrait of Louis XV (Fig. 79), undoubtedly done in preparation for this painting, but we can only reproduce it: the drawing, in black and white chalk, disappeared from the collection of the Comte de Salverte during the occupation of the Château de Saint-Thaurin near Luzarches between 1939 and 1946 (H. 31 cm.; W. 27 cm.; Opperman, 1972 [1977], II, pp. 646-647, cat. no. D114).

In the case of his own portrait, however, Oudry apparently did not trust himself. He commissioned an oval, bust-length portrait from Largillierre in 1729. It is lost, but it was engraved twice, by Oudry's wife and

Fig. 79 *Louis XV.* About 1728-1730. Formerly collection of the Comte de Salverte.

Fig. 80 Jacques-Nicolas Tardieu, *Portrait of Jean-Baptiste Oudry,* engraving after a lost painting of 1729 by Nicolas de Largillierre. About 1755-1760. Paris, Bibliothèque nationale, Cabinet des Estampes.

by Tardieu. The latter print (Fig. 80), which was in progress at the moment of Oudry's death and finished for his family, gives the date of the original painting, which coincides with Oudry's work on the picture now in Toulouse. Allowing for the fact that the engraving reverses the original composition, it is evident that Largillierre's painting was the model for Oudry's self-portrait. He must have commissioned it precisely for that purpose. We might also mention that the ornamental frame of the two prints was designed by Oudry himself (see *Mercure de France,* October 1762, 2e partie, pp.152-53).

The picture is striking in its verisimilitude, yet at the same time has an instinctively decorative quality in composition, poses of individual figures (particularly some of the dogs), and in the tree shapes and lighting of the landscape to the right. Of the many comments it has elicited, we shall cite two, beginning with Baillet de Saint-Julien's critique of the Salon of 1750:

Le plus considérable [de ses tableaux] est une fin de Chasse au Cerf, où il y a des effets dans l'eau admirables. On est surpris, surtout, de la vérité étonnante avec laquelle l'ardeur & la vivacité des Chiens sont exprimées. Il semble presque entendre leurs abboyemens. Ce Tableau est orné de plusieurs figures à cheval. ... Toutes ces figures sont extrêmement nobles & bien ressemblantes. Mais on n'est pas si content des chevaux qui la plupart sont dessinés d'une manière roide & un peu contrainte; & semblent manquer leur applond. Le fond de ce Tableau en récompense est tout ce qu'on peut de mieux traité. Il représente une partie de la Forêt de S. Germain, à travers laquelle on découvre les avenues du Petit Château. M. Oudry nous y rappelle dans cette partie le souvenir de ces beaux Paysages, qu'il a exposés à quelques Sallons précédens, & qui lui ont attiré tant d'applaudissemens. (*Lettres sur la peinture, à un Amateur,* Geneva, 1750, pp. 20-23)

It is true that Oudry is not always convincing in his representation of horses.

The other citation is from Clément de Ris, published in 1861. While criticizing the contemporary French school, he also presents a sensitive evaluation of Oudry's art:

141

[Le tableau est] peint avec un entrain, une verve, une science de la composition et de l'effet, au point de vue décoratif, qui n'est égalée, je le dis à regret, par aucun de nos artistes contemporains. On ne se préoccupe pas assez, de notre temps, du milieu sur lequel doit se détacher un tableau, de la position qu'il doit occuper, de l'effet qu'il est appelé à produire suivant tel ou tel plan. En disparaissant, les grands hotels, les châteaux princiers, les opulentes habitations ont emporté la peinture décorative. Quelques protestations solitaires, quelques efforts isolés, dus au caprice d'un riche particulier ou à l'imagination d'un pauvre artiste, n'infirment en rien ce que j'avance. Nous avons beaucoup de peintres très-supérieurs à Oudry, aucun ne serait capable de faire comme lui un tableau décoratif.

Taken together, these two observations — a century apart — are most revealing. On the one hand Oudry is appreciated for his fidelity to nature, and on the other for his decorative talent. In fact, the two qualities of nature and of art are inextricably united in this work, as in most of his paintings. Oudry here finds the ultimate coming together of all the talents he had so far demonstrated separately — landscape, portraiture, animals — and proves that he deserves the rank of history painter. After the great success of the painting for Marly, it is only a small step to the *Chasses royales* that follow naturally upon it.

See Paris 58 for some related studies of dogs. Oudry re-used many of the portrait drawings in the first *Chasses royales* model, where one finds heads (but not whole figures) in exactly the same positions. We might also point out that the group of hounds held by a valet in the lower right is repeated, with a different valet, in the second *Chasses royales* model, but that it is absent from the preliminary oil sketch for the latter (see Paris 61).

34
Two Horses Drawing a Carriage

H. 34; W. 56.5 (approximate; paper of irregular shape). Black and white chalk and some pastel on dark blue paper.
Inscribed below right, in graphite pencil: *Oudry ?*
Schwerin, Staatliches Museum (Lugt 2273, below right, recto), inv. no. 2101 Hz.

Provenance: Date of entry unrecorded, but must have come to Schwerin in Oudry's lifetime.

Exhibition: 1982-1983, Paris, no. 65 (repr.).

Bibliography: Opperman, 1972 [1977], I, pp. 144, 313, II, pp. 773-774, cat. no. D715, repr. p. 1080, fig. 215.

During our first visit to Schwerin in 1967, we found twenty-five drawings in the Oudry portfolios that had not already been cited by Seidel or Locquin, the only earlier publications of Oudry drawings there (Vergnet-Ruiz merely repeats Locquin). We have rejected six of them, but retained the remaining nineteen, several of which are exhibited here. The names of the persons responsible for making the attributions are not known; they must have been members of the Museum's curatorial staff. Although most of them pose no problems, we must admit to some difficulties concerning those of horses (among those exhibited, this one and the two following numbers). There is nothing comparable to them among the artist's other chalk drawings, but we have tried to explain this by suggesting that they were done very quickly, from nature, as part of Oudry's intensive preparation for the painting in Toulouse and for the *Chasses royales*.

There is great beauty in the spontaneous handling of chalks, and also an unexpected richness of color: the unfaded paper, the blue side panels and seat of the carriage, the red livery and wheels, touches of light yellow in the trim of the coach, and even a bit of yellow and red in the horses. Although the attribution is not absolutely firm, we have not been able to resist presenting this remarkable and essentially unknown drawing.

34

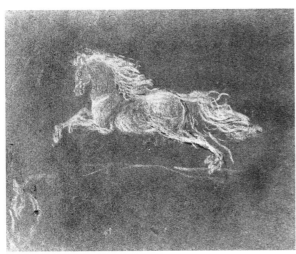

35

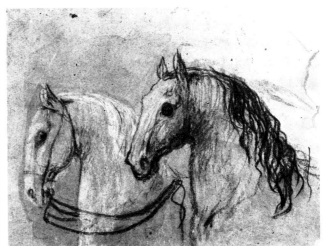

36

35
Study of a Running Horse

H. 30; W. 41 (approximate; paper of irregular shape).
White chalk, with some small touches of black chalk
and yellow pastel, on dark blue paper.
Schwerin, Staatliches Museum (Lugt 2273, below,
recto), inv. no. 1148 Hz.

Provenance: Date of entry unrecorded, but must have come to
Schwerin in Oudry's lifetime.

Exhibition: 1982-1983, Paris, no. 66 (repr.).

Bibliography: Opperman, 1972 [1977], I, pp. 144, 313, II, p. 773,
cat. no. D714, repr. p. 1080, fig. 216.

There is another slight study of a horse's head below
left, and still another on the verso, along with a
standing, draped male figure seen three-quarters from
behind. The latter may be after a statue, and may not
be by Oudry.

As we have already had the occasion to remark,
Oudry had trouble with the horses in his paintings.
They often appear stiff, unnaturally posed, and even
off balance (see also the remarks at the preceding
number). The conventional pose of a running horse
with both forelegs off the ground is common in the
Chasses nouvelles models, in the Toulouse painting,
and in the *Chasses royales*. In its extreme freedom,
this drawing is reminiscent of the horse sketches of
Van Dyck.

36
Two Heads of Horses

H. 22.5; W. 27 (approximate; paper of irregular shape).
Black and white chalk, with some pastel, on light blue
paper.
Inscribed below right, in black chalk: *Oudry ?*
Schwerin, Staatliches Museum (Lugt 2273, verso), inv.
no. 1149 Hz.

Provenance: Date of entry unrecorded, but must have come to
Schwerin in Oudry's lifetime.

Exhibition: 1982-1983, Paris, no. 67 (repr.).

Bibliography: Opperman, 1972 [1977], I, pp. 144, 313, II, p. 774,
cat. no. D716.

The head to the left is mostly in white chalk with
some black chalk, a yellow bridle, and a further bit of
blue in the reins. The other is in black chalk with a
little white. Oudry had not had to come to terms with
the horse prior to about 1726 (the Scarron drawings
and the *Chasses nouvelles* tapestries), but from then
on it became an important subject in his art. We would
like to situate this and the two preceding numbers
among his earliest studies of horses. The fact that he
was so noticeably less successful with the horse than
with other animals may serve as a reminder that
equestrian subjects, including battles, were still very
much considered as a separate specialty, one of the few
in which Oudry had not had some training. Among
his contemporaries, Charles Parrocel was the most
successful practitioner of the genre.

37
Two Studies of a Parrot

H. 27.7; W. 33.7.
Black and white chalk on blue paper.
Schwerin, Staatliches Museum, inv. no. 1177 Hz.

Provenance: Date of entry unrecorded, but must have come to
Schwerin in Oudry's lifetime.

Exhibition: 1982-1983, Paris, no. 68 (repr.).

Bibliography: Venzmer, 1967, repr. fig. 3; Opperman, 1972 [1977], I,
pp. 144, 313, II, p. 824, cat. no. D952.

There are three sheets of studies of parrots — or, more
correctly, macaws — in the Schwerin museum, of
which we exhibit two here. Like the studies of horses
just discussed, their attributions are recent and can-
not be proven in any of the usual ways. Oudry
includes parrots in paintings with some frequency,
and although we have not been able to identify any of
those in the Schwerin drawings as a direct preparatory
study, we have no doubts about their attributions.
They are fine studies of the natural attitudes of the
birds, sitting on perches. We would like to date them
to about the same period as those of horses, which
they resemble somewhat in their quick execution and
in the use of pastels. Perhaps they were done at the
menagerie of Versailles, where Oudry began working
in the late 1720s.

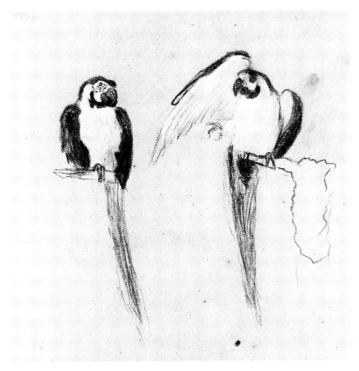

37

38 *(Colorplate on page 19)*
Two Studies of a Parrot

H. 27.1; W. 28.8.
Black and white chalk and pastel on blue paper.
Schwerin, Staatliches Museum, inv. no. 4579 Hz.

Provenance: Date of entry unrecorded, but must have come to
Schwerin in Oudry's lifetime.

Exhibition: 1982-1983, Paris, no. 69 (repr.).

Bibliography: Opperman, 1972 [1977], I, pp. 144, 313, II, p. 824, cat.
no. D953, repr. p. 1093, fig. 242.

The bird on the left is in black and white chalk alone,
while the larger one on the right adds dark blue pastel
along with yellow-orange for the breast and tail
borders. The drawing was obviously done rapidly and
from life. There are small strokes of color in the lower
right where the artist used the paper to form the point
of his pastels, including colors other than those used
in the drawing. One wonders whether he might not
have been working on a full-size sheet of blue paper
which he subsequently cut up into smaller drawings
with one or two birds on each.

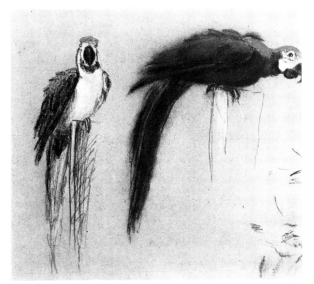

38

39
Le Chat et le rat

H. 31; W. 26.
Brush point and black ink, grey ink wash, white gouache heightening, with a frame of blue ink wash, on blue paper.
Signed and dated with the pen, below right: *J B. Oudry 1732*
Private collection.

Provenance: Sold by the artist to the *amateur* Montenault in about 1751; the brothers de Bure, booksellers in Paris, by 1828; sale of J. J. de Bure, Paris, 1-18 December 1853, no. 344; purchased there by comte A.-N. Thibaudeau for 1800 francs; according to Portalis, Thibaudeau sold them directly to Félix Solar in 1856; Girardin, however, gives some intermediate steps (offered by Thibaudeau to the famous actress Madame Doche; sold by the latter to the bookseller Fontaine for 2500 francs; purchased from Fontaine by Félix Solar for 5000 francs); sale of Félix Solar, Paris, 19 November-8 December 1860, no. 627; purchased there by Cléder for Baron Isidore Taylor, Paris, for 6100 francs; acquired (from Taylor ?) by the booksellers Morgand and Fatout, Paris, probably in 1876; sold by them to Emile Pereire; purchased from Pereire by Louis Olry-Roederer, Reims; acquired from the latter's heirs by the Rosenbach Company, New York, in 1923; purchased from Rosenbach in about 1946 by Raphael Esmerian, New York; sale of the library of Raphael Esmerian, 3rd part, Paris, Palais Galliera, 6 June 1973, no. 46 (2,000,000 francs); there acquired by a dealer; the first volume has been sold to the British Rail Pension Fund, and the second has been dismembered and the drawings sold individually.

Exhibition: 1982-1983, Paris, no. 78 (repr.).

Bibliography: [This drawing]: Locquin, *Catalogue*, 1912, no. 1112; Opperman, 1972 [1977], II, p. 701, cat. no. D399; [The La Fontaine illustrations in general]: Gougenot, 1761 [1854], p. 380; Brunet, 1860-1865, III, col. 753; *Bulletin de la Librairie Morgand et Fatout*, 1876-1881, I, p. 482; Portalis, 1877, II, p. 483 ff.; *L'Intermédiaire des Chercheurs et des Curieux*, XII (1879), col. 162; Després, 1892; Locquin, *Catalogue*, 1912, nos. 933-1209; Cohen, 1912, col. 548 ff.; Girardin, 1913; Ricci, 1923; Gaucheron, 1927; Rodocanachi, 1930; Vergnet-Ruiz, 1930, nos. II, 169-445; Roux *et al.*, 1931-(1977), I, pp. 57, 204-205, 332-335, 455-457, II, pp. 195-196, 209, III, pp. 503-504, IV, pp. 263-267, 288-289, 366, 386-387, V. pp. 74-78, VIII, pp. 396, 407, 498-499, IX, pp. 73, 215, 385, 427, XIII, pp. 307-308, 599-601, XIV, pp. 89-90, 121-122, 266-269; Genaille, 1933, p. 436 and *passim*.; catalogue of the bookseller Jean Rousseau-Girard, Paris, December 1964, pp. 21-23, no. 18367; Opperman, 1972 [1977], I, pp. 99-101, 128, 143, II, pp. 682-710, cat. nos. D221-D496, and p. 953; exhibition catalogue 1982-1983, Paris, under nos. 76-85.

Engraving: Engraved in reverse by Pierre-Quentin Chedel for the Montenault edition.

The two hundred seventy-six drawings comprising a complete set of illustrations for the *Fables*, including a frontispiece, have probably been talked about more, and have done more to establish the image of Oudry

39

that has come across the years, than any others of his productions. They were bound together in two albums of dark blue calf, an arrangment that probably dates to shortly after their having been engraved, around 1755-1760. Each sheet was attached to its album page by a spot of paste at the four corners. Nearly all of the drawings are signed and dated in pen and ink. The frontispiece is dated 1752, and the others from 1729 through 1734, in the sequence of La Fontaine's work. Oudry must have done them in order, one after another; Gougenot tells us that he did them in the evening, in his spare time, just as he had done for the much less ambitious series of illustrations for Scarron.

It is difficult to believe that Oudry would have carried out a *complete* set of illustrations had he not, right from the start, intended for them to be engraved. There is no evidence that Oudry made any systematic attempt to do so prior to 1751, when Montenault bought them and began to put together a team of engravers in view of the famous edition in four volumes, published between 1755 and 1760. The story of Montenault's edition is well known and thoroughly documented, so we shall give only its barest outlines here. The earliest announcement dates from the end of 1751, by which time some at least of the many engravers who participated in the project had been chosen. Because of their execution, the drawings were not considered finished enough to serve directly as models, so Montenault had Cochin re-draw them all, this time in "lead" pencil with precisely delineated contours; these drawings were in turn used by the engravers, are widely dispersed today. It must be said that the confrontation of Oudry's originals with the prints very much betrays the intermediary of Cochin. The human figures, in many cases, have benefited — but the animals have not. We state above that the La Fontaine illustrations, more than anything else, created and sustained posterity's idea of the scope and the intrinsic qualities of Oudry's art. But this judgment was based on the *prints*, not the drawings, which had almost never been seen: in fact, not one of them was even reproduced (in the modern sense) prior to the sale in 1973. So in some ways this was a judgment of Cochin as much or more than of Oudry.

Let us return to the history of the publication, which began with great energy. Already in the Salon of 1753 several of the finished engravings were exhibited, and the volumes appeared on schedule, the first two in 1755 and the third the following year. But Montenault then ran into financial problems. The printing of the fourth volume, which was supposed to have appeared in October of 1756, was delayed until 1760 (Gougenot). What finally enabled its publication was a gift of 80,000 livres from Louis XV, who had been approached by the editor (letter cited in the Rousseau-Girard catalogue of 1964). The original edition consisted of three separate printings on different sizes and qualities of paper. Further, impressions continued to be pulled for many years — the prints were obviously popular. All of the engravings exist in numerous states, and are commonly encountered in impressions from worn-out plates. The latest edition we have encountered was published in Paris in 1821 by Nepveu. It has only 110 illustrations from the original plates, in quarto format, so that they had to be cut down; many are retouched.

It happens that the most beloved of the *Fables* are contained in the early books, but only the second album has been broken up. If the poems of Books VII through XII are not always familiar, their illustrations are nonetheless enchanting. The striking effect of this drawing comes from Oudry's free and imaginative brush technique in depicting a wild, fantastic landscape with cascades on a steep mountainside in the distance and wind-bent trees. La Fontaine tells of four animals — a cat, an owl, a rat and a weasel — who were in the habit of frequenting an old hollow pine. Knowing this, a man set out a net and the cat got caught in it just before dawn. The rat came by, and the cat asked it to chew through the knots in exchange for an alliance against the rat's other enemies, the owl and the weasel. The rat refused and returned to its lair but, encountering these two, came back and released the cat (the moment Oudry illustrates). The fable concludes with a later encounter between the two new allies, where the wary rat keeps his distance from the cat, who calls out:

"Ah! mon frère, dit-il, viens m'embrasser; ton soin
 Me fait injure. Tu regardes
 Comme ennemi ton allié.
 Penses-tu que j'aie oublié
 Qu'après Dieu je te dois la vie?
— Et moi, reprit le rat, penses-tu que j'oublie
 Ton naturel? Aucun traité
Peut-il forcer un chat à la reconnaissance?
 S'assure-t-on sur l'alliance
 Qu'a faite la nécessité?"

Oudry's illustration is straightforward and it conveys the essence of the tale well, showing the precarious interdependence of conflicting self-interests that necessitates alliances in the face of the forces of nature.

40

40 (Colorplate on page 18)
Les Deux Chiens et l'Ane mort

H. 31; W. 26.
Brush point and black ink, grey ink wash, white gouache heightening, with a frame of blue ink wash, on blue paper.
Signed and dated with the pen, below right: *J B. Oudry 1732*
Private collection.

Provenance: as cat. no. 39.

Exhibition: 1982-1983, Paris, no. 79 (repr.).

Bibliography: Locquin, *Catalogue,* 1912, no. 1115 — Opperman, 1972 [1977], II, p. 702, cat. no. D402.

Engraving: Engraved in reverse by J[acques?] Mesnil for the Montenault edition.

Of the fables whose illustrations we have chosen this is certainly the best known (it comes from Aesop). La Fontaine reminds us that when a man possesses one vice he usually possesses them all, but that possession of one virtue rarely brings others with it. Thus the dog, who is attentive and faithful to his master, but otherwise foolish and gluttonous. Two dogs see a dead ass floating by, pushed further and further away by the wind. Deciding they cannot possibly swim out to get it, they decide to drink the river dry. Of course they burst and die:

> L'homme est ainsi bâti. Quand un sujet l'enflamme,
> L'impossibilité disparaît à son âme.
> Combien fait-il de voeux, combien perd-il de pas,
> S'outrant pour acquérir des biens ou de la gloire?
> "Si j'arrondissais mes Etats!
> Si je pouvais remplir mes coffres de ducats!
> Si j'apprenais l'hébreu, les sciences, l'histoire!"
> Tout cela, c'est la mer à boire;
> Mais rien à l'homme ne suffit:
> Pour fournir aux projets que forme un seul esprit
> Il faudrait quatre corps; encore, loin d'y suffire,
> A mi-chemin je crois que tous demeureraient:
> Quatre Mathusalems bout à bout ne pourraient
> Mettre à fin ce qu'un seul désire.

Oudry's drawing is a perfect illustration of the fable. The avidity of the animals whose bellies are already distended contrasts with the immensity of the river flowing off toward the sea, just as undiminished as the animals' blind resolve. Oudry gives us a splendid distant panorama not unlike some of his early landscape studies. The towers and rooftops of the city on the opposite bank of the broad river with hills in the distance are evocative of Normandy somewhere along the Seine, without being an accurate view.

1

This amusing and brilliantly executed drawing is the second of two illustrations Oudry prepared for a rather slight fable. The first depicts two adventurers who have discovered a sign with a message promising wondrous sights to him who would swim a deep and swift torrent, and finding on the other bank an elephant of stone, carry it without stopping for breath to the summit of a steep mountain. One of them reasons that the venture would be risky and the reward uncertain, while the other plunges into the stream, crosses it, shoulders the elephant and begins his climb, as one sees in the drawing here exhibited. Upon reaching the top he finds a city whose populace immediately proclaims him king. There follows an ambiguous and somewhat unconvincing moral to the effect that "le sage" sometimes does better to act at once without taking the time to consult "la sagesse." Our adventurer with his enormous burden approaches the mountain "qui menace les cieux de son superbe front." Oudry enters well into the improbable spirit of this "pays des romans" with its imaginary landscape of overhanging rocks in bright sunlight, rendered with the brush and white gouache.

41
Les Deux Aventuriers et le Talisman

H. 31; W. 26.
Brush point and black ink, grey ink wash, white gouache heightening, with a frame of blue ink wash, on blue paper.
Signed and dated with the pen and brown ink, below left: *J. B. Oudry 1732*
Private collection.

Provenance: as cat. no. 39.

Exhibition: 1982-1983, Paris, no. 85 (repr.).

Bibliography: Locquin, *Catalogue,* 1912, no. 1157; Opperman, 1972 [1977], II, p. 705, cat. no. D444.

Engraving: Engraved in reverse by Jean-Charles Baquoy for the Montenault edition.

42
Le Singe

H. 31; W. 26.
Brush point and black ink, grey ink wash, white gouache heightening, with a frame of blue ink wash, on blue paper.
Signed and dated with the pen, below left: *J B Oudry 1733*
Private collection.

Provenance: as cat. no. 39.

Exhibition: 1982-1983, Paris, no. 84 (repr.).

Bibliography: Locquin, *Catalogue,* 1912, no. 1192; Opperman, 1972 [1977], II, p. 707, cat. no. D463.

Engraving: Engraved in reverse by Pierre-Quentin Chedel for the Montenault edition.

La Fontaine's obscure poem about a drunken monkey who beats his wife to death, which is also an attack on an unknown author who must have been one of his many imitators, has never been considered successful.

42

It is enigmatic to the point of meaninglessness, and impossible to illustrate. Oudry simply ignored the poem, transforming the brutal husband attacking his wife into what might be taken as garden statuary. Perhaps he was thinking of the newly created Versailles in La Fontaine's day: the two monkeys are reminiscent of the lead statues of the Labyrinth which represented fables from Aesop, and the fountain along the descent to the left recalls the Allée d'Eau. The park setting, with superb effects of chiaroscuro obtained through Oudry's masterful brushwork with ink and gouache, looks forward to the famous chalk views of Arcueil begun a decade later (see cat. nos. 68-71 below), although this drawing was certainly done in the studio and not from nature.

43
The Catch of Glaucus

H. 32.5; W. 47.8.
Black and white chalk on blue paper.
Rouen, Musée des Beaux-Arts, inv. no. 975-4-1440.

Provenance: E. R. Lamponi-Leopardi (Lugt 1760, below left, recto); his sale, Florence, 10-19 November 1902, part of lot 968-980; sale of Jean Masson, Paris, Hôtel Drouot, 23 November 1927, no. 73; Suzanne and Henri Baderou; given by them to the museum in 1975.

Exhibition: 1981-1982, Washington-New York-Minneapolis-Malibu, no. 86 (repr.); 1982-1983, Paris, no. 70 (repr.).

Bibliography: Opperman, 1968-1969, pp. 60 ff.; Opperman, 1972 [1977], I, pp. 88, 143, II, p. 659, cat. no. D157; Opperman, 1980 (repr.).

Of the six sets of tapestry models Oudry designed for Beauvais, the first — the *Chasses nouvelles* of 1726-1727 (see Paris 48) — was largely derivative from his own earlier paintings. However, in 1728 Oudry was beginning to think about a tapestry series of the royal hunts for the Gobelins (see cat. no. 32 above), and at precisely that moment his work for Beauvais becomes much more original. We have elsewhere suggested that this new turn results from his desire to prove himself in tapestry, hoping to obtain the prestigious and lucrative Gobelins commission. His second, third and fourth Beauvais sets are the *Amusements champêtres* (eight pieces; preliminary drawings 1728, weavings begun 1729), the *Comédies de Molière* (four pieces; the original cartoons were dated 1732), and the *Métamorphoses d'Ovide* (eight pieces; preliminary drawings 1732, weavings begun 1734). Then, in 1733, Oudry obtains the coveted commission, and his remaining series for Beauvais will once more become derivative: the *Verdures fines* of 1735 (six subjects, with animals borrowed from earlier paintings) and the *Fables de La Fontaine* of 1736 (four panels, each with several fables, adapted from his complete set of drawings done between 1729 and 1734). Among all of his later Beauvais models we have chosen to discuss only the *Métamorphoses d'Ovide* for which many preparations survive (the cartoons, like all the others, have perished; see Paris 70-73).

Documentation from Beauvais is fragmentary. We have been able to piece together the history of the *Métamorphoses* only partially. It seems that they were

150

43

woven only once, in a complete set that has long since disappeared (see Opperman, 1972 [1977], I, pp. 377-78, cat. nos. P39-P46, and II, pp. 923-24). The cartoons were judged useless in 1761, and were transferred to Aubusson, where several panels were woven — but their history is very poorly known. We are not even certain of the exact subjects of some of the panels, and possess only the most summary descriptions of the cartoons. It also seems likely that at least a few of them combined two or more subjects, as Oudry was later to do for the La Fontaine tapestries.

Oudry's principal task as painter to the Beauvais manufactory was to update the models, many of which were fifty and more years old. There existed in fact *two* earlier series illustrating Ovid's book. One, with small figures, is still badly known; the other, with large figures and mostly from the designs of René-

Antoine Houasse, has recently been thoroughly studied by Bertrand Jestaz (in *Acts of the Tapestry Symposium, November 1976*, The Fine Arts Museums of San Francisco, published 1979, pp. 195-204). It goes back to the 1680s and represents the loves of the gods. Oudry's transformation is complete. Rather than showing encounters of figures (Pan and Syrinx, Cephalus and Procris, Diana and Endymion...) he depicts the metamorphoses proper, to the point that all human figures have disappeared, changed into animals or other forms.

Perhaps the largest single group of preparatory studies was that in the collection of Colonel E. R. Lamponi-Leopardi, sold in Florence in 1902. The fifteen drawings are all similar to this one in execution, done rapidly in black and white chalk on blue paper. We have identified about two-thirds of them; all except

Fig. 81 *The Catch of Glaucus.* About 1732. Oxford,
Ashmolean Museum.

Fig. 82 *The Catch of Glaucus.* About 1732. Cailleux,
Paris.

one relate to the *Métamorphoses d'Ovide*, and we may assume that the group consisted almost exclusively of *premières pensées* for the tapestry series, and that it had remained intact since Oudry's day.

The drawing illustrates the story of Glaucus, told in Book XIII of the *Metamorphoses*. Glaucus, a fisherman, one day drew his nets filled with fishes onto an undiscovered shore. The fishes immediately came back to life, jumped into the sea, and swam away. Glaucus, aware that the plants must possess some magical powers, chewed upon a blade of grass and was immediately transformed into a sea-god (he is visible in the water on the left). Two further drawings of the subject were in the Galichon and Deglatigny collections; one of them entered the Ashmolean Museum in 1938 (Opperman, 1972 [1977], II, pp. 658-59, cat. nos. D155-D156); we have seen only the latter and reproduce it as Fig. 81. It shares an unusual feature with the drawing in Rouen: the presence of an eagle wounded by an arrow, which has nothing to do with the story of Glaucus. The only explanation we have been able to find — and it is not completely satisfying — is that the bird refers to the story of Periclymenus, who possessed from Neptune the power to change forms at will. In order to escape from Hercules he changed himself into an eagle but was brought down by an arrow from Hercules' bow. This tale is told in Book XII of the *Metamorphoses*, but has not even the most tenuous connection with that of Glaucus. In the final tapestry cartoon, known only from an incomplete description, an eagle was present, as well as some dogs. It must have differed considerably from the preliminary drawings. This and certain others of the *Metamorphoses* studies constitute some of Oudry's most spontaneous and attractive essays in draughtsmanship.

Still another Oudry drawing of this subject from the Lamponi collection reappeared last year in Paris, and we reproduce it here (Fig. 82; presently Cailleux collection, Paris; black and white chalk on blue paper, H. 31 cm., W. 34.5 cm.; Lamponi mark below left; from the sale of Jean Masson, Paris, Hôtel Drouot, 23 November 1927, no. 73; Opperman, 1972 [1977], II, p. 659, cat. no. D157 [Masson sale]; exhibition catalogue 1982, Paris, no. 13).

44 *(Colorplate on page 17)*
Landscape with a Large Round Tower

Canvas. H. 130; W. 162.
Signed and dated, below center, on a piece of wood:
1737 / J B. Oudry
Private collection.

Provenance: The dealer Meffre (by 1860); his sale, Paris, Hôtel Drouot, 9-10 March 1863, no. 75 (3100 francs); Madame Emile Halphen, Paris; by descent to the present owner.

Exhibitions: 1738, Salon, no. 81 (?); 1860, Paris, no. 218; 1950, Paris, no. 48; 1982-1983, Paris, no. 89 (repr.).

Bibliography: Locquin, *Catalogue*, 1912, no. 416; Vergnet-Ruiz, 1930, no. I, 221, repr. pl. 30; Opperman, 1972 [1977], I, pp. 105-106, 584, cat. no. P602, II, repr. p. 1094, fig. 244.

Even though Oudry's third period shows a reduction in his production of nearly every genre of painting in favor of his tapestry designs, it would seem that landscape painting offers a partial exception. Prior to the series of small landscapes done for Beringhen in 1727 [**27-28**], Oudry cannot be said to have been more than an occasional painter of landscape. But from then on — and this was no doubt reinforced by his intensive experience of landscape brought about by the commission for the picture for Marly and for the *Chasses royales* — it became one of his principal occupations. In his list of pictures for sale in 1732, one finds no fewer than four landscapes, all of them indicated as having been done from nature (Opperman, 1972 [1977], I, p. 223). He exhibited one in the Salon of 1737 and three more in 1738; after that there are many. On the other hand, very few landscapes of the 1730s have been identified . . . and those that have cannot usually be matched up with those mentioned in contemporary sources.

It is tempting to identify this picture and its pendant of 1738, exhibited under the following number, with two works from the Salon of 1738:

81. Un petit Païsage, où paroît une grosse Tour, d'après nature. (This picture)

107. Un Païsage de cinq pieds sur quatre de large, representant un grand Pont, des Vaches & des Moutons sur le devant. (Its companion)

44

The problems have to do with dimensions. The first picture is said to be *small*, but in fact our painting is relatively large for an Oudry landscape. And the other is described as higher than wide (H. 162; W. 130). The *livret* of the Salon of 1738 is, however, notoriously imprecise, and perhaps inaccurate in this case.

For all of its brilliant array of what Oudry would have called "effets piquants" — which make of this picture and its companion true "rococo" landscapes — it is clear that the site is intended to be real rather than imaginary. They are set in the Ile de France, and are to be seen as interpretations of nature rather than as mere fancy. In this Oudry reveals himself to be the most important landscape artist of his day.

The correct width of the picture and its companion is 162 cm., as reported by earlier authors; we had measured them as they were hanging in 1980 and estimated the width as 148 cm., which we recorded in the Paris exhibition catalogue (146 cm. being visible inside the frame). We recently remeasured them from behind and rediscovered the true dimensions; the frames were removed so that new photographs could be made for the present publication. The additional width alleviates the crowded impression produced by the too-small frames and adds a certain monumentality to the compositions.

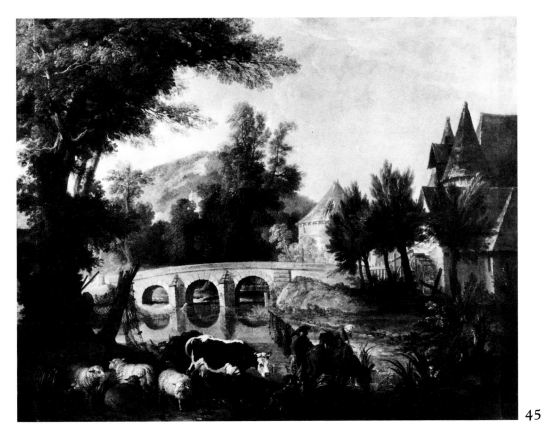

45

45
Landscape with a Large Stone Bridge and a Mill

Canvas. H. 130; W. 162.
Signed and dated, below left, on a wooden tub:
J B. Oudry 1738
Private collection.

Provenance: The dealer Meffre (by 1860); his sale, Paris, Hôtel Drouot, 9-10 March 1863, no. 74 (3100 francs); Madame Emile Halphen, Paris; by descent to the present owner.

Exhibitions: 1738, Salon, no. 107 (?); 1860, Paris, no. 219; 1982-1983, Paris, no. 90 (repr.).

Bibliography: Locquin, *Catalogue*, 1912, no. 418; Vergnet-Ruiz, 1930, no. I, 222; Opperman, 1972 [1977], I, pp. 105-106, 584, cat. no. P603.

This picture is an even more matter-of-fact statement, with less of the consciously picturesque, than its companion catalogued at the preceding number. In some ways both pictures make one think of Boucher, whose landscapes are much more familiar. And yet a Boucher landscape, even when it is supposed to represent a specific site, is so much more contrived. Boucher painted many landscapes, probably more than Oudry. The earlier ones — prior to about 1740 — are Italianate fantasies, contrasting markedly with Oudry's sense of observation. It is only after 1740, by which time he had begun to work for Oudry as a painter for Beauvais tapestry, that he does views of scenery near Paris. There can be little double that this was, initially at least, under the impetus of Oudry's example.

Oudry's landscapes were appreciated by contemporaries. In its report of the Salon of 1738, the *Mercure de France* (October 1738, pp. 2183-2184) indicates two landscapes as having been especially well received, including a picture that may be identical with the one we here exhibit (see also its *pendant* discussed in the preceding entry).

46

46
Imitation of a Bas-Relief

Canvas. H. 50; W. 108.
Signed and dated, below right: *J B. Oudry / 1730*
Edward Speelman Limited, London.

Provenance: Still with Oudry in 1743; La Live de Jully by 1757; the latter's sale, Paris, 2-14 May 1770, no. 72 (151 livres 1 sol to Monglat); sale of Charles Antiq, Paris, Hôtel Drouot, 23-25 April 1895, no. 324; probably anonymous sale, Paris, Hôtel Drouot, 7 December 1895, no. 11; anonymous sale, Paris, Hôtel Drouot, 29 November 1971, no. 201; Frederick Mont, New York.

Exhibitions: 1738, Salon, no. 16; 1743, Salon, no. 47.

Bibliography: A.-N. Dézallier d'Argenville, *Paris,* 3d ed., 1757, p. 152; Gougenot, 1761 [1854], pp. 401-402; La Live de Jully, 1764, p. 44; Hébert, 1766, I, p. 122; Seidel, 1890, p. 96; Locquin, *Catalogue,* 1912, nos. 64, 77; Vergnet-Ruiz, 1930, nos. I, 290 and VII, 14; Opperman, 1972 [1977], I, pp. 183, 190, 233, 548, cat. no. P497, II, p. 945, repr. p. 1198, fig. 423; Faré and Faré, *La Vie silencieuse . . .*, 1976, p. 146.

The *Mercure de France* and two other critiques mention that the picture was well received in the Salon of 1738. Prince Friedrich of Mecklenburg-Schwerin, who saw it there, wrote admiringly of it to his father (letter published by Seidel). Its subject, according to both of the Salon *livrets,* is *Silenus smeared with blackberries by the nymph Aegle.* The gilt bronze bas-relief on a lapis-lazuli ground attributed to François Duquesnoy that served as a model was then in the collection of Louis XV; today it belongs to an English private collector.

Georges de Lastic (1969 thesis, no. 1438) catalogues a very similar painting by Desportes, signed and dated 1732, in a Parisian private collection and almost exactly the same size as Oudry's (canvas, 51 by 101 cm.): "Amours et faunes entourant Silène endormi. Trompe l'oeil d'un bas-relief en bronze doré sur fond de marbre bleu." We have not seen this work; quite possibly it imitates the same original. Feigned bas-reliefs are not a common subject for Oudry; we know of only one other, after a plaster by Duquesnoy, shown in the Salon of 1751 and not cited since. Desportes did quite a few, including those exhibited in the Salons of 1725, 1737 and 1740, and bas-reliefs often occur within his large decorative pictures. This is also true of Chardin, who painted many

versions of *Children Playing with a Goat* after Duquesnoy in both bronze and plaster, beginning around 1730 (see Rosenberg, 1979, nos. 30 and 33), and reproduced several others at the end of his career.

Oudry must have painted this picture as a show piece. Probably he kept it until his death; in any case, d'Argenville records it in the collection of Ange-Laurent de La Live de Jully just two years later. It was one of four pictures by Oudry in La Live's famous "cabinet françois," the first systematic attempt to assemble a representative collection of modern French painting and sculpture, described in his *Catalogue historique* of 1764 and then, in its augmented form, in Pierre Remy's catalogue published in 1769 that

served for the auction in May of 1770, nine years before his death. La Live was particularly appreciative of Oudry's mastery of illusion and his carefully finished execution; all four of his pictures display these qualities to a high degree, even if only this one is a proper trompe-l'oeil (see Paris 121).

1730 seems to be the correct reading of the date; it is recorded thus in the catalogue of La Live's sale. Recently, though, 1736 has been suggested, and it is not impossible that the picture was done in 1738, when it was first shown in the Salon. A scientific examination of the paint layers in the area of the signature should be undertaken.

47

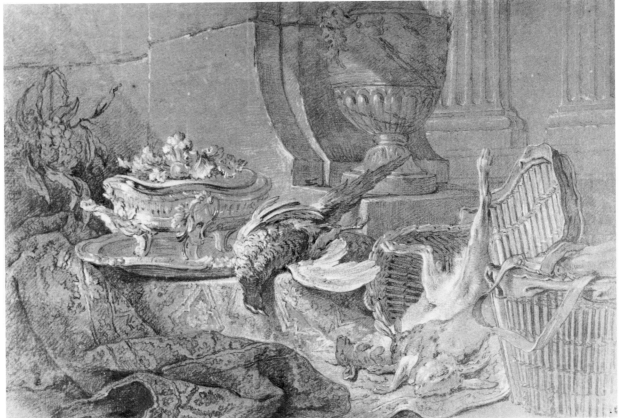

47
Still Life with a Turkish Carpet, Dead Game, and a Silver Tureen

H. 38.1; W. 52.8.
Black and white chalk on brown paper.
Schwerin, Staatliches Museum, inv. no. 2090 Hz.

Provenance: Purchased at Oudry's sale, Paris, 7 July 1755, for the Duke of Mecklenburg -Schwerin, with another drawing (30 livres 2 sols for the pair; the other one is lost).

Exhibition: 1982-1983, Paris, no. 87 (repr.).

Bibliography: Seidel, 1890, pp. 105, 106; Locquin, *Catalogue,* 1912, nos. 587, 588; Vergnet-Ruiz, 1930, no. II, 126; Opperman, 1972 [1977], I, pp. 143, 312, II, p. 841, cat. no. D1007, repr. p. 1095, fig. 246.

The painting of 1738 in Stockholm (Fig. 83) for which this is a study is an uncommon work whose lavish ornamental display recalls certain pictures of Largillierre and especially of Desportes. It has a curious hybrid quality; conceived as a pure "rococo" decoration, differing little if at all from the aesthetic of Oudry's second period, it yet has the careful finish and the richly elaborated chiaroscuro of a *tableau de cabinet,* despite its relatively large size (120 by 171 cm.). Oudry painted no other still life quite like it. One even wonders whether it is meant to be set indoors or out. The background of architecture, curving to the left and seen off-center, as well as the presence of dead game (a pheasant, a hare, and two rabbits), accoutrements of the hunt, and a basket of fruit, seem to indicate an outdoor setting . . . but then what of the luxurious carpet, the extraordinary tureen, and the highly controlled beam of light that seems to come through an opening such as a window? Oudry continues to mix together elements of the natural and the artificial so as to blur any clear distinction between the two. Such, perhaps, was his main intention, for the silver tureen reveals exactly the same picturesque blend of the forms of nature and those of art. The tureen was certainly the work of the famous goldsmith Jacques Roettiers (1707-1784). It is virtually identical with one of a pair of tureens that were part of the large service he made for Lord

Fig. 83 *Still Life with a Turkish Carpet, Dead Game, and a Silver Tureen.* Dated 1738. Stockholm, Nationalmuseum.

48

48
Erbprinz Friedrich von Mecklenburg-Schwerin

Canvas. H. 80.5; W. 66.
Formerly signed and dated 1739, on the back (the canvas has been relined).
Schwerin, Staatliches Museum, inv. no. 274.

Provenance: painted in Paris in the spring of 1739 — no doubt kept in the private apartments of the Schloss since it does not appear in the early catalogues of the picture gallery and museum, where it was sent only in the 1880s.

Exhibition: 1982-1983, Paris, no. 92 (repr.).

Bibliography: Seidel, 1890, pp. 89, 97, 109; Bode, 1891, p. 62; Locquin, *GBA,* 1906, repr. p. 305; Locquin, *Catalogue,* 1912, no. 18; Réau, 1928, p. 197; Vergnet-Ruiz, 1930, no. I, 323; *Katalog,* 1954, no. 287, repr. pl. I; Opperman, 1972 [1977], I, pp. 109, 364, cat. no. P8.

Friedrich, later Herzog von Mecklenburg-Schwerin, was born on 9 November 1717, the son of Duke Christian II Ludwig, ruler of a relatively poor duchy more or less completely under the domination of Prussia. Christian Ludwig first came into contact with Oudry through the commission of four pictures in 1732 (delivered in 1734). In the autumn of 1737, while on his way to study at the Academy of Angers, the young Friedrich visited Oudry in Paris. He then spent a whole year in Paris, from May 1738 to May 1739, before his return to Schwerin, and it was in

Berkeley between 1735 and 1738 (see *Les Grands Orfèvres de Louis XIII à Charles X* [Paris: Hachette, 1965], pp. 142-143). The painting is one of the most elaborate of Oudry's creations in the "rocaille" manner, and this is also true of Roettiers' tureen, which Oudry celebrates.

Oudry was so occupied with his various tapestry projects during the third period (1728-1739) that there are very few totally new still-life compositions. It is noteworthy that when he began to treat the theme seriously again toward the end of the period and into the early 1740s, he often did careful, completely thought-out preparatory drawings, as if he were working on a large hunt or some other ambitious subject with living animals. Oudry is essentially unique among still-life painters in having made, at least on occasion, this sort of drawing. That he did so indicates that his principal concern was for a precisely arranged composition and thoroughly studied distribution of light and shade no matter what the subject matter.

Fig. 84 Erbprinz Friedrich von Mecklenburg-Schwerin, *Drawing of Pictures in Oudry's Studio in 1739.* Schwerin, Staatsarchiv.

the last three months of his stay that Oudry painted his portrait. During this same period Friedrich was a frequent visitor to the artist's studio, acquiring several paintings and drawings and establishing the relationship that was to lead to the formation of the unique Oudry holdings of the Schwerin museum today. In one of his letters to his father in 1739 (see the correspondence published by Seidel, our source for most of the information in this entry), Friedrich singled out several pictures for special praise and recommended their purchase. He included a drawing in his own hand of some of them, which we reproduce here from the original conserved in the Staatsarchiv Scherin (Fig. 84). They are, from left to right beginning at the top:

— *Wolf Caught in a Trap*, from 1732, which Friedrich admired above all the others, and apparently purchased at once (Fig. 34; still today in Schwerin);

— *Mastiff attacking Swans*, from 1731, now in the Musée d'Art et d'Histoire, Geneva (Fig. 32);

— *Stag Hunt*, shown in the Salons of 1738 and 1751 but has since disappeared;

— *Leopard in a Cage*, dated 1739; purchased soon thereafter for the king of Sweden and today in the Nationalmuseum (Fig. 36);

— *Le Lion et le Moucheron*, dated 1732, also in the Nationalmuseum in Stockholm, purchased for the king of Sweden in 1747 (Fig. 33; cf. Paris 86);

— *Macaw, Fish and Shellfish*, a lost painting dated 1724 for which a related drawing exists (Fig. 21);

— *Hawk attacking Ducks*, perhaps identical with the painting of 1739 at Schloss Wilhelmshöhe (see Paris 102).

Duke Christian Ludwig acquired many other pictures directly from Oudry in later years, and had an agent in Paris with orders to purchase several canvases and drawings at the sale after his death in 1755. After the death of his father in 1756, Duke Friedrich continued to buy pictures, though not those of Oudry. He continued his father's interest in the Dutch masters, and contributed greatly to the unique Netherlandish collections in Schwerin. His reign,

49

after the end of the Seven Years War in 1763, was characterized by calm and relative prosperity. Friedrich founded the city of Ludwigslust, named for his father, where he died on 24 April 1785; he is buried in the church he had built there.

Oudry's portrait is more than competently painted, but does not rise above the conventional. As Bode suggested, it is of more interest as a document than as a work of art, and there were many better portraitists among Oudry's contemporaries. Friedrich's correspondence with his father gives an amusing — and instructive — detail of how Oudry, who had never been renowned for portraiture, came to be given the commission. It seems that Christian Ludwig had first thought of Rigaud . . . but he had second thoughts. His prices were too high.

49 *(Color reproduction on cover)*
Indian Blackbuck

Canvas. H. 162; W. 129.
Signed and dated below left, on a rock: *J B. Oudry/ 1739*
Schwerin, Staatliches Museum, inv. no. 870.

Provenance: commissioned from the artist by Louis XV, for the Royal Botanical Garden; left with the artist at the death in 1747 of La Peyronie, who supervised the commission; sold to the Duke of Mecklenburg-Schwerin in 1750 for 350 livres.

Exhibitions: 1739, Salon; 1978, Leipzig, no. 38 (repr. in color); 1982-1983, Paris, no. 96 (repr.).

Bibliography: Groth, 1792, p. 5, no. C7; Lenthe, 1836, no. 556; Dussieux, 1876, p. 191; Schlie, 1882, no. 784; Seidel, 1890, pp. 89, 99-101; Locquin, *Catalogue*, 1912, no. 308; Vergnet-Ruiz, 1930, no. I, 169; *Katalog*, 1954, no. 290; Venzmer, 1967, repr. in color, plate 5; Opperman, 1972 [1977], I, pp. 112-113, 127, 184, 485, cat. no. P342, II, p. 937, repr. p. 1100, fig. 255.

On 25 March 1750, in response to a letter from Schwerin, Oudry proposed to sell a large group of animal pictures to the Duke. His letter reveals how they had come to be painted.

Vous me faites l'honneur de me dire Monsieur [votre] desire d'avoir quelques tableaux de ma façon. J'en ai actuellement une suite propre à décorer une gallerie. Cette collection unique est composée des tableaux compris au mémoire ci joint. Ce sont les principaux animaux de la ménagerie du Roy que j'ai tous peints d'après nature par ordre de Sa Majesté et sous la direction de Mr. De la Peyronie Son premier chirurgien, qui voulait les faire graver, et former une suite d'histoire naturelle pour le Jardin de Botanique de Sa Mté. J'ai fait ces tableaux avec grand soin; ils me sont restés par la mort de M. De la Peyronie; aussy j'en demande moitié moins que je n'en demanderais si S. A. S. me les avait commandés. En détacher un nombre ce serait rendre la collection imparfaite, [et me] mettre dans la nécessité de hausser le prix de ceux qui seraient choisis.

There follows a list of ten pictures composing the series:
1) *Tiger*
2) *Hyena attacked by two Mastiffs* (Fig. 37)
3) *Leopard* [**52**]
4) *Leopardess* (Fig. 89)
5) *Barbary Sheep* (cf. Fig. 86)
6) *Gazelle* (the picture here catalogued; none of the eighteenth-century documents identifies the animal specifically)
7) *Bustard and Guinea Fowl*
8) *Tufted Crane, Demoiselle, and Toucan*
9) *Cassowary* (cf. Fig. 111)
10) *Crane* [**74**]

Fig. 85 Pierre-François Basan, *Lynx*, engraving after a painting of 1741 by Oudry formerly in Schwerin, Staatliches Museum (disappeared around 1945). About 1745-1750. Paris, Bibliothèque nationale, Cabinet des Estampes.

Fig. 86 Pierre-François Basan, *Barbary Sheep*, engraving after a painting of 1739 by Oudry in Schwerin, Staatliches Museum. About 1745-1750. Paris, Bibliothèque nationale, Cabinet des Estampes.

All of them were bought later in the year, and all are still today in Schwerin. They were painted between 1739 and 1745. All were shown in Salons, from 1739 through 1747, some of them twice, and the *livrets* in nearly all cases reconfirm that they had been painted for the king.

The group may originally have contained twelve rather than ten paintings. Oudry's memo of 1750 continues on after listing the first ten pictures:

> Le dit M. Oudry a encore quelques tableaux dont le detail est c'y après.
> 11) Le chat-cervier sur une toile de 3 pieds de largeur sur 2½ pieds de hauteur, du prix de 120.
> 12) Le Guide-Lion peint de la même grandeur de . 120.
> (there follows a life-size *Rhinoceros* which Oudry had just painted, and which cannot have belonged to the La Peyronie series).

"Chat-cervier" and "guide-lion" are two of the many picturesque eighteenth-century names for various species of the lynx. These two pictures were purchased at the same time as the others, as was the *Rhinoceros*; the latter is still in Schwerin, but the other two have disappeared. Now, Oudry's memo seems unequivocal that the two pictures of lynxes must not belong with the other ten animal paintings. Yet they, too, were shown in Salons, the first in 1741 and the second

Fig. 87 *Indian Blackbuck.* About 1739. Stockholm, Nationalmuseum.

a year later. Although the earlier *livret* does not state for whom the "chat-cervier" was done, that of 1742 indicates that the "Guide-lion" was painted "pour le Roy." The "chat-cervier" was in Schwerin until World War II, signed and dated 1741; there seems to be no surviving photograph, but it was engraved by Basan (Fig. 85) so we know what it looked like (here it receives still another name, the "chat-panthère"; the legend of the engraving states that the animal was "peint d'après Nature à la Ménagerie du Roy," which is further evidence for its having belonged to the La Peyronie series). There are problems with the "guide-lion," however; the picture may have disappeared from Schwerin even before the end of the eighteenth century (see Opperman, 1972 [1977], I, pp. 487-488, cat. no. P348, and Paris 96).

It is thus highly probable that both lynxes belonged to the La Peyronie set, making twelve pictures in all. But we do not know exactly why the series came to be commissioned. Oudry's letter to Schwerin states two things: that La Peyronie wanted to have them engraved, and that they were to "former une suite d'histoire naturelle pour le Jardin de Botanique de Sa Majesté." The usual interpretation has been that the *engravings* — not the paintings — would compose the "suite d'histoire naturelle." But this poses several problems, as we have elsewhere suggested. First of all: why would the Royal Botanical Garden get into the business of publishing a series of engravings of *animals*? Second, if the purpose were to commission models for the sole purpose of having engravings made, why do life-size, carefully finished oil paintings, which would be useless once they had been engraved? Drawings would have been the obvious choice for many reasons, not the least of which is price. Oudry received a total of 4240 livres for the twelve paintings in 1750, but this was discounted by half; he no doubt would have obtained a sum closer to 8000 livres if the original arrangement with La Peyronie had been honored. This is a lot to pay for engravings, particularly when one surmises that the engraver would probably have had to make drawings after the paintings anyway: the latter are too large to work from directly with any accuracy. Third, Oudry's letter says that the paintings were done *for* the Royal Botanical Garden. We believe that this statement should be accepted at face value,

that is, that the pictures were meant to enter into the decoration of one or more rooms within a building that either existed or was planned at Trianon, where the Garden was located. "Une suite d'histoire naturelle"... might one not imagine an herbarium filled with plant specimens from around the world in elegant wooden cases, with Oudry's pictures of animals decorating the walls? We have not so far been able to pursue this question further. If we assume that the *primary* reason for the commission was to provide a series of pictures to be used as we have suggested, then the matter of the engravings becomes secondary. It could be that La Peyronie hoped to recover some if not all of the cost of the paintings through royalties for the engravings. This would explain why they are not mentioned in the accounts of the Bâtiments du Roi, and why Oudry was left with them when La Peyronie died. We might add that only two of them were engraved, by Basan, one of the *Lynx* paintings discussed above, and the *Barbary Sheep* (Figs. 85-86). But the engravings cannot be dated beyond saying that they were done between the time the pictures were completed (1741 in the first case, 1739 for the other) and their sale to Schwerin (1750). So they could have been done either as the first step in La Peyronie's project, or only after his death in 1747, perhaps at Oudry's instigation as a form of advertising for the now unwanted pictures he hoped to sell.

The *Indian Blackbuck* is one of the first of these pictures, executed in 1739 along with the *Hyena*, the *Barbary Sheep*, and the *Bustard and Guinea Fowl*. It is also one of the most attractive of them, particularly in the form of the animal which Oudry has made more elegant than in his original study from nature, a gouache in Stockholm (Fig. 87; cf. Paris 95). The background is imaginary, designed only to set the animal off well and to create an exotic environment. Oudry's intentions are made clear in his letter of 1750 describing these very pictures: "Tous les tableaux," he says, "ont des fonds de paysage suivant les oppositions necessaires pour faire valoir les animaux." So Oudry, even in his last period where landscapes done directly from nature are so prominent in his *oeuvre*, continues to work "de génie" for pictures such as these.

It may be that the pictures were intended for the Jardin du Roi in Paris rather than for the much simpler botanical garden at Trianon. La Peyronie did have at least a semi-official connection with the famous garden in Paris through his interest in vertebrate anatomy. But he was never its director. Buffon was named to that post on 1 August 1739 and held it for almost fifty years. Le Peyronie must have commissioned the *Indian Blackbuck*, the *Hyena* and the *Barbary Sheep* before Buffon became director, since they were shown in the Salon of 1739 which opened on 6 September, and there would not have been time for Oudry to complete three large pictures in barely one month. The remaining nine were done under Buffon's directorship — yet his name is not mentioned in the documents, and the pictures remained on Oudry's hands at La Peyronie's death in 1747, rather than going to the Jardin du Roi (if they had ever in fact been intended to). We must admit that we have been unable to establish any connection between La Peyronie and the botanical garden at Trianon, which seems to have been somnolent until the 1750s and after. The commission remains problematic; perhaps one ought to look in the direction of the Academy of Sciences, and especially the Academy of Surgery, in whose activities La Peyronie was prominent. Basan's engraving of the *Barbary Sheep* (Fig. 86) was to have been reproduced in the Paris catalogue as Fig. 96c but was inadvertently omitted.

50
Study of a Leopard

H. 29.5; W. 33.5.
Black and white chalk on light blue paper.
Schwerin, Staatliches Museum (Lugt 2273, below recto), inv. no. 1172 Hz.

Provenance: Date of entry into the Schwerin collections unrecorded, although it almost certainly came there in Oudry's lifetime.

Exhibition: 1982-1983, Paris, no. 97 (repr.).

Bibliography: Opperman, 1972 [1977], I, pp. 153, 313, II, p. 776, cat. no. D725, repr. p. 1105, fig. 266.

This sort of extremely rapid and economical study is rare among Oudry's surviving drawings. It and a companion (Fig. 88), also in Schwerin (Opperman, 1972 [1977], II, p. 776, cat. no. D726), are studies for the *Leopard* [52] and the *Leopardess* (Fig. 89), both from 1741, from the La Peyronie series of animal pictures (see the preceding number). Certainly they were done directly from life at the Versailles ménagerie. Oudry must have waited for the animals

to strike attitudes he considered interesting, then set them down in black chalk in a matter of seconds, adding the white chalk highlights afterwards. Despite the rapidity with which he had to work, Oudry captured the essence of characteristic, momentary poses so well that he was able to carry them over into his paintings almost "as is."

Fig. 88 *Study of a Leopardess.* About 1741. Schwerin, Staatliches Museum.

51

51
Study of a Leopard (or Tiger) Walking Away

H. 33.5; W. 31.
Black and white chalk on light blue paper.
Schwerin, Staatliches Museum, inv. no. 1173 Hz.

Provenance: Date of entry into the Schwerin collections unrecorded, although it almost certainly came there in Oudry's lifetime.

Exhibition: 1982-1983, Paris, no. 99 (repr.).

Bibliography: Opperman, 1972 [1977], I, pp. 153, 313, II, p. 777, cat. no. D727, repr. p. 1107, fig. 269.

Similar in its spareness and rapidity to the studies of leopards discussed above under cat. no. 50, this sheet, like them, must have been done at the Versailles ménagerie around 1740 or 1741. In this case, though, it must not have been conceived as the potential study for a painting, since the animal is presented from a secondary viewpoint. Oudry must have made it only as part of a larger attempt to come to an understanding of the animal's characteristic movements and behavior. And yet, he must also have been aware that he had here achieved a complete work of art. The animal is positioned at the bottom of a sheet somewhat higher than wide, so that the blank paper above conveys a sense of space and of the distance toward which the animal retreats. Had the purpose been only to study movements, surely Oudry would have used the rest of the sheet for other sketches.

52
Leopard

Canvas. H. 131; W. 160.
Signed and dated below left: *J B. Oudry 1741*
Schwerin, Staatliches Museum, inv. no. 868.

Provenance: as cat. no. 49 above.

Exhibitions: 1741, Salon, no. 24; either this picture or its companion 1743, Salon, no. 50; 1982-1983, Paris, no. 98 (repr.).

Bibliography: Groth, 1792, p. 56, no. K20 or K21 (this picture and its companion); Lenthe, 1836, no. 112; Dussieux, 1876, p. 190; Schlie, 1882, no. 789; Seidel, 1890, pp. 89, 99-101; Locquin, *Catalogue*, 1912, nos. 315 (Schwerin), 317 (Salon of 1741), and perhaps 323 (Salon of 1743); Vergnet-Ruiz, 1930, no. I, 171; *Katalog*, 1954, no. 294; Opperman, 1972 [1977], I, pp. 112, 486, cat. no. P345 , II, p. 937, repr. p. 1105, fig. 265.

The *Mémoire* Oudry sent to Schwerin in 1750 describes this picture and its companion thus: "un tigre masle en colère;" "un tigre femelle dans une attitude tranquille." The two pictures are similarly listed as tigers in the *livret* of the Salon of 1741; that of 1743 mentions only "un Tigre de la Ménagerie du Roy; peint pour SA MAJESTÉ," without specifying sex or pose, so that we cannot tell whether it was this picture or its companion that was shown. Oudry consistently calls leopards tigers, and vice versa, as did most of his contemporaries.

The description of 1750 makes it clear that Oudry intended the two pictures as a study in contrasting expressions, and not just as representations of the

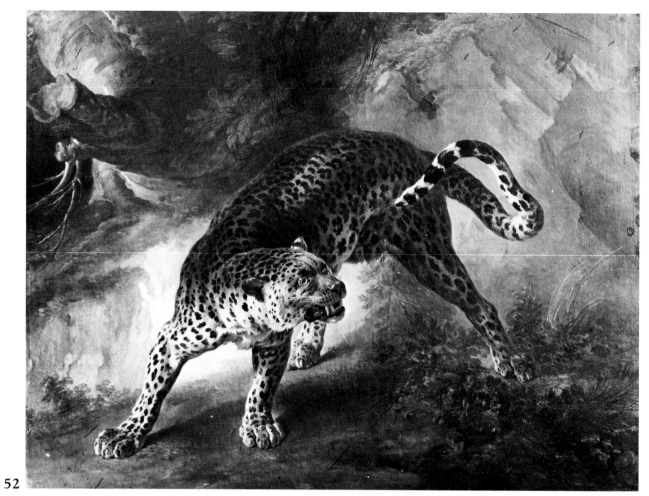

52

Fig. 89 *Leopardess*, painted for the Royal Botanical
Garden. Dated 1741. Schwerin, Staatliches Museum.

two sexes of the animal. The old concern with the theory of the passions is thus consciously carried over into the world of animals, and Oudry reveals himself as belonging to the proponents of attributing some sort of sensibility to animals. We would have liked to exhibit the *Leopardess* (Fig. 89), but reluctantly decided not to because of its fragile condition. While the *Leopard* is a striking picture, it does have a certain decorative aspect as well as a theatrical quality in both posture and lighting that make it more conventional than its companion. The *Leopardess* appeals for its quieter approach and the subtlety with which the animal's wariness is conveyed, qualities that are much more modern (hence less "baroque") than those of the *Leopard*, and for that matter than most of Oudry's representations of wild animals. The *Leopardess* foretells the new natural science of the last half of the century and, more than any other of Oudry's pictures, points the way to Stubbs.

Both pictures belong to the group originally destined for the Royal Botanical Garden (see cat. no. 49 above). After the four done in 1739, the series continues with a *Tiger* — the largest of them all — in

1740, then these two and a *Lynx* in 1741, followed by the other *Lynx* in 1742. There is then a break until 1745, when the remaining three pictures will be completed (see cat. no. 74 below).

53
Head of a Frightened Fox

H. 26.6; W. 41.3.
Pastels over a preparation of olive green; the underlying paper, when seen from behind, is dark blue. Schwerin, Staatliches Museum, inv. no. 4578 Hz.

Provenance: Not recorded in Schwerin before 1890, but must have come there in Oudry's lifetime.

Exhibition: 1982-1983, Paris, no. 100 (repr.)

Bibliography: Seidel, 1890, p. 106; Locquin, *Catalogue*, 1912, no. 787; Vergnet-Ruiz, 1930, no. II, 92; Opperman, 1972 [1977], I, pp. 153, 312, II, p. 785, cat. no. D750, repr. p. 1104, fig. 263.

The same head appears in a gouache of a *Fox* in the Nationalmuseum, Stockholm (Fig. 90), and in another, lost drawing of part of the same fox that was engraved in crayon-manner by Louis-Marin Bonnet around

53

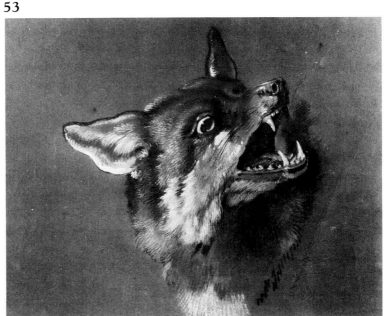

Fig. 90 *Fox.* About 1739-1741. Stockholm, Nationalmuseum.

54

1770 (cf. Paris 100). Oudry painted several pictures of foxes on the defensive, snarling, with open jaws, guarding birds they have killed or, in one case, protecting their young. But none of those we have been able to find corresponds precisely to the head in Schwerin. Yet we believe that some day a painting will come to light; the number of repetitions on paper suggests its existence. The pastel we here catalogue is a remarkable — and unique — work from the late period. Oudry displays the technique and the virtuosity of the pastel portraitist which, when combined with his perceptive rendering of animal expression, produce an unforgettable effect. Since there is no other drawing like it in his *oeuvre*, this cannot be a preparation, but rather must have been a virtuoso exercise, perhaps a present for Crown Prince Friedrich (it is probable that the many Oudry drawings in Schwerin whose provenance is unrecorded were obtained in this manner). It is also probably a partial replica of another work, either one of the drawings we have just mentioned or, more likely, a lost painting. But it is as a work in its own right that it must be understood.

54
Frightened Duck

H. 55.5; W. 64 (the four corners are missing).
Black and white chalk on blue paper.
Inscribed below right, in black chalk: *Oudry ?*
Schwerin, Staatliches Museum (Lugt 2273, verso), inv. no. 1178 Hz.

Provenance: Date of entry into the Schwerin collections unrecorded, although it almost certainly came there in Oudry's lifetime.

Exhibition: 1982-1983, Paris, no. 101 (repr. in black and white; color repr. p. 18).

Bibliography: Opperman, 1972 [1977], I, pp. 153, 313, II, pp. 817-818, cat. no. D929, repr. p. 1110, fig. 276.

The *Bird of Prey attacking Ducks* for which this sheet is a preparation exists in many versions, the earliest of them said to be dated to the late 1730s; the major version is the large painting of 1740, also in Schwerin, which we present at the following number. In its way, the *Frightened Duck* is every bit as astonishing as the *Head of a Frightened Fox* just

55

Fig. 91 Johann Heinrich Tischbein the Younger, *Bird of Prey attacking Ducks*, engraving after a lost painting of 1733 by Oudry. Dated 1773. Vienna, Graphische Sammlung Albertina.

discussed. This time, though, rather than a carefully finished work done for its own sake, we have what must be a study essentially from nature of a life-size mallard, spontaneous and rapid in execution yet completely convincing. Again, it is unique among the surviving drawings. Because of its unusually large size (many finished paintings by Oudry are smaller than this), it was folded in half at some point in the past, with the drawing size facing in, so that there has been some rubbing and an accumulation of black chalk along the fold; traces of inadvertent counterproofs can also be seen. But these accidents cannot detract from the effectiveness of the drawing and its importance.

55
Bird of Prey Attacking Ducks

Canvas. H. 129; W. 162.
Signed and dated on the tree-trunk to the left, as if incised: *J B. Oudry / 1740*
Schwerin, Staatliches Museum, inv. no. 219.

Provenance: Purchased at Oudry's sale, Paris, 7 July 1755, for the Duke of Mecklenburg-Schwerin (270 livres).

Exhibitions: 1740, Salon, no. 23; 1982-1983, Paris, no. 102 (repr.).

Bibliography: Groth, 1792, p. 56, no. K22; Lenthe, 1836, no. 119; Dussieux, 1876, p. 190; Schlie, 1882, no. 787; Seidel, 1890, pp. 89, 104; Locquin, *Catalogue*, 1912, no. 312; *Gemälde alter Meister*, n. d., repr. pl. 50; Vergnet-Ruiz, 1930, no. I, 54; *Katalog*, 1954, no. 292; Opperman, 1972 [1977], I, pp. 148, 185, 465, cat. no. P290, II, p. 936, repr. p. 1110, fig. 275.

Despite what today might seem like a somewhat frozen quality, the picture was evidently very popular in its day, given the large number of versions of it (see Paris 102). We are not quite certain of the identification of the bird of prey, which is probably a common buzzard ("buse variable" in French, so called

56

because markings vary considerably from one individual to the next). The *livret* of the Salon of 1740 avoids the problem by calling it a bird of prey, as we have done, while the list of pictures sold to Schwerin in 1755 describes it as a falcon, which we believe to be an error. The ducks, however, are mallards, the commonest of Europe's wild ducks.

In addition to the numerous versions of this particular composition, Oudry created several *different* compositions of a bird of prey attacking ducks (again, see Paris 102). We might mention, among a number of paintings of the subject that appear in eighteenth-century sales, one that belonged to Chardin — in fact the only Oudry in his collection (sale after his death, Paris, 6 March 1780, no. 10; canvas, H. 76, L. 82). But we do not know which of the several compositions this represented, because we have no reproductions. Oudry first turned to the theme, insofar as we can tell, in the early 1730s. In 1734 he sent a painting of a bird of prey falling on ducks among reeds as a present for the personal secretary of the Duke of Mecklenburg-Schwerin (Seidel, 1890, pp. 95-96). This picture did not enter the ducal collections and has long since disappeared. However,

we found recently in the Albertina an engraving (Fig. 91) dated 1773 by Johann Heinrich Tischbein the Younger, which has the additional inscription *Gemahlt von Oudrÿ. 1733*; quite possibly this reproduces the lost painting sent to Schwerin a year later.

56 *(Colorplate on page 20)*
Water Spaniel Attacking a Swan on its Nest

Canvas. H. 73; W. 91.
Signed and dated below left: *J B Oudry / 1740.*
Property of the Swedish Government, deposited in the Embassy of Sweden in Paris.

Provenance: apparently in its present location since the later part of the nineteenth century, although it was not fully recognized until the 1940s.

Exhibitions: 1740, Salon, no. 25; 1954-1955, London, no. 169; 1958, Stockholm, no. 69; 1967, Bordeaux, no. 28; 1982-1983, Paris, no. 106 (repr. in black and white; color repr. p. 19).

Bibliography: Locquin, *Catalogue*, 1912, no. 235 (Salon of 1740); Lundberg, 1949, pp. 234-235 (repr.); Opperman, 1966, pp. 399-400, repr. fig. 9; Opperman, 1972 [1977], I, pp. 117, 186, 437-438, cat. no. P218, II, p. 934, repr. p. 1109, fig. 273.

As has frequently been observed, this relatively small and carefully finished canvas is indebted to seventeenth-century Dutch art, and is particularly close to the well-known *Threatened Swan* by Jan Asselyn, now in the Rijksmuseum. The superb decorative sense of the arrangement is of course "modern," and French, but the rococo arabesques so characteristic of Oudry's pictures of the 1720's have all but disappeared. The painting is also beautifully preserved, which allows us to appreciate Oudry's effects of light and atmosphere unusually well. The theme of a swan attacked by a dog was not new to Oudry. A spectacular painting of the subject from 1731, now in the Geneva museum (Fig. 32), was unfortunately refused for our exhibition because of its delicate condition. It is much larger (192 by 256 cm.) and more dramatically staged. The bird in the Geneva picture is the orange-billed mute swan *(Cygnus olor)*, whereas the other is a whooper swan *(Cygnus cygnus)*, which is much less common in the Ile de France than the first.

The picture's history is mysterious. Due to an error by Edmond de Goncourt, who owned the related drawing, it was long thought to have been done for Samuel Bernard, but it is now known that this is not true. No owner's name is given in the *livret* of the Salon of 1740, usually an indication that a work was for sale. But the date coincides with Count Tessin's embassy in Paris (1739-1741), and it is tempting to think that he acquired it. Perhaps documentation will some day be discovered in Sweden so that the provenance can be traced further back.

There is some evidence that this picture was in fact in Sweden in the eighteenth century. A painting that appeared in an anonymous sale in Stockholm in 1926 (Fig. 92; cf. Opperman, 1972 [1977], II, p. 942, cat. no. P424A) combines the water spaniel from our painting with still-life elements of the *Dead Bustard* of 1724 (Fig. 93; Opperman, 1972 [1977], I, pp. 504-505, cat. no. P392). The latter picture must have been acquired from Oudry for the Swedish Crown. At some point (at least by 1867, and probably already by 1778) it was cut down by about 50 cm. in height, and the porphyry vase atop the ledge to the left disappeared. But the vase appears in the picture with the water spaniel, which has a Swedish provenance. We suspect that it is the work of a young Swedish artist who borrowed and recombined parts of two different pictures from the Swedish royal collections; there are many other instances of such copies. In fact, the students of the Swedish Royal Academy of Fine Arts had free access to the royal collections to make copies as part of their training (see the essay by Dag Widman in the catalogue of the exhibition 1979-1980, Stockholm, pp. 130-133).

Fig. 92 Swedish School (?), *Water Spaniel with a Rifle and Dead Game*, based on two pictures by Oudry. About 1760-1790 (?). Sale, Stockholm, Svensk-Franska Konstgall., 6 May 1926.

Fig. 93 *The Dead Bustard.* Dated 1724. Stockholm, Nationalmuseum.

57
Study for a Decorative Panel with Dogs, Exotic Birds, a Musical Still Life and Architecture in a Landscape

H. 46.1; W. 36.6.
Pen and black ink, brush point and black ink, grey ink wash, white gouache heightening, over a slight black chalk sketch, on blue paper.
Schwerin, Staatliches Museum (Lugt 2273, verso), inv. no. 2089 Hz.

Provenance: Purchased at Oudry's sale, Paris, 7 July 1755, for the Duke of Mecklenburg-Schwerin, with another drawing since lost, for 35 livres 2 sols.

Exhibition: 1982-1983, Paris, no. 112 (repr.).

Bibliography: Seidel, 1890, pp. 104, 105; Locquin, *Catalogue*, 1912, nos. 621 (drawing then in Schwerin), 631 (drawing purchased in 1755); Vergnet-Ruiz, 1930, no. II, 56; Opperman, 1966, pp. 386-387, repr. pl. 14; Opperman, 1972 [1977], I, pp. 151, 312, II, p. 832, cat. no. D984, repr. p. 1120, fig. 295; Mirimonde, 1977, II, p.,12, repr. fig. 5.

The drawing is a finished study for the painting of 1742 in Strasbourg, catalogued under the following number. When purchased in 1755 it was accompanied by another, since lost. The two are described thus in the original record of purchase published by Seidel: "2 dess. dont l'un 2 chiens avec un heron, une vase et une guirlande, l'autre un barbet s'elancant sur des canards." Since the subjects of both drawings correspond to those of the pair of pictures now in Strasbourg, it seems likely that the lost drawing was indeed the companion to the one that survives, not just randomly included with it in the sale.

The fine large sheet is a characteristic example of Oudry's finished compositional studies of his late period. Pen lines are thinner, washes more transparent, and the general effect is one of much tighter control and of diminished contrast, leading to a certain delicacy that is not found before. Here we definitely have a *preparatory* drawing, not a replica; because of Oudry's extreme care in execution it is not always easy to tell. But the black chalk underdrawing, including some ruled lines for the architecture, proves that in this case he started "from scratch." And there are a few *pentimenti*, for example to the left, where Oudry was not satisfied with the ledge

57

that jutted out beyond the column base, and so concealed it with a bit of otherwise superfluous drapery which he then carried over into the painting.

172

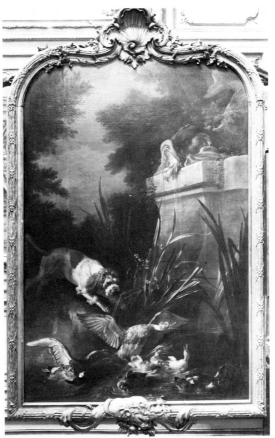

Fig. 94 *Water Spaniel pursuing a Family of Ducks at the Base of a Fountain*, painted for the dining-room of Samuel-Jacques Bernard. Dated 1742. Strasbourg, Musée des Beaux-Arts.

58

58
Decorative Panel with Dogs, Exotic Birds, a Musical Still Life and Architecture in a Landscape

Canvas. H. 227; W. 151 (rounded above).
Signed and dated on a rock, below left: *J B. Oudry / 1742*
Strasbourg, Musée des Beaux-Arts, inv. no. 1668.

Provenance: painted for the dining-room of the Parisian hôtel of Samuel-Jacques Bernard; sold with the contents of that hôtel in 1887; Baron Edmond de Rothschild; acquired by the museum on the Parisian art market in 1941.

Exhibitions: 1742, Salon no. 33; 1947, Basel, no. 178; 1969, Bordeaux, no. 92; 1982-1983, Paris, no. 113 (repr.).

Bibliography: Locquin, *Catalogue*, 1912, no. 158; Vergnet-Ruiz, 1930, no. VII, 40; *Natures mortes*, 1954, no. 55 (repr.); Haug, 1955, p. 6, no. 333 bis; Mirimonde, 1962, p. 107, repr. fig. 17; *Natures mortes*, 1964, no. 62 (repr.); Vergnet-Ruiz and Laclotte, 1965, p. 246; Opperman, 1966, p. 386, repr. fig. 1, and p. 401, note 7; Belloncle, 1967, detail repr. p. 22; Opperman, 1972 [1977], I, pp. 110, 115, 188, 508, cat. no. P400, II, repr. p. 1119, fig. 293; Faré and Faré, *La Vie silencieuse . . .*, 1976, p. 125; Mirimonde, 1977, II, p. 12.

Oudry's two large paintings for Samuel-Jacques Bernard's hôtel in the Faubourg Saint-Germain are among his most splendid decorations. We have decided not to exhibit the companion (Fig. 94), not because it is of lesser quality but rather because its subject of a dog pursuing waterfowl is much more common and represented elsewhere in the show through works that are easier to transport. The arrangement of the picture we exhibit is not new to Oudry. Its balanced placement of a variety of brilliantly colored objects, both animate and inanimate, against a simply stated horizontal/vertical grid formed by the architecture, is fairly common in his first period (cf. *L'Air*, Fig. 11, from the *Four Elements*, done in 1719). But Oudry got away from this formula in his second period, when he preferred the asymmetry and lack of equilibrium of the *genre pittoresque*. In his last period, though, he returns to a more "classical" approach, in this case to a compositional type that ultimately derives from seventeenth-century Holland, particularly the works of Melchior d'Hondecoeter.

But the colors belong to the French eighteenth century: the plumage of the tufted crane and of the pheasant (we have not identified the species, except to note that this is not one of the introduced varieties commonly encountered in Europe: it must be from the ménagerie at Versailles), is muted by shadow, while opposite two white dogs with liver markings stand in the sun, the four animals framing the peonies of deep red. The rose of the guitar's ribbon, the dark blue macaw with an orange breast, the burgundy drapery, the tones of paper, wood, leather, and porphyry in the still-life on the ledge . . . rarely did Oudry take the variety of the whole spectrum of colors and bring unity to it so successfully as in this work. To call it a decoration is not to denigrate it. This is decoration in the true sense of the word, as Clément de Ris used and understood it when discussing Oudry's *Hunt of Louis XV* in Toulouse (cf. cat. no. 33 above), and like that picture, it unites decorative qualities with the faithful observation of nature.

It is unfortunate that the paintings in Strasbourg can no longer be appreciated in their original decor. Samuel-Jacques Bernard inherited an immense fortune from his father in 1739 and proceeded to build one of the most lavish dwellings of his day. There was angry reaction among the *amateurs* of Old Paris when the Hôtel Bernard was stripped of its furnishings in 1887 and almost completely demolished, but nothing could be done. A modern building replaced it along the boulevard Saint-Germain, but one wing and a beautiful porte-cochère survive at number 46, rue du Bac. The two Oudry paintings have conserved their original sculpted-and-gilt frames which appear in our reproductions; but they are too fragile to travel. The carving is particularly fine, with delicate bunches of grapes and the lion-skin symbol of the Bernard family. The original *boiseries* of the dining-room also survive, in the Jerusalem Museum. Perhaps some day it will be possible to bring this brilliant ensemble together again temporarily, for Oudry's paintings do take on more significance as part of a total decor, as anyone will affirm who has seen them in the Hôtel des Rohan in Strasbourg.

59
Head of a Setter

H. 31.6; W. 47.3.
Black and white chalk on blue paper (faded green). Schwerin, Staatliches Museum (Lugt 2273, verso), inv. no. 1155 Hz.

Provenance: Unrecorded in Schwerin prior to 1890, although it undoubtedly came there in Oudry's lifetime.

Exhibition: 1982-1983, Paris, no. 114 (repr.)

Bibliography: Seidel, 1890, p. 106; Locquin, *Catalogue*, 1912, no. 624; Vergnet-Ruiz, 1930, no. II, 59; Opperman, 1966, pp. 387-388, repr. pl. 15a; Opperman, 1972 [1977], I, pp. 153, 312, II, p. 766, cat. no. D687.

The Schwerin Museum conserves two of these three-quarter-life-size drawings of heads of hunting dogs (the other is reproduced in our article of 1966). They are unique in his *oeuvre*. The high finish and large size may indicate that they were done for themselves rather than as studies; in fact, they may be replicas done after paintings rather than for them. This type of dog's head turns up often enough in Oudry's paintings of the last period. For example, the draw-

59

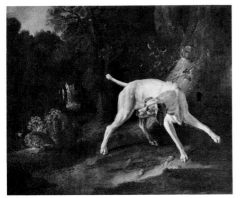

Fig. 95 *Setter pointing a Red-legged Partridge,* from Oudry's workshop. About 1740-1750 (?). Waddesdon Manor, England.

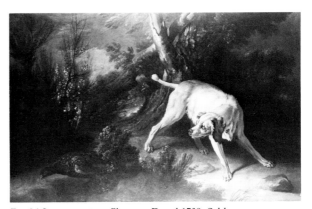

Fig. 96 *Setter pointing a Pheasant.* Dated 1739. Schloss Wilhelmshöhe, West Germany.

ing is close to one of the heads of dogs in the painting in Strasbourg, just discussed, and to that of a *Setter Pointing a Partridge* at Waddesdon Manor (Fig. 95; Opperman, 1972 [1977], I, p. 456, cat. no. P267). It can be found again in a *Setter Pointing a Pheasant,* dated 1739, at Schloss Wilhelmshöhe (Fig. 96; Opperman, 1972 [1977], I, p. 452, cat. no. P256). It is perhaps closest to the Waddesdon picture — cf. the positions of the right foreleg; but in the rendering

of light and shadow as well as the texture of the dog's fur it is the one in Wilhelmshöhe that it most resembles. In our opinion the latter picture is a collaboration between Oudry and his studio, or more accurately, a well-retouched studio production, while the Waddesdon version is entirely studio work. These are overdoors of the sort Oudry supplied in great number, and we know that he felt no qualms in relying on his assistants according to his client's means

(or meanness). Might not a drawing such as this one — large, carefully finished — have been done by Oudry to serve as a model for assistants? If this is so, it was not a common practice, unless large numbers of similar drawings have all been lost, which is not likely. As we have seen, it is associated with a painting dated 1739 . . . but it may have been done *later*. A date around 1740 — a bit before, a bit after — seems reasonable.

60 *(Color reproduction on frontispiece)*
A Lacquered Stool with Books, Engravings and a Musette ("Le Tabouret de Laque")

Canvas. H. 91; W. 72.
Signed and dated as if with pen and ink, on the edge of one of the engravings: *J B. Oudry 1742*
Cailleux, Paris.

Provenance: Painted for Watelet, receveur général des finances; sale of the Marquis de Clermont d'Amboise, Paris, 20 May 1790, no. 23; sale of M. . . . , Paris, Hôtel des Ventes, rue des Jeûneurs 42, 5-7 December 1850, no. 43; Léon Rattier, Château de Jeand'heurs (late nineteenth century); anonymous sale, Paris, Hôtel Drouot, 8 June 1928, no. 109 (repr. in its entire state); Cailleux, Paris, by 1935 (reduced to its present size).

Exhibitions: 1742, Salon, no. 41; 1935, Copenhagen, no. 155; 1937, Paris, no. 193; 1945, Paris, no. 26; 1946, Paris, no. 49; 1947, Paris, no. 353; 1952, Paris, no. 76; 1952-1953, Hamburg and Munich, no. 49 (repr.); 1954, Rotterdam, no. 40 (repr.); 1954-1955, London, no. 166 (repr. in *Illustrated Souvenir*, pl. 22); 1955, Zurich, no. 222 (repr.); 1958, Munich, no. 146 (repr.); 1959, Paris, no. 48 (repr.); 1961-1962, Montreal-Quebec-Ottawa-Toronto, no. 53 (repr.); 1969, Bordeaux, no. 91 (repr.); 1978, Bordeaux, no. 124 (repr., and color repr., p. 27); 1982, Paris, no. 15.

Bibliography: E. de Goncourt, 1881, I, pp. 131-132; Locquin, *Catalogue*, 1912, no. 161; Vergnet-Ruiz, 1930, no. I, 146; *L'Amour de l'Art*, XVI no. 7 (July 1935), repr. p. 231; *Le Siège en France*, 1948, no. 176 (repr.); Lastic, 1955, repr. in color on cover; Schönberger and Soehner, 1960, repr. pl. 263; Faré, 1962, I, repr. in color opp. p. 216; Keller, 1971, p. 393, repr. fig. 373; Opperman, 1972 [1977], I, pp. 116, 189, 507-508, cat. no. P399, II, p. 940, repr. p. 1118, fig. 292; Faré and Faré, *La Vie silencieuse . . .*, 1976, pp. 125-126; Bergström, Grimm et al., 1977, repr. p. 205; Ananoff, 1978 (repr.).

The *Tabouret de Laque* has been one of Oudry's most famous and familiar pictures for nearly fifty years, in the company of the *Canard blanc*: in fact, the two first gained widespread attention in the great

60

exhibition of *Chefs d'Oeuvre de l'Art français* in 1937. And for at least twenty five years it has been recognized by specialists as only part of a picture, beginning with Lastic in 1955 and 1959 (the recent article of Ananoff is a restatement of the obvious). This is a bit less than half of the fireplace screen painted for Watelet in 1742 whose full composition is known through descriptions, through the reproduction in the sale catalogue of 1928, and also in the preparatory drawing from the Goncourt collection, since 1967 in the Staatliche Kunsthalle, Karlsruhe (Fig. 97). The dog's tail and the shadow it casts across the edge of the book on the floor, the left hindquarter and the muzzle have been painted out,

and the leg of the stool below the paper is an addition. There are only two older sets of measurements: 94.7 by 130 cm. in 1790, and 93 by 129 cm. in 1928. The picture has lost a slight amount in height and about 58 cm. in width, almost all of it on the left.

At least in the case of Oudry, the fireplace screen has fallen doubly victim to technology and taste. It can no longer serve its original function of closing off a fireplace, and since the perspective is constructed to provide the illusion of objects in an open fireplace seen from above, the effect when placed at eye level on a wall can be unsettling. So Oudry's essays in this genre have more often than not been modified to make them suitable for "modern" consumption. The magnificent picture of 1751 in Glasgow (Fig. 43) now measures 90.2 by 113 cm.; it has been reduced in width, and the outlines of the firebricks of the floor have been painted over, in order to disguise the spatial configuration. The *Orange Tree in a Porcelain Vase* of 1740 — painted as a fireplace screen for Beringhen and shown in the Salon of 1741 — has been cut down on both sides so that it is now higher than wide (Opperman, 1972 [1977], cat. no. P506). These pictures, like the *Tabouret de Laque*, must originally have measured three French feet by four (97.5 by 130 cm.), apparently a standard fireplace size in the eighteenth century.

Fig. 97 *Dog beside a Lacquered Stool with Books, Engravings and a Musette.* About 1742. Karlsruhe, Staatliche Kunsthalle.

Fireplace pictures by other artists are fairly common earlier, but Oudry seems to have done all of his in the last period, beginning around 1739. Because of their dark backgrounds they are quite different from the trompe-l'oeil easel pictures of the same years [75-79]; instead of a uniform and rather intense light, they present a strong chiaroscuro not seen since some of his earliest still lifes [14, 15]. In the case of the *Tabouret de Laque* the chiaroscuro emphasizes the bright and contrasting colors of the different objects — a chromatically sharpened play of primaries, with the red of the lacquer and the blue velvet of the musette going off toward orange and green through the adjunction of yellow, while yellow itself in the gold brocade deepens into the ocher range. The success of this unique masterpiece derives from its combination of the bold decorative sense of the second period [18] with the consummate illusionism of the late works, while exploiting the pictorial possibilities offered by the fireplace type.

61
Two Dogs with a Dead Hare and Partridge

Copper. H. 16.7; W. 21.8.
Inscribed on the back in engraved Italic capitals, upside down:
> PEINT POUR LE ROY. PAR J. B. OUDRY /
> PEINTRE ORDINAIRE DE SA MAJESTÉ ET /
> PROFESSEUR EN SON ACADEMIE ROJALLE /
> DE PEINTURE ET SCULPTURE 1747.

Private collection, Paris.

Provenance: Originally painted for Louis XV (?); listed as belonging to Monsieur X...in the Salon of 1748, and to Oudry himself in the Salon of 1750; sale of the Duc de Maillé, Paris, 19-20 April 1837, no. 29; anonymous sale, Paris, 13-16 April 1845, no. 21; sale of Madame Louise Suzanne Oger de Bréart, Paris, 14, place Malesherbes, 17-22 May 1886, no. 47; entered the present collection about five years ago.

Exhibitions: 1748, Salon, no. 34; 1750, Salon, no. 48; 1982-1983, Paris, no. 117 (repr.).

Bibliography: Locquin, *Catalogue,* 1912, nos. 168 (Salon of 1748 and Oger de Bréart sale), 178 (Salon of 1750); Vergnet-Ruiz, 1930, no. I, 93 (whereabouts unknown); Opperman, 1972 [1977], I, pp. 129, 195-200, 511, cat. no. P405 (whereabouts unknown).

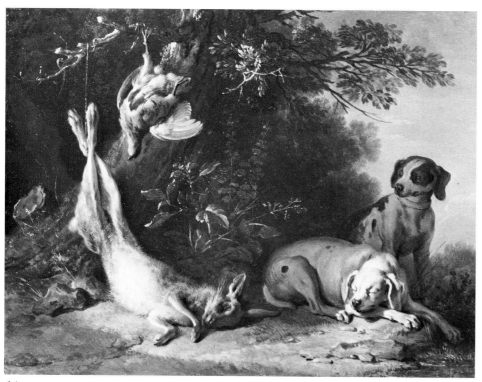

61

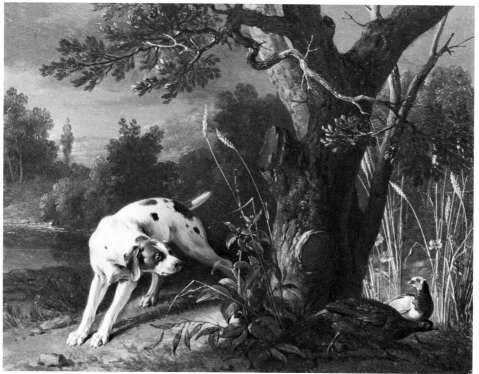

62

Fig. 98 *Birds perched in a Branch of Cherries with Carnations in an Earthen Pot*, painted for Madame de Pompadour. Dated 1750. Private collection.

Georges de Lastic recently brought this painting and its pendant [62] to our attention. They had been "missing" for nearly a century, ever since the Oger de Bréart sale. In fact that sale was anonymous; we give the owner's name from Lugt's repertory of catalogues. However, the annotated copy in the Bibliothèque d'Art et d'Archéologie, Paris, says the owner was Madame Oger de Brearf, and adds that she was formerly the mistress of Sir Richard Wallace. This is not the only interesting problem in the provenance of these pictures. The inscriptions on the back indicate that they were done for Louis XV, and there is no reason to believe that these were added later. Painted in 1747, they were shown in the Salon a year later as the property of Monsieur X . . . , then two years after that as belonging to the artist. Most probably they were *privately* commissioned by the king. No hint of them appears in the accounts of the Bâtiments du Roi; in any case they would have been quite unsuitable as decorations because of their small size. Likely the king intended them as a present, and for some reason changed his mind.

They attracted considerable attention in 1748 (but went unnoticed in 1750, perhaps because they were still familiar — there was no Salon in 1749). Critics admired Oudry's virtuosity and versatility. The same artist who could produce a *grande machine* as excellent as his *Wild Sow* (Fig. 39) could also work on an extremely small scale with as much success. The comments of Baillet de Saint-Julien are typical:

> M. Oudry, après différens morceaux considerables pour la grandeur (quand à la richesse & la vérité de la composition cela s'en va sans dire) a voulu s'essayer dans le petit & a donné de cette façon deux pendans de 7 [*sic!* lire 8] pouces de large sur 6 de haut. Son feu ne s'est point ralenti dans des bornes aussi étroites & on l'y retrouve tout entier; quoique ces deux morceaux soient aussi finis que de Mienis [Mieris] ou de Girard d'Ow [Dou]. (*Réflexions sur quelques circonstances presentes. Contenant Deux Lettres sur l'Exposition des Tableaux au Louvre cette année 1748. . . . , pp. 12-13*)

In fact they do not have the smooth, detailed finish of a Mieris or a Dou; the varied textures and visible brushwork account for a large part of their appeal.

They are also unusually colorful: their small size allows the varied colors to be seen in a single glance, and the copper support maintains and enhances their brilliance. The subject of dead game quietly protected by two dogs, one of them alseep, is similar to the larger picture from the same year in the Louvre (Paris 116), as is the mood and the chiaroscuro.

62
Dog Pointing Two Pheasants

Copper. H. 16.8; W. 22.

Inscribed on the back in engraved Roman capitals:
 PEINT POUR LE ROY. PAR J. B. OUDRY./
 PEINTRE ORDINAIRE DE SA MAJESTÉ./
 ET PROFESSEUR EN SON ACADEMIE
 ROYALLE /
 DE PEINTURE ET SCULPTURE 1747.
Private collection, Paris.

Provenance: as preceding number, but no. 30 of the Maillé sale (295 francs for the pair); no. 12 of the sale in 1845; no. 47 of the Oger de Bréart sale.

Exhibitions: 1748, Salon, no. 35; 1750, Salon, no. 47; 1982-1983, Paris, no. 118 (repr.).

Bibliography: Locquin, *Catalogue*, 1912, no. 169; Vergnet-Ruiz, 1930, no. I, 94; Opperman, 1972 [1977], I, pp. 129, 195-200, 454, cat. no. P261 (whereabouts unknown).

Although there is nothing new in the theme, the observations made about its companion piece [61] in terms of technique, light and color apply equally here. In his critique of the Salon of 1748 Gougenot mentions only the *Dog pointing two pheasants* and not its companion; he especially praises "un beau fini, une grande correction, une touche ferme & spirituelle" ([Louis Gougenot], *Lettre sur la Peinture, Sculpture et Architecture, à M. xxx*, Paris, 1748, pp. 110-112). Oudry did very few pictures on copper. *Les Oiseaux de Madame de Pompadour* from 1750 has been familiar for half a century now (Fig. 98). And there were two still lifes of dead birds, even smaller in size than ours. After an absence of two centuries, one of them has recently reappeared (see Paris 151). It, too, is dated 1750. It is curious that all five of the known paintings on copper plates were shown in the Salon that year, even though the two we exhibit remain the earliest in date of execution.

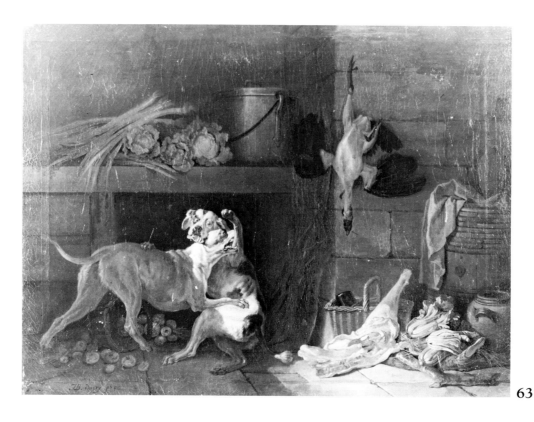

63

63
Two Mastiffs in a Kitchen, Fighting over a Leg of Lamb

Canvas. H. 72; W. 92.5.
Signed and dated, below left: *J B. Oudry 1750*
Schwerin, Staatliches Museum, inv. no. 532.

Provenance: Purchased at Oudry's sale, Paris, 7 July 1755, for the Duke of Mecklenburg-Schwerin, along with its pendant, for 800 livres the pair.

Exhibitions: 1750, Salon, no. 41; 1982-1983, Paris, no. 122 (repr.).

Bibliography: Groth, 1792, p. 104, no. U10; Lenthe, 1836, no. 89; Dussieux, 1876, p. 190; Schlie, 1882, no. 798; Seidel, 1890, pp. 90, 104; Locquin, *Catalogue*, 1912, no. 176; Vergnet-Ruiz, 1930, no. I, 149; *Katalog*, 1954, no. 303, repr. pl. V; Opperman, 1972 [1977], I, pp. 122, 200, 477-478, cat. no. P321, II, p. 936, repr. p. 1151, fig. 357.

We had not at first planned to ask for this picture, but on a recent visit to Schwerin we examined it again with close attention. Beneath the badly yellowed varnish there seemed to be an unusual and probably beautiful painting in good condition. It is to be cleaned before coming to Paris, and we hope that our intuition will be borne out. Dussieux, writing more than a century ago, admired the "bel effet de lumière." The interior is rather dark, but a beam of sunlight descends from the upper left onto the fighting dogs and the leg of lamb. In the preparatory drawing in the Albertina (Fig. 99) Oudry actually delimits this beam of light with ruled ink lines. The still life on the table, consisting of a copper cauldron with a lid, some cabbages and leeks, is in shadow yet the objects still take on their natural tones through dimly reflected light. Next to the meat in the right foreground, and fading gradually back into shadow toward the barrel at the edge, are a basket with an empty bottle in it, pieces of firewood on the floor and leaning in the corner by the table, chard, and an earthen pot. A plucked chicken hangs from the wall above. In addition to what we trust will be revealed as a sensitive study of light, shade and atmosphere, we also have here one of Oudry's very rare ventures into the kitchen, and it will be interesting to see just how much he owes to Chardin.

Fig. 99 *Two Mastiffs in a Kitchen, Fighting over a Leg of Lamb.* Dated 1750. Vienna, Graphische Sammlung Albertina.

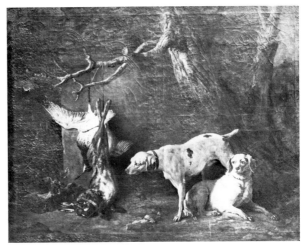

Fig. 100 *Two Dogs with a Dead Hare and a Curlew.* Dated 1750. Formerly Schwerin, Staatliches Museum (disappeared around 1945).

In the Salon and at the time of its purchase in 1755, the picture had a pendant representing two hunting dogs with a dead hare and a curlew. Signed and dated 1750, like the other, the companion piece disappeared from Schwerin during World War II. We reproduce it from an old and unsatisfactory photograph (Fig. 100). The pairing of the two pictures may at first seem odd because they are so different. Yet it is precisely this contrast that was intended. The two hunting dogs guarding dead game exhibit native intelligence as well as good manners, the result of education, while the mastiffs show only raw force and brutality. Calm and stability reign in the first picture — everything is as it should be, in its place. In the second the struggle has just begun; a basket of onions has already been upset, and the kitchen will soon be a shambles. The pictures taken together are moralizing: in the free pursuit of happiness reason must dominate the passions.

Oudry showed twenty-two pictures in the Salon of 1750, so we should not be surprised that this one was not noticed by the critics. And it has been reduced slightly in size, as can be seen by comparison with the preparatory drawing (the old photograph we reproduce shows the full dimensions). The dimensions given by the salon *livret* correspond to 81 by 97 cm.

After cleaning, the painting is still much yellower than it ought to be. And yet, one wonders if some of the yellowness might not have been intentional, a contribution to the "old master" quality of the Rembrandtesque interior Oudry was so obviously seeking to emulate.

64
Sleeping Dog

H. 21.6; W. 35.
Black chalk on white paper.
Signed and dated below left, with pen and brown ink:
J B. Oudry 1750
London, British Museum, inv. no. 1901-4-17-7.

Provenance: Paignon-Dijonval; B. Suermondt, Aachen; his sale, Frankfurt am Main, 5 May 1879 and following days, no. 109 (14 marks to Knowles); W. Pitcairn Knowles (Lugt 2643, verso); purchased from the latter collection by the museum in 1901.

Exhibition: 1982-1983, Paris, no. 123 (repr.).

Bibliography: Bénard, 1810, no. 3232; Locquin, *Catalogue,* 1912, no. 639 (Paignon-Dijonval); Opperman, 1972 [1977], I, p. 153, II, p. 763, cat. no. D678, repr. p. 1162, fig. 379.

Sleeping dogs occur with some frequency in Oudry's late pictures (for example, cat. no. 61 above), but the little-noticed drawing in London is certainly one of his most convincing representations of that subject. A keen sense of observation, and an understanding of the canine temperament born of long experience, reveal Oudry the student of nature with no admixture of Oudry the decorator, something that happens only rarely in his *oeuvre*. When it does we find ourselves transported decades beyond the age of rococo. In the Salon of 1751 Oudry exhibited "un petit Tableau représentant un Dogue en repos"; it has not been cited since then, and even its dimensions are unknown. But it must have stood out among the eighteen paintings he sent that year; Charles-Antoine Coypel remarked that "ignorans & connoisseurs tous sont frappés de la vérité...du Doguin en repos" (*Jugemens sur les principaux Ouvrages exposés au Louvre le 27 Août 1751*, Amsterdam, 1751, pp. 22-23). The *livret* says "dogue" (mastiff), but Coypel uses the word "doguin," that is, either a young mastiff or a small

variety of the race. It is therefore possible that the drawing in the British Museum is related to the lost painting.

Painted or not, it is as a drawing that the work must be appreciated. Oudry uses only black chalk and white paper — again, a rarity for him — and he indicates no setting. The cast shadow alone creates the floor on which the dog lies and along with the admirable foreshortening defines the viewing angle. Oudry's use of black chalk is superb and deserves to be studied closely: sometimes it is blunted and soft, sometimes sharpened to give crisp lines; sometimes he moistens it; he uses the stump and also a sharp scraping instrument along contours to give a sense of greys in shadow; he exploits the wire mesh pattern of the paper for shading. All in all this an extraordinary work, a consummate piece of craftsmanship over which the artist has total control. Among his drawings, it is the closest equivalent to the white-ground still-life paintings of the last years.

64

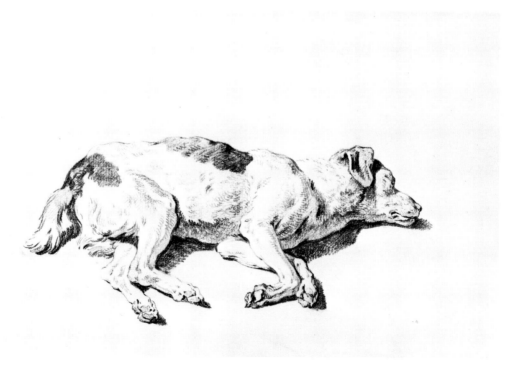

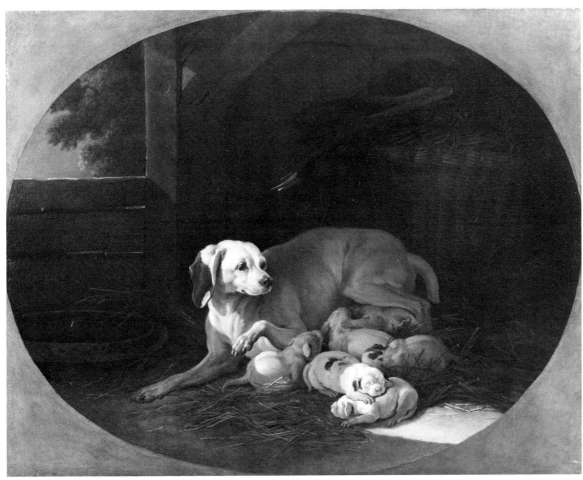

65

65
Bitch Hound Nursing her Pups

Canvas. H. 103.5; W.132.
Signed and dated to the left, on the second board:
J B. Oudry / 1752 (very difficult to read).
Paris, Musée de la Chasse et de la Nature, inv. no.
71.2.1.

Provenance: Purchased at the Salon of 1753 by Baron d'Holbach for 100 pistoles; his sale, Paris, 16 March 1789 and following days, no. 27; purchased by the museum in 1971.

Exhibitions: 1753, Salon, no. 22; 1982-1983, Paris, no. 124 (repr.).

Bibliography: Gougenot, 1761 [1854], pp. 376-377; *Correspondance littéraire*, 1877-1882, II, p. 478; Locquin, *Catalogue*, 1912, no. 189; Diderot, 1957-1967, III, pp. 54-55; Opperman, 1972 [1977], I, pp. 122-123, 204, 206-213, 478-479, cat. no. P323, II, repr. p. 1160, fig. 375.

Engravings: Engraved in 1758 by Jean Daullé, who showed the print in the Salon of 1759 (Opperman, 1972 [1977], I, p. 277, no. 24). There also exists a nineteenth-century lithograph by Tabariès de Gransaigne (repr. in Diderot, cited above, pl. 60).

As was the case of the *Wild Sow* now in Caen (Fig. 39), the *Bitch Hound Nursing her Pups* was immensely successful at the Salon and later in the eighteenth century, but does not seem to have found so appreciative an audience in our own day. Diderot tells how Baron d'Holbach recognized its merits at once, and bought it; only then did other critics and *amateurs* realize how good it was. If we may believe Diderot, Oudry called it his best picture. Grimm, writing in the *Correspondance littéraire*, said it was "le premier tableau du salon, en ce qu'il est sans défaut," and other critics follow suit (see our study of 1972 [1977],

I, pp. 206-214, where criticism of the Salon of 1753 is reproduced). Its success was twofold: "psychological" and technical. The *Mercure de France* (October 1753, pp. 160-161) puts it succinctly and well:

> Le public a été singulierement frappé d'une chienne blanche, avec ses petits de même poil; ils ne voyent pas encore le jour. La vérité de leur action est aussi belle & aussi bien rendue, que les oppositions de ce tableau sont recommendables: les ombres ne cachent rien à l'oeil; il voit clair par tout; un rayon de [lumière] qui seroit un obstacle pour un autre, vient embellir la couleur & enrichir la composition.

There is no need to quote the other critics who make similar statements at greater length and with unreserved praise. The only adverse comment we have found is a minor one: "A la supposer cependant éclairée par un rayon du Soleil, comme il faut nécessairement qu'elle le soit, je ne sçai, si la lumière n'en est pas trop blanchâtre; le Soleil colorie plus vigoureusement" ([Abbé Garrigues de Froment], *Sentimens d'un Amateur sur l'Exposition des Tableaux du Louvre, & la Critique qui en a été faite. III. Lettre*, Paris, ce 14. Septembre 1753, p. 40).

The critical categories being applied are still those of the Renaissance. As Alberti stated more than three centuries earlier, the goal of painting was a double one: to transfer the planes of natural objects onto a flat surface so that they appear to have relief and volume (the scientific part of painting), and to be able through the positions of the living bodies represented to show the state of their souls, thus to move the soul of the viewer (invention). The only difference is that Alberti would probably not have recommended an *istoria* acted out by dogs. By Oudry's day it was generally accepted that animals, to varying degrees, possessed interior qualities of sentiment and thus could enter into social intercourse with man. There is no better illustration of this than Buffon's famous article on the dog:

> La grandeur de la taille, l'élégance de la forme, la force du corps, la liberté des mouvemens, toutes les qualités extérieures, ne sont pas ce qu'il y a de plus noble dans un être animé: & comme nous préférons dans l'homme l'esprit à la figure, le courage à la force, les sentimens à la beauté, nous jugeons aussi que les qualités intérieures sont ce qu'il y a de plus relevé dans l'animal. ... La perfection de l'animal dépend donc de la perfection du sentiment; plus il est étendu, plus l'animal a de facultés & de ressources, plus il existe, plus il a de rapports avec le reste de l'Univers: & lorsque le sentiment est délicat, exquis, lorsqu'il peut encore être perfectionné par l'éducation, l'animal devient digne d'entrer en société avec l'homme. ... Le chien, indépendamment de la beauté de sa forme, de la vivacité, de la force, de la légèreté, a par excellence toutes les qualités intérieurs qui peuvent lui attirer les regards de l'homme. (*Histoire naturelle*, V, Paris, 1755, pp. 185-186)

Animal painting was thus judged within the same critical framework as history painting. More than one critic calls the bitch "la mère," humanizing her; another likens the puppies to the famous sculptures of infants by François Duquesnoy; one says that Descartes (who denied a rational soul to animals) would have renounced his system if he had seen Oudry's paintings. But this quality of sentiment has become foreign to us again, embarrassing even; it remains to be seen whether or not we can recapture it. To some extent it was already beginning to disappear by 1753 with the reaction against the lower genres in favor of true history painting: a dog may be noble to some extent, but surely man is (or can be) nobler still. One critic says, with open scorn: "La fécondité de M. Oudry est étonnante. De quelque côté qu'on se tourne dans le Sallon, ce sont toujours des Animaux qu'on apperçoit" ([Monsieur Estève], *Lettre à un ami sur l'Exposition des Tableaux faite dans le grand Sallon du Louvre, le 25. Août 1753*, pp. 8-11). But he was alone. An anonymous critic answered him: "On pourroit dire à plus juste titre, *de quelque côté qu'on se tourne dans le Sallon, ce sont toujours* de belles choses *qu'on apperçoit*" (*Lettre à un Amateur, en réponse aux Critiques qui ont paru sur l'exposition des Tableaux*, no place or date, pp. 20-23).

Leaving aside the question of sentiment, it certainly ought to be possible for the modern viewer to appreciate Oudry's technical mastery, the famous beam of light that picks out the dog's head and parts of the puppies, while the rest of the small interior is lit by

Fig. 101 Rembrandt Harmensz van Rijn, *Holy Family,*
called "Le Ménage du Menuisier". Dated 1640. Paris,
Musée du Louvre.

Fig. 102 *Bitch Hound Nursing her Pups.* Dated 1754.
Narbonne, Musée des Beaux-Arts.

reflected light. We shall quote one more of the many Salon critics on this subject:

> Ce qui rend ce groupe encore plus piquant, c'est le rayon de lumière dont il est éclairé. C'est du clair-obscur sans dureté. Ce qui est dans l'ombre n'est point noir. Les Reflets y sont si bien entendus, tout y est si bien rendu dans les tons de la nature, que l'on peut regarder ce Tableau comme un chef-d'oeuvre de clair-obscur. Il n'est pas d'un effet moins vigoureux que celui de ce genre que possede M. Gaignat. Ce n'est pas une petite gloire à M. Oudry que d'avoir sçu égaler Rembrandt dans une partie si difficile & qui demand autant d'intelligence. ([Abbé Le Blanc], *Observations sur les Ouvrages de MM. de l'Académie de peinture et de sculpture, exposés au Sallon du Louvre, en l'Année 1753...*, no place of publication, pp. 19-21)

The Rembrandt painting is the *Holy Family* of 1740 (Fig. 101), known as *Le Ménage du Menuisier*, which

entered the Louvre in 1793. It shows the Virgin nursing the Christ Child, lit by a beam of light (is Oudry's subject intended as a parallel?). Le Blanc does not mention the subject of the pictures in making his comparison; what was important for him and his contemporaries was that they were well painted. Without his comment we would probably never have thought that Oudry was seen as belonging to the eighteenth-century phenomenon of *Rembrandtisme* ... but clearly he was.

The smaller version now in Narbonne (Fig. 102; cf. Paris 124) is interesting evidence not only of the picture's success, but also of its novelty. Although it is not cited until the sale of the Marquis de Marigny (by then the Marquis de Ménars) in 1782, it is dated 1754; Marigny was director of the Bâtiments du Roi at that date and had commissioned several pictures from Oudry for the Crown. This one must have been done for him on private commission, in compensation for not possessing the original version. The ar-

rangement is different, and also there are only two pups and they are older. This is one of Oudry's last paintings; he was already ill, and we know of only a few others from 1754, and none from 1755. Another of these last pictures is similar to d'Holbach's and Marigny's, the *Fox in its Burrow* that was lost from Schwerin during the last war (H. 81, W. 66; Opperman, 1972 [1977], I, p. 489, cat. no. P351). We reproduce it from an etching by L. Kühn (Fig. 103) that illustrates Bode's article of 1891. The animal is startled, just like the bitch, and lies on a bed of grass in a beam of light. Bode appreciated it above all the others of Oudry's pictures in Schwerin. The great scholar of the Dutch was not attuned to the decorative qualities of eighteenth-century French art but was attracted to pictures like these. Perhaps we have here another connection between Oudry and *Rembrandtisme*.

Fig. 103 Ludwig Kühn, *Fox in its Burrow*, after a painting of 1754 by Oudry formerly in Schwerin, Staatliches Museum (disappeared around 1945). Original etching published in *Die Graphischen Künste*, XIV (1891).

66
Exterior of a Gardener's House

H. 35.4; W. 46.
Pen and black ink, washes of black and brown ink, white gouache heightening, over a black chalk sketch, on light yellow-brown paper. Squared for transfer in white chalk at 5 cm. intervals.
Signed and dated with the pen and grey ink, below right: *Oudry 1740*
Schwerin, Staatliches Museum, inv. no. 4574 Hz.

Provenance: Purchased at Oudry's sale, Paris, 7 July 1755, for the Duke of Mecklenburg-Schwerin, with another drawing (40 livres for the two; the other drawing is lost).

Exhibition: 1982-1983, Paris, no. 125 (repr.).

Bibliography: Seidel, 1890, p. 105; Locquin, *Catalogue*, 1912, nos. 791 (1755 purchase), 1265 (Schwerin); Vergnet-Ruiz, 1930, no. II, 164; Opperman, 1972 [1977], I, pp. 122, 151, 312, II, p. 720, repr. p. 1111, fig. 277.

The subject of the drawing is difficult to classify. One could call it genre because of the figure of the gardener leaning out a window and offering something to the parrot on a perch. Or it could be landscape because it is set out-of-doors, or animal painting (the fighting cocks), or even still life, with the vegetables and kitchen vessels grouped round the pump. Its combination of the various *talents* reminds us that the boundaries between them were often blurred in Oudry's *oeuvre*, as well as of the title of *peintre universel* which he was accorded in his own day. The drawing is similar in execution, subject, and particularly in the fine rendering of light, to that of *Two Mastiffs Fighting in a Kitchen*, from 1750 (Fig. 99.)

This is the finished study for a painting measuring 65 cm. by 81 wide, shown in the Salons of 1740 (no. 27), 1741 (no. 30) and 1747 (no. 48), which was in the collection of Ramel de Nogaret in the late eighteenth century, then in that of Baron Lepic. But the picture had been cut down, mostly at the right, and measured 65 by 48 cm. when it appeared in the Lepic sale in 1897 (no. 30; 5250 francs). It has since disappeared, and can be reproduced only from the illustration in the Lepic sale catalogue (Figure 104). In the Salon of 1747 the picture had a pendant. The *livret* describes the two simply as "la maison d'un jardinier" and "une Butte de Sable rouge, vaches et moutons,"

66

Fig. 104 *Exterior of a Gardener's House.* Dated 1740. Lepic sale, Paris, Galerie Georges Petit, 18 June 1897.

Fig. 105 *Landscape with a Hillock of Reddish Sand, Animals, and a Sleeping Shepherd.* Dated 1739. Private collection.

without dimensions. In the Salon of 1740 the picture already had appeared as "la maison d'un jardinier," with dimensions corresponding to 65 by 81 cm. in width. Just before it in the *livret* we find a picture of the same size "représentant des vaches et des moutons"; this could already have been the pendant, even though the *livret* does not say so. In 1741 the *Gardener's House* appeared alone, this time quite fully described and with the same dimensions as the year before: "une partie de maison de jardinier, garnie de légumes, et deux coqs qui se battent." We believe that the pendant, hitherto considered lost, should be identified with a painting now in a private collection, signed and dated 1739 and measuring 65 by 81 cm., that shows an eroded hillside of reddish sand with cows and sheep in the foreground (Fig. 105). It makes an interesting pair with the other, for two aspects of agriculture are shown: tending the flocks (with the witty presence of a sleeping shepherd) and cultivating the earth. Also, the one is a relatively untamed landscape, and the other thoroughly domestic. The Salon *livrets* do not say that the landscape was done from nature, but it probably was.

The Abbé Le Blanc appreciated the two pictures in the Salon of 1747:

> Il y a plusieurs morceaux de Monsieur Oudry où l'on trouve l'esprit & la vérité qu'il est accoutumé de mettre en tout ce qu'il fait. Les deux petits Tableaux marqués N° 47 & N° 48. dont l'un représente une Butte de sable rouge avec des Animaux, & l'autre la Maison d'un Jardinier, sont aussi bien peints & ont autant de couleur que les morceaux de ce genre des plus habiles Peintres Flamands; ils ne différent qu'en ce qu'ils sont touchés avec plus d'esprit & de force. L'attitude de la petite figure qui est dans le second a des graces & une noblesse où ceux de l'Ecole Flamande ne sont arrivés que rarement. (*Lettre sur l'exposition des Ouvrages de peinture, sculpture, &c. de L'Année 1747...*, Paris, 1747, pp. 94-95)

Although they are not mentioned elsewhere in the critical literature of the Salons we can probably assume that they were popular with the public, particularly the *Gardener's House*, since Oudry sent it three times. This is a charming subject, a particularly

happy union of Oudry's different interests and abilities brought to bear on the theme of rural life. We can be grateful that the beautiful drawing in Schwerin preserves the complete composition.

67
Landscape with the Aqueduct of Arcueil

Canvas. H. 98; W. 131.
Signed and dated, below right: *J B. Oudry 1745*
Schwerin, Staatliches Museum, inv. no. 217.

Provenance: Purchased at Oudry's sale, Paris, 7 July 1755, for the Duke of Mecklenburg-Schwerin, along with its pendant (879 livres 5 sols the pair).

Exhibition: 1745, Salon, no. 40; 1982-1983, Paris, no. 128 (repr.).

Bibliography: Groth, 1792, p. 6, no. C3 or C4; Lenthe, 1836, no. 561; Dussieux, 1876, p. 191; Schlie, 1882, no. 794; Seidel, 1890, pp. 89, 104, 110; Bode, 1891, p. 63; Locquin, *GBA*, 1906, repr. p. 309; Locquin, *Catalogue*, 1912, no. 440; Réau, 1928, p. 197; Vergnet-Ruiz, 1930, no. I, 227; Desguine, 1950, p. 7, repr. p. 23; *Katalog*, 1954, no. 297, repr. pl. VI; Venzmer, 1967, repr. in color, pl. 6; Opperman, 1972 [1977], I, pp. 124, 191, 587-588, cat. no. P608, II, p. 950, repr. p. 1127, fig. 309.

The picture has a kind of semi-official pendant, of the same size but executed three years earlier, in 1742, and shown in the Salon that year (Fig. 106). It reappeared in the Salon of 1745 just before the one here

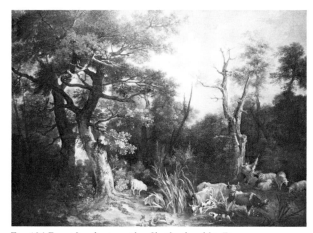

Fig. 106 *Forest Landscape with a Shepherd and his Dog, Cows and Sheep.* Dated 1742. Schwerin, Staatliches Museum.

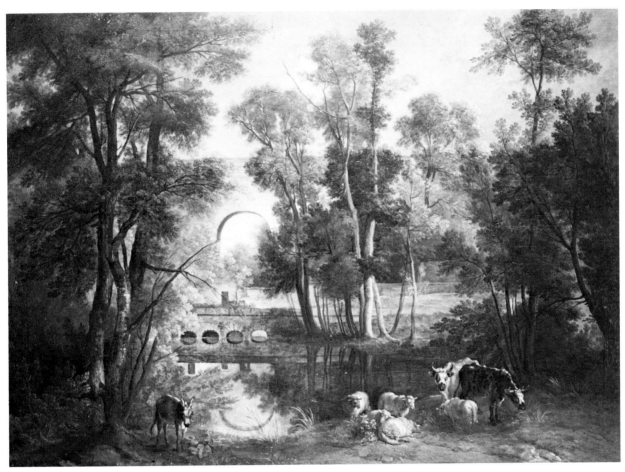

67

catalogued ... but the *livret* does not call them pendants. They were sold to Schwerin together, but, again, the word *pendant* does not appear. It is difficult to conceive of the calm, dignified painting of the aqueduct as a pendant to the other; a Flemish rather than a Dutch influence is visible in the former, the lesson of Rubens transmitted through Largillierre. As in the case of another "mismatched" pair discussed above (cat. no. 63) the intent must be to show opposites: man's imposition of order on nature in the picture of the aqueduct, and the reign of wild nature, to which man nonetheless adapts, in the other. Bode in 1891 appreciated the naturalism of both of them as opposed to the decorative landscape backdrops of some of Oudry's animal pictures in Schwerin (cf. cat. no. 49). They were also widely appreciated at the Salon of 1745 (*Mercure de France*, September 1745, pp. 135-136).

The aqueduct was built between 1614 and 1624 for Marie de Médicis, to carry water from the springs at Rungis to the Luxembourg Gardens, very near the site of a Roman aqueduct some traces of which remain. It crossed the valley of the Bièvre, partly on the grounds of the château of the Prince de Guise at Arcueil, which is where the picture must have been painted (see the following entry). The aqueduct that one sees at Arcueil today, near the Autoroute du Sud, is the one in Oudry's painting, but with an upper arcade that was added between 1868 and 1872 as part of the system bringing the waters of the Vanne to Paris.

68 *(Colorplate on page 26)*
View of a Park with a Pavilion and a Bench

H. 35.7; W. 57.4.
Black and white chalk on blue paper (now faded yellow-green).
Schwerin, Staatliches Museum (Lugt 2273, verso), inv. no. 2096 Hz.

Provenance: Purchased at Oudry's sale, Paris, 7 July 1755, for the Duke of Mecklenburg-Schwerin, along with three other, similar drawings (49 livres 2 sols for the lot).

Exhibition: 1982-1983, Paris, no. 129 (repr.).

Bibliography: Seidel, 1890, pp. 104-105; Locquin, *Catalogue*, 1912, part of nos. 915-918; Vergnet-Ruiz, 1930, part of nos. II, 154,157; Opperman, 1972 [1977], I, pp. 108, 128, 154-156 (the Arcueil drawings in general), 312, II, p. 861, cat. no. D1083, repr. p. 1131, fig. 318.

Between 1744 and 1747 Oudry frequently visited the abandoned park and gardens of the château of the Prince de Guise at Arcueil where he made many drawings of a very familiar type, in black and white chalk on blue paper. Gougenot talks about this:

> Avant la destruction totale des jardins d'Arcueil, il ne manquoit pas d'y aller dessiner dès qu'il pouvoit trouver un moment de loisir. Ces jardins, qui excitoient les regrets de ceux qui les avoient vus dans leur premier éclat, lorsqu'ils furent entièrement abandonnés prirent de nouveaux charmes aux yeux de la peinture. Partout on ne rencontroit que dessinateurs; chacun s'empressoit de consulter M. Oudry, et dans ces récréations pittoresques, il primoit comme un professeur au milieu de son école. C'est dans ces divers dessins de paysage qu'il a développé clairement les grands principes qu'il tenoit de M. de Largillierre sur l'intelligence du clair-obscur, et l'on y découvre les effets les plus vrais et les plus hardis. (Gougenot, 1761 [1854], p. 378)

The gardens of Arcueil were visited in the 1740s for much the same reason as the ruins of Châalis in the 1840s — a sense of the picturesque. Boucher, Natoire, Pierre, Portail and Wille are among the other artists who drew there, but not nearly as much as Oudry; we have catalogued nearly fifty "Arcueil" views, and

they appear with great frequency in eighteenth-century sales. It is likely that he produced a hundred or more of them. It might seem curious that Gougenot sees here the development of Largillierre's principles of chiaroscuro, since Oudry's master produced very few landscapes. However, Oudry tells us that studying landscape directly from nature was an important element of Largillierre's teaching. It has to do with avoiding the artificial convention of creating recession by successive planes; it is opposition of light and shade that creates depth in a picture, according to Oudry and Largillierre (see our study of 1981, especially pp. 316-318).

Unfortunately it is Oudry's drawings that give us the best idea about what Arcueil looked like (the buildings and gardens were almost completely destroyed beginning in 1752, and the property broken up) — unfortunately, because we cannot be sure how many of them were done at Arcueil. Most of them no doubt; but at least some may have been done elsewhere. The best study of the problem is that of Desguine (1950), who brings together many of Oudry's drawings along with descriptions of the property from guide books, legal documents, and records of excavations in the nineteenth century.

The domain was fairly large (about twelve hectares), in a roughly rectangular shape with the longer axis east-west. The river Bièvre crossed it from south to north, and the gardens were terraced on the valley slopes, apparently on both sides. The aqueduct of Marie de Médicis traversed the valley, partly on the Guise property, toward the southern edge. It is pointless to try to reconstruct the exact appearance. We will simply quote one contemporary description:

> Anne-Marie-Joseph de Lorraine . . . avoit à Arcueil une maison de plaisance qui a de grandes beautés. La rivière de Bièvre en parcourt le jardin dans toute sa longeur, et lui procure de grands agrémens. Le parterre et le potager sont dans le vallon, et règnent des deux côtés de cette petite rivière; mais la plupart des allées couvertes sont horizontalement tracées dans la montagne, et servent pour ainsi dire, d'échelons pour monter de l'une à l'autre. Les arbres dont elles sont alignées, et qui les couvrent de leur ombre, produisent ici un effet

68

69

70

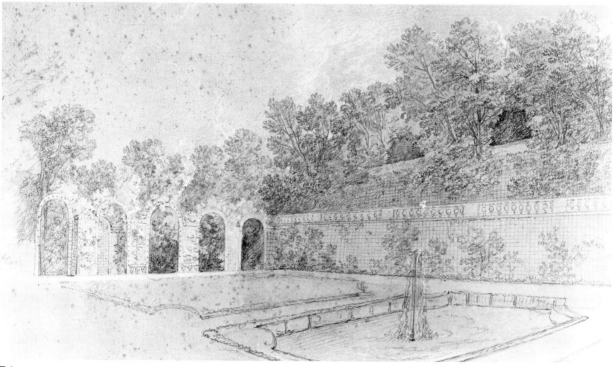

71

peu ordinaire ailleurs, qui est que plus l'on monte, moins on voit; au contraire de la plupart des autres lieux élevés, où plus l'on monte, plus la vue est étendue. (Piganiol de la Force, 1765, IX, p. 5; cited by Desguine, 1950, pp. 13-14)

This sensitive study portrays a strong beam of light coming from the right that picks out some tree trunks, the bench, and the ground in front of it while leaving the pavilion in soft shadow. The site is almost certainly Arcueil. We are high up on one side of the valley and the ground falls off beyond the bench. The tops of the trees on the other slope of the valley are visible in the distance, in white chalk alone.

69
Pavilion and Basin in a Park

H. 35.7; W. 57.7.
Black and white chalk on blue paper (now faded yellow-green).
Schwerin, Staatliches Museum (Lugt 2273, verso), inv. no. 2095 Hz.

Provenance: as preceding number.

Exhibition: 1982-1983, Paris, no. 130 (repr.)

Bibliography: as preceding number, except Opperman, II, p. 860, cat. no. D1080, repr. p. 1133, fig. 322.

Oudry achieves contrast among several different levels of light intensity. The darkest parts are the undersides of the crowns of trees, where he uses the stump effectively. If the site is Arcueil (and there is no reason to believe otherwise) we must be looking toward the north, with the valley to our left. The drawing must have been done entirely on the spot, and not "finished" afterwards in the studio: despite the artist's use of a ruler for some of the lines of the building there are small mistakes of perspective there and in the left end of the basin, due, we think, to his working out-of-doors in make-shift conditions. These errors could easily have been corrected later if he had chosen to.

70
View of a Park with a Jet of Water in a Clearing

H. 35.7; W. 57.6.
Black and white chalk on blue paper (now faded yellow-green).
Schwerin, Staatliches Museum (Lugt 2273, verso), inv. no. 2094 Hz.

Provenance: as cat. no. 68 above.

Exhibition: 1982-1983, Paris, no. 131 (repr.).

Bibliography: as cat. no. 68 above, except Opperman, II, p. 861, cat. no. D1081.

Here we appear to be on one of the terraces along the right bank of the Bièvre, looking west, with the sun in the south. Oudry again uses the stump in foliage and around the edges of the pool with the jet of water. There is an instinctive capturing of the picturesque by choosing an off-center viewpoint so that we "read" the scene beginning in the left foreground with the jet and move diagonally into depth toward the right, through an opening and down the hill to a second clearing with a fountain. Oudry avoids a frontal presentation along a primary axis (the park at Arcueil was laid out symmetrically in the seventeenth-century fashion) in order to bring out the variety of his site. The sense of the picturesque is enhanced by the evident neglect of the park — the jet of water seems to be eroding its banks, and the young trees have not been pruned. Again, one suspects that this drawing was done entirely on the spot, and not retouched later; it is not even finished at the left. One particularly effective device is the tree trunk just to the left of center that is strongly highlighted with white chalk. The actual center of the drawing lies between it and the tree to its right which is further away, and in the shade. The eye is thus "invited" to move back into depth at this crucial point.

71
Parterre with two Basins and a Jet of Water

H. 35.5; W. 57.4.
Black and white chalk on blue paper (now faded yellow-green).
Schwerin, Staatliches Museum, inv. no. 2093 Hz.

Provenance: as cat. no. 68 above.

Exhibition: 1982-1983, Paris, no. 132 (repr.)

Bibliography: as cat. no. 68 above, except Opperman, II, p. 861, cat. no. D1082.

This must be the principal parterre of the château at Arcueil, located in the valley on level ground. Another drawing of the same spot is in the Musée Carnavalet (Fig. 107). We see the same trellis with the hillside sloping up behind it, but in the drawing from Schwerin the artist looks diagonally across the parterre to his left, while in the one at Carnavalet he turns to his right and shows the grille as well as part of the garden façade of the château itself. Despite some foxing, this is an unusually economical and attractive drawing, with less contrast in light and dark and more bare paper than in most of the others.

72 *(Colorplate on page 27)*
A Farm

Canvas. H. 130; W. 212.
Signed and dated below right, on the edge of the well:
J B. Oudry / Peintre Ordinaire du Roy / 1750
Paris, Musée du Louvre, inv. no. INV. 7044.

Provenance: Painted in 1750 for Louis de France, the Dauphin; remained at Versailles until the Revolution, although it seems to have been in storage most of the time; French national collections; recorded as having been sent to Versailles from the Louvre in 1826; sent to Compiègne in 1832; appears in the 1832 and 1837 catalogues of pictures at Compiègne, but no longer in that of 1841; first exhibited in the Louvre following the reorganization of 1848.

Exhibitions: 1751, Salon, no. 16; 1929, Amsterdam, no. 66 (repr.); 1960, Paris, no. 650; 1982-1983, Paris, no. 144 (repr. in black and white; color repr. p. 30).

Bibliography: Notice des Tableaux placés dans les appartements du palais royal de Compiègne, 1832, p. 13, no. 151; *Idem,* 1837, p. 21, no. 160; Villot, 1855, pp. 246-247, no. 390; Luynes, 1860-1865, XIII, p. 130; *Musées nationaux. Catalogue sommaire des peintures . . . du Louvre,* 1889, no. 670; Engerand, 1900, pp. 357-358; Locquin, 1908, pp. 373 ff., repr. p. 377; Locquin, *Catalogue,* 1912, no. 459; Demonts and Huteau, 1922, p. 58, no. 670; Brière, 1924, p. 196, no. 670; Hildebrandt, 1924, pp. 154-155, repr. fig. 201; Gillet, 1929, p. 28, repr. p. 23; Vergnet-Ruiz, 1930, no. I, 235; Belloncle, 1967, repr. p. 23; Jallut, 1969, pp. 316-317; Keller, 1971, p. 393, repr. fig. 374; Opperman, 1972 [1977], I, pp. 123-124, 128, 202, 592, cat. no. P621, II, p. 950, repr. p. 1154, fig. 363; Rosenberg, Reynaud and Compin, 1974, II, no. 609 (repr.).

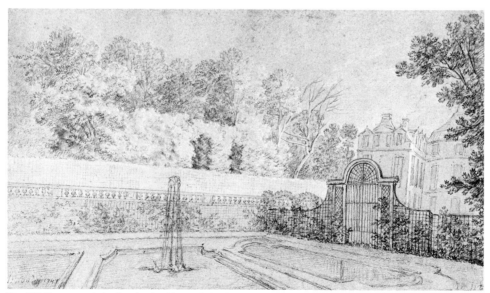

Fig. 107 *Parterre with the Façade of a Château behind a Grille.* Dated 1747. Paris, Musée Carnavalet.

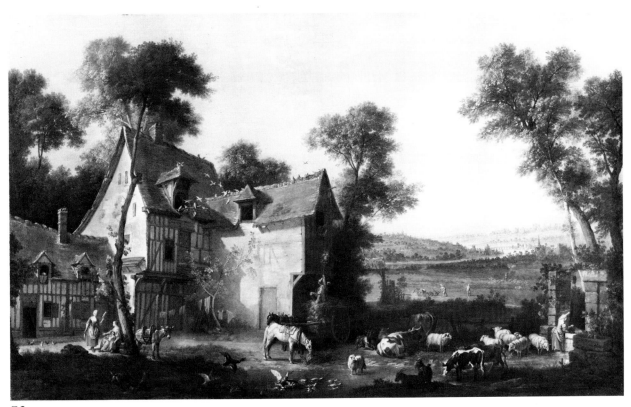

72

In a memorandum dated 17 January 1751, published by Engerand, Oudry describes the picture thus:

Livré pour Monseigneur le Dauphin un tableau . . . représentant à un costé du tableau *une ferme,* une grange à costé, une charette attelée de deux chevaux pleine de foin, deux hommes qui le serrent dans laditte grange; devant la ferme une femme qui file, une autre avec un enfant, un homme qui dort; à l'autre costé dudit tableau, une femme qui tire de l'eau. Sur le devant dudit tableau, une mare, sur le bord de laquelle il y a un chien qui tient un canard, des cannes avec leurs petits qui s'enfuyent dans la mare et, à l'autre bord, des vaches, des chèvres et des moutons. Sur le second plan un labourer avec sa charüe, un autre qui sème derrière, un berger avec son troupeáu, une rivière, un pont et un lointain considérable. C'est ainsy que Monseigneur le Dauphin l'a dicté audit sieur *Oudry,* et en a fait faire l'esquisse devant luy. Ce

tableau est des plus fins, il a tenu à faire plus de quatre mois audit sieur Oudry, sans l'esquisse, les voyages et le temps perdu.

The reasons for spelling out the contents of the picture in so much detail are, first, that the Dauphin had dictated them, and second, to call attention to the unusual amount of work required with payment in mind (Oudry requested 3000 livres and received an additional 1000 livres as a gratification). It is not mentioned in the critical literature of the Salon of 1751, even though Oudry had it listed first in the *livret,* usually a sign that he considered a work to be particularly important. And it has not always been well received since then, precisely because of all the anectodal detail and also because it was not done from nature. Louis Gillet represents this position well:

Le tableau de *la Ferme* est surfait: il est dispersé,

décousu, nulle grande impression d'ensemble. Dix motifs secondaires éparpillent l'intérêt; c'est l'ouvrage d'un parisien qui va se distraire à la campagne et prend des notes sur ce qu'il voit, sans vraie intimité ni sentiment rural; ce n'est pas la nature, on n'en est qu'à l'opéra-comique.

But this is being unfair to the artist to some extent. The "parisien qui va se distraire à la campagne" is the Dauphin, not Oudry, whose landscapes after nature are much more direct and convincing. Even then, the picture is so much more matter-of-fact than Boucher's views of mills and cottages which truly deserve the epithet of "opéra-comique."

In another of the payment documents published by Engerand the painting receives a title, *L'Agriculture*, and in inventories from the eighteenth century it is called *La France* (the present title, *La Ferme*, first appears with Villot in the middle of the nineteenth century). From the original titles the significance of the painting becomes clear. Jean Locquin in his perceptive article of 1908 sees Oudry as a member of a moralizing circle around the Dauphin and the Queen, intent on praising the rustic life of agricultural productivity, in opposition to the artificial pastoral landscapes of Boucher. In fact Oudry's painting is one of the very first manifestations of this new worthiness of agriculture as a subject in art and literature. Daniel Mornet, in his classic study on *Le Sentiment de la Nature en France*, published in 1907, speaks of the phenomenon:

> Aussi longtemps que les champs furent seulement la villégiature des ennuis opulents et l'aimable décor des sentimentalités faciles, ils furent élégamment méconnus. Si l'idylle s'est rapprochée de la vie, c'est qu'on a fini par voir dans la campagne ce qu'elle demeure avant tout, tant qu'on ne la vêt pas de rêves sentimentaux ou métaphysiques: la terre nourricière, la raison et la nécessité du travail vivifiant.

Mornet goes on to situate in the 1750s "ce puissant mouvement d'idées qui permit enfin, sans déchoir, d'aller chercher aux champs, au lieu des aimables chimères, la forte réalité de l'agriculture" (pp. 108-111). Among the earliest and most important steps

in this movement is the publication in 1750 of the *Traité de la culture des terres* by H.-L. Duhamel de Monceau. The work was extremely successful and suddenly made agriculture respectable; it is quite possible that is the immediate inspiration of Oudry's picture which was painted in the latter part of 1750. But Mornet somehow overlooked the painting, even though it was then hanging in the Louvre. If he had seen it, would he have recognized it for what it is, a proto-Romantic return to nature created eleven years before *La Nouvelle Héloïse?* Or would he rather have seen those qualities that link it to the past: a a lingering rococo attitude in the decorative groupings and the curving tree to the left; a sort of early Enlightenment deism that emphasizes the harmony and happiness of man in this friendly environment with a hint of pastoral escapism; the relation to his earlier landscapes of similar subjects done for the Marquis de Beringhen in 1727 and which stand outside true naturalism [27-28]; and the derivation of the subject from seventeenth-century Flemish artists, particularly Teniers and Siberechts (the picture is listed in the Salon *livret* as being "dans le genre Flamand")?

La Ferme (to use its by now universally accepted name) for many years has been disfigured by dirt and yellow varnish, but a successful cleaning undertaken in 1980 has revealed its original appearance and has also confirmed what Oudry states in his various memoranda, that it is "fini avec un soin extraordinaire." In this it recalls two paintings in the Metropolitan Museum (Paris 121, 146), from 1753. But these are small works; in a painting as large as *La Ferme* such careful finish, and so much detail, does not seem appropriate. Nonetheless, despite its problems, this is a remarkable painting, perhaps a unique one, that deserves a much more prominent place in the development of landscape painting than it is usually assigned.

73 *(Colorplate on page 23)*
A Bed of Tulips and a Vase of Flowers at the Base of a Wall

Canvas. H. 129; W. 162.
Signed and dated below left, on the stone pedestal of the vase: *J B. Oudry / 1744*
Detroit, The Detroit Institute of Arts, Founders Society Purchase, The John N. and Rhoda Lord Family Fund and General Endowment Fund, inv. no. 67.78.

Provenance: Commissioned by Monsieur "de la Bruiere"; sale of the Duc de Richelieu, Paris, 18 December 1788 and following days, no. 10; Marquis de Breteuil; Galerie Heim, Paris; acquired by the museum in 1967.

Exhibitions: 1745, Salon, no. 33; 1975-1976, Toledo-Chicago-Ottawa, no. 77 (repr.); 1978, Bordeaux, no. 125 (repr.; also repr. in color, p. 28); 1982-1983, Paris, no. 147 (repr. in black and white; color repr. p. 31).

Bibliography: Locquin, *Catalogue,* 1912, no. 79 (Salon); Vergnet-Ruiz, 1930, no. VII, 49 (Salon); *Bulletin of the Detroit Institute of Arts,* XLVII, no. 1 (1968), pp. 3-4, 15, detail repr. in color on cover; *Chronique des Arts,* no. 1189 (February 1968), p. 63, no. 244 (repr.); *Art Quarterly,* XXXI, no. 1 (Spring 1968), p. 94, repr. on cover; Cummings and Elam, 1971, p. 116 (repr.); Opperman, 1972 [1977], I, pp. 191, 532-533, cat. no. P457, II, p. 943; Faré and Faré, *La Vie silencieuse . . . ,* 1976, repr. in color p. 123; Bergström, Grimm et al., 1977, repr. p. 205; exhibition catalogue 1979-1980 Münster-Baden-Baden, p. 302 (repr. and discussed but not in the exhibition).

The *Tulips* is a picture that defies classification. Oudry listed it first among the eleven works he sent to the Salon of 1745 and gave it a long description in the *livret.* Afterwards it went underground (Georges de Lastic only recently noticed it in the Richelieu sale and gave us the reference) until its acquisition by Detroit fifteen years ago. Since then its success has been spectacular. We will simply cite the words of Pierre Rosenberg, in the catalogue of his *Age of Louis XV* exhibition:

> On ne sait ce qu'il faut le plus admirer dans la toile de Detroit: de la fantaisie de l'artiste qui, pour animer cette planche de botanique, y ajoute un perroquet et deux gros papillons de nuit, de l'originalité de la mise en page avec son subtil jeu de droites dessinées sur le sol, ou de la sumptuosité des coloris.

Oudry tells us that all the flowers are from the garden of Monsieur de la Bruiere, who commissioned the picture. The rich bouquet contains hyacinths that had been brought from Holland for the King, primroses, an iris, two tulips, and also oriental poppies, peonies and strawflowers. The picture represents the exotic, walled off from common nature whose treetops are visible in only one corner. The moth near the vase is the Atlas moth, considered the largest in the world, a native of South Asia. The flying moth above, though, is the common emperor-moth of Europe; it is coming into the garden from outside, and is greeted by the tropical parrot. Norbert Schneider recognizes here the continuation of the sixteenth-century theme of the court garden, with the exotic plants being an equivalent of the *cabinets de curiosité* so much in vogue (catalogue of the exhibition in Münster and Baden-Baden).

According to reliable sources, the painting appeared in a sale at the Hôtel Drouot shortly before 1960, of works of art from the Château de Breteuil. There does not seem to have been a catalogue; at least we have not been able to find it. Those who saw the picture at that time claim that it had been cut up into several pieces which had been rearranged on a larger canvas. It would have been reassembled in its present form prior to its acquisition by the Detroit Institute of Arts in 1967. Superficially it shows no traces of this drastic operation, however. At our suggestion the museum undertook a full laboratory examination early in 1980 and the reassembly was confirmed (cf. x-ray photograph, Fig. 108). The original reaction was consternation, but this soon turned into fascination as careful analysis of the canvas continued. Although we cannot yet propose a definitive answer to the problem — perhaps this will never be possible — it has become clear that the picture was reassembled more than once.

The original appearance of the composition is approximated by the photomontage here reproduced (Fig. 109). This was made by the museum's laboratory staff based on a painstaking matching up of the threads of the canvas. In the painting as we see it today, the major difference is that the Atlas moth has been moved from the left side of the picture to a position between the vase of flowers and the tulip-bed. In order to accommodate it the tulip-

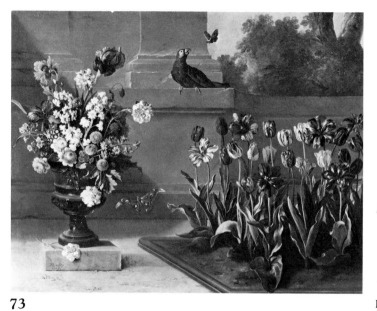

73

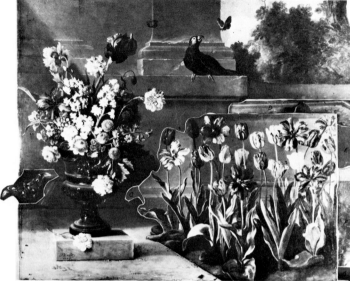

Fig. 109 *Photomontage: the Pieces of Catalogue Number 73 reassembled in their original Position (intact canvas).*

Fig. 108 *X-Radiograph of Catalogue Number 73.*

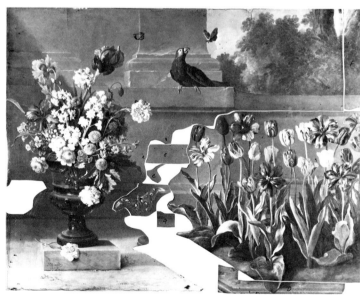

Fig. 110 *Photomontage: the Pieces of Catalogue Number 73 as they are presently assembled, with modern additions removed.*

bed has been shifted to the right and also, for some reason, has been moved up a bit. This required the enlargement of the picture by about 11 cm. to the right; a corresponding reduction in width was made at the left edge. It is most curious that the canvas was cut up into so many irregular pieces in order to effect the change, and that all of these odd scraps (except the left edge above and below the original position of the moth) were reused. A reconstruction based on the x-radiograph shows this re-use (Fig. 110). The areas that are blank in this reproduction are a different, coarser canvas — presumably modern — with much less white lead in the ground. The strip to the right of the tulip-bed in the original composition has been cut into three pieces. The central and longest piece, inverted, was re-used in the upper right corner and now shows a tree trunk. The two other, smaller pieces are fitted into the space created by the shifting of the tulip-bed, above and below the moth. Another oddly shaped fragment — removed to make way for the left wing-tip of the moth — has also been placed in the void above the insect, surrounded by new canvas. Finally, a long, narrow section that initially was located between the tops of the tulips and the top of the wall has been inverted and placed at the bottom edge of the tulip-bed.

These changes would have necessitated a certain amount of repainting. For example, in the original arrangement, did the tulips extend all the way to the right edge of the picture? If so, the strip of canvas removed there, cut into three pieces used elsewhere, must have had the tulips painted out. And the architecture behind the tulips does not match up at all with the wall in the first version of the composition. Was the background carefully painted over when that section was moved? The major problem, though, is the blue border around the bed. Clearly there was none at first: and the present border is almost entirely painted on new canvas. The exceptions — its upper left corner and the piece extending from its lower left corner most of the way over to the right edge — show up as recent overpainting in an infrared photograph.

We thus have several different possible compositions. First, there is the original version with the moth at the left and the tulips lower down and closer to the vase. Second, there is a composition similar to what we see today, but very probably *without* the raised border around the tulip-bed. It is possible that Oudry himself is responsible for the changes, responding, perhaps, to the wishes of his patron. Then comes the third version, about which we know nothing: the pieces arranged differently on a larger canvas. And finally there is the picture now in Detroit which is a close approximation of the appearance of version number two. This is as far as we can go at present. What is needed is an intensive analysis of the paint layers of the canvas; the laboratory report mentions overpaints both atop and beneath the present varnish. Or we need to discover complete descriptions of the picture at various times in the past (the catalogue of the Richelieu sale only says that the tulip-bed is on the right, and the bronze vase of flowers to the left; it does not mention the position of the moth). All we can be absolutely sure of is that at least two of the possible four versions just listed did exist: the first one (intact canvas) and the last. What happened in between, and most important, *when* it happened, remains obscure.

Oudry talks about the technical aspects of flower painting in one of his discourses, and this passage is worth citing here because the Detroit picture is certainly his most ambitious flower piece:

> Pour peindre les fleurs, on est assez dans l'usage d'ébaucher, mais légèrement et par grandes masses, et uniquement afin d'avoir un fond qui, par son ton, puisse faciliter la pureté et la netteté du travail qu'on veut faire dessus. J'ai encore à observer qu'il y a pour les fleurs une sorte de travail particulier qui ne doit pas moins contribuer que la couleur à indiquer le degré juste du brillant, du satiné, du velouté et du mat, qui caractérise chacune d'elles, ainsi que sa minceur et son épaisseur. L'illustre Baptiste [Monnoyer] est, à mon gré, un grand maître en cette partie, et bien plus utile à consulter que tout ce que les Flamands nous ont envoyé de plus fini et de plus précieux. Chez eux, fleurs et fruits, tout est peint de la même façon, de la même touche, d'un travail aussi fouillé dans les ombres que dans les clairs; toutes leurs fleurs, toutes leurs feuilles indiquent une même épaisseur. Chez lui, chaque objet est caractérisé par un

travail qui lui est spécialement propre; ses roses sont minces, ses lis ont du corps; son intelligence est toujours juste par des tournants sacrifiés à propos qui mettent tout en valeur. Quelle bizarrerie qu'un aussi excellent modèle soit si peu recherché par notre jeunesse au milieu du besoin que dans tous les genres on a de ce talent! (Oudry, 1752 [1861-1862], p. 115)

Oudry's naturalism comes across well in this passage: no two species of flower are the same, and each must be painted differently in order to capture its individuality. The care and the love with which he approached flowers can be seen to perfection in the Detroit *Tulips*. Even if the present arrangement may not be quite like Oudry intended it, nevertheless this is a marvellous piece of painting.

The patron was probably Charles-Antoine Leclerc de la Bruère (1715-1754), a playwright in favor at the court of Louis XV. Late in 1744, under royal *privilège*, he became co-publisher of the *Mercure de France*. In 1748 his protector, the Duc de Nivernais, was named ambassador to Rome; la Bruère accompanied him as secretary and remained in Rome as chargé d'affaires; he died there of smallpox in 1754. Several of the short operas for which he wrote the words were presented at Versailles in 1747, 1748, 1749 and 1750, with Madame de Pompadour in prominent roles. La Bruère, to our knowledge, was not among the important collectors and patrons of his day. There are some coincidences, perhaps of no consequence, but which might be pursued: Madame de Pompadour was an avid gardener; it was very early in 1744 (the date of Oudry's picture) that she was first presented to Louis XV, and she became the king's official mistress in 1745, when Oudry's picture was shown in the Salon. Another question might also be worth pursuing: Oudry's picture is a combination of two types, one of them extremely common (vases of flowers) and the other excessively rare (flowers growing in the earth). Of the latter type there exists the unique painting of a *Tulip-Bed*, dated 1638, by Jacob Gerritsz Cuyp, which recently entered the Dordrecht museum (cf. L. J. Bol, *The Bosschaert Dynasty*, Leigh-on-Sea, 1960, p. 55, repr. pl. 62b). Oudry may have known a similar prototype.

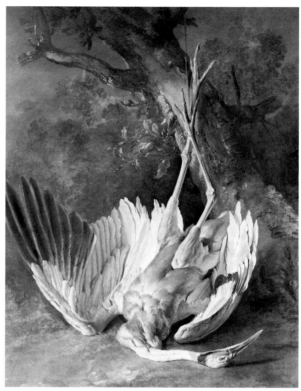

74

74 *(Colorplate on page 21)*
Dead Crane

Canvas. H. 162; W. 127.5.
Schwerin, Staatliches Museum, inv. no. 187.

Provenance: as cat. no. 49 above.

Exhibitions: 1745, Salon, no. 36; 1982-1983, Paris, no. 104 (repr.).

Bibliography: Groth, 1792, p. 56, no. K26; Lenthe, 1836, no. 118; Dussieux, 1876, p. 190; Schlie, 1882, no. 804; Seidel, 1890, pp. 90, 99 ff., 109; Locquin, GBA, 1906, repr. p. 301; Locquin, *Catalogue*, 1912, no. 78; *Gemälde alter Meister*, n. d., repr. pl. 50; Réau, 1928, p. 197; Vergnet-Ruiz, 1930, no. I, 298; *Katalog*, 1954, no. 300, repr. pl. II; *Führer durch die Kunstsammlungen des Staatliches Museums Schwerin*, 1965, repr. p. 15; Lauts, 1967, repr. pl. 9; Venzmer, 1967, repr. in color, pl. 7; Opperman, 1972 [1977], I, pp. 112, 191, 554-555, cat. no. P514, II, p. 946, repr. p. 1126, fig. 307; Faré and Faré, *La Vie silencieuse* ... , 1976, p. 126, repr. fig. 174.

In the Salon of 1745, Oudry exhibited three final pictures from the series of animals done for the Royal Botanical Garden (see cat. nos. 49 and 52 above):

this one, a *Cassowary*, and a *Tufted Crane, Demoiselle and Toucan*. All were purchased for Schwerin in 1750, and are still there today. The last two are signed and dated 1745, but the *Dead Crane* is not signed in its present state. It has almost exactly the same dimensions now as when it was painted (five French feet by four, or 162 by 130 cm.), but it shows some paint losses, particularly below. No doubt it was once signed and dated 1745, like the others.

The bird is not the common crane of Europe (*Grus grus*); although it is somewhat similar in coloration, there are differences in the amount of red on the head and neck, in the white-tipped wing feathers, and in other details, particularly size. Rather this is the much larger Sarus crane (*Grus antigone*), a native of India, although neither the Salon *livret* nor Oudry's memorandum for Schwerin says so. Thus nearly all of the birds and animals represented in the twelve pictures for La Peyronie were exotic. Perhaps the most exotic of all was the cassowary, which we reproduce here from the preparatory drawing in the Albertina (Fig. 111) rather than the painting in Schwerin. Its behavior is described with great relish in the *livret* of the Salon of 1745:

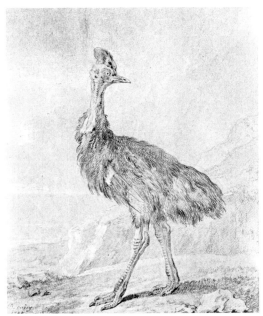

Fig. 111 *Cassowary.* Dated 1745. Vienna, Graphische Sammlung Albertina.

Cet Oiseau est extrêmement rare, il vient de l'Isle de Benda [i. e., from one of the small islands forming the Banda group, in the Moluccas, in the eastern part of present-day Indonesia], & n'a ni langue, ni queuë, ni aîles; il avale indifferemment tout ce qu'on lui donne, même jusqu'aux charbons les plus ardens; il casseroit la jambe d'un homme avec sa patte.

The *Crane* is the only one of the series to depict a dead animal, and we should perhaps be thankful to Oudry for this innovation, for he here created one of his most appealing still lifes. In the description sent to Schwerin in 1750 it is described thus: "La Grue, c'est un oyseau qui a de haut 5 pieds estant debout; mais le sr Oudry l'a peinte morte, attachée à un tronc d'arbre." Why he chose to do so is not known. Perhaps it was just for variety, or perhaps he happened to visit the ménagerie at Versailles at a time when a crane had just died. In addition to the instinctively satisfying arrangement of the crane and the tree behind it, and the sensitive distribution of light, the picture is an especially successful essay in the rendering of feathers, which are painted quickly and thinly to achieve their full effect. A couple of passages from Oudry's second *conférence* are revealing in this respect (Oudry, 1752 [1861-1862], pp. 114-115):

La manoeuvre requise pour peindre les oiseaux, ou, comme l'on dit, *la plume*, est presque l'opposé de celle [requise pour peindre un animal à poil]. Pour imiter ce beau lisse dont la nature embellit l'objet, il faut un travail très-uni depuis la première préparation jusqu'à la fin. Il faut en même temps que ce travail soit très-net pour donner à la plume cet oeil mince et délié qui la caractérise. On conçoit aisément que la térébenthine ne doit point être épargnée; des couleurs trop épaisses ne pourraient manquer de rendre lourd et raboteux; les petits glacis y sont souvent d'un grand secours pour donner certaines transparences et certaines finesses dans les passages: mais il ne faut jamais faire ces glacis qu'avec des couleurs qui soient extrêmement bien broyées, parce sans cela elles pourraient laisser des petits grumeaux qui donneraient à ce travail un oeil terne et sablonneux. . . .

Les procédés requis pour peindre le poil et la plume ... présupposent un point particulier de pratique que nous appelons *peindre au premier coup*. Elle m'est devenue très-familière par une espèce de nécessité. Les modèles dont je me sers pour mon talent, étant rarement en vie, sont sujets à se corrompre promptement, surtout en été; je me suis donc accoutumé à les expédier tout de suite, et pense en avoir trouvé le moyen, et avec autant de fraîcheur, même pour les blancs, que si j'y mettais nos préparations successives. ...

Ce que j'ai dit ci-devant sur l'attention que je voudrais qu'on donnât à faire des teintes bien justes sur le naturel, doit être pris ici à la grande rigeur. Ces teintes ainsi faites, il faut commencer par bien dessiner son objet avec celles qu'on aura faites pour les ombres. On doit accuser ce dessin largement, c'est-à-dire par masses, et non par un simple trait. Il faut ensuite former les parties claires de l'objet de la même façon et avec les teintes qui leur sont propres; mais il faut être prévenu que ce premier travail doit être fait très mincement, et toutefois avec des couleurs non délayés. La raison est que, si l'on débutait par empâter un peu épais avant qu'on eût suffisamment préparé les formes contenues dans les diverses masses, la superficie de cet empâtement graisserait avant les dessous, ferait rouler la couleur, empêcherait qu'on pût travailler les teintes les unes dans les autres et s'étendre sur toutes les demi-teintes par les épaisseurs qu'on trouverait dans son chemin. On sent bien aussi pourquoi je demande que ce premier fond de travail soit fait avec des couleurs non délayées, et que c'est afin que ce fond soit assez solide pour recevoir le travail qu'il y aura à faire dessus, sans céder au premier coup de brosse ou de pinceau, et s'en aller comme par égratignure. Ce travail s'y doit établir en modelant et en prononçant à mesure les formes particulières, toujours avec des teintes justes, en renchérissant un peu sur celles qu'on aura commencé à employer, et avec cette attention de ne jamais porter le pinceau ou la brosse sur la toile sans l'avoir auparavant chargée de couleur, peu à la fois à la vérité, mais non autrement. En opér-

ant de cette façon, on verra, à mesure qu'on avancera, l'ouvrage se caractériser, s'arrondir, se colorer et devenir susceptible de recevoir dans le gras ces derniers coups de finesse et ces touches spirituelles et moelleuses qui font le beau terminé et l'âme de la bonne exécution.

We have thought it useful to present these somewhat technical passages here, because they explain the "look" of the birds painted in Oudry's last period, by which time he had developed a much more rapid and economical technique than before, as part of his aesthetic of the "beau terminé."

75

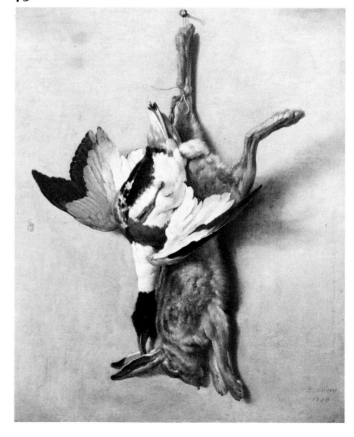

75 *(Colorplate on page 22)*
Still Life of a Hare and a Sheldrake

Canvas. H. 88; W. 71.
Signed and dated, below left: *J B. Oudry / 1740*
Private collection, U.S.A.

Provenance: Sale of Monsieur de Merval, Paris, 9-17 May 1768, no. 116 (72 livres to Renouard); anonymous sale, London (Sotheby's), 8 July 1981, no. 113 (repr. in color); acquired by the present owner on the New York art market in 1982.

Bibliography: Opperman, 1972 [1977], I, pp. 232, 551, cat. no. P505 (Merval sale).

"Un rond à fond blanc, représentant un lapin et une perdrix:" this excerpt from the *livret* of the Salon of 1739 was for two centuries all that historians had as a reminder of the splendid picture from Drottningholm Castle (Fig. 35; cf. Paris 148). And yet that picture — the first of the "white ground" still lifes so characteristic of the last period — was quietly there all along. It is one of the most fascinating aspects of Oudry's critical fortune that essentially every one of his late trompe-l'oeil pictures should have fallen into near-total oblivion until very recently, given their great success in the eighteenth century. Even though they disappeared from public view they did not perish, but were carefully, even preciously, preserved in private by those who knew how to appreciate their merits, and now they are coming to light again.

The Drottningholm still life was not available for exhibition in America; we have substituted for it this equally beautiful and even less known work executed a year later, which itself was not available for the Grand Palais. It was not shown in a Salon, which is highly unusual for such pictures. It must have been commissioned by someone too jealous of his new possession to give it up even for a month. Perhaps this was Monsieur de Merval, with whose collection the picture was sold in 1768, precisely described: "Un Lievre & un Canard groupés ensemble, attachés par une ficelle à un clou sur la muraille. Ce Tableau a été peint en 1740 sur toile de 2 pieds 9 pouces de haut [89.4 cm.], sur 2 pieds 2 pouces de large [70.4 cm.]." We have found no mention of it afterwards until 1981 when it was sold as "the property of a gentleman," having been "in the present owner's family since at least the middle of the last century."

The Merval picture — for want of a better name — is painted on a darker wall than the one from Drottningholm and is not, perhaps, a "fond blanc" in the strict sense of the word; its background is light and neutral, though, and it is a trompe-l'oeil exercise in the same vein as the *Hare, Duck, Bottles, Bread and Cheese* (Fig. 45) and the *Antlers* (Fig. 112), both from 1742. It is a superbly constructed study in equilibrium, based on the centered perpendicular of the hanging game, with the projecting wing and the hare's ears sharply silhouetted on the left, balanced by the single leg on the right and the "weight" of the graduated shadows. The color range moves out from the dirty white feathers of the duck to the mat black of its wingtips and head (with accents in the ears of the hare), and to the browns and greys of the soft pile of the fur. The rusty band across the bird's breast is picked up in the tailfeathers and in the drop of blood suspended from the nose of the hare; the background of an earthy grey serves as a sounding board for the tonal harmony of the subject group. This is a consummate trompe-l'oeil, and begs to be compared to Oudry's rival, Chardin. Over the last century such comparisons have often been made, usually in Chardin's favor, implying that Chardin, with his greater impasto and more profound understanding of color and form, was a true artist while Oudry was nothing but a master of cheap illusion. Charles Sterling has devoted several paragraphs to this relatively recent phenomenon of looking at trompe-l'oeil pejoratively, and we would like to quote him at some length, for he sensitively recaptures the attitude of Oudry's contemporaries who admired pictures such as this.

As the easel picture, ever since Van Eyck, has been essentially an "open window on nature," an illusive representation of depth and relief, what is the difference between it and *trompe-l'oeil?* This difference comes down to the following points. A *trompe-l'oeil* is a *painting which sets out to make us forget the fact that it is a painting, which aspires to be a fragment of reality.* To achieve this end, it suggests not only spatial recession but also the space *in front* of the picture surface; it sets up a *continuity* between the space figured in the painting and the real space in which the spectator stands — and does so by making the relief of the body represented (an

object, a hand etc.) project out aggressively beyond the frame, towards us. It keeps the *exact dimensions* of nature. Lastly, it employs a smoothly blended, *invisible execution*.

When this aim and these three conditons are rigorously respected, then — but only then — we can speak of a perfect *trompe-l'oeil*. But this perfect *trompe-l'oeil* is very rarely achieved: it may be said that it can only be achieved by pure craftsmen, by non-artists; this moreover is obvious, inasmuch as the essential purpose of such a work is to make us forget that it stems from art, that it resorts to an artifice. A certain number of recipes and "tricks of the trade" suffice. But ask a real painter, an artist, to abide by the three conditions: he will try hard, but the chances are he will prove incapable of not transgressing them; he will produce a work of art in spite of himself. He will exactly reproduce the dimensions of nature, he will make his brushwork invisible, he will create the impression that the picture surface does not exist, that objects really stand in the same space as we do; but instinctively, in the arrangement of objects and in the color scheme, he will cause a rhythm, a harmony, a choice, a taste to show through, and we shall at once be made to feel *the presence of art*, we shall at once be given notice that *we are in front of a painting* and not in front of reality. The fundamental, the exclusive purpose of *trompe-l'oeil* will have miscarried; the work in question will be a painting of a particular realistic tone, often more powerful than that of reality itself, imbued with a disquieting magic of the palpable, of the present. Such is the case with the *"trompe-l'oeil"* paintings of [many masters from the sixteenth through the nineteenth centuries] who, while aspiring to make decorations indistinguishable from reality, all ended by frankly acknowledging their capacity as poets and artists. Their works are examples of *artistic trompe-l'oeil*. ...

Are we to conclude that the use of the term should be exclusively reserved to successful *trompe-l'oeil*, in other words to the craftsman's entertaining mystifications? For my part, I cannot approve of any such purism. These works are quite rare, whereas artistic *trompe-l'oeil* pictures have been preserved in large numbers — which proves, incidentally,

that the public was not taken in, that it sensed the presence of art and acquiesced in the destruction of paintings which were no more than playthings. The latter I would designate *"trompe-l'oeil* properly so called;"* and I shall speak of a *"trompe-l'oeil* quality"* or *"trompe-l'oeil* procedures"* in connection with fine paintings which on the surface tend towards literal verisimilitude — on the surface, for actually they go well beyond it. (Sterling, 1959 [1981], pp. 152-153)

Oudry's "artistic trompe-l'oeil" pictures have survived and continue to be admired as they deserve to be for their qualities of composition and color, not just because they are illusions. The arrangement of a hare and a sheldrake, seemingly so simple, so natural, so artless, is in fact thought out with great care, every bit as much as in the late still lifes of Chardin.

76 *(Colorplate on page 24)*
Deformed Stag Antlers against a Background of Boards

Canvas. H. 115, including additions of 4 cm. below and 11 cm. above; W. 69.
Inscribed on a piece of paper attached to the wall, above left: *Teste bizarre d'un Cerf/pris par Le Roy/le 3. Juillet 1741.* Signed and dated, below left: *Peint Par J. B. Oudry 1741*
Fontainebleau, Musée national du Château de Fontainebleau, inv. no. B 901.

Provenance: Painted for Louis XV; according to Lastic, was displayed at Versailles "dans l'escalier demi circulaire qui mène aux petits appartements royaux près de la cour des cerfs"; French national collections; sent from the Louvre to Compiègne in 1834; returned to the Louvre in 1838; sent to Fontainebleau in 1845.

Exhibitions: 1741, Salon, no. 36; 1975-1976, Toledo-Chicago-Ottawa, no. 76 (repr. in color); 1982-1983, Paris, no. 149 (repr. in black and white; color repr. p. 35).

Bibliography: Notice des Tableaux placés dans les appartements du palais royal de Compiègne, 1837, p. 8, no. 13; Locquin, *Catalogue,* 1912, no. 71; Vergnet-Ruiz, 1930, no. I, 295; Lastic, 1967, repr. fig. 7; Opperman, 1972 [1977], I, pp. 118-119, 187-188, 551-552, cat. no. P507, II, p. 945, repr. p. 1114, fig. 283; Faré and Faré, *La Vie silencieuse* . . . , 1976, p. 128; Faré and Faré, *L'Oeil,* 1976, p. 5; Lastic, 1977, p. 299 (wrongly dated 1740).

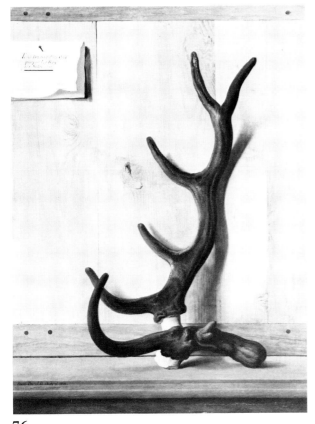

76

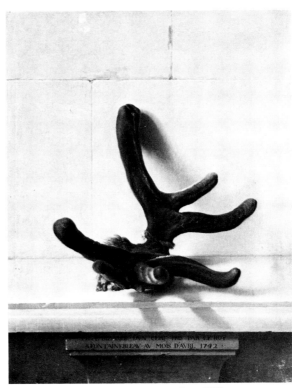

Fig. 112 *Deformed Stag Antlers against a Stone Wall*, painted for Louis XV. Dated 1742. Fontainebleau, Musée national du Château de Fontainebleau.

As with the *Tulips* in Detroit we are once more in the domain of "curiosité." There are six paintings of "bizarre" antlers of stags hunted by the King in Oudry's *oeuvre*, and this is the first. All are today at Fontainebleau. Let us list them rapidly: 1) the picture here catalogued, on a background of boards; according to Lastic, the stag was taken in the forest of Rambouillet; 2) a painting dated 1742, on a stone background (Fig. 112); the stag was taken at Fontainebleau; 3) antlers on a light blue background, very probably the stag taken at Marly in April of 1749, although the date is concealed by a strip of new canvas; 4) antlers on a background of boards, very similar to the picture here catalogued, of a stag taken at Compiègne in 1749; 5) the head of the stag hunted at Fontainebleau in 1750 [**78**]; 6) finally, antlers of a stag taken at Compiègne in 1752, which Lastic proposes to identify — correctly, in our opinion — with an unsigned painting of antlers

on a background of feigned marble. The first two are not mentioned in the accounts of the Bâtiments du Roi, published by Engerand; but in a document concerning the third of them, dated 1749, Oudry mentions that he had previously done two. He asked 240 livres, plus expenses, for each of the six.

Although most of the *trompe-l'oeil* pictures of the late period have backgrounds of stone or plastered walls, there are a few where the objects appear against rough boards, following a tradition of similar paintings by Netherlandish masters of the preceding century. But the most striking analogy is the famous panel in Munich by Jacopo de Barbari, painted in 1504. Not only is the theme of the hunt the same, as well as the background, but Oudry even employs the illusionistic *cartellino*, by then quite old fashioned. That picture, though, was painted in Germany and probably never

left that country. It is first cited in the late eighteenth century, and it would seem impossible for Oudry to have known it.

The "point" of a picture like this is, of course, illusion — the more difficult task of making the object appear to advance from a background similar to it in color and texture rather than from a clear and uniform wall. Late in his career Oudry would paint two pairs of pictures where these two problems of illusionism would be set forth as lessons: white objects on a white ground and colored ones on a colored ground (see cat. no. 79). It would seem that the origins of that didactic idea should be sought in the antler pictures, particularly the first two of them with their contrasting grounds.

The illusionism of these *Antlers* was appreciated by a critic of the Salon of 1741:

> Je ne crois pas qu'il y ait jamais eu ni qu'il y ait jamais rien de mieux en ce genre. *Le Bois de Cerf* est à prendre à la main. Il paroît posé contre des *Planches* qui sont si trompeuses, qu'on ne sçauroit se défendre de croire que le Peintre a travaillé sur des Ais ajustés ensemble, & quoi qu'on sache qu'on est dans un Salon de Peinture, il faut raisoner pour s'imaginer que ce soit un Ouvrage de cet Art. (*Lettre à Monsieur de Poiresson-Chamarande... au sujet des Tablaux exposés au Salon du Louvre*, Paris, 1741, pp. 9-11)

But this is not illusion alone. The carefully chosen position of the antlers, their relationship to the piece of paper and to the cast shadow, make a solid, stable composition interesting from a purely formal point of view. Oudry seems to have struggled to achieve regularity while depicting an irregular object, or perhaps more accurately, to create a tension between the regular and the irregular; in his "rococo" still lifes of the 1720s, on the contrary, he deliberately sought imbalance. Evidence of his effort to counteract it here is visible to the naked eye. The antlers were originally positioned with the top leaning quite a bit further to the left, but Oudry changed his mind. The first version of the composition has been painted over and persists, shadow-like, beneath the grain of the boards.

Our colorplate shows the added strips above and below; they have been cropped in the half-tone reproduction.

77
Still Life of a Hare and a Leg of Mutton

Canvas. H. 98; W. 73.
Signed and dated below left: *J B. Oudry/1742*
Cleveland, The Cleveland Museum of Art, Purchase, John L. Severance Fund, inv. no. 69.53.

Provenance: Painted for the dining-room of Monsieur de Vaize; reappeared in 1956 as having remained in the family of the patron; anonymous sale, Paris, Galerie Charpentier, 15-16 December 1958, no. 64 (repr.); anonymous sale, Paris, Palais Galliera, 4 December 1963, no. 200 (repr.; 19,000 francs); Cailleux, Paris; private collection, New York; Knoedler, New York; acquired by the museum in 1969.

Exhibitions: 1742, Salon, no. 35; 1956, Paris, no. 81; 1979, Cleveland, no. 5, discussed and repr. p. 21, repr. in color opp. p. 10.

Bibliography: Locquin, *Catalogue*, 1912, no. 74; *Bulletin of the Cleveland Museum of Art*, LVII, January 1970, p. 48, repr. p. 18; *Chronique des Arts*, February 1970, p. 70, no. 323 (repr.); Talbot, 1970 (repr. in black and white and in color); Davidson, 1970, p. 705 (repr.); Opperman, 1972 [1977], I, pp. 120, 189, 552-553, cat. no. P509, II, p. 945, repr. p. 1116, fig. 288; Clark, 1974, repr. p. 309; Faré and Faré, *La Vie silencieuse...*, 1976, p. 125, repr. in color p. 121; *Handbook*, 1978, p. 178 (repr.).

The only information about the picture's origins comes from the *livret* of the Salon of 1742 where it is described (without dimensions) as "destiné pour la Salle à manger de M. de Vaize." Attempts to identify the patron — should Vèze be the correct spelling? — have proved unsuccessful. Here again we have one of those startling trompe-l'oeil still lifes of Oudry's last years that were all but unknown to modern critics prior to relatively recent times. The Cleveland picture is one of the most accomplished and certainly the least compromising of them all in the simple force of its compositional mechanics and the dispassionate juxtaposition of the dead but unskinned hare and the bone, muscle and subcutaneous fat of the joint of meat, with a lighting source so bright and even, against a surface so clean and bare, that one cannot help but sense a clinical atmosphere that seems today more appropriate to dissection than to dining. William Talbot, in 1970 and also in the exhibition catalogue of 1979, has insightfully compared the

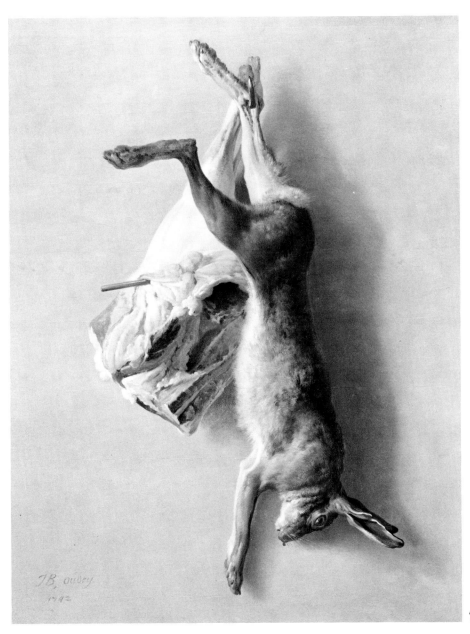

77

picture to similar subjects by Chardin in formal and technical terms. To his observations might perhaps be added another more essential difference, on a psycho-social plane. Chardin's still lifes always communicate a sense of human presence born of daily use and loving familiarity with the objects they portray: even his dead game somehow conveys a sense of history, of time on an ordinary human scale. But Oudry's pictures seem so new, as if removed from life's routine, non-continuous with past and future, with no subjectivity other than their own. There is a consciousness of "mode" — fashion of taste — that is certainly a reflection of upward mobility in the bourgeois society from which he drew his patrons, and of that of Oudry himself.

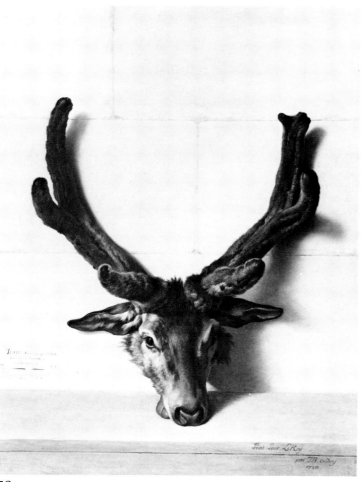

78

Provenance: painted for Louis XV; probably at Versailles throughout the eighteenth century; French national collections; recorded as having been sent to Fontainebleau in 1834, and again in 1845.

Exhibition: 1982-1983, Paris, no. 150 (repr.).

Bibliography: Engerand, 1900, pp. 373-374; Locquin, *Catalogue,* 1912, no. 86; Vergnet-Ruiz, 1930, no. I, 301; Lastic, 1967, repr. fig. 10; Opperman, 1972 [1977], I, p. 557, cat. no. P519; Faré and Faré, *La Vie silencieuse...,* 1976, p. 128; Lastic, 1977, p. 299.

Du 16 novembre 1750:
Reçu un ordre de M. de Tournehem pour me rendre à Choisy avec toille et couleurs et pour peindre une tête bizarre d'un cerf, que le Roy a pris en revenant de Fontainebleau, ledit tableau a été ébauché à Choisy et fini à Paris, pour le tableau . 240 livres
Frais de carosse de remise 13 livres
Deux hommes avec un brancard pour porter plusieurs toilles ne sachant pas la grandeur que le Roy désiroit qu'elle fut peinte, pour ce . 8 livres
Le 20, renvoyé de l'ordre du Roy, à Choisy, la tête peinte et finie, pour ce 4 livres
Livré le 22 à Versailles ledit tableau (de 5 pieds 3 pouces de haut sur 3 pieds 3 pouces de largeur), pour port du crocheteur 4 livres
Pour frais de voiture de carosse 12 livres
En tout . 281 livres

The entire history of a picture, from start to finish, is encapsulated in this memorandum which we decided to cite in full, following Engerand's text, supplemented by a clarification from the Duc de Luynes (1860-1865, IX, p. 372). On Sunday, 15 November, the King left Fontainebleau in the morning with the Dauphin and the Dauphine to hunt the stag at Epine-Foireuse, intending to go on to Choisy after the hunt to spend the night there. There is a Carrefour de l'Epine in the northwest part of the forest, in the vicinity of Barbizon and also in the direction of Choisy; today it is traversed by the Route Nationale 7. The Mare aux Evées, where the stag was taken, is about 3 km 800 to the north of there. But the hunt took place on the fifteenth, not the sixteenth as the inscription states. Oudry must have received the order to come out to Choisy on Monday, the day after the stag was killed. He did his preliminary work directly on the canvas at Choisy, probably the same day, then took it

78 *(Colorplate on page 25)*
Head of a Stag with Deformed Antlers, against a Stone Wall

Canvas. H. 171, including additions of 21 cm. above and 6 cm. below; W. 108, including additions of a bit less than 2 cm. at each side.
Signed and dated below right: *Peint Pour Le Roy/par J B. Oudry/1750;* inscribed below left: *Teste D'un Cerf pris par Le Roy/dans la forêt de Fontainebleau/ 'le 16. Novembre 1750/Attaqué à la basse Pommeraye et pris à la/Mare aux Evées. P. M.*
Fontainebleau, Musée national du Château de, Fontainebleau, inv. no. B 899.

back to Paris to finish it. By Friday 20 November it had been completed, varnished, and had dried sufficiently to be sent back to Choisy that day. Allowing for drying time, this means that Oudry did all of the finishing work in not much more than a day. The careful, meticulous appearance of his paintings is deceptive, and the case of the *Stag Head* reveals just how quickly he could paint. Oudry had perfected the technique he called *peindre au premier coup*, described in his own words under catalogue number 74 above. With the documentation of this painting we can see how efficacious it was.

Oudry asked 240 livres for it — the same basic price as for the others [cf. **76**] — but he received 300 in addition to his expenses. Could this be because he had to paint the entire head, not just the antlers? Or did the King recognize some special quality that distinguishes it from the rest? Certainly this is a haunting, unsettling work, surrealistic in some ways. The beauty of the composition — again, so simple and direct — and of the light and shade, the harmony of the color scheme in browns and greys, all of these aesthetic qualities that attract and please are brought to bear on a work whose only subject is death.

We examined the canvas in the ateliers of the Louvre in 1981 (it had not been removed from the woodwork in the passageway of the Appartements des ducs d'Aumale et de Montpensier since 1845), but cleaning and restoration had not yet begun. It appeared to us that the size of the surviving original canvas was about 144 by 105 cm. However, the *total* size of the canvas, including what look to be crudely painted additions, approximates the original dimensions from the document of payment, which correspond to 170 by 105 cm. It may well be that cleaning will reveal that only the two strips at the sides are additions, and that what seem to be extensions above and below are in fact part of the original canvas. Our colorplate shows the full dimensions, while the supposed additions have been cropped in the half-tone reproduction.

79 *(Colorplate on page 28)*
Still Life with a Hare, a Pheasant, and a Red-legged Partridge

Canvas. H. 97; W. 65.
Signed and dated, below left: *J B. Oudry/1753*
Paris, Musée du Louvre, inv. no. M.N.R. 116.

Provenance: Property of the painter when shown in the Salon of 1753; Chevalier Damery in 1761; sale of Jean-François de Troy and others, Paris, 9-19 April 1764, no. 112 (250 livres 10 sols to De Hangeac or De Langeac; the picture cannot have belonged to de Troy, since he died in 1752, before it was painted); Lieutand sale, Paris, Hôtel Drouot, 8 December 1923, no. 27 (1600 francs to Barachin); found in Austria after the last war and returned to France as part of the "récupération artistique"; assigned to the Louvre by the Office des Biens privés in 1950.

Exhibitions: 1753, Salon, no. 24; 1959, Paris, no. 49 (repr.); 1967, Rambouillet, no. 39 (repr.); 1982-1983, Paris, no. 152 (repr.).

Bibliography: Gougenot, 1761 [1854], p. 400; Locquin, *Catalogue,* 1912, no. 95 (Salon of 1753, Damery collection, and sale of 1764); Vergnet-Ruiz, 1930, no. VII, 36 (sale of 1764); Faré, 1962, II, repr. fig. 345; Opperman, 1972 [1977], I, pp. 120, 204, 206-208, 212, 230, 560, cat. no. P525, II, p. 946, repr. p. 1161, fig. 377; Rosenberg, Reynaud and Compin, 1974, II, no. 610 (repr); Faré and Faré, *La Vie silencieuse...,* 1976, p. 132, repr. fig. 203.

This picture cannot be discussed without first recalling in some detail its celebrated pendant, the *Canard blanc* (Fig. 113). We would have liked to exhibit the two pictures side by side for the first time since the Salon of 1753, but regrettably this was not possible. The *Canard blanc* was bought from the artist for Count Tessin, through an intermediary, even before the opening of the Salon; Oudry insisted on exhibiting it, and it went to Sweden as soon as the Salon closed (see the essay by Gunnar Lundberg, in Bjurström, 1970, pp. 76-80). Between the Tessin sale of 1771, held in Sweden, and its reappearance in the Montesquiou-Fezensac sale in Paris in 1929, historians seem to have been completely unaware of the picture. Georges de Lastic has recently given us references to two sale catalogues that go a long way toward completing the pedigree. The painting was sold (for 51 francs!) with the collection of the Comte de Montesquiou in Paris, 3 February 1823 and following days, no. 43. Since it was still in the Montesquiou family more than a hundred years later, there can be little doubt that the *Canard blanc* was simply repurchased in 1823, and that it was quietly passed along, unnoticed by specialists. M. de Lastic also pointed out the painting in the sale of Lieutenant General Baron Thiébault, Paris, 25-26

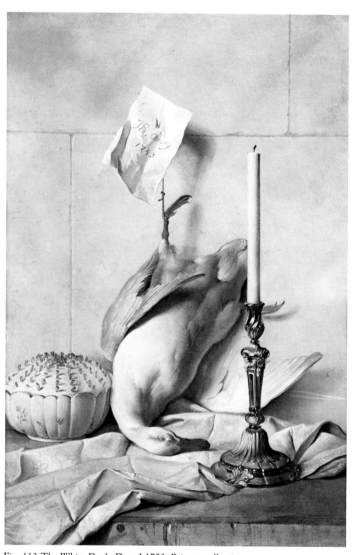

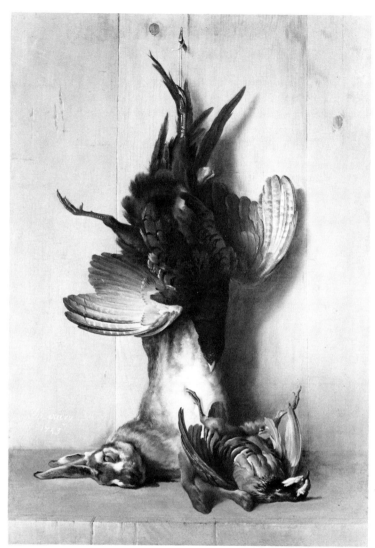

Fig. 113 *The White Duck*. Dated 1753. Private collection.

79

February 1817, no. 73 (50 francs). It must have gone to the Comte de Montesquiou directly from this sale or soon thereafter. But where had it been since Tessin's Swedish sale of 1771? We have no proof, but would like to suggest a plausible answer to this question. Baron Thiébault (1769-1846) was a highly successful military officer during the Revolution and the Empire; his army career ended in 1814. There is no particular evidence that he was interested in the arts. The collection he sold in 1817 was both large and high in quality, and it is difficult to believe that Thiébault could have put it together during his years of extraordinary activity as a soldier all over Europe (beginning in 1789, when he was only twenty) or in the short period between 1814 and the sale in 1817. Further, if he possessed the love of painting and the excellent taste requisite for assembling such a collection, why did he sell it nearly thirty years before his death? These objections disappear if we assume that he inherited all or most of the collection from his father, Dieudonné Thiébault (1733-1807), a well-known intellectual in his day. In 1765 the elder Thiébault accepted the chair of general grammar in the Military School founded by Frederick the Great and moved to Berlin, where his son was born; he remained there for twenty years, returning definitively to France in 1784. According to various biographical dictionaries of the early nineteenth century, Dieudonné Thiébault was held in high esteem by members of the Prussian royal family, most particularly Frederick's brother Prince Henry, whose interest in painting is well known, and his sister Lovisa Ulrika (1720-1782), who in 1744 had married Adolphus Frederick, King of Sweden from 1751 to 1771. Here is the Swedish connection we have been looking for. Lovisa Ulrika and her son, the future Gustavus III, were avid collectors of painting and acquired many works from the collection of Count Tessin prior to his death in 1770. The *Canard blanc* must have gone from the Tessin sale in 1771 to the Thiébault collection, perhaps via the intermediary of Lovisa Ulrika. It may some day be possible to confirm this through the *inventaire après décès* of Thiébault père; through the latter's long publication on Frederick the Great, his family and his court, a work we have not yet consulted; through the *Mémoires* of the son, published by his daughter, which again we have not seen; or through the correspondence and other papers of Lovisa Ulrika. If our hypothesis is correct, an essentially unbroken provenance will have been established for Oudry's most celebrated picture.

The triumph of the *Canard blanc* in the Salon of 1753 was complete. Most critiques mention it, usually at length and always with praise. This is an "academic" picture, designed, as Grimm tells us in his account of the Salon (*Correspondance littéraire*, 1877-1882, II, pp. 282-283), to illustrate a point Oudry had made in his *conférence* of 1749:

> Je suppose que vous vouliez peindre seul, sur une toile, un vase d'argent: l'idée générale qu'on se fait de la couleur d'argent est qu'elle est blanche; mais pour rendre ce métal dans son vrai, il faut déterminer ce blanc juste qui lui est propre en particulier. Et comment déterminer cela? Le voici: c'est en mettant auprès de votre vase d'argent plusieurs objets d'autre blanc, comme linge, papier, satin, porcelaine. Ces différents blancs vous feront évaluer le ton précis du blanc qu'il vous faut pour rendre votre vase d'argent, parce que vous connaîtrez par la comparaison que les teintes de l'un de ces objets blancs ne seront jamais celles des autres, et vous éviterez les fausses teintes que sans elles vous courez risque d'employer toujours. (Oudry, 1749 [1844], p. 39)

In fact, this idea of the relativity of whiteness is not new to Oudry. It is stated in practically the same words by the father of Renaissance art theory, Leon Battista Alberti, in his *Della pittura* of 1435, which was widely read in French academic circles following the French translation by DuFresne published in Paris in 1651 (re-edition, Naples, 1733). We quote here from the modern English edition by John Spencer (Yale University Press, revised 1966, pp. 54-55):

> All knowledge of large, small; long, short; high, low; broad, narrow; clear, dark; light and shadow and every similar attribute is obtained by comparison. ...Ivory and silver are white; placed next to the swan or the snow they would seem pallid. For this reason things appear most splendid in painting where there is good proportion of white and black similar to that which is in the objects — from the lighted to the shadowed.

For Oudry, then, an exercise in extreme *trompe-l'oeil* such as the *Canard blanc* was not a mere game, but the demonstration of a fundamental principle of illusionism backed by the full authority of academic tradition. This is confirmed by the judgment of his contemporaries, all of whom took the picture seriously.

The uniqueness of Oudry's picture lies not just in its assembly of "white" objects, but in his presenting them on a white ground. He had made one previous essay in this, a picture last cited in a sale in 1933, representing three gulls against a white stone wall, painted in 1750 and exhibited in the Salon that year (Fig. 114). Like the *Canard blanc*, this was received with great favor by the critics and for the same reasons. And like the *Canard blanc* it had a companion piece, showing a dead hare, red-legged partridge and two snipes with a dark stone wall behind them, today in the Worcester Art Museum (Fig. 115). The latter is a beautiful still life...but it went absolutely unnoticed in the Salon. The same is almost as true of the painting from 1753 in the Louvre, which was all but invisible beside the *Canard blanc* (as it is, we must admit, in our entry). Among the critiques, three

discuss or allude to only the *Canard blanc*; two present both pictures equally favorably; one speaks of both, but clearly assigns first place to the *Canard blanc*; one admires the latter picture while displaying frank dislike of its companion; and none mentions the Louvre painting alone. The favorable critics indicate that they have understood why the pictures belong together, as the *livret* already makes explicit: "[un tableau] représentant sur un fond blanc tous objets blancs"; "autre, au précédent pendant, où sont représentés sur un fond de planche de sapin tous objets coloriés." Let us cite only the abbé Laugier:

> Je ne vous parlerai que de deux singularités de cet Auteur qui m'ont plus arrêté que les autres. La Première représente sur un fond blanc tous objets blancs, canard blanc, serviette, porcelaine, crême, bougie, chandelier d'argent & papier. Cette composition n'a rien de fade; chaque objet est fortement prononcé & a son véritable relief. L'autre sur fond de planche de sapin, représente tous objets coloriés, un faisan, un liévre, une perdrix rouge. Cette composition réussit très-bien. Quoique le fonds soit ingrat, les objets y paroissent avec toute leur rondeur

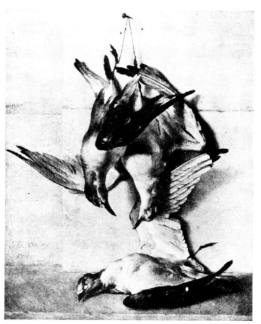

Fig. 114 *Still Life of Sea Gulls on a White Background.* Dated 1750. Schropp sale, Nice, 27 November 1933.

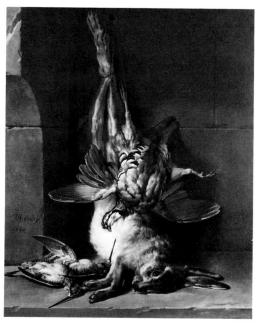

Fig. 115 *Still Life of a Hare, a Red-legged Partridge and two Snipes.* Dated 1750. Worcester, Massachusetts, Worcester Art Museum.

& toute leur force. (*Jugement d'un Amateur sur l'Exposition des Tableaux. Lettre à M. le Marquis de V*ˣˣˣ, 1753, pp. 30-33)

The most critical of the brochures was that of Estève, who appreciated the *Canard blanc* but also spoke of still lifes representing "du Gibier jetté négligemment sur un mauvais fond" and of pictures "qui représentent des planches de sapin mal assemblées, & qui quoique très-bien peintes, n'ont point réussi". (*Lettre à un ami sur L'Exposition des Tableaux faite dans le grand Sallon du Louvre, le 25. Août 1753*, pp. 8-11)

Estève exaggerates. The composition is anything but negligent. It is carefully studied, displaying an intellectual rigor in its equilibrium, both on the surface and in depth, that is worthy of Chardin. This is one of Oudry's most perfect still lifes; it suffers only, but inevitably, from being the poor relative of the *Canard blanc*. The artist must have realized this, since he mandated the separation of his two pictures by sending one of them off to Sweden, alone.

A meticulous cleaning for the Paris exhibition enhanced the remarkable color scheme, bringing out the contrast between the cold bluish tonalities of the undersides of the birds and the earth colors of the rest of the painting. Concerning the provenance of the *Canard blanc*, Diane Hyde has looked into the publications of Thiébault père and fils. She has found nothing whatsoever on the father's side. The collection of the son, though, turns out to have been an investment, begun in 1804 under the guidance of the Parisian dealer Thomas Henry, whose judgment Thiébault trusted completely (see *Mémoires du général b*ᵒⁿ *Thiébault*, publiés sous les auspices de sa fille Mˡˡᵉ Claire Thiébault, par F. Calmettes, 9th ed., III, Paris, Plon, 1895, pp. 534-537). The sale of this collection in 1817 was due to his difficulties under the Bourbon Restoration. The *Canard blanc* may still have come from his father. It is not mentioned in the *Mémoires*.

Exhibitions

We list only exhibitions with catalogues that are cited in our own. Those of the eighteenth century — Expositions de la Jeunesse, Salons — are not included here, but of course they are cited in the entries.

1860, PARIS, *Tableaux et dessins de l'Ecole française principalement du XVIII^e siècle tirés de collections d'amateurs*, 2^e édition, Galerie Martinet, 26, boulevard des Italiens.

1923, PARIS, *La Vénerie française*, Musée des Arts décoratifs.

1929, AMSTERDAM, *International Exhibition of Economic History*.

1934, PARIS, *Art animalier rétrospectif*, Muséum d'Histoire naturelle.

1935, COPENHAGEN, *L'Art français au XVIII^e siècle*, Charlottenborg Palace.

1937, PARIS, *Chefs-d'oeuvre de l'art français*, Palais national des Arts.

1945, PARIS, *Peintures de la Réalité au XVIII^e siècle*, Galerie Cailleux.

1946, PARIS, *La Vie silencieuse*, Galerie Charpentier.

1947, BASEL, *Kunstschätze aus den Strassburger Museen*, Kunsthalle.

1947, PARIS, *Exposition du Siège français du moyen age à nos jours*, Musée des Arts décoratifs.

1950, PARIS, *Chefs-d'oeuvre des collections parisiennes*, Musée Carnavalet.

1952, PARIS, *La Nature morte de l'antiquité à nos jours*, Musée de l'Orangerie.

1952-1953, HAMBURG-MUNICH, *Meisterwerke der französischen Malerei von Poussin bis Ingres*, Kunsthalle and Alte Pinakothek.

1954, ROTTERDAM, *Vier eeuwen Stilleven in Frankrijk*, Museum Boymans.

1954-1955, LONDON, *European Masters of the eighteenth century*, Royal Academy of Arts.

1955, ZURICH, *Schönheit des 18. Jahrhunderts*, Kunsthaus.

1956, PARIS, *Le Cabinet de l'Amateur*, Orangerie des Tuileries.

1958, MUNICH, *Le Siècle du Rococo*, Residenz.

1958, STOCKHOLM, *Fem sekler fransk konst*, Nationalmuseum.

1959, PARIS, *Hommage à Chardin*, Galerie Heim.

1960, PARIS, *Exposition de 700 tableaux...tirés des réserves du département des peintures*, Musée du Louvre.

1961-1962, MONTREAL-QUEBEC-OTTAWA-TORONTO, *Héritage de France: French Painting 1610-1760*, Montreal Museum of Fine Arts, Musée de la Province de Québec, National Gallery of Canada, Art Gallery of Toronto.

1965, LUDWIGSBURG, *Das Buch als Kunstwerk. Französische illustrierte Bücher des 18. Jahrhunderts aus der Bibliothek Hans Fürstenberg*, Schloss Ludwigsburg.

1967, BORDEAUX, *La Peinture française en Suède*, Musée des Beaux-Arts.

1967, RAMBOUILLET, *Les Oiseaux*, Préfecture.

1968, LONDON, *France in the Eighteenth Century*, Royal Academy of Arts.

1969, BORDEAUX, *L'Art et la Musique*, Galerie des Beaux-Arts.

1972-1973, TORONTO-OTTAWA-SAN FRANCISCO-NEW YORK, *French Master Drawings of the 17th and 18th centuries in North American collections*, Art Gallery of Ontario, National Gallery of Canada, California Palace of the Legion of Honor, New York Cultural Center.

1974, LONDON, *Summer Exhibiton*, Partridge.

1975-1976, TOLEDO-CHICAGO-OTTAWA, *The Age of Louis XV — French Painting 1710-1774*, Toledo Museum of Art, Art Institute of Chicago, National Gallery of Canada.

1976-1977, PARIS, *L'Animal de Lascaux à Picasso*, Muséum d'Histoire naturelle.

1978, BORDEAUX, *La Nature morte de Brueghel à Soutine*, Galerie des Beaux-Arts.

1978, LEIPZIG, *Tiere der Wildnis in Malerei, Graphik und Plastik aus fünf Jahrhunderten*, Museum der bildenden Künste.

1978, SARASOTA, *Masterworks on Paper. Prints and Drawings from the Ringling Museum of Art*, Ringling Museum of Art (catalogue published without date).

1978-1979, PARIS, *Dessins originaux anciens et modernes, Catalogue "centenaire", 2^e partie — Dessins*, Paul Prouté.

1979, CLEVELAND, *Chardin and the Still-Life Tradition in France*, Cleveland Museum of Art.

1979-1980, MOSCOW-LENINGRAD, *Ot Vatto do Davida. Frantsuzkaia zhivopis' XVIII veka iz muzeev frantsii*, Pushkin Museum of Fine Arts and Hermitage Museum.

1979-1980, MÜNSTER-BADEN-BADEN, *Stilleben in Europa*, Westfälisches Landesmuseum and Staatliche Kunsthalle Baden-Baden.

1979-1980, STOCKHOLM, *1700-tal Tanke och form i rokokon*, Nationalmuseum.

1980-1981, PARIS-GENEVA, *Des Monts et des eaux, Paysages de 1715 à 1850*, Galerie Cailleux.

1981, MONTREAL, *Largillierre and the eighteenth-century Portrait*, Montreal Museum of Fine Arts (catalogue published in 1982).

1981-1982, WASHINGTON-NEW YORK-MINNEAPOLIS-MALIBU, *French Master Drawings from the Rouen Museum from Caron to Delacroix*, National Gallery of Art, National Academy of Design, Minneapolis Institute of Arts, J. Paul Getty Museum.

1982, PARIS, *Jean-Baptiste (1686-1755) et Jacques-Charles (1723-1778) Oudry*, Galerie Cailleux.

1982-1983, PARIS, *J.-B. Oudry 1686-1755*, Galeries nationales du Grand Palais.

Bibliography

This bibliography includes all of the works cited under that rubric in our entries, alphabetically by author; the anonymous works are alphabetized by title and mixed with the others. We have also included a good number of other titles that have served us in our research and continue to be useful, but this listing is far from being complete. The periodical press of the eighteenth century, and the critiques of the Salons, are not included. We give full citations of them in the entries when they are quoted.

Äldre utländska målningar och skuplturer, Stockholm, National-museum, 1958.

Ananoff (A.): "Un Oudry perdu et retrouvé," *L'Oeil*, nos. 276-277, July-August 1978, pp. 18-19.

Antonsson, (O.): "Fem Återfunna skisser av Oudry," *National-musei Årsbok*, XI, 1929, pp. 81-88.

The Art Institute of Chicago 100 Masterpieces, Chicago, Art Institute, 1978.

Babeau (A.): "Les habitants du palais des Tuileries au XVIIIᵉ siècle," *Bulletin de la Société de l'Histoire de Paris et de l'Ile de France*, XXXI, 1904, pp. 53-71.

Badin, (J.): *La Manufacture de tapisseries de Beauvais depuis ses origines jusqu'à nos jours*, Paris, Société de Propagation des Livres d'Art, 1909.

Basan (P. F.): *Dictionnaire des graveurs anciens et modernes*, 2 volumes, Paris, chez l'auteur, 1767.

Bazin (G.): "J.-B. Oudry, animalier, décorateur et paysagiste," *L'Art et les Artistes*, nouvelle série, XVII, 1928-1929, pp. 109-115.

Bellier de La Chavignerie (E.): "Notes pour servir à l'histoire de l'exposition de la jeunesse," *Revue universelle des Arts*, XIX, 1864, pp. 38-67.

Bellier de La Chavignerie (E.) and Auvray (L.): *Dictionnaire général des artistes de l'école française*, 3 volumes, Paris, Renouard, 1882-1887.

Belloncle (M.): "Oudry l'animalier," *Jardin des Arts*, no. 151, June 1967, pp. 20-35.

Bénard (N.): *Cabinet de M. Paignon-Dijonval*, Paris, de l'imprimerie de Madame Huzard, 1810.

Bergström (I.): Grimm (C.), Rosci (M.), Faré (M. and F.), Gaya Nuño (J. A.): *Natura in Posa, la grande stagione della natura morta europea*, Milan, Rizzoli, 1977.

Bjurström (P.), editor: *Carl Gustaf Tessin och konsten*, Stockholm, Rabén & Sjögren, 1970.

Blanc (C.), editor: *Histoire des peintres de toutes les écoles*, 14 volumes, Paris, Renouard, 1861-1876.

Blumer (M. L.): "Quelques tableaux d'Oudry, de Desportes et de Bachelier peints pour le château de Choisy et actuellement au Muséum d'Histoire naturelle," *Bulletin de la Société de l'Histoire de l'Art français*, 1945-1946, pp. 61-66.

Bode (W.): "Die Franzosen in der Schweriner Galerie," *Die Graphischen Künste*, XIV, 1891, pp. 60-63.

Brière (G.): *Musée national du Louvre, Catalogue des peintures exposées dans les galeries, I. Ecole française*, Paris, Musées nationaux, 1924.

Brière (G.) and Communaux (E.), "Emplacements actuels des tableaux du musée du Louvre catalogués par F. Villot, Tauzia et retirés des galeries. Ecole français," *Bulletin de la Société de l'Histoire de l'Art français*, 1924, pp. 273-352.

Bruand (Y.): "Un grand collectionneur, marchand et graveur du XVIIIᵉ siècle, Gabriel Huquier," *Gazette des Beaux-Arts*, 6ᵉ période, XXXVII bis, 1950, pp. 99-114.

Brunet (J.-C.): *Manuel du libraire et de l'amateur de livres*, 5ᵉ édition, 6 volumes, Paris, Firmin Didot, 1860-1865.

Bulletin de la librairie Morgand et Fatout, 2 volumes, Paris, Damascène Morgand et Charles Fatout, 1876-1881.

Cailleux (J.): "M. Oudry le fils ou Les Avatars de la paternite," *L'Art du dix-huitième siècle*, advertisement supplement to the *Burlington Magazine* (CXXIV, 1982), no. 41 (July 1982), pp. i-viii.

Catalogue de la collection Rodolphe Kann, Tableaux, Tome II, Paris, Charles Sedelmeyer, 1907.

Catalogue raisonné des tableaux exposés au musée de Rouen, Rouen, de l'imp. de Fˢ Marie, 1820.

Charléty (G.): "Un album d'aquarelles attribuées à J.-B. Oudry, donné à la Bibliothèque d'Art et d'Archéologie," *Bulletin semestriel de la Société des Amis de la Bibliothèque d'Art et d'Archéologie de l'Université de Paris*, 2ᵉ Semestre 1929, no. 2, pp. 22-26.

Charléty (G.): "Un album d'aquarelles attribuées à Jean-Baptiste Oudry," *Gazette des Beaux-Arts*, 6ᵉ période, III, 1930, pp. 11-17.

Clark (C.): "Jean-Baptiste Siméon Chardin: Still Life with Herring," *Bulletin of the Cleveland Museum of Art*, LXI, 1974, pp. 309-313.

Clément de Ris (L.): *Les Musées de Province*, 2 volumes, Paris, Vᵉ Jules Renouard, 1859-1861.

Cohen (H.): *Guide de l'amateur de livres à gravure du XVIIIème siècle*, 6ᵉ édition revue par Seymour de Ricci, Paris, 1912.

Conisbee (P.): *Painting in eighteenth-century France*, Ithaca, Cornell University Press, 1981.

Constans (C.): *Musée national du château de Versailles. Catalogue des peintures*, Paris, Editions de la Réunion des Musées nationaux, 1980.

Cordey (J.): "Deux albums de portraits inédits peints par Oudry," *Bulletin de la Société de l'Histoire de l'Art français*, 1920, pp. 140-191.

Cordey, (J.): "Deux albums de portraits peints par Oudry," *Revue de l'Art ancien et moderne*, XXXVIII, 1920, pp. 209-223.

Cordey (J.): *Esquisses de portraits peints par J.-B. Oudry*, Paris, pour la Société des Bibliophiles françois, Francisque Lefrançois, 1929.

Cordey (J.): *Inventaire des biens de Madame de Pompadour rédigé après son décès*, Paris, pour la Société des Bibliophiles françois, Francisque Lefrançois, 1939.

Cordey (J.): "J.-B. Oudry peintre de la famille de Noailles," *Bulletin de la Société de l'Histoire de l'Art français*, 1921, pp. 166-171.

Cordey (J.): "Quelques portraits d'Oudry à l'étranger," *Bulletin de la Société de l'Histoire de l'Art français*, 1934, pp. 280-285.

Correspondance littéraire, philosophique et critique par Grimm, Diderot, Raynal, Meister..., edited by Maurice Tourneux, 16 volumes, Paris, Garnier frères, 1877-1882.

Courajod (L.): *Alexandre Lenoir, son journal et le musée des monuments français*, I, Paris, Honoré Champion, 1878.

Courajod (L.): "Objets d'art concédés en jouissance par la Restauration," *Nouvelles Archives de l'Art français*, 1878, pp. 371-399.

Courboin (F.): *Histoire illustrée de la gravure en France*, 3 volumes plus 3 of plates, Paris, Le Garrec, 1923-1926.

Courboin (F.): and Roux (M.): *La Gravure française: essai de bibliographie*, 3 volumes, Paris, Le Garrec, 1927-1928.

Cummings (F. J.) and Elam (C. H.), editors: *The Detroit Institute of Arts Illustrated Handbook*, Detroit, published for the Detroit Institute of Arts by Wayne State University Press, 1971.

Dacier (E.): *Catalogues de ventes et livrets de salons illustrés et annotés par Gabriel de Saint-Aubin*, 11 nos. in 6 volumes, Paris, Société de Reproduction des dessins de maîtres, 1909-1921; nos. 12 and 13 in *Gazette des Beaux-Arts*, 6ᵉ période, XLI, 1953, pp. 297-334, and XLIV, 1954, pp. 5-46.

Dacier (E.): *La gravure de genre et de moeurs*, coll. *La Gravure en France au XVIIIᵉ siècle*, Paris and Brussels, G. van Oest, 1925.

Dacier (E.) and Ratouis de Limay (P.): *Pastels français des XVIIᵉ et XVIIIᵉ siècles*, Paris and Brussels, G. Van Oest, 1927.

Davidson (R.): "Museum Acquisitions," *Antiques*, XCVIII, 1970, pp. 704-705, 708, 712.

Demonts (L.) and Huteau (L.): *Musée national du Louvre. Catalogue général des peintures*, Paris, Braun, 1922.

Desguine (A.): *L'Oeuvre de J.-B. Oudry sur le parc et les jardins d'Arcueil*, Paris, Floury, 1950.

Després (Dr. A.): *Les éditions illustrées des* Fables de La Fontaine, Paris, Rouquette et fils, 1892.

Deville (E.): *Index du* Mercure de France, Paris, Jean Schemit, 1910.

Dézallier d'Argenville (A.-J.): *Abrégé de la vie des plus fameux peintres*, 2ᵉ édition, 4 volumes, Paris, de Bure l'aîne, 1762.

Dézallier d'Argenville (A.-N.): *Voyage pittoresque de Paris*, Paris, de Bure l'aîne, 1749 (2ᵉ édition 1752, 3ᵉ 1757, 4ᵉ 1765, 6ᵉ 1778).

Dézallier d'Argenville (A.-N.): *Voyage pittoresque des environs de Paris*, Paris, de Bure l'aîne, 1755 (2ᵉ édition 1762, 3ᵉ 1768, 4ᵉ 1779).

Diderot (D.): *Salons*, edited by Jean Seznec and Jean Adhémar, 4 volumes, Oxford, at the Clarendon Press, 1957-1967.

Dobrzycka (A.): "Jean-Baptiste Oudry: scena mitologiczna u grobu Faetona," *Studia Muzealne, Muzeum Narodowe w Poznaniu*, X, 1974, pp. 75-80.

Doria (A.): "Oudry, portraitiste," *L'Art et les Artistes*, nouvelle série, XX, 1930, pp. 289-295.

Duclaux (L.): *Musée du Louvre. Cabinet des dessins. Inventaire général des dessins. Ecole française, XII. Nadar-Ozanne*, Paris, Editions des Musées nationaux, 1975.

Dussieux (L.-E.): *Les artistes français à l'étranger*, 3ᵉ édition, Paris and Lyon, Lecoffre fils, 1876.

Encyclopédie méthodique. Beaux-Arts, 2 volumes, Paris, Panckoucke, 1788-1791.

Engerand (F.): "Les commandes officielles de tableaux au XVIIIᵉ siècle: J.-B. Oudry," *Chronique des Arts et de la Curiosité*, 1895, pp. 119-121, 131-134, 144-146, 151-153.

Engerand (F.): *Inventaire des tableaux commandés et achetés par la direction des Bâtiments du roi (1709-1792)*, Paris, Ernest Leroux, 1900.

Engerand (F.): "Modèles et bordures de tapisseries des XVIIᵉ et XVIIIᵉ siècles," *Nouvelles Archives de l'Art français*, 1896, 3ᵉ série, XII, 1896, pp. 137-148.

Evans (T.), Mirimonde (A. P. de), Abondance (F.), Abondance (P.): *Guitares: Chefs-d'oeuvre des collections de France*, Paris, La Flûte de Pan, 1980.

Explication des peintures, sculptures, et autres ouvrages de Messieurs de l'Académie royale; dont l'exposition a été ordonnée...dans le grand Salon du Louvre..., 14 volumes, Paris, Jacques Collombat et successeurs, 1737-1753.

Fage (R.): "Les Noailles peints par Oudry," extrait du *Bulletin de la Société scientifique, historique et archéologique de la Corrèze*, XLIV, 1922.

Faré (M.): *La Nature morte en France*, 2 volumes, Geneva, Pierre Cailler, 1962.

Faré (M. and F.): "Le trompe-l'oeil dans la peinture française du XVIIIᵉ siècle," *L'Oeil*, no. 257, December 1976, pp. 2-7, 60.

Faré (M. and F.): *La Vie silencieuse en France, la Nature morte au XVIIIᵉ siècle*, Fribourg, Office du Livre, and Paris, Société française du livre, 1976.

Fenaille (M.): *Etat général des tapisseries de la manufacture des Gobelins*, 5 volumes, Paris, Imprimerie nationale, 1903-1923.

Florisoone (M.): *La Peinture française, le dix-huitième siècle*, Paris, Pierre Tisné, 1948.

Fontaine (A.): *Les Collections de l'Académie royale de peinture et de sculpture*, Paris, Société de propagation des livres d'art, 1930.

Führer durch die Kunstsammlungen des Staatliches Museums Schwerin, Schwerin, 1965.

Furcy-Raynaud (M.): "Correspondance de Lenormant de Tournehem...avec Charles Coypel...et N.-B. Lépicié," *Nouvelles Archives de l'Art français*, 3ᵉ série, XXII, 1906, pp. 321-358.

Furcy-Raynaud (M.): *Correspondance de M. de Marigny avec Coypel, Lépicié, et Cochin*, 2 volumes, coll. *Nouvelles Archives de l'Art français*, 3ᵉ série, XIX-XX, Paris, Schemit, 1904-1905.

Furcy-Raynaud (M.): "Les objets d'art saisis chez les émigrés et condamnés et envoyés au Muséum central," *Archives de l'Art français*, nouvelle période, VI, 1912, pp. 245-343.

Fürstenberg (H.): *Das französische Buch im achtzehnten Jahrhundert und in der Empirezeit*, Weimar, Gesellschaft der Bibliophilen, 1929.

Fürstenberg (H.): *La Gravure originale dans l'illustration du livre français an dix-huitième siècle. Die Original-Graphik in der französischen Buch-Illustration des achtzehnten Jahrhunderts*, Hamburg, Dʳ Ernst Hauswedell & Co., 1975 (published under the name of Jean Furstenberg).

Gaucheron (R.): "La préparation et le lancement d'un livre de luxe au XVIIIᵉ siècle, l'édition des Fables de La Fontaine, dite d'Oudry," *Arts et Métiers graphiques*, no. 2, 1 December 1927, pp. 77-82.

Gemälde alter Meister der grossherzogl. Sammlung im Museum zu Schwerin. 100 Lichtdrucktafeln, Leipzig, A. Schumann's Verlag, no date.

Genaille (R.): "Les Fables de La Fontaine en tapisseries de Beauvais du XVIIIᵉ siècle: contribution à l'étude de J.-B. Oudry," *Mémoires de la Société d'Archéologie, Sciences et Arts du Départment de l'Oise*, XXVII, 1933, pp. 429-481.

George: *Catalogue raisonné des tableaux du Musée de Toulouse,* Toulouse, Imprimerie I. Viguier, 1864.

George: *Rapport sur l'état actuel du musée de Toulouse,* Toulouse, Typographie Mélanie Dupin, 1873.

Gerson (H.): *Ausbreitung und Nachwirkung der holländischen Malerei des 17. Jahrhunderts,* Haarlem, de Erven F. Bohn N. V., 1942.

Gerspach (E.): "Cartons de tapisseries peints par Oudry," *Nouvelles Archives de l'Art français,* 3ᵉ série, IV, 1888, pp. 227-228.

Gerspach (E.): *Répertoire détaillé des tapisseries des Gobelins exécutées de 1662 à 1892,* Paris, Le Vasseur, 1893.

Gillet (L.): "XVIIIᵉ siècle," in *La Peinture au musée du Louvre, Tome I. Ecole française,* Paris, S.N.E.P.-Illustration, no date [1929].

Girardin (Marquis de): "L'édition des Fables de La Fontaine, dite d'Oudry," *Bulletin du Bibliophile,* 1913, pp. 217-236, 277-292, 330-347, 386-398.

Göbel (H.): *Wandteppiche,* 3 volumes in 6, Leipzig, Klinkhardt und Biermann, 1923-1924.

Goncourt (E. de): *La Maison d'un artiste,* 2 volumes, Paris, G. Charpentier, 1881.

Goncourt (E. and J. de): *L'Art du dix-huitième siècle,* 3ᵉ édition, 2 volumes, Paris, A. Quantin, 1880-1882.

Göthe (G.): *Notice descriptive des tableaux du Musée national de Stockholm, Iʳᵉ partie: Maîtres étrangers (non Scandinaves),* Stockholm, Imprimerie Ivar Haeggström, 1893.

Gougenot (L.): "Vie de Monsieur Oudry," read to the Académie royale de peinture et de sculpture on 10 January 1761, and published by L. Dussieux, E. Soulié, Ph. de Chennevières, P. Mantz and A. de Montaiglon, *Mémoires inédits sur la vie et les ouvrages des membres de l'Académie royale de peinture et de sculpture,* 2 volumes, Paris, J.-B. Dumoulin, 1854, II, pp. 365-403.

Grigaut (P.): "Baroque and Rococo France in Toledo," *Art Quarterly,* XIX, 1956, pp. 50-54.

Groth (J.G.): *Verzeichniss der Gemälde in der herzoglichen Gallerie,* Schwerin, Wilhelm Bärensprung, 1792.

Grouchy (Vicomte de): "Artistes français des XVIIᵉ et XVIIIᵉ siècles," *Nouvelles Archives de l'Art français,* 3ᵉ série, VII, 1891, pp. 86-101.

Gruyer (F.-A.): *Chantilly, Musée Condé. Notice des peintures,* Paris, Braun, Clément et Cie, 1899.

Guiffrey (J.), editor: *Collection des livrets des anciennes expositions depuis 1673 jusqu'en 1800.* IV-XVII, Paris, Liepmannssohn et Dufour, 1869.

Guiffrey (J.): "Congés accordés à des artistes français pour travailler à l'étranger," *Nouvelles Archives de l'Art français,* 1878, pp. 1-68.

Guiffrey (J.): *Histoire de l'Académie de Saint-Luc,* volume IX of *Archives de l'Art français,* nouvelle période, 1915.

Guiffrey (J.): "Logements d'artistes au Louvre," *Nouvelles Archives de l'Art français,* 1873, pp. 1-221.

Guiffrey (J.): "Les modèles des Gobelins devant le Jury des Arts en septembre 1794," *Nouvelles Archives de l'Art français,* 3ᵉ série, XIII, 1897, pp. 349-389.

Guiffrey (J.): *Scellés et inventaires d'artistes,* volumes IV-VI of *Nouvelles Archives de l'Art français,* 2ᵉ série, 1883-1885.

Handbook of the Cleveland Museum of Art, Cleveland, Cleveland Museum of Art, 1978.

Hand List of Drawings in the Witt Collection, London, Courtauld Institute of Art, 1956.

Haug (H.): *La peinture française au musée de Strasbourg,* Strasbourg, Editions des musées de la ville, 1955.

Hébert: *Dictionnaire pittoresque et historique...par M. Hébert, Amateur,* 2 volumes, Paris, Claude Herissaut, 1766.

Heine (A.): "Fra 'Christian VII's Palae'," *Samleren,* VII, 1930, pp. 129-140.

Hendy (P.): "Two great decorators of the reign of Louis XV," *Apollo,* XV, 1932, pp. 99-103.

Hennique (N.): *Jean-Baptiste Oudry 1686-1755,* coll. *Maîtres anciens et modernes,* Paris, Editions Nilsson, 1926.

Herluison (H.): *Actes d'état civil d'artistes français,* Orléans, aux frais de l'auteur, 1873.

Hildebrandt (E.): *Malerei und Plastik des achtzehnten Jahrhunderts in Frankreich,* series *Handbuch der Kunstwissenschaft.* Potsdam Akademische Verlagsgesellschaft Athenaion, 1924.

Hourticq (L.) *et al.: Le Paysage français de Poussin à Corot,* Paris, Editions de la Gazette des Beaux-Arts, 1926.

Ingersoll-Smouse (F.): *Pater,* coll. *L'Art français,* Paris, Les Beaux-Arts, 1928.

Inventaire général des richesses d'art de la France, 22 volumes in 24, Paris, Librairie Plon, 1876-1913.

"J. B. Oudry," *The Illustrated Magazine of Art,* III, 1854, pp. 405-414, 416, 417, 420.

"J.-B. Oudry," *Le Magasin pittoresque,* XIX, 1851, pp. 114-118.

Jal (A.): *Dictionnaire critique de biographie et d'histoire,* Paris, Henri Plon, 1867.

Jallut (M.): "Marie Leczinska et la peinture," *Gazette des Beaux-Arts,* 6ᵉ période, LXXIII, 1969, pp. 305-322.

Janneau (G.): *Evolution de la tapisserie,* Paris, Compagnie des arts photomécaniques, 1947.

Jarry (M.): "Eighteenth-century French tapestry: a re-assessment," *Apollo,* LXXXIX, 1969, pp. 424-429.

Jensen (C. A.): "Christiansborg — det sidste Kobenhavns slot og det forste Christiansborg," *Ord och Bild,* XXXIV, 1925, pp. 141-152.

Jesse (W.): *Geschichte der Stadt Schwerin,* 2 volumes, Schwerin, L. Davids, 1913-1914.

Jusserand (J.-J.): *The Comical Romance, and other Tales. By Paul Scarron.* Done into English by Tom Brown of Shifnal, John Savage, and others. With an introduction by J.-J. Jusserand, 2 volumes, London, 1892.

Kalnein (W.) and Levey (M.): *Art and Architecture of the eighteenth century in France,* series *Pelican History of Art,* Harmondsworth, Penguin Books, 1972.

Katalog. Malerei des 18. Jahrhunderts im Staatlichen Museum Schwerin, Schwerin, Staatliches Museum, 1954.

Keller (H.): *Die Kunst des 18. Jahrhunderts,* series *Propyläen Kunstgeschichte,* X, Berlin, Propyläen Verlag, 1971.

Kimball (F.): *The Creation of the Rococo,* New York, W. W. Norton, 1964 (reprint of the original edition of 1943).

Krohn (M.): *Frankrigs og Danmarks kunstneriske forbindelse i det 18. aarhundrede*, 2 volumes, Copenhagen, Henrik Koppels Forlag, 1922.

Lacordaire (A.-L.): *Notice historique sur les manufactures impériales de tapisseries des Gobelins et de tapis de la Savonnerie*, Paris, à la Manufacture des Gobelins, 1853.

Lacroix (P.): "Jugements de Bachaumont sur les meilleurs artistes de son temps," *Revue universelle des Arts*, V, 1857, pp.418-427.

Lacroix (P.): "Sentiments de Noël Coypel et d'Oudry sur le coloris," *Revue universelle des Arts*, XV, 1862, pp. 320-334, 391-410.

La Live de Jully (A.-L. de): *Catalogue historique du cabinet de peinture et sculpture françoise, de M. de Lalive*, Paris, impr. de P.-A. Le Prieur, 1764.

Lastic (G. de): "Catalogue raisonné de l'oeuvre peint et dessiné de François Desportes," typewritten thesis, Paris, 1969.

Lastic (G. de): "Desportes et Oudry peintres des chasses royales," *Connoisseur*, CXCVI, December 1977, pp. 290-299.

Lastic (G. de): "Les Devants de cheminée," *Connaissance des Arts*, no. 39 (May 1955), pp. 26-31.

Lastic (G. de): "Louis XV, ses trophées de chasse peints par Oudry et Bachelier," *Connaissance des Arts*, no. 188, October 1967, pp. 110-115.

Lauts (J.): *Jean-Baptiste Oudry*, series *Die Jagd in der Kunst*, Hamburg and Berlin, Verlag Paul Parey, 1967.

Lavallée (P.): *J. B. Oudry. Quatorze Dessins. Musée de Louvre. Coll. Reproductions de dessins* publiée sous la direction de Gabriel Rouchès XII, Paris, Musées nationaux, 1939.

Lebel (E.): *Musée de Rouen. Catalogue des ouvrages de peinture, dessin, sculpture et architecture...*, Rouen, Imprimerie Julien Lecerf, 1890.

Le Blanc (C.): *Manuel de l'Amateur d'Estampes*, 4 volumes, Paris, Emile Bouillon, P. Jannet, F. Viewig, 1854-1888/1890.

Lenoir (A.): "Catalogue historique et chronologique des peintures et tableaux réunis au dépôt national des monuments français... adressé au Comité d'instruction publique, le 11 vendémiaire an III," *Bulletin archéologique publié par le Comité historique des arts et monuments*, III 1844-1845, pp. 276-327. There exists a second edition annotated by A. de Montaiglon, *Revue universelle des Arts*, XXI, 1865, pp. 61-86, 125-160.

Lenthe (F. C. G.): *Verzeichniss der Grossherzoglichen Gemälde-Sammlung, welche sich auf dem alten Schlosse in Schwerin befindet*, Schwerin Hofbuchdruckerei, 1836.

Lespinasse (M.): "Quelques tableaux du Musée de Toulouse," *Mémoires de l'Academie des Sciences, Inscriptions et Belles-Lettres de Toulouse*, 12e série, XV, 1937, pp. 279-298.

Lespinasse (P.): "L'Art français en Suède de 1686 à 1816," *Bulletin de la Société de l'Histoire de l'Art français*, 1911, pp. 54-133, 293-337.

Lespinasse (P.): *Les Artistes français en Scandinavie*, Paris, La Renaissance du Livre, 1929.

Lespinasse (P.): "Les voyages d'Hårleman et de Tessin en France (1732-1742)," *Bulletin de la Société de l'Histoire de l'Art français*, 1910, pp. 276-298.

Locquin (J.): "L'Art français à la cour de Mecklembourg au XVIIIe siècle, J.-B. Oudry et le grand-duc Christian-Ludwig," *Gazette des Beaux-Arts*, 3e période, XXXVI, 1906, pp. 301-314.

Locquin (J.): *Catalogue raisonné de l'oeuvre de Jean-Baptiste Oudry peintre du roi (1686-1755)*, in *Archives de l'Art français*, nouvelle période, VI, 1912, pp. i-viii, 1-209.

Locquin (J.): "Les 'Cinq sens' de J.-B. Oudry peints pour les appartements de Marie Leczinska à Versailles," *Musées et Monuments de France*, 1907, pp. 73-75.

Locquin (J.): "Jean-Baptiste Oudry, peintre et directeur de la Manufacture royale de tapisseries de Beauvais," *Bulletin de la Société d'Etudes historiques et scientifiques de l'Oise*, II, 1906, pp. 67-78, 107-125.

Locquin (J.): "L'Oeuvre gravé du peintre Jean-Baptiste Oudry," *Annuaire de la gravure française*, 1912, pp. 173-176.

Locquin (J.): "Le Paysage en France au début du XVIIIe siècle et l'oeuvre de J.-B. Oudry," *Gazette des Beaux-Arts*, 3e période, XL, 1908, pp. 353-380.

Lugt (F.): *Les Marques de collections de dessins et d'estampes*, 2 volumes, The Hague, Martinus Nijhoff, 1922-1956.

Lundberg (G.): "Svenska Ambassaden in Paris," *Svenska Hem i Ord och Bilder*, XXXVII, 1949, pp. 234-235.

Luynes (duc de): *Mémoires du duc de Luynes sur la cour de Louis XV*, published by L. Dussieux and E. Soulié, 17 volumes, Paris, Firmin Didot, 1860-1865.

Magne (E.): *Bibliographie générale des oeuvres de Scarron*, Paris, 1924.

Malmborg (B. van), editor: *Drottningholm*, series *Årsbok för svenska statens Konstsamlingar*, XIII, Stockholm, Rabén & Sjögren, 1966.

Marcus (C. G.): "Jean-Baptiste Oudry peintre de poissons," *Art et Curiosité*, November-December 1965, pp. 5-7.

Mariette (P. J.): *Abecedario de P.-J. Mariette et autres notes de cet amateur sur les arts et les artistes*, published by Ph. de Chennevières and A. de Montaiglon, coll. *Archives de l'Art français*, vols. II, IV, VI, VIII, X, XII, Paris, Dumoulin, 1851-1860.

Maumené (Ch.) and Harcourt (Comte d'): *Iconographie des rois de France*, 2 volumes, coll. *Archives de l'Art français*, nouvelle période, XV-XVI, Paris, Armand Colin, 1928-1931.

"Mémoire pour servir à l'éloge de M. Oudry, peintre du Roi," *Revue universelle des Arts*, VIII, 1858, pp. 234-237.

Mesuret (R.): *Les Expositions de l'Académie royale de Toulouse de 1751 à 1791*, Toulouse, Editions Espic, 1972.

Mesuret (R.): "Le Musée d'Agen," supplement to *La Revue française*, no. 98, February 1958; reprinted in *Trésors des Musées de Province*, 3 volumes, Paris, Société d'Editions de la Revue française, 1957-1959, vol. III.

Minet (E.): *Musée de Rouen, Catalogue des ouvrages de peinture, dessin, sculpture et d'architecture*, Rouen, Imprimerie J. Girieud, 1911.

Mirimonde (A. P. de): *L'Iconographie musicale sous les rois bourbons, La Musique dans les arts plastiques*, 2 volumes, Paris, A. et J. Picard, 1977.

Mirimonde (A. P. de): "La Musique au Musée de Strasbourg," *Cahiers alsaciens d'archéologie d'art et d'histoire*, VI, 1962, pp. 83-112.

Mirimonde (A. P. de): "Les Oeuvres françaises à sujet de musique au musée du Louvre," *Revue du Louvre et des Musées de France*, XV, 1965, pp. 111-124.

Monavon (A.): *Notice descriptive de l'intérieur des palais de Trianon*, Versailles, Cerf et fils, 1876.

Mongan (A.): "An Album of Watercolors by Oudry," *Annual Report*, Fogg Art Museum, Harvard University, 1953-1954, pp. 10-11.

Montaiglon (A. de): *Descriptions de l'Académie royale de peinture et de sculpture par son secrétaire Nicolas Guérin et par Antoine-Nicolas Dézallier d'Argenville le fils 1715-1781*, Paris, Société de propagation de livres d'art, 1893.

Montaiglon (A. de): "J.-B. Oudry. Documents communiqués par MM. E. Daudet et Mathon," *Archives de l'Art français*, IX, 1857-1858, pp. 270-272.

Musées nationaux. Catalogue sommaire des peintures...du Louvre, Paris, Librairies-Imprimeries réunies, 1889.

Natures mortes. Catalogue de la collection du Musée des Beaux-Arts de Strasbourg, Strasbourg, Editions des Musées de la Ville, 1954; nouvelle édition revue et augmentée, *idem*, 1964.

Niclausse (J.): " 'Chasses nouvelles' de Monsieur Oudry," *Gazette des Beaux-Arts*, 6e période, XLIX, 1957, pp. 311-320.

Niclausse (J.) and Janneau (G.): *Le Musée des Gobelins 1939. De la tapisserie décor à la tapisserie peinture*, Paris, Editions des Bibliothèques nationales de France, 1939.

Nothaft (E. G.): "Zhan Batist Udri i ego proizvedniia v Ermitazhe," *Gosudarstvennyĭ Ermitazh. Trudy otdela zapadnoevropeĭskogo iskusstva*, II, 1941, pp. 171-192.

Notice des peintures et sculptures placées dans les cours et les appartements du palais de Fontainebleau, Paris, Vinchon, 1841.

Notice des tableaux appartenant à la collection du Louvre exposés dans les salles du palais de Fontainebleau, Paris, Musées nationaux, 1881.

Notice des tableaux placés dans les appartements du palais royal de Compiègne, Paris, Vinchon, 1832.

Notice des tableaux placés dans les appartements du palais royal de Compiègne, Paris, Vinchon, 1837.

Notice des tableaux, statues, bustes, dessins, etc. composant le musée de Toulouse, Toulouse, de l'Imprimerie de J.n-M.eu Douladoure, 1813.

Opperman (H.): "Un dessin d'Oudry pour les *Métamorphoses d'Ovide*," *Études de la Revue du Louvre et des Musées de France*, I, 1980, pp. 67-69.

Opperman (H.): "The Genesis of the 'Chasses royales'," *Burlington Magazine*, CXII, 1970, pp. 216-224.

Opperman (H.): *Jean-Baptiste Oudry*, 2 volumes, New York and London, Garland Publishing, 1977; revision of doctoral dissertation, University of Chicago, 1972.

Opperman (H.): "Largillierre and his pupil Jean-Baptiste Oudry," in exhibition catalogue *Largillierre and the Eighteenth-Century Portrait*, Montreal, Musée des Beaux-Arts, 1981 (published 1982), pp. 310-321.

Opperman (H.): "Notes sur les éditions du *Roman comique* d'Oudry," *Nouvelles de l'Estampe*, 1967, no. 6, pp. 213-217.

Opperman (H.): "Observations on the tapestry designs of J.-B. Oudry for Beauvais," *Allen Memorial Art Museum Bulletin*, XXVI, 1968-1969, pp. 49-71.

Opperman (H.): "Oudry aux Gobelins," *Revue de l'Art*, no. 22, 1973, pp. 57-65.

Opperman (H.): "Oudry illustrateur: le *Roman comique* de Scarron," *Gazette des Beaux-Arts*, 6e période, LXX, 1967, pp. 329-348.

Opperman (H.): "Some animal drawings by Jean-Baptiste Oudry," *Master Drawings*, IV, 1966, pp. 384-409.

Orlandi (P. A.): *Abcedario (sic) pittorico*, 2d edition, Bologna, Costantino Pissari, 1719.

Oudry (J.-B.): "Discours sur la pratique de la peinture et ses procédés principaux, ébaucher, peindre à fond, et retoucher," read to the Académie royale, 2 December 1752, and published from the manuscript in the library of the Ecole des Beaux-Arts by E. Piot, *Cabinet de l'Amateur*, nouvelle série, 1861-1862, pp. 107-117. New edition, not quite complete, by Camille Versini, in *Cahiers de l'Académie Anquetin*, XII, 1970, pp. 61-86.

Oudry (J.-B.): "Réflexions sur la manière d'étudier la couleur en comparant les objets les uns avec les autres," read to the Académie royale, 7 June 1749, and published from the manuscript in the library of the Ecole des Beaux-Arts by E. Piot, *Cabinet de l'Amateur et de l'Antiquaire*, III, 1844, pp. 33-52. Several subsequent editions exist.

Pérathon (C.): "Iconographie des tapisseries d'Aubusson," *Réunion des Sociétés des Beaux-Arts des Départements*, 1899, pp. 558-588.

Piganiol de la Force (J.-A.): *Description de Paris, de Versailles...*, 8 volumes, Paris, C.-N. Poirion, 1742.

Piganiol de la Force (J.-A.): *Description historique de la ville de Paris et de ses environs, par feu M. Piganiol de la Force*, nouvelle édition, 10 volumes, Paris, G. Desprez, 1765.

Piganiol de la Force (J.-A.): *Nouvelle description des châteaux et parcs de Versailles et de Marly*, 2 volumes, 6e édition, Paris, Veuve de F. Delaulne, 1730 (7e éd., *idem*, 1738; 8e éd., Paris, Poirion, 1751; 9e éd., Paris, E. F. Savoye, 1764).

Popovitch (O.): *Catalogue des peintures du Musée des Beaux-Arts de Rouen*, Sotteville-lès-Rouen, Rouen Offset-Fernandez Frères, 1978.

Portalis (Baron R.): *Les Dessinateurs d'illustrations au dix-huitième siècle*, 2 parts, Paris, Damascène Morgand et Charles Fatout, 1877.

Portalis (Baron R.) and Béraldi (H.): *Les Graveurs du dix-huitième siècle*, 3 volumes, Paris, Damascène Morgand et Charles Fatout, 1880-1882.

Procès-verbaux de l'Académie royale de peinture et de sculpture (1648-1792), published by A. de Montaiglon, 10 volumes, Paris, Baur et Charavay, 1875-1892.

Rambaud (M.): *Documents du Minutier central concernant l'histoire de l'art (1700-1750)*, 2 volumes, Paris, S.E.V.P.E.N., 1964-1972.

Ratouis de Limay (P.): *Le Pastel en France au dix-huitième siècle*, Paris, Editions Baudinière, 1946.

Réau (L.): *Histoire de l'expansion de l'art français*, Paris, Henri Laurens: *Le monde slave et l'orient* (1924); *Belgique et Hollande — Suisse — Allemagne et Autriche — Bohème et Hongrie* (1928) *— Pays scandinaves — Angleterre — Amérique du Nord* (1931).

Réau (L.): *Histoire de la Peinture française au XVIIIe siècle*, 2 volumes, Paris and Brussels, G. van Oest, 1925-1926.

Recours (L.): *Musée d'Agen. Guide du visiteur*, 4e édition, Agen, Imprimerie moderne, 1933.

Reynaud (H.-J.): *Notes supplémentaires sur les livres à gravures du XVIIIème siècle*, Geneva and Lyon, 1955.

Ricci (S. de): *Les Chasses royales de Louis XV. Peintures par Jean-Baptiste Oudry*, Paris, 1921.

Ricci (S. de): *The Roederer Library of French Books Prints and Drawings of the Eighteenth Century*, Philadelphia and New York, Rosenbach Company, 1923.

Robert-Dumesnil (A.P.F.): *Le Peintre-graveur français*, 11 volumes including supplement by Georges Duplessis, Paris, Warée et Hazard, 1835-1871.

Robiquet (J.): *Pour mieux connaître le palais de Compiègne*, Compiègne, 1938.

Rodocanachi (E.): "Les petites-filles de La Fontaine et la propriété littéraire," *Séances et Travaux de l'Académie des sciences morales et politiques, Compte rendu*, 90e année, 1930, pp. 95-104.

Roland Michel (M.) and Rambaud (A.): "On the subject of some works exhibited by the Galerie Cailleux at the Burlington International Fine Art Fair," *L'Art du dix-huitième siècle*, advertisement supplement to the *Burlington Magazine* (CXIX, 1977), no. 34 (December 1977), pp. i-viii.

Romand (D.): "La cote des peintres: Jean-Baptiste Oudry 1686-1755," *Gazette de l'Hôtel Drouot*, LXXX, no. 7, 12 February 1971, pp. 7-9, and rectification, no. 9, 26 February, p. 14.

Rosenberg (P.): *Chardin*, catalogue of the exhibition, Paris, Grand Palais, 1979.

Rosenberg (P.), Reynaud (N.), and Compin (I.): *Musée du Louvre. Catalogue illustré des peintures. Ecole française XVIIe et XVIIIe siècles*, 2 volumes, Paris, Editions des Musées nationaux, 1974.

Roucoule (M.): *Catalogue raisonné de la galerie de peinture du musée de Toulouse*, Toulouse, Imprimerie de Jean-Matthieu Douladoure, 1836.

Roux (M.) *et al.: Inventaire du fonds français, Graveurs du dix-huitième siècle*, 14 volumes so far published, Paris, Bibliothèque nationale, 1931-1977.

Sander (F.): *Nationalmuseum. Bidrag till tafelgalleriets historia*, 4 volumes, Stockholm, Samson & Wallin, 1872-1876.

Schlie (F.): *Beschreibendes Verzeichniss der Werke älterer Meister in der grossherzoglichen Gemälde-Gallerie zu Schwerin*, Schwerin, Bärensprungschen Hofbuchdruckerei, 1882.

Schnapper (A.) and Ternois (D.): "Une vente de tableaux provenant des églises parisiennes en 1810," *Bulletin de la Société de l'Histoire de l'Art français*, 1976, pp. 115-162.

Schönberger (A.) and Soehner (H.): *The Rococo Age*, New York, Toronto and London, McGraw-Hill, 1960.

Scott (B.): "La Live de Jully Pioneer of neo-Classicism," *Apollo*, XCVII, 1976, pp. 72-77.

Seidel (P.): "Beiträge zur Lebensgeschichte Jean-Baptiste Oudry's," *Repertorium für Kunstwissenschaft*, XIII, 1890, pp. 80-110.

Setterwall (Å.): "Lovisa Ulrikas matsal på Stockholms slott," *Rig*, 1962, pp. 49-59.

Le Siège en France du moyen age à nos jours, physiologie du siège de G. Janneau, commentaire et tables de M. Jarry, Paris, P. Hartman, 1948.

Soulié (Eud.): *Notice des peintures et sculptures placées dans les appartements et dans les jardins des palais de Trianon*, Versailles, Montalant-Bougleux, 1852.

Stein (H.): "État des objets d'art placés dans les monuments religieux et civils de Paris au début de la Révolution française," *Nouvelles Archives de l'Art français*, 3e série, VI, 1890, pp. 1-131.

Sterling (Ch.): *La Nature morte de l'antiquité à nos jours*, 2e édition revue, Paris, Editions Pierre Tisné, 1959. Second revised English edition, New York, Harper & Row, 1981: *Still Life Painting from Antiquity to the Twentieth Century*.

Suau (P.-T.): *Notice des tableaux exposés dans le musée de Toulouse*, Toulouse, Imprimerie de A. Chauvin et Ce, 1850.

Talbot (W.): "Jean-Baptiste Oudry. Hare and leg of lamb," *Bulletin of the Cleveland Museum of Art*, May 1970, pp. 149-159.

Thiéry (L.-V.): *Guide des Amateurs et des étrangers voyageurs à Paris*, 2 volumes, Paris, Hardouin et Gattey, 1787.

Thiéry (L.-V.): *Guide des Amateurs et des étrangers voyageurs... aux environs de Paris*, 2 volumes, Paris, Hardouin et Gattey, 1788.

Thuillier (J.) and Châtelet (A.): *French Painting from Le Nain to Fragonard*, Geneva, Skira, 1964.

Toledo Museum of Art. European Paintings, Toledo, The Museum, 1976.

Tuetey (L.): *Procès-verbaux de la commission des monuments*, 2 volumes, coll. *Nouvelles Archives de l'Art français*, 3e série, XVII-XVIII, Paris, Charavay, 1901-1902.

Tuetey (L.): *Procès-verbaux de la commission temporaire des arts*, 2 volumes, coll. *Documents inédits sur l'histoire de la France...*, Paris, Imprimerie nationale, 1912-1917.

Vaultier (R): "Peintres de la chasse," *Jardin des Arts*, no. 23, November 1956, pp. 681-687.

Venzmer (E.): *J. B. Oudry, Farbige Gemäldewiedergaben*, Leipzig, VEB E. A. Seeman Verlag, 1967.

Vergnet-Ruiz (J.): "Oudry," in *Les Peintres français du XVIIIe siècle*, edited by Louis Dimier (2 volumes, Paris and Brussels, G. van Oest, 1928-1930), II, pp. 135-194.

Vergnet-Ruiz (J.) and Laclotte (M.): *Great French Paintings from the Regional Musuems of France*, New York, H. N. Abrams, 1965.

Villot (Fr.): *Notice des tableaux exposés dans les galeries du Musée impérial du Louvre*, 3e partie, école française, Paris, Vinchon, 1855.

V[ollmer] (H.): "Oudry, Jean-Baptiste," in *Allgemeines Lexikon der bildenden Künstler*, edited by U. Thieme, F. Becker *et al.*, XXVI, pp. 98-99, Leipzig, Seeman, 1932.

Wallace Collection Catalogues, Pictures and Drawings, 16th edition, London, printed for the Trustees by William Clowes and Sons Ltd, 1968.

Watson (F. J. B.): "Eighteenth-century painting and decorative arts," *Apollo*, LXXVI, 1967, pp. 454-465.

Weigert (R.-A.): "La manufacture royale de tapisseries de Beauvais en 1754," *Bulletin de la Société de l'Histoire de l'Art français*, 1933, pp. 226-242.

Wildenstein (D.): *Documents inédits sur les artistes français du XVIIIe siècle conservés au Minutier central des notaires de la Seine aux Archives nationales*, Paris, Les Beaux-Arts, 1966.

Wildenstein (D.): *Inventaires après décès d'artistes et de collectionneurs français du XVIIIe siècle*, Paris, Les Beaux-Arts, 1967.

Wildenstein (G.): *Le Salon de 1725, compte rendu par le Mercure de France*, Paris, G. Levrault, 1924.

W[yzewa] (T. [de]): "Les relations de J.-B. Oudry avec la cour de Schwerin," *Chronique des Arts et de la Curiosité*, 1890, pp. 124-125, 133-134.

Zmijewska (H.): "La critique des Salons en France avant Diderot," *Gazette des Beaux-Arts*, 6e période, LXXVI, 1970, pp. 1-144.

Index of Lenders